MATERIAL CULTURE AND SOCIAL IDENTITIES IN THE ANCIENT WORLD

Recent studies have highlighted the diversity, complexity, and plurality of identities in the ancient world. At the same time, scholars have acknowledged the dynamic role of material culture, not simply in reflecting those identities but in creating and transforming them as well. This volume explores and compares two influential approaches to the study of social and cultural identities, the model of globalization and theories of hybrid cultural development. In a series of case studies, an international team of archaeologists and art historians considers how various aspects of material culture can be used to explore complex global and local identity structures across the geographical and chronological span of antiquity. The essays examine the civilizations of the Greeks, Romans, Etruscans, Persians, Phoenicians, and Celts. Reflecting on the current state of our understanding of cultural interaction and antiquity, they also dwell on contemporary thoughts of identity, cultural globalization, and resistance that shape and are shaped by academic discourses on the cultural empires of Greece and Rome.

Shelley Hales is Senior Lecturer in the Department of Classics and Ancient History, University of Bristol. She is the author of *Roman Houses and Social Identity* and is co-editor, with Joanna Paul, of *Pompeii in the Public Imagination from Its Rediscovery to Today*.

Tamar Hodos is Senior Lecturer in the Department of Archaeology and Anthropology, University of Bristol. Author of *Local Responses to Colonization in the Iron Age Mediterranean*, she co-directs the Çaltılar (Lycia) field project and serves on the editorial board of *Anatolian Studies*.

MATERIAL CULTURE AND SOCIAL IDENTITIES IN THE ANCIENT WORLD

Edited by

SHELLEY HALES
University of Bristol

TAMAR HODOS
University of Bristol

CAMBRIDGE
UNIVERSITY PRESS

CAMBRIDGE UNIVERSITY PRESS
Cambridge, New York, Melbourne, Madrid, Cape Town, Singapore,
São Paulo, Delhi, Dubai, Tokyo

Cambridge University Press
32 Avenue of the Americas, New York, NY 10013-2473, USA

www.cambridge.org
Information on this title: www.cambridge.org/9780521767743

© Cambridge University Press 2010

First published 2010

Printed in the United States of America

A catalog record for this publication is available from the British Library.

Library of Congress Cataloging in Publication data
Material culture and social identities in the ancient world /
 edited by Shelley Hales and Tamar Hodos.
 p. cm.
 Includes bibliographical references and index.
 ISBN 978-0-521-76774-3 (hardback)
 1. Material culture – Social aspects. 2. Group identity. 3. Social evolution.
 4. Social archaeology. 5. Civilization, Ancient. I. Hales, Shelley, 1971–
 II. Hodos, Tamar. III. Title.
 GN406.M34916 2009
 306–dc22 2008054356

ISBN 978-0-521-76774-3 Hardback

for MHL, RHL, and EJ

CONTENTS

ILLUSTRATIONS

ABOUT THE CONTRIBUTORS

ANNETTA ALEXANDRIDIS is Assistant Professor of Classical Art and Archaeology at Cornell University. She is the author of *Die Frauen des römischen Kaiserhauses. Eine Untersuchung ihrer bildlichen Darstellung von Livia bis Iulia Domna* (Philipp von Zabern 2004).

CARLA M. ANTONACCIO is Professor of Archaeology and Chair of the Department of Classical Studies at Duke University, and co-director of the Morgantina Excavations in Sicily. She has held fellowships at the Center for Hellenic Studies and the National Humanities Center. She is the author of numerous articles on the archaeology of ethnicity and identity.

SHELLEY HALES is Senior Lecturer in Art and Visual Culture at Bristol University. She is the author of *Roman Houses and Social Identity* (Cambridge University Press, 2003).

RICHARD HINGLEY is Reader in Archaeology at Durham University. His most recent book is *The Recovery of Roman Britain: 'A Colony so Fertile'* (Oxford University Press, 2008).

TAMAR HODOS is Senior Lecturer in Archaeology at Bristol University. She is the author of *Local Responses to Colonization in the Iron Age Mediterranean* (Routledge, 2006).

PETYA ILIEVA is an archaeologist with the Greek Archaeological Service in Komitini. Her doctoral dissertation was entitled 'Aegean Thrace between Lake Bistonis and Propontis (8th–6th c. BC)' (Sofia University 'St. Kliment Ohridski,' 2006). She was a British Academy Postdoctoral Academic Visitor at Oxford University in 2007.

ELENA ISAYEV is Senior Lecturer in Ancient History at Exeter University. She is the author of *Inside Ancient Lucania: Dialogues in History and Archaeology* (Institute of Classical Studies, 2007), and co-editor (with C. Riva and G. Bradley) of *Ancient Italy: Regions without Boundaries* (Exeter University Press, 2007).

LLOYD LLEWELLYN-JONES is Lecturer in Classics at the University of Edinburgh. He is the author of *Aphrodite's Tortoise: The Veiled Woman of Ancient Greece* (Classical Press of Wales, 2003) and other works on ancient gender, Greek and Persian sociocultural history, and reception studies.

DAVID MATTINGLY is Professor of Roman Archaeology at Leicester University. His most recent monograph is *An Imperial Possession: Britain in the Roman Empire* (Penguin, 2006). He is a Fellow of the British Academy.

CORINNA RIVA is Lecturer in Mediterranean Archaeology at the Institute of Archaeology, University College London. Most recently, she has co-edited (with G. Bradley and E. Isayev) *Ancient Italy: Regions without Boundaries* (Exeter University Press, 2007).

MICHAEL SOMMER is Lecturer in Ancient History at the University of Liverpool. He has recently published *Römische Geschichte II. Rom und sein Imperium in der Kaiserzeit* (Alfred Kröner Verlag, 2009).

ACKNOWLEDGEMENTS

The editors would like to express their gratitude, for support in making this volume possible, to BIRTHA; the Institute of Greece, Rome, and the Classical Tradition; the Department of Classics and Ancient History; the Department of Archaeology and Anthropology, all at the University of Bristol.

Our gratitude also to Sinclair Bell, Rachael J. Dann, Angela di Nero, Hella Eckardt, Sue Grice, Alexandra Grigorieva, Linda Jones Hall, Inge Hansen, Marietta Horster, Frances Liardet, Kathryn Lomas, Jonathan Lucas, John Manley, Janett Morgan, Robin Osborne, Hannah Platts, Ian Stewardson, Marlene Suano, Peter van Dommelen, Henner von Hesberg, Greg Woolf, Beatrice Rehl and Tracy Steel at Cambridge, the anonymous reviewers of the manuscript, and, of course, all our contributors, some of whom make their own acknowledgements at the end of their chapters.

MATERIAL CULTURE AND SOCIAL IDENTITIES IN
THE ANCIENT WORLD

THEORETICAL
FRAMEWORKS

CHAPTER ONE

LOCAL AND GLOBAL PERSPECTIVES IN THE STUDY OF SOCIAL AND CULTURAL IDENTITIES

Tamar Hodos

Introduction

What do we mean when we talk about identity in the past? Are we referring to the way individuals thought about themselves and the way they communicated that to others through actions or material belongings (whether through active choice or more passive reflection)? Or do we mean the way individuals and groups are seen as collectivities by others? In fact, it is both, and more. Identity may be defined as the collective aspect of the set of characteristics by which something or someone is recognizable or known. These may be behavioural or personal characteristics, or the quality or condition of being the same as something else. This sense of collective similarity among entities, be they objects or individuals, implies that the very notion of identity also depends upon opposition through a contrast with something else. Such identification markers therefore are both active and passive, and they can be performative and receptive.

The relationship between the notion of identity and our mechanisms of social distinction enables us to examine different kinds of identities, whether they be cultural, personal, or social. Culture encompasses the social production and reproduction of meaning.[1] It represents a coherent system of values, norms, and habits that, through repetition, engender a sense of unified belonging, individually and collectively, over time. Paradoxically, within its own system, culture serves as its own agent for change while maintaining its continuity and perpetuity. In other words,

culture, while constantly evolving, perpetuates as a result of its urge to modify its representative patterns over time.[2] Efforts to define culture have highlighted that it has a dual nature, that it is defined both by inclusion and exclusion. We rely upon our ability to identify both repetition and differentiation of practices in order to distinguish who belongs and who does not; a distinction already noted with regard to attempts to establish and to recognize identity. Cultural identity may be seen in the use and shared practice of those characteristics that go into generating the repetitive system of values, norms, and habits of a culture. Within this, other forms of identity exist: a sense of personal identity may be seen as giving meaning to 'I,' while social identity guarantees that meaning and allows one to speak of the 'we.'[3] Ethnicity is one specific form of social identity that relates to self-conscious identification with a particular sociocultural group.[4]

This volume reconsiders the ways we recognize the perceived and projected identities of past cultures through their material and visual remains. In particular, the contributions to this volume are articulated around two major perspectives in the recent study of ancient cultural and social identities. One is the notion of hybrid cultures and their roles within our perceptions of culture, while the other adopts a more global perspective of culture that is derived from these internal cultures. The former focuses on the reinterpretation of material culture as it appears in contexts different from that in which it originated. Material selected by an individual or group is deliberate, and the reasons behind such explicit choice within these new contexts are explored here. One might argue that this avenue emphasizes the cultures within a culture (terminology that is preferable to subculture, which implies a distinct and more exclusive cultural layer hiding under a broader umbrella, and is often characterized as deviant from that broader norm). The latter examines how the heterogeneous natures of these regional cultures work together to create a sense of broader cultural unity while still emphasizing their distinctiveness. In the case of the ancient world, these would be the regional or more geographically local cultures that contributed to the greater notions of Greek and Roman culture. The papers in the present volume grapple with both these perspectives. At the same time they establish the important role that material and visual cultures play in shaping as well as simply reflecting identities, both within their own media and through

their relationships with literary texts. Antonaccio (in Chapter Two), for example, explicitly challenges the prevalent thought that material culture is secondary to a sense of ethnic identity, which is often derived by scholars from ancient literature. The case studies in these papers represent the first effort to consolidate these theoretical frameworks with regard to the ancient world to derive working methodologies across a range of approaches in order to demonstrate how theory might be applied to this unique intersection of material, visual, and literary cultures. The case studies are not exhaustive, however, and thus the concluding chapter highlights additional avenues that might be explored.

The Development of Identity Studies

The following overview is not intended to present a history of identity studies in the disciplines of ancient history, classical art, and archaeology, but to provide an indication of key moments when the relation between cultures and identity has been stressed in these disciplines.[5] This relationship has often centred upon ethnicity, and many of the papers in the present volume focus upon constructs of ethnic identities. This is, however, only one strand in the debate about the relationship between culture and identity, and other narratives could be presented that emphasize different aspects of identity, such as gender or class. Indeed, several papers here too confront ideas about culture, gender, and class to produce new frameworks for considering the depth and diversity of meaning that the term identity encapsulates.

From the necessarily selective perspective of key moments, therefore, the study of identities of past civilizations may be seen to find its origins in eighteenth- and nineteenth-century Romantic interest in the environmental and racial determinants of specifically ethnic identity. Romantic thought's emphasis on race as a natural and immutable characteristic, as expressed in novels as early as Mme De Staël's *Corinne, or Italy*, in 1807, led in part to theories of racialism that would eventually culminate with the Darwinian evolutionary thinking of the 1860s, which popularized the belief that biological inequality existed between human groups. On the one hand, such ideas should be understood against a backdrop of the increasing sense of nationalism and the search for nationhood across Europe, particularly the unification of Italy (1850s–70s)

and then Germany (1871). On the other hand, such perspectives were quickly extended to account for cultural differences between Western and non-Western societies, for many believed that, as a result of natural selection, human groups had evolved not only culturally but also in their biological abilities to utilize culture. Popularized by the writings of Lubbock,[6] the idea quickly took hold that technologically less advanced peoples were not only culturally but also intellectually and emotionally more primitive than civilized communities. This perspective justified European political and economic control of other regions and territories beyond Europe and supported Europe's colonial empires, which were viewed as promoting the general progress of the human species by advancing Western ideals. Scholarship, in particular, viewed prehistory as linked to Europe's cultural pre-eminence: by the nineteenth century, this was manifested in the search for confirmation in the classical world of the evolutionary lineage of cultural development to which nineteenth-century Europeans believed they were heir.[7] It is in this atmosphere that European prehistory and classical archaeology thus emerged as disciplines (although arguably discontinuously and somewhat diversely in each national tradition).

Romanticism and modernism defined ideas of identity, not only by giving birth to nationalism and racialism but also, via psychoanalysis, by defining for the Western white audience a sense of self and other, of identity and identification.[8] These two strands, of the collective community and personal self, have subsequently dominated understandings of identity. At the same time, modernism's sense of progress and of faith in the success of Western Europe and its interconnectedness to the imperial programmes of nineteenth-century Europe further encouraged thinking in terms of polarities from the vantage point of 'dead white European males.' Such influence is most immediately obvious in the development of concepts such as Romanization, a term that has been widely dissected in recent years.[9] While, as will be discussed, studies of material culture have moved on to postmodern ideas, psychoanalytic thought, particularly as developed by Lacan's work on the gaze, has remained a great influence on the more theoretical scholars of ancient visual culture.[10]

The influence of evolutionary thought on the classical archaeologists of the nineteenth and earlier twentieth centuries can be observed in

attempts to assess artefacts as stages of cultural development illustrated through seriation and typological development (see, e.g., Furtwängler on gems and other objects; Mau on Pompeian wall painting styles; Beazley on Greek vase painting).[11] In many respects, classical archaeology of this period was very much the study of art of the ancient world. Ancient art examined alongside ancient architecture, dress, philosophy, customs, political forms, and literary genres characterized the study of antiquity as the foundations for European cultural and political world sovereignty,[12] although efforts were also made to define a relationship between specific social groups and material culture through the systematic compilation of typical object types, their chronological development and their geographical distribution in Europe.[13] It was not until the early twentieth century, however, and especially through the work of Childe, who produced the first large-scale synthesis of European prehistory with his 1925 *The Dawn of European Civilization*, that the emphasis moved from artefact types to the significance of the assemblages of material as a means of defining a cultural group.[14] Childe emphasized that assemblages of objects typify, or identify, a particular culture. The underlying premise was that bounded, homogeneous cultural entities corresponded with particular peoples, based upon the assumption that any such people shared ideas, beliefs, space, and material culture.[15] This led to the study of the origins of, and the movements and interactions between, archaeological cultures, such as the search for the Minoans.[16]

This new emphasis on how groups of people lived and interacted with one another in the past enabled that past to be visualized as a mosaic of delineated cultural groups. Each group had materials distinguishable from those of another, and, by inference, must therefore have had specific ethnic identities as well. For Childe, a material's significance was determined by its functional role, rather than serving an emblematic purpose. The utilitarian value of objects such as tools and weapons understandably would result in a rapid diffusion from one group to another, while modes of burial, decorative ornaments, or household pottery would reflect more local tastes and were therefore less likely to change over time.[17] In other words, in this functionalist view, ethnic traits did not diffuse readily, whereas technological ones did.[18]

Since Childe's interest was in understanding cultural changes, which he argued were due to culturally external factors, such as migration or

diffusion, including of technology, and not internal ones, in his view the absence of external factors resulted in cultural continuity. He began to doubt whether much could be learned about ethnicity from archaeological data alone or whether ethnicity was even a concept that could be central to the study of prehistory.[19] During subsequent years, archaeological thinking continued to address issues of change but began to examine these from the perspective of the systems that make up a culture. Such approaches characterized the so-called New Archaeology, which dominated the study of archaeology largely until the 1980s,[20] and equally did not focus on ethnic identity, or even on other social identities. Rather, their preoccupation rested in holistic systemic views of culture, cross-cultural generalizations, and culture's relationship with environmental, technological, and economic factors, rather than a specific culture's social aspects (ideologies, religion, etc.) or historical contexts. This is despite the development of diverse schools of interpretation in archaeology during these years, such as Marxist perspectives (especially in the Soviet Union and to a lesser extent in postwar Italy).[21] Thus, studies of identity and identities were overlooked by these approaches, which emphasized the processes of culture development rather than the social lives of those of the cultures under examination.[22]

During this period, classical archaeology, although no longer an Antiquarian pursuit, nevertheless continued to emphasize its artefacts as typologically ordered art, especially within the sphere of Greek archaeology,[23] remaining largely unconcerned with interpretations that regarded the objects and their styles as reflections of culture in material and visual forms.[24] Thus, little headway was made in the study of ethnicity, or indeed of other forms of social identities, despite a burgeoning interest in the overseas settlements of the Greeks and Romans.[25] Rather, such sites were intellectually trawled for information about the development of homogenized concepts of Greek and Roman culture and artistic output; indeed, such unified models of culture dominated in classics itself during this time.[26] The influence of modernist beliefs during this period is reflected elsewhere in the humanities, and across the social sciences as well.[27]

By the 1980s, critical momentum overflowed across the social sciences in Western scholarship with a backlash against such systemic methodologies. In classical archaeology (which by now in North America and the

United Kingdom was beginning to become lodged between the separate disciplines of archaeology, classics, and art history, each of which followed its own theoretical trajectories)[28] and ancient history, this can be seen in a shift of interest to the more social interpretations that could be inferred from a text or drawn from material and visual culture, by which artefacts, art, and texts began to be seen widely as the meaningfully constructed material representations and literary/historical products of a culture.[29] These could then be viewed as reflections of various social meanings, including ethnic identity, though not exclusively so. The emphasis since this paradigm shift has been on the interpretation of the social meanings inferred from a critical analysis of texts or gleaned behind the design, manufacture, uses, and deposition of styles and material from the past, which must be regarded holistically as aspects of material and visual culture, be they as small as a single object or as large as an empire. This has given rise to a number of perspectives by which the same text, artefact, or work of art may be read, such as for gendered interpretations,[30] power through agency,[31] or for extrapolating the experiences of the non-elite,[32] frameworks often garnered from other disciplines, such as sociology.

Postmodernism and the Study of Identity

The variety of approaches to the material and visual pasts, which articulate different aspects of the social past (focusing on gender, age, class, on individuals as agents, or the voices of the colonized, to suggest but a few), is one facet of the wider postmodern movement prevalent in Western intellectual thinking since the 1980s. The very name 'postmodernism' implies a development beyond the ideals of modernist thinking,[33] which focused on metanarratives and world systems. In contrast, postmodernism witnesses, embraces, and thrives upon the fragmentation of the very master narratives that guided modernity. Within the movement, there is thus an emphasis on decentring, on diversity, on otherness, and hence on the local. Postmodernists have sought to break down the power balances and interdependencies that bind together groups of people, emphasizing instead variety at a more vernacular level, where pluralities can be placed alongside each other without hierarchical distinction.[34] In conjunction with postcolonialism, this encouragement of

pluralities was in many cases explicitly supported in order to give others (once labelled in modernist discourse as 'the other') a voice. Inevitably, such an approach, which deliberately contests the hegemony of 'dead white European males,' threatens the very foundations on which our visions of the classical world have been built. At the same time, some regard postmodernism as a particularly Western ideology, and explicitly as a purely cultural phenomenon expressive of an evolution of Western capitalist society.[35] For some classicists, postmodernism's connection to capitalism renders it redundant for exploring the classical world.[36] This volume, however, seeks to explore ways in which, while acknowledging the artificiality of borrowed models, postmodern concepts of identities can reinvigorate our understanding of personal and collective identities in antiquity, and stimulate a reconsideration of the material we study. The present collection of case studies interrogates the assumptions we make when we discuss identity and explores how various postmodern models of identity may be used to forge more potent interpretations of how material and visual culture was created and manipulated in the past.

One of the most influential texts in reassessing ideas of 'the other' was Edward Said's *Orientalism*,[37] which highlighted how the West produced and circulated knowledge of eastern Mediterranean cultures over time to accompany, enable, support, and maintain colonial power in the Middle East and by extension elsewhere. The colonial discourse Said highlighted promoted a timeless opposition between Western and non-Western peoples and circulated ideas that encouraged the Western subjugation of the supposedly less-civilized Oriental populations. By highlighting this discourse, Said was able to demonstrate that other narratives could be told that shed a different perspective on cultural practices, traditions, beliefs, meanings, and intentions. In breaking down the Western metanarrative, Said opened a door that enabled non-Western perspectives to articulate themselves in broader spheres. (It should be pointed out that Said was explicitly opposed to and critical of Western metanarratives rather than politically neutral to them, and critics of his work have emphasized his double standard in priorities; see especially Bernard Lewis.) It is from this vista that we see the rise of subaltern and postcolonial studies, which seek to draw out the voices of the others, the oppressed, those not the drivers of the metanarratives of Western capitalism and colonialism.

This explains the particular emphasis among ideologically postmodern scholars and writers on identities and on the impact colonial domination has had upon local cultures.[38]

For much of this period, archaeological and historical scholarship's interest in identity has remained largely focused on the identification and development of specifically ethnic, or national, identity as reflected in material culture or elucidated through textual evidence of genealogy, linguistic diversity, and myth-history.[39] Art history, particularly where concerned with the ancient world, has similarly emphasized ethnicity, especially with regard to power.[40] Cultures have often been viewed as indicators of ethnicity, defined as a self-conscious identification with a particular social group.[41] One might argue, however, that ethnicity is an active designate of an explicitly political nature, whereas a cultural identity arises from a broader social patterning. Sociologists have noted that it is easier to identify a common ethnic core where there has been a long-term process of national formation,[42] which by its nature is borne out of political direction. This can be applied to the past as much as the present, for ethnicity must be constituted in the context of specific cultural practices and historical experiences that provide the basis of the perception of similarity and difference.[43] These experiences must inevitably be tied to events in history that can be deemed political, having affected cultural landscapes and resulted in the need for cultural groups to distinguish themselves from one another. This is not to say that ethnicity and culture are strictly correlated. On the contrary, an ethnic group is, in fact, a fluid, dynamic, and contested form of identity, and one that is embedded in economic and political relations.[44] In extinguishing the Romantic passion for ethnicity as biological essentialism, such ideas place new emphasis on the active relationship between 'ethnicity' and material culture.

Thus, some archaeologists, ancient historians, and art historians have tried to outline methodologies for extrapolating markers of ethnic identity from the material record of the past. For some, these are reflected in a set of specific defining criteria, particularly a common myth of descent, territory, and shared history, with secondary indicia including shared language, religious practices, and even biological features.[45] It could be argued, in fact, that a sense of home is sustained by collective memory, which itself depends upon ritual performances,

bodily practices, and commemorative ceremonies.[46] For others, marks of a distinct ethnic identity can be seen in the shared habitual practices that provide the basis for the perception of cultural affinities, arising specifically from the systematic communication of cultural difference in relation to other groups. Thus, manifestations of ethnicity 'are the product of an ongoing process involving multiple objectifications of cultural difference and the internalization of those differences within the shared dispositions of the *habitus*.'[47] One could argue that ethnic identity provides a common repository of myths, heroes, events, landscapes, and memories that are organized and made to assume a primordial quality.[48] Several papers within this volume (e.g. those of Antonaccio, Chapter Two, and Isayev, Chapter Eight) explicitly see the idea of the ethnicity of a group as developing almost as a social label superfluous to the observed connectivity through a shared material culture.

It is important to distinguish ethnicity from another closely related term: race. While both refer to a common geographical and/or biological descent or origin,[49] race, especially when applied to its use in the ancient world, can be defined as a group of people who are believed to share imagined common nonsocial characteristics that are thought to be determined by unalterable, stable physical factors, such as hereditary or external traits (e.g. shared geographical origin).[50] One key aspect of this definition is that such characteristics are often believed of a particular group of people by others (an etic perspective), rather than by the group itself (an emic perspective). Thus Isaac is able to identify and discuss not just races but racism explicitly as racial hatred in Greek and Roman writings because ancient authors spoke of other populations, and did so often in bigoted terms and with social hatred as a means of political, social, and/or imperialistic justification for the Greeks and Romans,[51] giving rise to the various connotations surrounding the terms race, and racism itself, today.[52] Although the boundary between race and ethnicity is historically variable, ethnicity may be regarded as a wider classificatory principle, especially as a group identification, while race is often more closely related to situations of domination, usually with regard to social organization as perceived externally by the dominating power.[53] Thus, ethnicity may be considered as an ideological framework for a more emic analytical discourse – that is, within the context of the group(s) in question – rather than an etic approach – as perceptions by one group of another

or others. This is, of course, a simplified distinction. Nevertheless, since many of the papers in the present volume consider ethnicity from emic perspectives, race is not a concept that is emphasized here.

Nevertheless, many of the papers do draw upon Greek and Roman written sources as a starting point for discussion about other populations, or Greeks and Romans living elsewhere, and even different classes within a particular population. But they do so always within interpretative frameworks rather than using the texts as direct evidence,[54] and in the context of material and visual culture. Thus, Sommer (Chapter Five) is able to chart the rise and identity of the merchant class within Phoenician society using textual evidence written by external recorders of the Phoenicians, for no Phoenician historical texts survive. It is the analysis of these literary sources in harmony with material culture, however, that enables him to examine the international interplay of the merchant class within the Mediterranean arena of the Early Iron Age. Llewellyn-Jones (Chapter Seven) turns this around in his use of visual evidence to elucidate more appropriate interpretations of ancient texts. Thus, while literary scholars have recently claimed that Xenophon intended to emphasize the height of Persian women by calling them *megalai,* visual cultural evidence demonstrates that it is their ample girth he was discussing. A converse approach can also be enlightening, however. Riva (Chapter Four), for instance, demonstrates that Pindar's reference to the Argonauts at the Lemnian games is not helpful in understanding the social meaning of the San Paolo olpe in its own cultural context of Iron Age Italy. Isayev plays with both the internal and external projections of the ethnic tag of Lucanian to demolish the notion that ethnic identity could be a helpful framework for interpreting past communities, since any such collectivity was fluid over time and determined more by immediate context than by any sense of timelessness. These various methodologies are drawn together in Hales' discussion of the performative and represented aspects of both the reflective capacity and the iconography of mirrors in the funerary monuments from Klagenfurt (Chapter Nine). Hales plays these aspects off against literary references to the distortional nature of reflected images in the writings of contemporary Roman social commentators to illustrate how Romanness could only be regarded as the sum of its parts.

The breakdown into the elements that make up a sense of ethnic identity has contributed to the further deconstruction of the factors creating our broader ideologies of Greek and Roman culture beyond ethnicity, for in the 1990s there emerged a new wave of scholarship that has focused on the more geographically localized contexts that inform our sense of the ancient super-cultures. Such scholarship analyses those material, artistic, and historical factors that created the impression of global cultures rather than merely how these others defined and represented themselves.[55] There has also been an increasing awareness of factors affecting identity and the use of particular items that may intersect with but sometimes oppose ethnic lines: a marker of gender, status, or cultic identity may also serve as an indicator of another type of identity, such as ethnic, for example.[56] Important work by Woolf,[57] for instance, has demonstrated that elite status was perhaps more important than ethnicity to those attempting to buy into the Roman Empire. In recent years, the increasing influence of other disciplines, such as sociology and philosophy, has helped archaeologists and art historians to rethink Roman imperial identities.[58]

Yet how are these localized contexts defined? What makes something 'local'? Within the sociological tradition, the term *local*, and its derivatives *locality* and *localism*, have generally been associated with the notion of a particular bounded space with a set of close-knit social relationships based upon strong kinship ties and length of residence. There is usually the assumption of a stable, homogeneous, and integrated cultural identity that is both enduring and unique. Thus, empirically, it has often been assumed that members of a locality formed a distinctive community with its own unique culture.[59] One facet of this distinctive quality is its relational opposition to others.[60]

There are two sets of difficulties within these assumptions, however. First, questions can be raised surrounding the mechanisms whereby we delineate the boundaries of a locality: not only are there geographical questions as to the extent of the physical environment (does it include certain streets, an area bounded by city walls, or a territory under single political control?), but there are also interrelationship questions, for even geographically isolated communities may still function as parts of greater sociocultural groupings, and politics, as a human-generated factor that may well influence migration or exchange, can often play a role

in defining such groupings. Are there limits to the size of the group and place to be considered a local community? Yaeger and Canuto define a community as a 'dynamic socially constituted institution that is contingent upon human agency for its creation and continued existence…[and that is] focused on the communal aspect of interaction and identity formation.'[61] It is the emphasis upon agency rather than just geography that allows a community to range in size from a social entity of two to a national level. It is, in fact, in the sense of communal interaction in a shared space that 'local' finds its working definition.

The second set of difficulties stem particularly from assumptions of stability and homogeneity. Culture is used as a differential consisting of a set of social behavioural and representational properties attributed to a given population.[62] It can never be static, for it is ever evolving, both in anticipation of and in response to internal and external events that its individuals and collective groups enact and experience. The same can be said for identities, both projected and perceived; they may be hybrid or not, but they are constantly evolving, even if simply in response to internal conditions. Equally, culture is not homogeneous. Rather, it is an assemblage of practices, ideas, customs, traditions, beliefs, institutions, and products of work and thought. Within this there is an assumption that culture is somehow a real existing entity, object, or system of relations, that is bounded in some way, but is also differential,[63] since the notion is the product of a relationship between the observer and those being observed, whereby the observer can distinguish between his own group and that of others. The frame of reference, however, remains essential by its very nature. Not all these essences are required all the time to impart or imbue a sense of association with a particular social status, construct, or stratum, however. In the case of ethnicity, for instance, there is unlikely to be a one-to-one correlation between expressions of ethnic identity and the full range of social practices and materials associated with that particular cultural group.[64]

Habitus, Cultural Codes, and the Creation of Local Culture

The link between the expression of ethnicity and of other forms of social identity is the notion of shared habitual practices in shaping any sense of identity (i.e. not just as applied to ethnicity, but as underwriting any kind

of identity). This draws upon Bourdieu's notion of *habitus*, the concept of a series of strategies for ordering experience and informing action. For Bourdieu, human actions are embodied: the body is conceived as a bounded entity through which action is channelled, whether as internal motivation or external stimulation.[65] Thus, *habitus* may be conceptualized around the unconscious embodied practices that make up a way of being,[66] although to define it formally contradicts its essence of ambiguity and unpredictability in its contexts of use. Habitual practices contribute to the development of many of our social identities, be they cultural, ethnic, gendered, ageic (i.e. of age or life stage), classist, and so forth, since all of these require social interaction for their development, representation, and reflection. These shared ways may include shared customs and traditions, or shared material or visual culture, or, more precisely, the shared significance or social value invested in material and visual culture and imparted by their use. These shared practices and value forms contribute to identity through their shared, collective aspect. Yet because culture is constantly evolving, any normative mechanism of expression can be fixed and determined only at a given moment. As we endeavour to discern identity symbols from the records of the past, one of the difficulties we face is defining that collective expression over time, since culture, its representations, and its reflections constantly evolve from and in response to the events, ideas, and experiences of contemporary life. The expression of any comparative cultural difference therefore depends upon the particular cultural practices and historical experiences activated in any given social context, as well as broader idioms of cultural difference.[67]

Within the postmodern movement, we may find 'an emphasis on the way in which master narratives occlude more complex combinations of differences, local diversities and otherness, the voices which were ignored or suppressed in the unified models.'[68] This often entails the deconstruction of generalizations in order to recognize the multicoded nature of cultural materials and beliefs. As Featherstone has noted, the problem arises when it is assumed that the repertoire of forms used in everyday life, the commonsense routines and typifications (or Bourdieu's *habitus*) become destabilized and more fluid.[69]

He further observes that a local culture may have a common set of work and kinship relationships that reinforce the practical everyday

lived culture, which has sedimented into taken-for-granted knowledge and beliefs, or *habitus*. The articulation of these beliefs and sense of the particularity of the local place, however, will tend to become sharpened and more clearly defined when the locality engages in power struggles with its neighbours. This is precisely the case with the development of an explicitly Lucanian coin ethnic during the Second Punic War, as demonstrated by Isayev (Chapter Eight). In such situations, the local culture emphasizes its own identity and often presents an oversimplified unified image of itself to outsiders, or, perhaps, has such a simplified image imposed on it by those outsiders.[70] This image can be likened to the local community's face, or mask. This is highlighted again in central Italy, where some Lucanian communities chose not to display the Lucanian ethnic in their coins. This does not mean that inside the locality social differentiation had been eliminated and relationships were necessarily more egalitarian, simple, and homogeneous; rather, its internal differences and discourses may very well have been complex. Yet under certain circumstances, internal conflicts may be forgotten. Individual differences are subsumed into a larger collective and appropriate cultural work is undertaken to develop an acceptable public face for this collective/wider community. This process entails the mobilization of the repertoire of communal symbols, sentiments, and collective memories.[71] This is perhaps best illustrated by Riva (in Chapter Four) with the spread of the Argonaut myth from the Greeks to the Etruscans, where it served as a global language of mythology between Greek and Etruscan elites in their commercial and cultural exchanges, but then was also manipulated by the Etruscans themselves in competitions for status and prestige within their own communities. The common material culture between Samothrace and the north-eastern Aegean allows Ilieva (in Chapter Six) to suggest that the historical record of the island's colonization by Samians must be questioned further. In all of these cases, it is the routinized action that created the meaning of the images and symbols that are then manipulated in the invention of social and cultural, including community, identities.

Knowledge of social and historical contexts is therefore essential in order to identify the performative aspects of the construction of social identities, and to recognize the characteristics that serve as those identity constructs, whether actively designated or merely perceived as such

by others, perhaps habitually so. Butler's theory of performativity[72] advocates that any such understanding of identity is predicated by the repetition of its performance since identities are created through sustained social performances. The repetition acts both as a reenactment and reexperiencing of the set of socially established meanings, which have become legitimized over time through the stylized repetition of the acts. This is the means by which identities are constructed and maintained. Identity attributes therefore become performative (active) rather than expressive (passive), constituting the identity they are said to express or reveal.[73] This notion of performativity revolves around the ways in which an identity produces that which it posits as outside itself. What we take to be the internal essence of an identity is manufactured through a sustained set of acts that become materialized. In other words, acts of identity signification are performative in the sense that the essence of the identity that they otherwise purport to express is a fabrication manufactured and sustained through corporeal signs and other discursive means.[74] An individual will express a social identity by an act that is both intentional and performative as a contingent construction of meaning.[75] This notion of the performativity of social identity is further picked up in this volume in the papers by Antonaccio (Chapter Two), Alexandridis (Chapter Ten), and Hales (Chapter Nine).

Such acts, however, can only be understood in the social and temporal contexts in which they appear. Sociohistorical knowledge is essential for interpreting such performances in the past, particularly when we try to understand and reconstruct elements of past societies from their fragmentary material and literary records. Furthermore, we must recognize that these acts cannot be regarded as unchanging repetitions, since performance transformations occur over time, or at least in the repetition of the act from one performance to the next, and changes arise from the arbitrary relation between such acts, such as a failure to repeat, or a modified or de-formed performance. It is also essential to consider that an act or performative marker may be intended to express more than one identity (or aspect of identity); it may be intended by the performer that the act can be read in multiple ways that depend upon the perspective of the reader/viewer. Thus, what may be regarded as an ethnic indicator may equally reflect other socially constructed identities beyond ethnicity, depending upon the contexts of the viewer, as

well as the performer. This may be illustrated by architectural continuity in religious structures among the Lucanians: while one might argue that such forms indicate a Lucanian identity, they may in fact have been reflections of religious practices and ideologies rather than an explicit and deliberate expression of cultural identity.[76] Images – whether portrait types in sculpture or on coinage, or implied or visualized reflections through mirrors or on glyptics[77] – require similar consideration of broader sociocultural and political contexts for the exchange and interpretations of performative intentions. Each indicator and identity construction must be contextualized: even Butler herself concedes that the assertion of universality conjures a reality that does not yet exist.[78] Since culture is a socially constructed concept, one can argue that any cultural or social identity articulated through material culture is performative in the ways in which these identities are expressed, whether through the repeated use of an object in specific contexts or particular ways.

Consumption and Material/Visual Social Value

The communication of such performances relies upon shared frames of reference not only of object functionality but also object symbolism, for material culture entails codependency of mind, action, and matter.[79] The same can be argued for visual culture. Therefore, it is not just the use of similar material or visual culture that is significant in the reinforcement of identity but also the meanings behind the use of such material. Goods from the past would have been part of a live information-exchanging social system. It is not so much the individual objects themselves that would have been significant in this communication but the ideas embodied within: the culture gives rise to and also arises from the material. Thus, material and visual cultures embody strategies of communication that may be articulated and mediated through shared cultural codes.[80] Consumption, therefore, which entails the selection, adoption, and use of goods, is an integral aspect of this system, and one that accounts for the drive to have mediating materials for relating to other people.[81]

If culture is a practised product, it cannot be understood as an autonomous object that has somehow become heterogenized.[82] Products can move across borders, but in order for culture to be thus transferred, the

practice of signifying must also be displaced, as identity and meaning become reinterpreted in new contexts. Consumption research therefore may focus on the symbolic aspect of goods and how they look, and their role as communicators (as well as loss of meaning, appropriation, or revaluing, for example). Goods may mark boundaries between groups, and create and demarcate differences or communality between individuals and groups.[83] Goods, therefore, can be used to draw the lines of social relationships.

Friedman has observed that consumption remains an aspect of the broader cultural strategies an individual adopts for self-definition and self-maintenance. The relationship between self-identification and consumption is important to articulate. Self-identification may be a conscious act to make a statement about the relation between self and world, or it may be a taken-for-granted aspect of everyday life, as part of a predefined, culturally contextual identity. Consumption may be regarded as an aspect of a more general strategy or set of strategies for the establishment and/or maintenance of selfhood. Other practices of cultural self-constitution – ethnic, class, gender, and religious – which consume specific objects and construct life spaces, may be viewed as higher order modes of channelling consumption to specific ends. These specific ends are the means of identification.[84]

Therefore, the practice of identity generation encompasses a practice of consumption and even production. If we assume a global historical frame of reference it is possible to detect and even to account for the differences among broad classes of identity strategies, and therefore of consumption and production, as well as their transformations in time. This is the case, at least, to the extent that the different strategies of identity, which are always local, just like the subsumed forms of consumption and production, have emerged in interaction with one another in the global arena.[85] This can be seen in Riva's work (Chapter Four) on elite discourse between Greeks and Etruscans as articulated through mythological consumption alongside technological development, as well as in Ilieva's study (Chapter Six) of the ceramic assemblage of Samothrace, where production and consumption challenge traditional interpretations of Greek colonization on the island during the Iron Age.

Consumption within the bounds of the world system is always a consumption of identity, canalized by a negotiation between self-definition

and the array of possibilities offered by the market.[86] Our modern concept of *consumer culture* points not only to the increasing production and salience of cultural goods as commodities, but also to the way in which the majority of cultural activities and signifying practices become mediated through consumption. Hence, the phrase *consumer culture* outlines the ways in which consumption ceases to be a simple appropriation of utilities, or use values, to become a consumption of symbols.[87]

It is through consumption that modifications to the cultural codes develop (although not exclusively by this means), resulting in new methods of thinking and reading material culture, social customs, practices, and the performance of traditions. This gives rise to what may be viewed as hybrid cultures. Ideas of hybrid cultures find their origins in criticisms of colonial discourses, which could not produce stable and fixed identities of the colonizers or colonized, despite their efforts to do so, because of the differences within each and the cross-over between them that colonial discourses did not recognize.[88] The notion of cultural hybridity may be expanded to represent the social cross-fertilizations of diverse communities, which often occur (though not always) as a result of specifically colonial encounters, and from which new and complex identities arise, as well as new forms of internal and external cultural communication. The idea of hybridity accounts for the dynamics of cultural differences between cultures, or even communities, as they are never in simple binary opposition, given the complex social make-up and diversity of social representations, reflections, and identities within those groups.[89]

The spheres in which the mechanisms of cross-community or cross-cultural dialogue engage, and from which new means of discourse develop that are acceptable to the different sides, are often assumed to be neutral spaces, for only in a neutral context can the various sides be *mutually accommodated* in the new vocabulary of interaction. Such contexts have been called a Middle Ground. Following White's definition,[90] the Middle Ground serves as a means of interpreting the physical, material, and social interactions of cultures, interactions in which everyone has agency and mutual need. It acts as core and periphery, in both geographic and social contexts. It emphasizes mutual accommodation and requires an inability of both sides to gain their ends through force, which is why new conventions for cooperation must develop. Those operating in a Middle Ground act for interests derived from their own cultures but

they must convince those of another culture that some mutual action is fair and legitimate. As a process, therefore, it unites value systems to create a working relationship between them, often resulting in new sets of meanings and interactions over time. In turn, discourse within the Middle Ground may affect the conventions of the contributing parties, imparting long-term changes in the local cultures.[91]

The emphasis on accommodation distinguishes the Middle Ground and the hybridized cultures arising out of the accommodating discourses from the idea of a Third Culture, which similarly has a mediating function. The Third Culture has been defined as the behaviour patterns created, shared, and learned by members of different societies who are, by their activities, engaged in relating their societies to each other. It is not merely a mutual accommodation or amalgamation of two separate, parallel cultures, however, but the creation of something new organizationally that serves as a conduit for cultural flows that are more than just the product of bilateral exchanges.[92] Examples cited by contemporary sociologists include organizations such as the European Union and the United Nations, and even the ecumenical movement among Christian churches.[93] In other words, a Third Culture is a deliberately created organizational forum that is separate and distinct from the contributing parties in which communications between the members take place.

Mutual accommodation is not articulated materially through shared material and visual culture but through the shared symbols of the material (as objects and what they display). Ideas deriving from the *consumer culture* of contemporary times therefore have application in the past, where mutually accommodating symbolism explains the rapid exchange of ideas alongside material goods, often as a means of social advancement. Riva's exposition on the development of metal-working technologies alongside the spread of the Argonaut myth from the Greeks to the Etruscans is an example. The myth itself, which centres on the search for natural resources and the development of new technologies, epitomized the overarching interactions between the Greeks and Etruscans during the seventh century BCE, which saw the interchange of vessel technologies (metalworking and clay vase painting) intertwined with commercial exchanges for raw materials. However, social advancement may not be the driving factor. A different kind of consumer culture may be inferred

from the contemporary ceramic assemblage of Samothrace, as Ilieva discusses, where material from the regional ceramic *koine* was consumed by the various populations of the island to such an extent that the literary sources attesting Samian colonists appear unreliable.

Globalizing the Local

The meanings, symbolisms, and material culture shared between various Mediterranean populations have allowed the Greek and Roman worlds to be regarded through the lens of the contemporary idea of globalization. Globalization refers to the current sense of global compression in which the world is increasingly regarded as a coherently bounded place. Today, with the advent of world technologies and communication abilities, such as the internet, mobile telephony, and satellite transmissions, it has become much more difficult for states and cultures to avoid the consequences of a sense of one-placeness generated by the increase in volume and decrease in dissemination time of money, goods, people, information, technology, and images.[94]

Globalization has been defined as the process whereby the world increasingly becomes seen as one place and the ways in which we are made conscious of this process.[95] Yet the cultural diversities highlighted by postmodern scholarship seem to direct us away from a single world or systemic view of the world towards a more fragmented outlook that accentuates the local. This is not a contradiction in perspective, however. As Featherstone has pointed out, this seeming discrepancy is a misunderstanding of the nature of globalization, which should not be taken to imply that there is a unified world society or culture.[96] Rather, we should consider two aspects of the process of globalization. The first is the existence of a global culture comprised of sets of practices or bodies of knowledge that transgress national or cultural ideas. The second is that one result of growing intensity of contact and communication at such a level can be a clash of cultures, which leads to heightened attempts to draw the boundaries more strongly between different groups. Thus, changes that take place as a result of intensified contact can be understood as provoking reactions that seek to rediscover particularity, localism, and difference. This is, in fact, one of the paradoxes of the process of globalization: that, instead of culture homogeneity,

it has highlighted and reinforced cultural heterogeneities. So in one sense it can be argued that globalization produces an emphasis on local diversities. Hales (in Chapter Nine) offers the example of Catrona Severra's attempts to articulate a social status identity for herself and her husband, which, while embracing 'global' practices of iconography, epigraphy, and monumentalization, nevertheless results in a peculiarly 'local' product.

Usually, a local culture is perceived as being a particularity, which is the opposite of the global. A sense of local belonging returns us to the ideas behind community identity, which are not necessarily physically bounded. Rather, the taken-for-granted, habitual, and repetitive nature of the everyday culture of which individuals have a practical mastery[97] creates a sense of belonging. These will include reinterpreted ideas and materials originating externally but blended with existing customs, traditions, and forms as much as indigenous continuity. The sense of distinction from others can be found in identifying what makes the other. In fact, many societies have defined themselves explicitly by contrast with others, with the unifying elements as the substratum rather than the highlighted elements. The Greeks, for instance, identified themselves from others based upon language, for anyone who did not speak Greek was a *barbaros*. This distinction has given rise to our use of barbarian to mean someone who is uncivilized, which is actually closer to Roman notions of the differences between Romans and non-Romans.[98] Nevertheless, when defining what it was that made the other, past cultures were at the same time defining themselves, their own identities, what made them them. This was replicated in a very real and practical sense by individuals through their choice of material usages, religious beliefs, and practices, by town planners, architects, and their patrons through the forms of buildings designed and constructed, and was described by classical authors in literature, recorded for history or to be played out for audiences to share.

The movement of goods, styles, and ideas led to developments, accommodations, and assimilations of practices, goods, and ideas. In today's terminology, the mechanisms by which forms, ideas, and practices are adapted and modified to create an intersection are sometimes called 'glocalization' or 'local globalization.'[99] This interpenetration of the global and the local is a defining feature of global society. It is evident

in the various aspects of social life in which the global ideologies are tailored to local needs, which in turn inform those very global-level aspirations. The assimilation of objects and ideas from outside often involves transformations that reassert self-identity at a local level.[100] Alexandridis (in Chapter Ten) illustrates this clearly in her study of the developments of Pudicitia imagery and the changing performative nature of the representation of virtue over a wide geographical region as a direct result of localized developments that further reinforced local ideologies. Hales (Chapter Nine) demonstrates explicitly a duality of influence between local dialogues and an empire-wide discourse in her study of reflected images in different areas of the Roman world.

While it is perhaps easiest to illustrate such examples when the global ideologies that inform and are being informed are empirical, since the political superstructure offered by empire can be enabling (as well as restricting),[101] the global entity need not be limited to a political empire. Greek culture, with all of its localized variations, still maintained a number of shared traits, beliefs, customs, and practices across a wide swathe of the Mediterranean that allow us to conceive of it as a global culture in its time. Riva (Chapter Four) shows this clearly with the articulation in Etruria of the Greek Argonaut myth, widely circulated at that time in the Greek world. Both Ilieva (Chapter Six) and Antonaccio (Chapter Two) remind us of the significance of the contexts where cross-cultural interactions take place, and the impact they have on both local cultures and global ideas. Ilieva demonstrates this by illustrating Thracian and Ionian elements that contributed to the material culture of Samothrace during the Iron Age, while Antonaccio's discussion of the Sikels highlights that the Greek culture with which the Sikels interacted was a specifically Sicilian Greek culture. Yet, in each case, the localized aspects inform and perpetuate notions of the more global Greek culture.

Localizing the Global

Global cultures may be viewed as providing an enabling role to encourage local integration and incorporation, through administrative or economic policies for instance. But it is a two-way street, and a different interpretation is possible, such as one that sees dominant cultures keeping local populations in a more dependent position and excluded

from the centres of power. As Hingley, among other contributors to this volume, points out (in Chapter Three), while we should not deny that many local populations and individuals were able to capitalize upon global changes to their own benefit, we must also remember to examine the degree to which local populations were manipulated by more globally encompassing cultures.

Hingley illustrates how Batavia was integrated into the Roman Empire through the inclusion of its soldiers in the Roman army but, at the same time, was kept in a position of dependency by other aspects of cultural exclusion. Isayev (in Chapter Eight) demonstrates that the idea of the Lucanians as a community was both internally and externally created and perpetuated, transmuting over time in response to social and political developments generated by engagement with Rome and its territorial expansion. Alexandridis (Chapter Ten) shows how local developments in portraiture informed global ideas of appropriate mechanisms for displaying female virtue in the Roman world, yet were kept in check by Roman convention. Llewellyn-Jones (Chapter Seven) makes a similar argument for the Persian Empire through the medium of gemstones, with their localized representations of ideal beauty both within and contributing to a Hellenized means of expression. Riva (Chapter Four) highlights the complexity of local and global discourses through the epic of the Argonauts, which was used as a means of common communication between Etruscan and Greek elites, though the vocabulary was still Greek. This notion can also be extended to non-elites, as Sommer (Chapter Five) demonstrates clearly in his study of the Phoenician merchant class, which both manipulated and was manipulated by the global frameworks within which it operated, global in both the sense of Phoenician-wide culture and also the Mediterranean network of contact and exchange and common understanding.

Many of the case studies assembled here also address the multiplicity of social identities that may be enacted by material and visual culture. Riva, for instance, shows how advances in technology and the transmission of myth contributed to the very development of a sense of cultural identity among the Etruscans yet also provided an arena for social status competition and display. Alexandridis demonstrates the variety of performative interpretations in an artefact while assessing evidence for social standing within a society. Hales emphasizes that the performance

projected by an individual may be interpreted in diverse ways by different audiences.

Equally important, but in the past often little understood or explored, are the occasions in which communities deliberately do not interact with particular sets of material culture although the opportunities are available to do so,[102] a corollary to Antonaccio's discussion of material choices for circulation. Ilieva's emphasis on commercial relationships on Samothrace allows for a reinterpretation of who the colonists might have been, based as much upon what the populations did not consume as what they did. Isayev's deconstruction of the concept of the Lucanians, similarly based upon selective consumption, also addresses the notion of unintentional identities in mixed cultural contexts.

These contributors not only revisit the relationship between the local and the global in light of the recognized complex structures of social identities in the ancient Mediterranean but also present new avenues for research. No longer can it be considered acceptable to isolate one facet of social life or cultural aspect for study, because the interrelationships that inform the representation, reflection, and performance of that facet have been demonstrated to be intrinsically integrated with other sociocultural elements. The papers in this volume reflect the fact that no identity can be studied independently of other social forms. The methodologies outlined here demand recognition of the intermingling of social and cultural identities and demonstrate the complexities and interrelationships between them, since whatever aspect of whichever identity is being performed or reflected informs aspects of other social and cultural identities that contribute to the creation, definition, and symbolism of sociocultural groupings. Together, these papers serve to illustrate the ways in which various aspects of material and visual culture can be used to explore precisely the genesis, development, and relationship of social and cultural identities in local and global contexts of the ancient world.

Acknowledgements

I am grateful to Greg Woolf, Shelley Hales, and the anonymous readers for Cambridge University Press for valuable suggestions to earlier drafts of this contribution. The ideas expressed here are purely my own

and derive from a number of inspirations and perspectives. Many readers will no doubt find elements that will disagree with their own alternative narratives, which, by necessity, will have derived from different sets of inspirations. It is only through engaging with current issues in such a manner that discussion can be generated, for this is how scholarship progresses. The overviews presented here serve as the first step in the cross-fertilization between all the papers in the present volume, which is intended to be just such a move forward.

Notes

1. Shanks 2001, 289.
2. See Bauman 1999, xvii–xx.
3. Bauman 1999, xxxi.
4. Shennan 1989, 5–6; see also Meskell 2001, 189.
5. See Díaz-Andreu and Lucy 2005 for an overview of the history of identity study in the broader discipline of archaeology. For a recent perspective on the balance between identity and agency, see Knapp and van Dommelen 2008.
6. Lubbock 1865; Lubbock 1870.
7. For summaries, see Trigger 1989, 110–47; J. Hall 1997, 1–16.
8. Hales mentions the failures of psychoanalysis in relation to colonial and postcolonial audiences: see Chapter Nine.
9. Curti, Dench, and Patterson 1996; Webster and Cooper 1996; Mattingly 1997b.
10. E.g. Stewart 1997; Elsner 2000.
11. Furtwängler 1900; Mau 1882; Beazley 1925.
12. See also Morris 1994; Morris 2000, 37–76. Classical archaeology as a discipline has always been more rooted in the classical tradition than in the field of art history. The following brief historiography of the discipline therefore more appropriately tracks developments in classics and archaeology, especially as related to the study of social identities.
13. Jones 1997, 15.
14. Childe, himself, drew upon the thinking of the German archaeologist Kossina: see Veit 1984. See also Marchand 1996, 180–7.
15. E.g. Childe 1925; Childe 1929; see also Trigger 1989, 167–74.
16. Evans 1921–1936.
17. Childe 1925, viii and 248; Trigger 1989, 170–1.
18. Trigger 1989, 297.
19. Childe 1930, 240–7; Trigger 1989, 244.
20. Trigger remains the best summary of these developments. While it may appear to be a leap from Childe to the 1980s, the fact remains that the processualist approaches, which really began with Childe and continued largely until the postmodern era (and there are still scholars who continue to utilize processual frameworks), ignored the study of social identities. Therefore, these periods are not as directly relevant to the present discussion.
21. Khatchadourian 2008; Dyson 2006, 214, 217; Trigger 1989, 207–43.

22. For example, while Soviet archaeology explored the classical world, it did so to mine it for examples of precapitalist social systems that relied on the slave mode of production: Dyson 2006, 214.
23. Snodgrass 2007, 14–15; Neer 1997; see also Marchand 1996.
24. In other words, for much of this period, classical archaeology remained rooted in its art historical perspective and largely excluded the application of other interpretative archaeological frameworks; nevertheless, despite its art historical tradition, the study of the art of the ancient world has always been more closely allied with the fields of classics and archaeology than art history itself. Donohue 2003, 2; Osborne and Alcock 2007, 4; Millett 2007, 38–9.
25. Dyson 2006, 228–36.
26. This is illustrated very clearly in changing portrayals of the Greeks over this period, recounted in narratives of classics' survival as a discipline since the modernist ideologies of the 1960s informed curriculum reform. See Bloom 1987; Hanson and Heath 1998; duBois 2001; Cartledge 1998a. Bulwer 2006 highlights national diversities within Europe.
27. See, for instance, Robertson and Lechner 1985.
28. See also Donohue 2003, 3–4.
29. E.g. Hodder 1982; Dougherty and Kurke 2003.
30. E.g. Koloski-Ostrow and Lyons 1997.
31. Gell 1998.
32. E.g. Clarke 2003.
33. As opposed to a rupture with modernism: Featherstone 1988, 197.
34. Lyotard 1984; Harvey 1989; Featherstone 1991; Featherstone 1995. For an example of such a re-examination and self-reflection within the discipline of archaeology, see Gramsch 2000 and Kaeser 2000, 34–6.
35. E.g. Friedman 1994, 102; Featherstone 1995, 89.
36. Dench 2005.
37. Said 2003 [1978].
38. E.g. Bhabha 1994; Spivak 1987. For summaries of its development see also Loomba 1998, Hoogvelt 2001 [1997]; van Dommelen 1997; van Dommelen 2006a. Bernal's *Black Athena* volumes of 1987, 1991, and 2006 collectively represent perhaps one of the best-known examples from the ancient world, albeit widely contested: Peradotto and Levine 1989; Lefkowitz and Rogers 1996; Berlinerblau 1999.
39. E.g. Shennan 1989; Graves-Brown, Jones, and Gamble 1996; Jones 1997; Emberling 1997; Hall 1997; Hall 2002; Woolf 1998; Millett 1990. See also Laurence 2004, 99–113; and Sauer 2004b, for dialogues between the two disciplines. For the influence of postmodernism on archaeology, see Renfrew 1989 and Bintliff 1993; see also Fenton 2003.
40. Donohue 2003, 1 and 9; Stearns 2003.
41. Shennan 1989, 5–6. Culture in this sense has been seen as both representative of and constitutive of the people concerned: Jones 1996, 65. For anthropologists, ethnicity is seen as one form of identity: see, e.g., Cohen 1985; but see also Jenkins 1997.
42. Featherstone 1995, 112.
43. Jones 1996, 70; Jones 1997.
44. Jones 1996, 66.
45. Hall 1997, 17–33; Hall 2002, 9–24.
46. Connerton 1989.

47. Jones 1996, 70; Jones 1997.
48. Smith 1990, 171–91.
49. Isaac 2004, 25–33; Hall 1997, 17–33; Hall 2002, 9–24. See also Gosden 2006; Isaac 2006; Jones 1997, 40–55.
50. After Isaac 2004, 35–6, and 37–8. More specifically, racial identity in the ancient world was based upon environmental determinism combined with a belief in the inheritance of acquired characteristics, the constitution and form of government, autochthony and pure lineage: Isaac 2006. For responses to Isaac's perspective, see Tuplin, Burstein, and Dominguez 2007, 327–45.
51. Isaac 2004, 503–16.
52. Isaac 2004, 25–38.
53. Jenkins 1997, 21–4.
54. See also Hall 2007a.
55. Beginning with re-examinations of Roman Imperialism that drew on postcolonial thought: see Webster and Cooper 1996; see also Dench 2005; Hingley 2005; Woolf 1998. For re-examinations of Greek culture, see Hall 1997; Dougherty and Kurke 2003; Lomas 2004; Malkin 2001b.
56. Casella and Fowler 2004, 1–8.
57. Woolf 1994b, 84–98; Woolf 1998.
58. Hales 2003; Hingley 2005.
59. Featherstone 1995, 103.
60. Cohen 1985, 12.
61. Yaeger and Canuto 2000, 5–7.
62. Friedman 1994, 72.
63. Friedman 1994, 73.
64. Jones 1996, 70.
65. Bourdieu 1990.
66. Bourdieu 1977.
67. Jones 1996, 70.
68. Featherstone 1995, 80.
69. Featherstone 1995, 80.
70. See, for instance, Webster's examination of Roman thinking about Gaul: Webster 1996a.
71. Featherstone 1995, 110.
72. Butler 1999 [1990].
73. Butler 1999 [1990], 178–80.
74. Butler 1999 [1990], 173; Butler 1993.
75. Butler 1999 [1990], 177.
76. Isayev, Chapter Eight.
77. For portraiture, see Alexandridis, Chapter Ten; for mirrors, see Hales, Chapter Nine; for glyptics, see Llewellyn-Jones, Chapter Seven.
78. Butler 1999 [1990], xvii.
79. Knappett 2005, 131.
80. See, for instance, Appadurai 1986.
81. Douglas and Isherwood 1996 [1979]), viii–xiv.
82. Friedman 1994, 75.
83. Douglas and Isherwood 1996 [1979]; Sahlins 1976; Appadurai 1986.
84. Friedman 1994, 103–4.
85. Friedman 1994, 115–16.
86. Friedman 1994, 104.

87. Featherstone 1995, 75.
88. Bhabha 1983; Bhabha 1984; Bhabha 1990; Loomba 1998.
89. For a succinct summary, see Knapp 2008, 59–61.
90. White 1991, 50–3.
91. See Antonaccio, Chapter Two.
92. Useem, Hill Useem, and Donoghue 1963, 169–70; Featherstone 1990, 1.
93. Useem, Hill Useem, and Donoghue 1963; Gessner and Schade 1990, 259–60.
94. Featherstone 1995, 81.
95. Robertson 1992.
96. Featherstone 1995, 114.
97. Bourdieu 1977.
98. See Hingley 2005, 61, for references.
99. Robertson 1995; see also Holton 1998, 16.
100. Bauman 1999.
101. See Hingley's discussion in Chapter Three.
102. Hodos 2006.

CHAPTER TWO

(RE)DEFINING ETHNICITY: CULTURE, MATERIAL CULTURE, AND IDENTITY

Carla M. Antonaccio

Colonialism is a process by which things shape people, rather than the reverse. Colonialism exists where material culture moves people, both culturally and physically, leading them to expand geographically, to accept new material forms and to set up power structures around a desire for material culture.[1]

The category of ethnicity has become highly contested ground in all fields of archaeology, not just classical. Illustrating the point that "Classics is an active agent in the construction of modern ideologies, which is to say the constitutive illusions of modern cultural life,"[2] ethnicity's emergence as a topic of the moment should not surprise us. The focus on ethnicity, a specific kind of identity, emerged in classical studies from (or through) a more general interest in diversity in the ancient world. In the vanguard of such an interest in the late twentieth century was the focus on 'the other' (or, The Other) – most notably, the Persians.[3] Identities expressed by concepts such as gender, class, age, and the other now familiar usual suspects have also been introduced. But perhaps somewhat surprisingly in a field that focuses on the oldest dead white males in the world,[4] the last ten years have produced rich discussions about diversity in Greek culture, and about Greek ethnicity, not just about how 'The Greeks' confronted 'The Other.' The emergence of ethnicity in studies of the Greek past has also been part of larger projects that question assumptions about the uniformity, coherence, continuity, and boundedness of Greek identity both in the past and in the present, and about the origins and production of Greek identity.

In taking on ethnicity, scholarship first had to repudiate the racialist approaches that produced and continue to produce the many catastrophes of recent history, and reject essentialist notions of ethnic identity, founded in Romanticism, as well.[5] Some scholars champion definitions of ethnicity that are familiar to us moderns in our own experience, an ethnicity based on shared notions such as ideologies (religion, ideas, beliefs) and histories (myths, collective memories) – that is, as a subset of cultural identity. Cultural identity differs from ethnic identity in that it transcends characteristics such as gender, class, age, sex, and so forth.[6] This kind of definition, however, has been strongly challenged in recent work on ethnic identity in classical antiquity, which has emphasized criteria for ethnicity that are based on narratives or discourses of descent and homelands. Ethnicity is an identity that uses criteria in the form of kinship or descent (real or contrived) and territorial homeland to articulate its specific boundaries. While it may be seen as a kind of cultural identity, it is not the same thing as cultural identity per se.[7] Cultural attributes that may articulate ethnicity, on the other hand, constitute its indicia. But culture need have nothing to do with the distinctive identity that is ethnicity. Thus, in considering Greek antiquity, what matters in defining a specifically ethnic identity is descent from a common ancestor, such as Ion for the Ionians, Doris for the Dorians, Hellen for the Hellenes, and the identification of an original home territory. Traits that we might consider decisive criteria, such as using a particular kind of pottery, wearing one's hair in a particular way, speaking a particular dialect, or any other cultural practice or material articulation of identity, do not constitute criteria for the specific kind of identity that is ethnicity.

All this work has also included a consideration of the status of the concept of 'culture' itself, and an inoffensive and usefully broad notion of 'identity' sometimes substitutes for the contentious 'ethnicity' or 'culture.' The effort to define what is distinctive about a specifically ethnic identity also meant confronting the old culture-history method, which essentially equates the pattern of artefacts in a bounded territory and time with a particular culture (and a population, a 'people,' or an ethnic group). Culture-history had come under justifiable criticism some time ago in the wider field of archaeology.[8] Indeed, related work documented ethnographic cases that contradicted a corollary assumption to the culture-historical model, that is, that ethnicity is reliably expressed

through cultural indicia. Such indicia, which encompass familiar categories such as language, religion, physical attributes, foodways, modes of dress, and so on, would of course include material culture. And material culture is just what archaeology concerns itself with, in categories such as artefact style or type, burial customs, ritual, personal ornamentation, inscriptions, and so forth. Jonathan Hall concluded that archaeology could not get at ethnic identity without having an account of the criteria (descent and territory), and of the specific indicia that might articulate the ethnicity in question. Needless to say, archaeologists were reluctant to accept this conclusion, and not just because it relegated the field to the status of handmaiden to the written record, a traditional position that archaeologists have long been struggling to overcome (see, for example, Isayev's discussion in Chapter Eight). Accepting this conclusion likewise meant accepting that, in general, considering meaning and identity in the very long human past not documented by written sources was also futile. And it meant accepting the primacy of written or spoken discourse, a fragmentary discourse and often an elite discourse, as determining meaning for an entire culture, group, or population.

I have argued elsewhere that not only can ethnicity be predicated on criteria of descent and territory, but also that material culture (as well as other aspects of culture) more often than not has a role in expressing this particular kind of identity (although there are, as Hall has pointed out, instances where this is not the case). A recent treatment of ethnicity and archaeology has suggested that what distinguishes a specifically ethnic identity is that an agreed notion of origin is the point of reference.[9] In addition possibly to expressing or reflecting ethnicity, however, material culture has an active role in shaping it, and in contesting it.[10] While the boundaries delineated by criteria may not be mirrored in consistent patterns of material (or other forms of) culture, I have suggested that material culture forms an alternative discourse, as a discourse of things. A material discourse does not (merely) reflect or express a particular spoken discourse of ethnic identity – nor should it, necessarily. When the discourse of things contradicts, negates, contests, or merely crosses the boundaries expected from the criteria, it must not be discounted, but, rather, closely attended to.[11] At the same time, chosen objects (or customs, words, modes of dress, and so on), while they do not always retain their original meaning when recontextualized (as part of an elite transcultural

idiom, for example), may still retain particular resonances for their users.
Riva (Chapter Four) demonstrates this with regard to Etruria, while
Alexandridis (Chapter Ten) makes the point with Roman statue types.
I have also argued that examples of this kind of active constituency as a
form of material ethnicity can be identified in colonial societies as well
as other situations where contact and conflict tend to produce ethnic dif-
ferentiation just as contact and assimilation do. I want to consider fur-
ther here the possibilities for understanding these different discourses
in the context of Archaic Greek history, and in particular in the colonial
milieu.[12]

The discourse on ethnicity in Greek antiquity has taken two paths:
one considers the ethnogenesis of Greek ethnic identities 'at home,' in
the core regions that, ironically enough, are considered Greek by virtue of
the very cultural-historical model that is being rejected; the other consid-
ers ethnicity in the context in which one might expect it to be produced,
in an oppositional and conflictive milieu in which Greek identity would
be defined against an opposite, that is, in the colonial sphere. In recent
years, classicists have looked especially to Sicily and southern Italy to
explore Greek identity and ethnicity further. This turn may have to do
in part with the exhaustion of the discourse on the relations of Greece
and 'the East,' and the phenomena generally subsumed under the rubric
of 'Orientalism.' But another reason is that this field of early colonialism
might provide important insights into the formation of Greek identities
in the period when so much of what we think of as distinctively Greek
was emerging (political institutions, major sanctuaries and cults, forms
and styles of material culture, and so on) and when, as shown by Hall,
Greek ethnicities were also formed. It also allows the Greeks, and the
phenomenon of Greek colonization, to be considered more fully within a
Mediterranean, or even a global, historical context (and thus to be com-
fortingly relevant in contemporary Western discourse). Finally, the dom-
inant models of ancient colonization and imperialism – Hellenization
and Romanization – were both proving unsatisfactory, despite their dif-
ferent trajectories and mechanisms. The move away from imperial mod-
els in Greek colonization has involved complex debates about the status
of 'home(land)' (Greek colonies were called *apoikiai*, or [places] away from
home) and whether early colonizing Greeks would have perceived them-
selves to be so very different from those they encountered 'abroad.' It has

been argued that, in the eighth century BCE, Greeks who were trading with and settling among non-Greeks may have seen their counterparts more as *xenoi* – a category of ritual guest-friends – than as *barbaroi*, an oppositional identity forged in the conflict with the Persians, perhaps not until the fifth century.[13] Thus, interactions with non-Greeks may be parsed as exchanges among peers, elites who participated in a common discourse of luxury goods, high-status customs such as drinking and elaborate burials, and who created a common discourse about relations through genealogies and myth.[14]

It is beyond the scope here to tackle the entire paradigm of colonialism, but recent work on ancient colonization has also been the context for putting forward competing claims about the relevance of ethnicity and the utility of concepts drawn from postcolonial studies such as hybridity or creolization in ancient colonial contexts. Hybridity is a space of mediation in which the interdependence of colonizer and colonized is acknowledged, and considers the cultural forms with which it manifests. Adopting hybridity as a model is very attractive, since it resolves the unproductive polarity inherent in Greek and barbarian/native in favour of a productive and mutual acculturation that produces new and vigorous forms. These strategies are of a piece with the idea that the mobility of early Greeks and of non-Greeks was structured as an encounter among peers – elites – rather than a cultural, economic, and military domination by a superior culture. The field of Greek colonization thus becomes a 'Middle Ground' of encounter, one in which accommodation, but also mutual incomprehension, is a crucible in which mixed or hybrid cultures and societies are formed.[15] Yet, one of the most important contemporary scholars of Mediterranean history, Nicholas Purcell, has recently pronounced ethnicity to be a veritable red herring in understanding ancient colonization: 'it is clear that the discourse of ethnicity is fundamentally unhelpful in analysing these data.'[16] Instead, in order to understand what Purcell construes as 'the history of Mediterranean exploitation' and 'the study of the interactions between exploiter and exploited in "colonial" contexts,' we must 'get beyond an essentially ethnic mode of modelling the relationship. If that mode was sometimes used by people in antiquity, it was usually as a simplifying and legitimating strategy, and there is no reason for us to adopt it too.' Instead, the 'competition for control of the zone where

the maritime and the terrestrially-oriented ecological systems abut is recursive.'[17] Such an approach may be viewed as a new kind of processualism – 'the archaic expansion as a variation on a recurring theme,' in the words of Ian Morris,[18] who, on the other hand, argues that these views actually 'flatten the flow of history in a static Mediterraneanism' and deny process. They also tend to deny individual agency or the specific textures of particular interactions.[19]

Of course, we have ancient textual sources to draw on to provide detail and texture, but texts alone do not fully encompass the totality of ancient lived experience, and material culture provides a critically important perspective on experience, at all levels of society, not just elite.[20] The problem of understanding just what is expressed with or by material culture is, of course, extraordinarily complex, and it remains central to the entire enterprise of archaeology. Most classical archaeologists would not be satisfied with the classic aphorism of Lewis Binford, which defines culture as humankind's extrasomatic means of adaptation.[21] Yet, as noted earlier in discussing how casually we all use the term 'Greek' or even 'non-Greek,' consciously or not, we all participate in a variation on the culture-history to which processual archaeology, with Binford as a leading proponent, was responding in radical ways.[22]

For their part, archaeologists have often not distinguished clearly enough what constitutes ethnic, as opposed to cultural or class-based, identities. Some have argued that linking material culture to any group that shared any kind of identity cannot be secure without already knowing the identities through texts.[23] For Hall, the bottom line would be ethnicity as defined by the spoken and written criteria of homeland, shared history, and descent. As noted already, for archaeologists, this insistence on spoken or written discourse makes inaccessible much of the past, whether the preliterate (or aliterate) past or the past experience for nonelite persons. It also denies the relevance of a discourse of material culture to ethnicity, substituting a different kind of essentialism – not a biological one, but one grounded in particular criteria, even if false descent is one of them – for the old Romantic essentialist notions. Meanwhile, anti-essentialists have stressed the performativity of identities, or their strategic uses, as Hales and Alexandridis both demonstrate in their chapters.[24] At the same time, the notion that 'individuals' freely constructed themselves from whatever material was in existence in the same

time, space, and place is not tenable, but it does appeal to liberal notions of self-determination and freedom. Cultures may not always have firm rules, but in order to be coherent there is patterning that, while malleable to some degree, is not infinitely flexible. But broadening our field of reference from the idea of discourse to the discourse of things, to encompass a more complete lived experience in the past, is an attractive alternative. Reference to lived experience does not imply that there is some autonomous agent who, paradoxically, merely experiences something, but that experience constitutes identity in important ways. Experience, even if not the same experience, is also universal to all members of a group; written and spoken discourses are not.[25] Experience encompasses the built environment in a recursive relationship; material culture makes us as much as we make things. Moreover, material culture includes knowing how something functions, how it is used, and what to use it with. This can be tested by observing the recurring patterns of material culture associated with the contexts in which objects are found – and also by observing when there are divergences from a pattern.[26]

Nearly everyone involved in these discussions insists on the importance not only of context, a central concern of archaeology (of course), but also on connection. The connectedness or connectivity or networks that structure relations may be primarily economic, or they may be broadly cultural and include such things as shared myths or the taste for certain luxuries. These are social relations that, it is claimed, produce and entail material culture. Indeed, artefacts may mediate relations between individuals, human beings interact with artefacts through their production and consumption, and artefacts also interact with each other, in relation with each other. In insisting on material culture's centrality, we may have to refine its pertinence to an expressed or external identity, and recognise that it may not be necessary to interior identities. Agency, but not necessarily intentionality, is the operative category. That is also to say that we in the present should not be bound by the past actors' intentions or experiences, since we cannot retrieve them with completeness or certainty. Rather, we can have a kind of overview that transcends these, focusing on identity that depends on interactions between artefacts and actors. (While skirting the status of ethnicity, this does not dismiss it entirely, as does Purcell; ethnicity might be viewed as one of the categories of past actors' experience here alluded to.)

Gosden has also treated identity in his recent extended consideration of archaeology and colonialism. Writing about the relationship of individuals to groups, and their identities as individuals or members of a group, he states that 'a relational view helps to sensitize us to the creation of people of different kinds through changing networks of relationships. Importantly for archaeologists, these relationships include objects as well as people....People and objects are mutually entangled and bring each other into being in a social sense, so that the efficacy of the physical world and that of social relations are mutually dependent.'[27] One of the very important points he makes is the difficulty of refusing the modern notion of individuals as consumers who are able to own property and thereby make themselves through things. Using Melanesian society as an example, he points to a model in which individuals are created through their social encounters. Gosden draws upon the work of Alfred Gell, which usefully (for archaeologists) focuses on the agency of objects.[28] Once again, however, this seems to be applicable only to elites.

> Early colonialism begins at the point at which objects are starting to break out of purely local value systems, but where a mixture of values of quantity and quality still remains. A quantitative evaluation of objects offers possibilities that detach people from their local group and move them in search of new opportunities for personal advancement.[29]

Elsewhere, he points out that any individual object would exist within an assemblage of other objects, and would also participate in a web of links in time and space – as would people: 'individuality either of objects or of people was tightly constrained by a mass of links.'[30]

In contrast to my 'ethnic resonance,' Hall has proposed that foreign luxuries that were sought after by Greek or by non-Greek elites were prized not because of their ethnic associations, but because of the elite relationships of *xenia* or guest-friendship that were necessary to obtain them. Foreign objects associated, for example, with the drinking of wine (a commodity that is also introduced, together with its associated material culture, into non-Greek spheres), such as mixing bowls (kraters), different types of cups, strainers, and other paraphernalia, were adopted as elements of a prestige goods economy, and

did not signal anything about cultural assimilation. Rather, elites 'were conversant in a symbolic vocabulary that transected ethnic and linguistic boundaries.' Moreover, despite the mediating function of Greek wine and Greek sympotic practices, 'to describe both cultural universes as "Greek" would be seriously misleading.'[31] This is because, among other things, the drinking of wine does not necessarily bring with it all the social and political baggage of the Greeks when adopted by local elites (Etruscans, Gauls, or Sicilians) any more than does the drinking of tea (e.g. Riva's chapter with regard to Etruria). For Hall

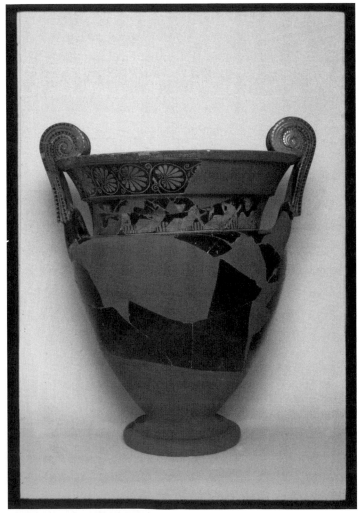

2.1a. Imported Attic red figure krater by Euthymides, late sixth century BCE (Photo: C. Antonaccio)

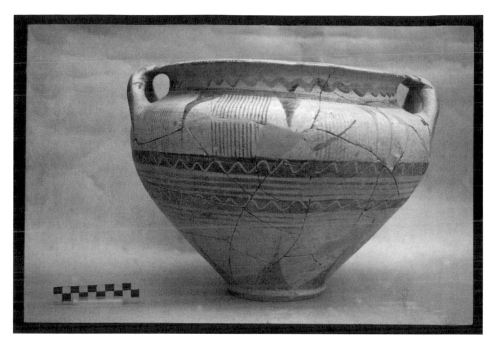

2.1b. Local Corinthianizing krater from Morgantina tomb 52, early sixth century BCE (Photo: C. Antonaccio)

and Purcell as well, what is at work in the transcultural hybridities of the Mediterranean past, such as drinking and dining, is an elite discourse that, in Greek terms, is about notions of *habrosyné* (luxury), not ethnicity. Figure 2.1a shows a late sixth-century imported Attic red figure krater from Morgantina, which might be considered a prestige item, and Figure 2.1b shows a locally produced Archaic krater of the seventh century, itself a transculturated or hybrid object: local clay has been formed into a krater clearly modelled after a Corinthian import, but the decorative scheme is only derived from the Greek original, not closely copied. Figure 2.2 records the finds from a single Archaic tomb, a hybrid assemblage of local and imported drinking wares that indicates the importance not only of drinking, but of the diversity of the assemblage itself.

According to Hall, however, while elites might have been the agents of Greek ethnicity, class had little to do with exclusion from the fictive Greek kinship systems that Hellenic ethnicities reference. Rather, elite exclusivity made use of a prestige goods economy 'to participate in a symbolic universe that did not terminate at ethnic or cultural boundaries.'[32]

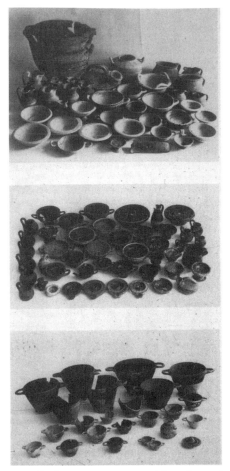

2.2. Sixth-century BCE assemblage from chamber tomb four at Morgantina (Photo: C. Antonaccio)

Yet one may agree that there existed an elite discourse without jettison-ing difference entirely. Indeed, this analysis ignores the crosscultural importance of exoticism in a prestige goods economy. Objects or materi-als are not just intrinsically valuable, but the control of space and time that is implicit in the presence of an exotic item is as much a part of elite discourse as are the commonalities in assemblages that enable that dis-course. In other words, the origins, and the age and attendant stories of a given item and its derivatives are themselves criteria in a discourse of materiality.[33]

In considering another historical situation, Nicola Terrenato notes that in the Roman Empire it may have meant little to its elites if their

fine pottery was locally produced or imported from afar, for the material discourse was essentially the same, and did not seriously affect self-perception.[34] The idea of a shared material discourse is comparable, but elites of imperial Rome disregarded the actual origins of an object or class of material so long as the qualities of that class remained. (This would make sense if the original regional, local, or qualitative aspects of the objects that were retained in its materiality were more important than the particular centre of production – the kind of resonance I have already identified.) Terrenato sees most human actors during the period of Roman consolidation and expansion as essentially unaffected by the changes and their material manifestations that are most often emphasized by modern scholars. Elite culture, moreover, is something that could undergo very rapid change, but the same was not true for everyone in the Mediterranean: 'development in these conservative groups only happened slowly and within a limited range, allowing cultural continuity and self-consistency to be maintained.'[35] Thus, for Terrenato as well, ethnicity is not a particularly useful category, but rather a kind of contemporary fixation inappropriately projected onto antiquity.[36] I would like to turn back to the western Mediterranean, and the colonial Greek sphere, to focus on a more particular context in which to address these competing claims and ideas.

Hall examines the paradigm of Hellenization in Sicily and concludes that if attention is paid to context, rather than to the formal style of artefacts, the persistence of 'local cultural traditions in the colonial world' will be detected. But whether, 'on the other hand, these traditions have an ethnic significance – as opposed to being the product of enculturating tendencies and/or a response to specific geographically-defined environmental, technological, economic and social factors – is another matter.'[37] It is interesting to detect echoes of the Binfordian definition of culture in this view. It is not, says Hall, that common ancestry cannot be signalled by material culture, and he cites the strong case that 'ancestralizing strategies' in the Argolid (the reuse of Bronze Age chamber tombs, for example) during the Late Iron Age were doing just that. But in 'the absence of an explicitly articulated ethnic discourse, there is nothing about these archaeological phenomena that necessarily makes them ethnic strategies.'[38] Indeed, by using the term 'local' and warning elsewhere of the fallacy of conflating regional cultural distinctiveness

with ethnic distinctiveness, Hall's analyses of cultural indicia nearly always end up excluding any necessary relationship between material culture and ethnicity. It is unwarranted to dismiss the distinctiveness or marked qualities of objects as too vaguely 'local,' or 'indigenous' (as opposed to specifically ethnic, or to have 'ethnic resonance') to be useful.

Here it seems useful to remind ourselves that Hall's definition of ethnicity is admirably precise, but unrecognizable to most social scientists, especially anthropologists (and archaeologists). Gosden, for instance, concludes that ethnicity only emerges 'in the manner we understand it now' at the same time as 'an instituted view of territory which fixes a group to a particular spot, tethering its identity.'[39] Thus, for Gosden, ethnicity, like hybridity, does not arise in the early Greek colonial context because of the fluidity of communities and identities. It required the rise of the city state in the Mediterranean region (Greek, Etruscan, Punic) and the territories that these urban communities controlled to produce ethnic differentiation.[40] In the Greek case, however, the kind of territory that is implicated in ethnic identity is not that of the city state, but that of the region; communities attach themselves to ancestors and their associated homelands through myths of foundation and descent. Ethnicity is expressed as a tribal identity, not a civic one predicated on citizenship. It transcends any particular city, though a city may claim to be home to an ethnic hero.

Ian Morris, from the perspective of an interior site in western Sicily, has placed stress on native persistence until the fifth century, as seen in ritual, ceramic types, and architectural forms – an ethnic identity predicated on cultural and material difference. Noting the falseness of a particular assimilation model (Hellenization), he instead posits the emergence of 'winners and losers' in a kind of globalization to which resistance was futile, just like modern instances of resistance to globalization. But Morris's identification of 'local,' 'culture,' and 'ethnicity' would not satisfy Hall because it does not deal with a specifically ethnic identity as defined by criteria.

Meanwhile, and importantly, Irad Malkin has adopted the powerful model of a colonial Middle Ground from the Midwest of North America in the seventeenth and eighteenth centuries and transferred it to the western Mediterranean (see also Sommer in Chapter Five).[41] As a case study, Malkin focuses on western Sicily in particular 'as a place of

mutual negotiation within the Mediterranean network.[42] This ground, then, is not merely a metaphor but an actual physical space in which emerges a mutually intelligible world, imposed and controlled by no single party – though it must be recognized that this world might be predicated on misunderstandings and misperceptions – in contrast to the easily permeable elite culture previously discussed. Malkin stresses a mythical framework for this intelligibility; in his most recent work it is the figure of Herakles/Melqart that mediates between Greeks and Phoenicians, and between these two groups and the local indigenes (Elymians in western Sicily). In central Italy, Malkin suggests, it was Odysseus/Utuse who was a mediating figure between Euboian Greeks and Etruscans.

Malkin makes little reference to material culture, however, or to trade or the exchange or circulation of objects in this argument, except to note the thoroughly Greek-built environment of the Elymians of Segesta (or the prevalence of Odyssean imagery or heroic cult in central or southern Italy). Yet he concludes: 'Observing ancient Greek colonization through the prism of modern imperialism and colonialism is…misleading,' as are related postcolonial concepts of hybridity ('too many biological connotations, and…[it] means little in and of itself') and suggests instead the concepts of network (or the French *réseau*). The network is not a tree, with a trunk, roots, and branches, and thus a hierarchical structure, but something more like a rhizome or a perhaps a web.[43] The lack of consideration of the wider built environment, defined broadly to include all artefacts or objects, ensures that a focus only on this kind of connectivity will miss a large part of the picture. And if hybridity seems too biological, why then is a rhizome acceptable? Hybridity does encompass well a kind of lifecycle of objects, to say nothing of the mixing of those organisms that constitute individual actors, which are operative in the colonial sphere. Indeed, Malkin omits the discourse about *métissage*, which can be applied to cultures and also to persons, for example the mestizos, who are what Gosden calls the 'living embodiments of the middle ground.' Gosden also criticizes the use of the term hybridity in colonial contexts, on the grounds that it supposes the blending of bounded, separate entities that he believes did not exist in colonial situations 'in a shared cultural milieu' such as that which applies in the case of Greek colonization.[44] Malkin's rhizome model is attractive as a way

of getting around this, but no organism, by its definition as a biological entity, is completely bounded: reproduction, which is necessary for survival, ensures change over time through adaptation and evolution.

A rhizome, as Carl Knappett notes, is moreover 'antigenealogical,' and 'deterritorializing.'[45] And so it is precisely because of the criteria of homeland and descent, in the midst of mobility, contact, and interchange, that ethnicity is a relevant and powerful category to consider.[46] Archaeologists, of course, construct typological and chronological lineages for objects – a way of thinking that employs the metaphor of coming into being, changing over time, grafting on new characteristics or losing them in the process, and eventual demise. As noted, objects have biographies – sometimes in the form of genealogies of their own, histories of their origins and exchanges. Objects interact with humans and with each other in various relationships and networks.[47] In complex societies, and in interconnected societies, situations where objects from a wide variety of origins, materials, and styles may circulate, the assembling of artefacts (among other things) involves such relationships and to some degree involves various choices. These factors are just as creative and constitutive of identity as the construction of spoken or written discourses of descent. The identity I am referencing is one that provides an orientation in space and in time, and in relation to or in dialogue with others – whether those others are artefacts or individual members of a society.

Against this we may adopt the strategy of not tying our hands by considering only the intentions and experience of long-gone actors, but to locate identities that ancient actors might not have. As noted, all identity is produced in social interaction, of which material culture is the trace (and also, as I have shown, constitutive). While focused on and formed with regard to a colonial context, these observations are important for understanding the particular identity that constitutes ethnicity. Ethnicity is a particular kind of cultural identity, though we must refuse the idea that all material culture necessarily expresses ethnic identity. Rather than contest the importance of the criteria of ethnicity proposed by Hall, it seems more useful to contest the status of material culture in this discussion. For criteria of descent and homeland *can* be extended to constitute a definitive aspect of material culture. We archaeologists do, in fact, participate in this kind of discourse already – even if we do not explicitly acknowledge it – when we construct

archaeological typologies, chronologies, horizons, all of which identify the emergence of an artefact, and then follow change through time.

As I have tried to suggest in my own work on Sicily, the process that is ancient Greek colonization takes both individuals and their cultures from one region to another, bringing into contact things and persons that developed separately and distinctly, for the most part, in periods of relative isolation (I do not deny that contact, exchange, and other forms of connectivity existed before the eighth century).[48] This particular contact and the settling down of stranger newcomers in territories they had not previously permanently inhabited is a context in which new hybrid cultures developed. As I have argued, both indigenous and Greek communities were hybridized, but what was signalled by their respective hybridities was different. For Sikels in eastern Sicily, Greek objects and practices were assimilated into an elite discourse similar to that proposed by Hall and others for the Greeks themselves in their Orientalizing (or hedonizing) turn (see Llewelyn-Jones in Chapter Seven). One could say that the Sikels were Hellenizing, rather than Hellenized, implying their active appropriation of a culture, and a degree of choice and self-determination.[49] This agency, or individual ability to affect systems like social structures operates within a field of material culture in which some shared meaning makes intelligibility possible. For example, if local Sicilian populations had no ceramic tradition of their own, that vector for absorbing new types of vessels, new decorative schemes, and new technologies would not have operated in the way that it did. Meanwhile, the continued preference for certain forms (e.g. carinated cups and bowls, illustrated in Figure 2.3) is significant because of the context of change in so many other forms of ceramics – and indeed of the general matrix of material culture. For the 'western Greeks' (a term that itself implies a kind of local, hence territorial and quasi-ethnic, identity), the particular ways in which their colonial experiences gave them a particularly Greek cultural identity, and could produce such ethnicites as the Sikeliotai (Sicilian Greeks), is equally determinative.[50]

While 'local' may not be coterminous with 'ethnic,' humans' ability to associate a thing with some other place gives it one of the criteria for ethnicity: an original homeland. The persistence of 'local' or 'indigenous' traits, habits, styles, and so on constitutes a kind of descent. Similarly, for the Sikeliotan ethnogenesis of the fifth century, Sicilian Greek ethnicity

was formulated on the basis of the shared territory of Sicily and their nearly three hundred years of shared history, as well as their local cultures, which constituted a variation on the theme of being Greek. That one could still speak of Greek or Sikel, or Elymian for that matter, well into the fifth century is a signal of the lingering ethnic consciousness – as I have defined ethnicity. It was not the case, as Hall also notes, that these different cultural systems were all 'Greek.' But to be able to make this distinction is to identify the original homeland of Greek, Sikel, or Elymian elements and to trace their descent until the process of hybridization makes something completely new. Of course, a hybrid may become so completely naturalized that it seems ancient and native; indeed, a hybrid may become the default and the process is endless. At the same time it is interesting to acknowledge that in the biological realm from which this metaphor comes, hybrids are often sterile, unable to reproduce.

The persistence of certain forms of material culture in colonial Sicily (to take just this one situation) must be considered within an understanding of objects as things, actions, and ideas all at the same time. Of course, the meanings of things are subject to change both through time and through space. What they index, in terms of actions or ideas, may also change from place to place and time to time. In other words, the 'meaning' of a vessel with a particular profile or decorative scheme in the seventh century may very well not be the same 200 years later. Indeed, the recontextualization of objects often entails a change in their meaning; thus an Attic Greek red figure krater in central Sicily does not carry with it all the institutions and customs of its producers, as previously noted.[51] The co-occurrence of other forms of material culture also contributes to constituting its meaning, use, status, and so forth. So, of course, would the individuals in their social networks who used it; and, in turn, it would have helped to constitute them. The co-occurrence of local forms is particularly indicative, when they are found to continue to be made and used in times and places where the overwhelming majority of material culture (not just pottery) now originates from another place and culture. This kind of assemblage, hybridized both with transculturated objects that partake of both local and Greek form and decoration in one and the same artefact, as well as hybridized as a whole, with imported objects, locally made imitations, and completely local types and fabrics, is perhaps an example of how material culture

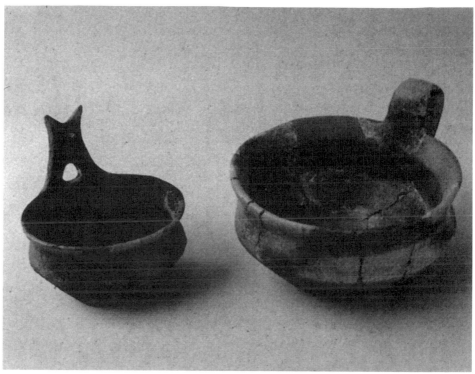

2.3a. Carinated cups of the Late Bronze and Iron Ages from Morgantina (Photo: C. Antonaccio)

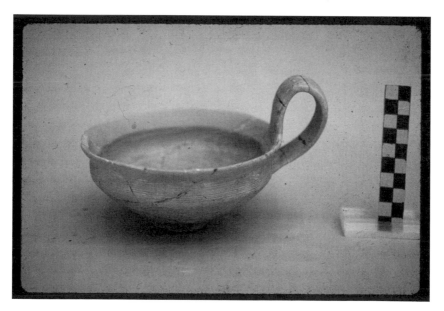

2.3b. Carinated cup of the sixth century BCE from Morgantina (Photo: C. Antonaccio)

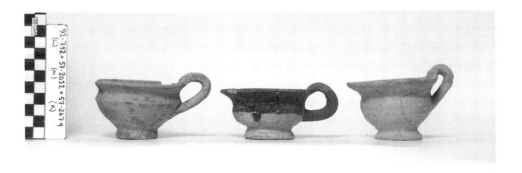

2.3c. Carinated cups of the Classical period or later from Morgantina (Photo: C. Antonaccio)

may shape humans as much as vice versa. For example, the significance of carinated forms in colonial Sicily lies in their persistence over time (see, e.g., Figure 2.3). This persistence in a home territory through time, changing but recognizable in their descent, makes them local – that is, territorially based – ancestral, and even, therefore, ethnic.

I have attempted to press the primacy of lived experience in the sense that it emphasizes the inclusion of the total built environment and also the different kinds of discourses and relations (or connections or networks, if one prefers) that pertained in the ancient Mediterranean. A full past means considering all aspects of what constituted and constructed experience in the past, as well as the present. While we are not bound by experience as a test of an identity, I suggest that the field of experience should include identities that might contradict what the actors would have *said* about themselves, sometimes called the emic view. Artefacts – produced through the interactions of humans, and also productive in relationships with themselves – generate a hybridity that may be defined as cultural, rather than ethnic, in the sense of an ethnicity of an individual person or group of people. The mixing of genealogies and origins of things that is at the heart of the concept of hybridity, however, makes the discourse of things inherently ethnic.

Acknowledgements

Thanks to the editors for inviting me to contribute this paper and their great patience while I revised it, to Karen Bassi and Peter Euben for

sharing their work, and to Donald Haggis for introducing me to the thinking of Knappett.

Notes

1. Gosden 2004, 153.
2. Porter 2003, 64–5.
3. See, e.g., Cartledge 2002 [1993]; and Hall 1991.
4. Knox 1993.
5. Jonathan Hall has drawn attention to Myres 1930 as an Anglophone example of this kind of thinking as applied to Greece: see Hall forthcoming; and Hall 2002. See also Hodos in Chapter One; and Thomas 2004, 137–48.
6. Woolf 1998, 11–15, on culture; Jenkins 1997; and Antonaccio 2003. Lucy 2005 includes a recent summary of earlier work.
7. See especially Hall 1997; and Hall 2002; outside the field of classical studies, see Lucy 2005, affirming the importance of notional shared origins or descent, rather than indicia.
8. On this, see the convenient summary in Hall 1997, 128–31; and Hall 2002, 19–29. See also Díaz-Andreu, Lucy, Babić, and Edwards 2005 for recent approaches.
9. Lucy 2005, 87.
10. See the recent comments of Cochran and Beaudry 2006, 193–9. I have set out earlier views in Antonaccio 2001; Antonaccio 2003; Antonaccio 2004; Antonaccio 2005. See now Lucy 2005, 101, suggesting that ethnicity in the past is better rendered as a spectrum of 'communal identities' expressed by means of 'behaviour, everyday practice, use of space, architecture and landscape, and personal appearance.' The best way of getting at ethnicity through archaeology is to study social practice that determines 'shared ways of doing things.'
11. See Gell 1998, 163–6; and Knappett 2005, ch. 1, on the problems with using a linguistic concept, such as 'discourse,' in considering material culture; cf. Pinney 2005, esp. 266, on Lyotard and the limits of meaning as signification, contesting the notion of discourse, and 270: 'there is an alterity (or "torque") of materiality that can never be assimilated to a disembodied "linguistic-philosophical closure," "culture," or "history."'
12. For a different take on colonialism, see Murray 2004, defining 'settler societies' as a global phenomenon. These societies, defined as 'the product of a mass European immigration where people settled on land appropriated by conquest, treaty, or simple dispossession from indigenous groups' and marked 'by a link between mass migration, major ecological change, the introduction of new diseases, and a catastrophic impact on the viability of indigenous populations' (5–6), do not seem to present an appropriate model for the situations discussed here.
13. Gosden 2004, 26, table 3.1.
14. Malkin 1998; Malkin 2002; Malkin 2004; Hall 2002, 103; as well as Hall forthcoming.
15. Malkin has been responsible for introducing the 'Middle Ground' paradigm into the discourse on the ancient Mediterranean, most recently in Malkin 2004, though without reference to Purcell and much other recent work. See now Gosden 2004, ch. 5.

16. Purcell 2005, 126, also rejecting attempts to use the models of cultural hybridity or creolization, adopted from postcolonial theorizing.
17. Purcell 2005, 133.
18. Morris 2003, 50.
19. Terrenato 2005 also urges attention to individual agency and the individual agents who enact and participate in broader processes. On the other hand, some commentators question whether the very notion of the individual is valid for the past, e.g. Thomas 2004, 6.
20. Thomas 2004, 54, drawing an analogy between the knowledge of creation beyond scripture and the use of archaeology to understand the past outside texts.
21. Binford 1965. He was building on the definition of his mentor, Leslie White.
22. Gosden 2004 is an important book that deals with this and related issues in detail.
23. Hall 1997, 142.
24. I have touched on the concept of 'strategic essentialism' in Antonaccio 2003.
25. Bassi and Euben 2003, 5.
26. See Knappett 2005, 5–6, and 137, on *connaisance* and *savoire faire*, respectively – as well as the limits of this model of material culture and human interaction with it. Drinking and feasting customs, as well as burial or other ritual contexts, are possible contexts to consider, but the possibilities include the 'mundane' (i.e. the household). See Lucy 2005, as well.
27. Gosden 2004, 35–6. We may compare this to the definition by Díaz-Andreu et al. 2005, 1–2: '"Identity" [is] understood as individuals' identification with broader groups on the basis of differences socially sanctioned as significant' and is 'inextricably linked to the sense of belonging.' Moreover, 'identification' is a process and requires individual agency, and 'identities can be hybrid or multiple.'
28. Gell 1998. See also the papers in Miller 2005.
29. Gosden 2004, 39; Gell 1998.
30. Gosden 2004, 154.
31. Hall forthcoming.
32. Hall forthcoming.
33. This has been discussed recently in the form of biographies of objects, in a number of contexts and cultures; see Malkin 2004.
34. Terrenato 2005, 67–8.
35. Terrenato 2005, 68. See also Hurst 2005 against integration and a focus on elites, and stressing local variability.
36. See Isayev in Chapter Nine.
37. Hall 2002, 110.
38. Hall 2002, 23. Gosden (2004, 157) notes that 'it is a condition of novelty to seek links with the past.'
39. Gosden 2004, 69.
40. Gosden 2004, 71.
41. Malkin 2004, and also Malkin 1998; Malkin 2002; Malkin 2003. Knappett (2005, 78) suggests that there need be no dichotomy between the notions of 'arborescent,' hierarchical systems and the 'rhizomatic,' decentered and fluid ones. He advocates 'a hybrid topology that combines the arborescent and the rhizomatic, the solid and the fluid, the striated and the smooth.'
42. Malkin 2004, 360.

43. Malkin 2004, 358–9. See also Malkin 2003, which makes many of the same points. On the ideas of networks, *réseau*, and rhizome see Knappett 2005, 64–84.
44. See Thomas 2004, 26, pointing out (with Bruno Latour) that 'modern technologies and social systems depend on creating integrated hybrids of people and things,' trumping all attempts at keeping categories separate. It seems to me that Malkin's preference for creolization (despite his ultimate rejection of this term and concept as well) with its linguistic model is a telling detail; see Antonaccio 2003 on both models; Gosden 2004, 91, on mestizos, and 69, on hybridity.
45. Knappett 2005, 78.
46. Gosden 2004, 155: 'Middle grounds allowed new scope for individuality…through the possibility that the middle ground offered of stepping out of his native group. But such individuality was unstable through time and over space, depending as it did on the ever changing conditions of the middle ground.'
47. On the biographies of objects, see Appadurai 1986; Kopytoff 1986; Thomas 1991; Gosden and Marshall 1999.
48. See Mace, Holden, and Shennan 2005 for an exploration of the notion of descent in cultural diversification on a global scale.
49. Antonaccio 2001; Antonaccio 2003; Antonaccio 2004; Antonaccio 2005; Hall forthcoming. Knappett 2005, ch. 4, and 68, suggests that 'most sociotechnical networks we observe in the world are hybrid forms' and discusses the concepts of flow and structure in communication and trade networks.
50. On the Sikeliotai, see Antonaccio 2001.
51. See Antonaccio 2003; Antonaccio 2004.

CHAPTER THREE

CULTURAL DIVERSITY AND UNITY: EMPIRE AND ROME

Richard Hingley

An older world...of dominant core and subject periphery, is breaking down, and in its place a less dichotomous and more intricate pattern of inequality is emerging. 'Empire' could be described as the planetary *gestalt* of these flows and hierarchies.[1]

Introduction: Providing a Context for Research

Studies of classical Rome are modified through time to match a changing academic discourse.[2] Here I seek to explore an aspect of the relationships between the world of ancient Rome and our contemporary times by focusing upon a developing perspective within classical studies – the analysis of cultural diversity, plurality, and heterogeneity. Ideas about the cultural diversity of the world of classical Rome provide an increasingly powerful agenda in the United Kingdom and the USA.[3] My contribution to the present volume raises the issue of the political and social context within which such ideas have emerged and are flourishing.[4]

 I propose that we should work to develop a Roman past that enables us to challenge, as well as to ground, contemporary ideas about our own world. Studies of classical Rome often explain ancient historical phenomena in terms that satisfy modern tastes and interests.[5] The development, alongside these works, of a critical perspective on the ways that classical concepts have been used to support the creation of political power and imperial relations between dominant and subject peoples

will help to make our studies relevant, enlightening, and appropriate. Through such an approach, we should seek to challenge the tradition of study in which accounts of the classical past do no more than mirror either our aspirations for or our nightmares about our contemporary situations.[6] An exploration of hybrid Roman identity will form the core of my investigation of these issues.

Discourses of Domination – the (Re-)Creation of Imperial Civilization

Today's influential approaches to diversity and heterogeneity have developed as a reaction to an earlier school of thought that modelled Graeco-Roman culture as culturally dominant, effectively bounded, and highly incorporative. These earlier writings, developed in the context of interpreting classical Rome through the theory of Romanization, suggested that Roman civilization overwhelmed and subsumed native populations across the western empire. They drew upon simple and directional concepts of Western 'civilization' and 'progress' that few scholars today would propound.[7] I shall explore this complex topic in a very general manner, studying the ways by which a fundamentally modernist discipline has reacted to postmodern critique.[8] Such an account, necessarily, simplifies a very complex history in the development of the ideas of a multiplicity of authors.

A concept of Roman culture and identity was drawn upon in the western empire throughout the period of Roman rule. Since the fall of the Roman Empire in the West during the fifth century CE, classical Rome has been drawn upon to enlighten the present in varied and contrasting ways,[9] but I shall focus on one particular issue. The writings produced by educated elite males within the Roman Empire defined what has been titled by Potter a 'discourse of domination,' one that has provided a powerful legacy for those who have sought to inherit it through the ages.[10] One strongly teleological idea, which originated with classical writers, suggests that Rome played a fundamental role in the development of Western 'civilization,' taking a legacy from ancient Greece and transforming it through the creation of a vast empire with global pretensions.[11] One important aspect of this perspective concerns the Roman concept of *humanitas*, sometimes translated as 'civilization.' Greg Woolf has

explored how this idea provided a moral justification, through the creation of an ideal Roman identity, for the process of imperialism and the domination of other communities.[12] The definition of the 'barbarity' of the colonized society by their Roman masters was taken to provide a direct justification for the territorial, military, and political domination of these people, through the argument that imperial control was allowing a higher civilization to be passed on to culturally inferior peoples. The idea that this civilization had, itself, been passed on to the Romans by the classical Greeks helped to provide a strong ideological justification for the conquest and control of societies on the margins of imperial order. That the Romans had inherited these ideas as a result of the influence of the peoples of classical Greece upon their societies, was, in turn, taken to provide justification for the Roman domination of what were termed 'barbarian' societies.[13]

This powerful idea was received and transformed by Western powers during the nineteenth century to justify imperial relations. During the early twentieth century, Rome was interpreted as having disseminated a unique 'civilization' across a considerable part of the world, including areas that today lie within Europe, North Africa, and the Near East. This idea provided a conceptual legacy for emulation by the modern nations that have revisited and reinterpreted Rome's imperial ambitions, giving Europe, especially Western Europe, a precedent for imperial ambition.[14] Early accounts of Roman culture projected such conceptions by focusing on the supposed unity of Roman imperial civilization through the use of the theory (or theories) of 'Romanization,' ideas that stressed a process of 'progress' from 'barbarian' to 'Roman' culture in the expanding empire.[15] In doing so, classical studies adopted and helped to create the polarities and hierarchies that formed powerful tools in the conceptual armouries of modern imperial nations.

In these terms, classical knowledge was reinvented in the modern world to form a vital element of a developing discourse of modernity through which imperial relations were created and transformed. Modernity has been defined as a conceptual schema that was (and is) fundamental to the imperial undertakings of Western powers – a body of thought through which the world was imagined and manipulated. Knowledge was constructed through modernist thought that mapped the world from the secure position of the centre, a place that defined itself as the highest and

most advanced in symbolic and material terms.[16] The periphery, the colonies or colonial possessions, were defined as subservient to this centre, occupying positions in the hierarchy according to their degree of 'civilization,' which was defined by those who created the system.

Although this discourse of modernity, developing in particular circumstances following the Enlightenment, marked a dramatic discontinuity with the past, many of the concepts on which modernity drew were ultimately derived from the Graeco-Roman texts.[17] Germane ideas were adopted and adapted through the rereading of an inherited and powerful discourse of domination. Classical images formed a rich source of inspiration for the ruling classes of European nations during the imperial ventures of the late nineteenth and early twentieth centuries, because they spoke within these contexts in powerful and authoritative ways.[18] Part of the power of these images, however, derived from the inheritance (or reformulation) of classical concepts, which were felt to provide added authenticity to the ideas that were developed.[19] As such, Romanization theory derived much of its explanatory power from concepts that are articulated in classical texts.[20] Romanization is linked to more recent national and imperial ideologies, while owing much to accounts of empire and civilization formulated in the late Republican and early Imperial Roman periods. At its core are imperial ideas that projected the empire as divinely sanctioned, with a mission to civilize barbarians.[21] Some of the ideas inherent from the past – for instance, 'civilization,' 'barbarism,' and the idea of the 'just war' – have remained popular, and are being redefined again in order to justify the international actions of Western nations.[22]

The classical inheritance constitutes a vital element in the ways that the world has been imagined and manipulated. The significant role played in this debate by classical 'knowledge' (texts, language, and archaeological remains) requires that we address the ideological role performed by classical archaeology and ancient history throughout modern times.[23] How do current understandings of imperial order and Roman culture relate to empire today?

Modelling Heterogeneity Today

Reacting against the continuity inherent in such a modernist approach, with its stress upon the unity and incorporative ideology of Roman

imperial civilization, during the 1960s the focus of study gradually started to shift onto the variability of local responses to Rome. Initially, changing perspectives were used to inform the new approaches to regional survey and excavation across Western Europe and the Mediterranean.[24] A variety of new types of site and landscape came to be recognized, which helped to challenge earlier understandings and to develop new approaches to the interpretation of society.[25] Some early 'post-imperial' accounts were 'nativist,' identifying local populations as integrated wholes, and setting these groups up through the idea of their opposition to the dominating Roman power.[26] These accounts perpetuated the simple distinctions between Roman and native presented in earlier writings, but gave priority to the latter rather than the former.[27] They reacted against the imperial agendas of earlier studies, but did not effectively challenge the conceptual foundations on which these earlier accounts had been based, merely refocusing attention on the resistance of natives to Roman control rather than their simple and directional Romanization.[28]

Approaches to the interpretation of Romanization continued to change gradually, increasingly focusing, from the 1980s, upon the methods by which local groups within Italy and the provinces came to adopt a variable form of Roman culture.[29] A number of interpretations developed during the 1990s to account for the active role of local elites in the adoption and adaptation of the imperial culture offered to them by the expanding imperial system, elements that were used because of their distinct roles in new ways of life.[30] We should not imagine that such accounts are in some way value free when contrasted to the earlier approaches to Romanization.[31] Instead, they address value in a different way from earlier accounts, by creating a distinct significance for tradition and locality, in contrast to the imperial focus of much earlier work.[32]

The Roman Empire is reconstructed as focused on numerous elites, within the imperial core of the Mediterranean, who negotiated their own identities to create an imperial system that worked to the benefit of all, or at least a significant proportion (the most significant?). 'Roman' culture is no longer viewed as a clearly bounded and monolithic entity, but as being derived from a variety of sources spread across the Mediterranean. During the final centuries of the first millennium BCE, elite groups

across Italy developed a growing unity through a process that Nicola Terrenato has called 'elite negotiation.' A new culture arose as a result of the benefits brought to these groups through closer contacts with the growing power of Rome.[33] Nicola Terrenato has argued that as part of this process, communities within the expanding empire became allied with Rome and incorporated precisely because they were offered, or bargained for, or struggled for the privilege of retaining the core of their traditional organization within an imperial framework that was intended to guarantee order and stability.[34] Greg Woolf's account of 'becoming Roman' in Gaul has explored such an approach to focus upon the elite groups within these provinces. Concepts of Roman and native are seen to break down entirely in a global empire that recreates itself through local engagement.[35] The most advanced forms of such theory integrate imperial force and local interest by explaining the ways that the attempts of people from outside Rome and Italy to 'become Roman' fed back into a gradually evolving conception of what it was to be Roman across much of the empire.[36]

This approach can be subject to criticism because of its emphasis upon consensus building.[37] It can also be critiqued for its focus upon the elite, projecting a bias inherent in previous approaches to Romanization.[38] Carol van Driel-Murray has argued that the application of recent approaches to the Batavians of the Lower Rhine Valley creates 'undefined, undifferentiated and apparently entirely male' elites, a critique that may also be applied in general terms to the important studies produced by Terrenato, Woolf, and, recently, by Emma Dench.[39] In response to such critiques of elitism, studies during the early twenty-first century have started to fragment Roman identity,[40] by turning to more complex interpretations that often draw upon material remains. This is achieved, for example, through the creation of the ideas of 'subcultures' and regional cultures, now argued by some to have formed constituent parts of a heterogeneous but relatively unified empire.[41] These new approaches seek to establish the degree to which Roman culture (broadly defined) appealed to groups of different status and wealth across the empire. As a reaction to former ideas of the centrality of power, scholarship has transformed itself once again by modelling new approaches that explore 'the puzzling complexity of cultural identities' (to quote

Sommer, from Chapter Five), including those that are wealth-based, occupational, regional, and gender-specific. Dench defines this idea of Roman citizenship, and also Roman identity, as a 'virtual community.'[42]

Groups such as soldiers, their wives, and families, traders, workers, and farmers can be seen to have redefined themselves in the new contexts created by the expansion of empire.[43] For example, soldiers were recruited from native peoples into the auxiliary units of the Roman army, where they were taught a version of Roman culture. If they survived to retirement they became Roman citizens after twenty-five years of service. These soldiers usually served abroad and, together with traders who lived outside their native communities, may have helped to spread an international Roman culture that identified them within a challenging and alien cultural milieu.[44]

This brief survey of a number of studies explores transformations in the academic context of knowledge. The nature of this changing debate can be characterized in terms of the developing influence of broader ideas about society.[45] Shifting attitudes to the current world, together with the collection of new classes of archaeological data that have helped to challenge inherited ideas, enable classicists and classical archaeologists to imagine the Roman past in new and more complex ways. This allows the Roman Empire to be perceived as a more heterogeneous society, in which groups and individuals acted in different ways to 'become Roman,' while retaining the core of their inherited identities and also contributing to a centralizing imperial cultural initiative. These new areas of understanding relate to how interpretations of the classical past have developed in the context of our ideas about the contemporary world.

These new perspectives are intended to allow for a greater variety of cultural experiences across the empire.[46] In so doing, classical studies reflect changing perspectives in the humanities (sociology, politics, cultural studies, development studies, and anthropology), where an appreciation of 'locality' has become increasingly significant since the 1960s.[47] A previous focus upon cultures as fairly coherent and bounded entities and the investigation of 'development' or 'modernization' as a fairly simple form of 'progress' from the traditional to the modern has slowly shifted to a situation in which the indigenous context of change

is taken far more into account. These approaches aim to broaden (decentre) understanding and to challenge earlier interpretations of the centrality of imperial civilization and its progressive logic by exploring the complexity of identities, through a focus upon the locality. Indeed, regional variability is taken in some recent works to represent a tool in the creation and maintenance of the global world order, integrating people into complex, dichotomous, and transformative structures of power.[48] It is argued that cultural heterogeneity and hybridity in the modern world enable the integration of economic and political systems through a transformation of pre-existing power relations. Hardt and Negri's writings suggest that far from being oppositional, diversity articulates the inclusive logic of a spontaneous order that no longer formulates itself around the creation of categories and hierarchies.[49] As Balakrishnan has suggested in a review of Hardt and Negri's book *Empire*, even the distinction between 'systematic and anti-systematic agency is blurred beyond recognition.'[50] A state of global 'Empire' is created through the bringing into being of 'less dichotomous' and 'more intricate patterns of inequality' (and opposition) than those that formed the fundamental tools of imperialism during much of the twentieth century.[51]

Drawing upon these writings, I have argued that some recent accounts of the Roman Empire develop an empire-wide *gestalt* of flows and hierarchies – a less dichotomous and more intricate pattern of inequality than demonstrated by former interpretations.[52] Ideas of Roman and native, elite and non-elite, incorporation and resistance, are seen to break down, at least to a degree, in a global empire that recreates itself through local engagement. The Roman Empire becomes a highly variable series of local groups, roughly held together by directional forces of integration that formed an organized whole and lasted for several centuries.[53] Heterogeneity becomes a binding force of imperial stability – a tool for the creation of perpetual imperial order.[54]

This new focus upon the centrality of imperial power helps to explain the variable local response to changing power relations, as people were enabled to change their ways.[55] At the same time, it also raises an ethical issue, which focuses upon the continuing importance of the classical past to ideas of Western identity. Our accounts of Roman culture continue, on the whole, to take a fairly positive attitude to the effects

of Roman imperialism that can, perhaps, be taken to provide a historical foundation for comprehensions of the enabling influence of globalization. The Roman elite appears from this perspective to have been involved in a series of connected political actions that enabled members of various native societies to define their identities in new and stimulatingly original ways, also enabling the incorporation into these developments of many members of the non-elite. Changes in identity were accomplished through the use of surplus and widespread contacts, including service in the Roman army, and involvement in industry, trade, and agriculture. If we pursue such a perspective, the Roman Empire is viewed as having come into being and survived because of the variable character of the relations that were established between peoples over a vast area. The incorporation of diverse peoples into the variable structure of the empire was a fundamental constituent in both the ideas held by Romans about their own identity and also the methods that led to the creation and perpetuation of the empire.[56] This can be taken to suggest that, despite vigorous attempts since the 1960s to deconstruct the narratives of Graeco-Roman identity, the overtly positive assessment of classical culture that formed the basis for many accounts of the nineteenth and early twentieth centuries has yet to be replaced by a more balanced perspective.[57]

Many of today's most influential accounts of identity and social change in the Augustan and post-Augustan empire stress negotiation and cultural interaction. In the terms explored by Hodos, in Chapter One, these develop new master narratives, but ones that do not provide a balanced viewpoint, since they continue to downgrade differences, local diversity, and othernesses. Membership in the army, together with involvement in expanded industrial and agricultural production, may have incorporated a substantial proportion of the population (perhaps 25 per cent), but these people will have remained in the minority. By contrast, the agricultural peasants and slaves that made up the majority of the population are largely excluded from dominant and masculinist 'Roman' cultural discourses.[58] Indeed, even the substantial minority who were partly incorporated have continued to be marginalized through the nature of the assimilation processes to which they were subjected. Roman culture by the Augustan period acted as a powerful culture of imperial incorporation, but as Dench has recently

argued, it also represented, at one and the same time, a 'highly ideologically laden and increasingly international culture of social exclusion.'[59] Certain highly visible aspects of culture – such as the correct diction in the pronunciation of Latin, the wearing of the toga, or correct etiquette at a banquet – will have helped to create an 'international' coherence in the hybrid local 'Roman' cultures that developed to exclude those who lacked advance knowledge and experience. These issues of incorporation and marginalization find echoes in recent writings about the colonial present that require us to reflect further on the theories that we develop.[60]

Elena Isayev (Chapter Eight) and Tamar Hodos (Chapter One) suggest that we should be cautious of thinking about regional groups, or locality, in Roman terms, since Rome was responsible for manipulating the boundaries of regional groups. Isayev suggests that boundaries, which were in the minds of post-conquest authors, were projecting back to an earlier time to define the ethnic identities of various provincial populations.[61] We need an increased focus on the administration of the processes of marginalization within the Roman Empire, together with new attention to issues that most people find less palatable, including the commonplace imposition of order, genocide, deportation, enslavement, and enforced military recruitment,[62] issues that will often have represented what Shelley Hales (Chapter Nine) calls 'the Romans' ad hoc solutions for imperial rule.' Emmanuele Curti, for example, drawing attention to the violent imposition of order, social norms, and new cultural practices that often accompany modern colonial situations, argues that recent theoretical approaches to Roman archaeology effectively sanitize the past for the sake of political correctness. Simon James explores how influential models of Roman elite negotiation underplay the significance of violence, from the symbolic and implicit to the threatened and lethal. Carol van Driel-Murray addresses the creation and recruitment of 'ethnic soldiery' among the Batavi of the Lower Rhine valley and how the uses made of these people kept them excluded from the centres of imperial power.[63] The detailed development of case studies involving such perspectives remains, however, a rare occurrence.

A balanced study should not explore the lives of those who were enabled to the exclusion of those who were killed, marginalized,

or exploited;[64] indeed, in some cases, the two groups will not have formed exclusive categories, since we have seen that people can be assimilated in ways that serve to develop their otherness and relative marginality. Only by balancing what we might regard as negative and positive attributes of empire, and by exploring the marginalized groups that archaeologists, ancient historians, and classicists often appear to have difficult identifying and understanding can we provide a critical context for the idea that Rome enabled regional and interregional integration, bringing benefits to all, a position that (unconsciously) reinforces positive concepts by providing a genealogy for ideas about the emancipating nature of contemporary globalization.

I should stress that such a critique does not make invalid the analysis of subcultures and cultural heterogeneity within the world of Rome, since recent research on classical literature and archaeological materials would appear to support the highly variable character of society, presenting a picture of complexity that was oversimplified by earlier interpretations. Indeed, the immediacy of the relevance of the complex articulation of integration and hybridity makes the relationship between imperial power and the local response to changing power relations of vital contemporary importance.[65]

Enabling and Constraining Local Literacy

There are various ways to pursue the agenda that I am proposing, some focusing upon particular groups (including soldiers and traders) and some addressing variations in regional cultures across the empire and the forces that brought these about. Some of these fields of research involve areas in which the semi-distinct disciplines of ancient history and archaeology should hold common interests.[66] I shall provide a brief account of the military exploitation of one particular provincial society on the margin of imperial control in order to support the need for balance in our accounts. This involves a review of the development of Latin literacy among the Batavi of the Lower Rhine Valley (Figure 3.1), a study that draws upon the writings of Ton Derks and Nico Roymans, and Carol van Driel-Murray.[67] Derks and Roymans's study provides a compelling account of one of the variable ways in which native peoples were integrated into a Roman

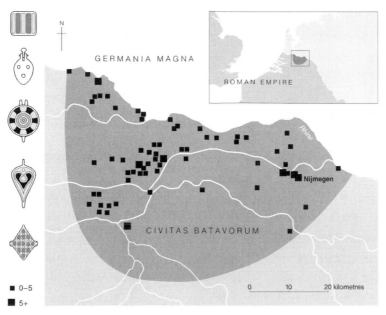

3.1. An attempt to map the territory of the Batavi, showing the locations in which seal boxes have been found and the five types of artefacts that have been found (After Derks and Roymans 2002, figs 7.5 and 7.6; pls 7.I to 7.XII)

imperial culture that was itself highly variable.[68] It can also be formulated as a critique of the idea that the development of a variable Roman culture across the empire was primarily an enabling process, applying a more critical perspective to the aims and results of the actions by which these people (and others) were incorporated into the empire.[69]

Ton Derks and Nico Roymans have argued that Latin spread through the agency of the Roman army in part of the Lower Rhine Valley. This appears to have been the homeland of a number of different tribal groupings, including the Batavi.[70] In this area, the development of native society has often been seen by archaeologists, including Derks and Roymans, as aberrant or abnormal in comparison with the supposedly 'standard' development of cities and villas in many regions of the Roman West.[71] It has been argued that the Batavians witnessed a slower, or less thorough, Romanization than did the neighbouring areas of Gaul to the south,[72] as the result of the development of a different form of social organization with origins in the pre-Roman period. The territory has been defined as mainly a 'non-villa landscape,' one that contrasts in a dramatic fashion with areas such as Gaul, where villas and successful towns became common.[73]

The dominant settlements consisted of one or more traditional timber longhouses, comprising a living area and byre in the same domestic space.[74] The economy of this area also appears to differ from the neighbouring villa zones in its emphasis upon cattle-rearing rather than arable agriculture.[75] A number of settlements developed elements of Roman architecture (such as a timber portico, stone cellar, painted wall-plaster, or a partly tiled roof), but these innovations did not usually affect the basic traditional organization of domestic space within the individual house.[76] The few villas that do occur in this area have been tentatively interpreted as the homes of veteran soldiers who had returned after a period of military service. It has been argued that the Roman-period urban centres of the Lower Rhine were established, as part of official Roman policy, in an area that contained societies unaccustomed to urbanism.[77] These urban centres may have been dominated by settlers from further to the south and by the Roman army, while the local elite had, at the very most, only a limited input into their establishment, development, and administration.[78] Nico Roymans has recently challenged this argument, proposing a more active role for the native elite in the creation of these towns.[79] This interpretation fits a developing perspective on Roman urbanism, which argues that the Roman administration, wherever possible, would have used the native elite in the development of local urban centres.[80]

Despite the relative lack of native urbanization and villas, it has been argued that considerable evidence exists among the rural native population for Latin literacy.[81] The discovery of many so-called seal boxes may indicate the spread of Latin literacy through the recruitment of Batavians into the Roman auxiliary. Batavians were renowned for their fighting skills, and men from the community were taken in large numbers for the auxiliary units of the army,[82] perhaps by recruitment that utilized a pre-Roman native system, adapted as the result of treaties between the Roman administration and the native leaders.[83] When they were recruited, Batavian auxiliary units may have been allowed to serve under their own commanders, recruited from the elite families of the tribe.[84] Almost every family may have supplied one or two members for the Roman army.[85] This practice of military recruitment may have had a major impact upon the development of society.

Seal boxes are usually interpreted as containers that were used to hold a range of items, particularly written documents. Those found in the territory of the Batavians are on military sites, at Nijmegen, and the major temple complex of Empel, but they are also widespread on rural settlements. Derks and Roymans have taken this to indicate a high degree of literacy among the people living within the non-villa settlements of this area during the first and second centuries, contrasting with neighbouring areas of north Gaul, where seal boxes are rare.[86]

Evidence for literacy among this population may reflect the fact that auxiliary soldiers were required to communicate in Latin within their military units.[87] Indeed, the acquisition of literacy may have been one of the benefits of military service.[88] The military personnel at the fort of Vindolanda in Britain included Batavian and Tungrian auxiliary units, who, according to the evidence from archaeological excavations, were literate.[89] The diversity of writing styles on the writing tablets from this site, which dates from between 90 and 120 CE, probably indicates that literacy was fairly widespread among these military units, although it is likely that members of the common soldiery were unable to read and write to as high a standard as the officers. The seal boxes on non-villa settlements in the territory of the Batavi may indicate that the population of the Lower Rhine drew upon aspects of Roman culture – Latin language and the technology of writing – through a creative engagement with the imperial system. The large-scale recruitment of auxiliaries from the Batavians during the Julio-Claudian period may have led to an intensification of the martial ideology of traditional society.[90] The emphasis upon a military culture and apparent high esteem for the ownership of cattle may have resulted in a society in which elements of elite Roman culture, such as villa building and urban competition, had little cultural relevance for the vast majority of the population;[91] conversely, Latin literacy and writing appear to have been vital for these people.

Derks and Roymans' study is of particular interest because, in the past, Latin in provincial contexts has usually been associated with the imperial and provincial elites. In the elite context, the adoption of Latin could be connected with a desire to 'become Roman.'[92] The spread of the language to other less-privileged people within native societies across the Roman West has then to be explained through the idea that these people wished

to be Roman, assuming some form of passive acceptance of imperial culture.[93] The evidence from the Lower Rhine, however, expresses the practical value of both the Latin language and the technology of writing to a broader range of people.[94] Language and the practice of writing may actually have been used widely by different members of society as a result of the potential value of the various context-dependent forms of communication that it offered to many people.[95] Comprehension of the Latin language and an ability to write in it perhaps spread widely as a result of the recruitment of auxiliary soldiers from these communities.[96] These abilities may have been required in order for the individual soldier to function effectively in the Roman army and to communicate with distant friends and relatives. Language and literacy may also have enabled members of the deceased soldier's family to communicate with their own distant relatives and, for instance, to claim the savings of the men who had died.[97]

The adoption of Latin in this context need not indicate a direct wish to participate more widely in the culture of the Roman elite. Indeed, for the Batavians, it coincides with only a gradual adoption of the various material aspects usually taken to define Roman culture.[98] The adoption of Latin and writing may indicate the practical advantages of two particular major innovations that spread to northern Europe with the empire: a common language that allowed communication between people who were separated by great distances; and the technologies that enabled this to occur. In other words, these people were not necessarily seeking their own regionally distinctive local way of 'becoming Roman,' but were retaining the core of their cultural identity, with the addition of certain powerful innovations that assisted them to perform their lives in new ways under changing political conditions.[99]

One way to view these developments is to argue that the Roman administrative system enabled certain Batavian people to adopt such an approach by providing a flexible means through which members of the tribe were recruited into the armed forces. The Roman Empire is reconstructed as an enabling empire with a whole batch of administrative policies for the encouragement of local integration and incorporation, but we have seen that such explanations sideline other perspectives. An alternative orientation is to view developments among

the Batavi in terms of the recruitment of peripheral peoples as 'ethnic soldiery,' a situation that kept these people in a dependent position and excluded them from the centres of political power.[100] Such an approach stresses the asymmetrical nature of the relationship between Batavians and Romans, arguing that 'ethnic soldiers' represented an aspect of the deliberate creation of unequal imperial relations.

Latin language and literacy among the Batavi will have been highly symbolic of this cultural subservience, since the education of young members of the governing Roman elite will have ensured its significance as a highly effective culture of exclusion; correct diction will have provided an extremely reliable way of differentiating the highly educated from the relatively uneducated across the empire.[101] The imperial elite recruited and used these soldiers for their own purposes, encouraging the development of a pre-existing military ethnicity that acted to keep Batavian soldiers in a position of dependency, symbolized in an effective manner by the un-Roman character of their cultures, their relative lack of involvement in urban life, and the general absence of villas and other aspects of imperial culture in their territory.[102] Aspects of Batavian culture will have projected the marginalization of these people from central concepts of 'Roman' imperial culture, both within their own territory and when they travelled to other areas of the empire.

In these terms, in addressing the observations made by Isayev that were referred to earlier, we can follow van Driel-Murray by interpreting the active formation and transformation of the community of the Batavi, together with the territory that they occupied, as the creation by Rome of a new ethnicity that served imperial strategic ends.[103] New categories of thought, together with the creation of artificial and imposed boundaries, enabled Roman administrators to form a new and partly unified military identity among the formerly fragmented groups of the Lower Rhine Valley; this identity was particularly effective since it built upon some original concepts that derived from these subject peoples.[104] Modern scholars have used the reference to the Batavi in classical sources since the sixteenth century, together with the archaeological materials from this area, to tell useful tales about national origins; they define a valiant proto-nation (or ethnic group) that was both clearly bounded and distinctly un-Roman, providing a native origin for Dutch civility.[105]

Summarizing Heterogeneity and Empire

The difficulty with many accounts of imperial integration is that they stress the ways that empire enabled local peoples to integrate themselves into imperial society, creating a context in which they could promote themselves and their families by exploiting their own innate abilities and resources. In the context of the latter part of the twentieth century, with the growing criticism of the outcome of Western empire building, this may have appeared a useful approach to take, since it emphasized the agency of native peoples, constructing their variable identities within an autocratic empire. Today, this idea appears more problematic, since many current interpretations fail to pay sufficient attention both to the negative aspects of the imposition of Roman order and to the dispossessed within Roman and provincial societies. Taking a more balanced perspective, however, is not to deny that many people were able to explore new situations for their own benefit; but it does require us to explore the degree to which local contexts were created, manipulated, and articulated by the imperial administration, in addition to how local people responded to these situations. Empires depend on negotiation and compromise to come into existence and to survive, but other strategies, including force and violence, also play a part. As Dick Whittaker has argued, the two positions of an interventionist Roman state and a responsive native population need not act in opposition; direct intervention and innovation could occur alongside one another.[106] Local societies were not established entirely in the form of either the marginalized or the assimilated, since such categories in most cases were not discrete but overlapped.

The issues discussed here raise questions for contemporary practice in Roman studies, focusing upon purpose, theory, and method.[107] These include the role of studies of the Roman past in the context of changing knowledge of the present. Hardt and Negri's *Empire* places great stock in the ancient genealogies of the postmodern world.[108] To conclude, I wish to emphasize a particular idea – that classical scholars should work in the opposite direction, in order to pursue the context in which our understanding of Roman imperialism has developed.[109] I have stressed the ideological value of ideas drawn from Republican and Imperial Rome to Western nations throughout the ages. If we do not address head-on the political context of the work that we produce, we

will follow a long academic tradition of recreating the imaginary and the impossible – an apolitically and neutral field within which classical studies might operate.[110]

Acknowledgements

I am grateful to AHRC and Durham University for the two periods of research leave in 2003–4 and 2006–7 that enabled me to develop and finalize the arguments developed in the paper. I am also grateful to Shelley Hales and Tamar Hodos for asking me to write this paper, and for their help and comments on previous versions of my text. Observations in early drafts of a number of the individual papers included in this volume helped me to articulate a number of the points I developed, as did the comments of two anonymous referees. David Mattingly, Alison Wylie, and Greg Woolf provided helpful comments on ideas discussed in this paper, while Simon James, Ian Haynes, and Fernando Wulff Alonso pointed out several relevant references. Nico Roymans and Carol van Driel-Murray provided information and advice about the Batavian case study, while Christina Unwin helped me to refine the ideas presented here. I am also grateful to the audiences at meetings in Stanford (USA, Cultures of Contact Conference, 2006), Birmingham (Roman Archaeology Conference, 2005), Canterbury (Meeting on Rural Settlement either side of the North Sea/Channel, 2007), and Bristol (Crossing Cultures Conference, 2005) for various comments on earlier versions of this paper.

Notes

1. Balakrishnan 2003a, x.
2. Hingley 2005. For some earlier ideas, see Hingley 2003, 112–19.
3. The perspective has influenced classical studies in general, including research on Greece, Rome, and other Mediterranean societies. Recent publications include Dench 2005; Dougherty and Kurke 2003; Golden and Toohey 1997; Huskinson 2000.
4. Dench 2005, 233.
5. See Dench 2005, 231, who refers to works upon class, race, the military and technological 'developments,' to which we might add the various works on 'becoming Roman' discussed later.
6. Dench 2005, 11. Some studies have used the idea of 'multiculturalism' to explore these topics. I will not use the term in this study, neither should my paper be judged simplistically as an attack on multiculturalism.

7. It should be noted that the concept of 'Romanization' remains in very common use.

8. Hingley 2005 provides more detailed discussion.

9. Examples of an extensive body of relevant studies include: Dondin-Payre 1991; Ferrary 1994; Hingley 2000; Mattingly 1996; Settis 2006; Wulff Alonso 1991; Wulff Alonso 2003; and papers in Edwards 1999; Hingley 2001; Wyke and Biddiss 1999.

10. Potter 1999, 152; and see Habinek 1998.

11. Hingley 2001; Hingley 2005; Kennedy 1992; Woolf 1998; Woolf 2001a.

12. Woolf 1998, 54–60.

13. Hingley 2005, 62–7.

14. Ferrary 1994; Freeman 1993; Freeman 1996; Hingley 2001; Hingley 2005; Münkler 2007.

15. See the significant works of Wulff Alonso 1991, Terrenato 1998b, and Terrenato 2001, 1–6, on the contribution of Mommsen. See Freeman 1993, Freeman 1996, and Hingley 2005, 31–7, on Haverfield.

16. Featherstone 1995, 10; Tomlinson 1999, 32–47. For a contrasting approach to contemporary modernities, see Knauft 2002a.

17. Giddens 1984, 239; Tomlinson 1999, 36.

18. Desideri 1991; Hingley 2000.

19. For the relatively unchallenged position of classical text in previous ages, see Farrell 2001; Kennedy 1992, 37; and Wyke and Biddiss 1999.

20. Woolf 1997, 339; Woolf 1998, 54–67; Hingley 2005, 15.

21. Woolf 1997, 339.

22. Gregory 2004, 47–8; Hingley 2005, 15; Münkler 2007. Differences of opinion exist as to whether we now live in a postcolonial or postimperial, world, projecting comparable ideas about the continuation of modernity. Many, such as Hardt and Negri (2000), argue that the current world system is no longer an imperial one, while others affirm that imperialism is still present and has been revived in powerful new ways in the past few years. See, for instance, Brennan 2003, 93; Johnson 2004; Petras and Veltmeyer 2001; and Said 2003 [1978], xiii–xvi. For the use of the concept of the 'just war' in the Roman world see articles in Rich and Shipley 1993; and Webster 1995, 1–10; for the idea in the contemporary world, see Hardt and Negri 2000, 12, 36–7; and Petras and Veltmeyer 2001.

23. Goff 2005b, 1–24; Hingley 2000; Hingley 2001; Hingley 2005; Owen 2005; Settis 2006, 106–7; Vasunia 2003.

24. Van Dommelen 1993; Dyson 2003, 53.

25. Dench 2005, 232; Hingley 2005, 36.

26. Examples of such studies include Bénabou 1976; and Reece 1980, 77–91.

27. Curchin 2004, 9–10; Dench 2005, 84–5; van Dommelen 1993; Hingley 2005, 40–1.

28. Van Dommelen 1997.

29. See Hodos, this volume. For a corresponding increasing interest in the use of classical literature to study gender, sexuality, 'race' and 'disability,' see Dench 2005, 225–6.

30. Millett 1990; Terrenato 1998a, 20–7; Woolf 1998; papers in Keay and Terranato 2001.

31. Dench 2005, 11; Hanson 1994.

32. For the contemporary context, see Knauft 2002b, 25.

33. Terrenato 1998a; Terrenato 2001, in particular 3; see also Wallace-Hadrill 2000, 311; and Dench 2005.
34. Terrenato 2001, 5.
35. Woolf 1997; Woolf 1998; Woolf 2001b.
36. For example, Terrenato 1998a; Terrenato 2001; Woolf 1997; Woolf 1998. Woolf 2001b, 183, in the discussion of the 'Roman Cultural Revolution in Gaul,' provides the examples of bathing, *terra sigillata*, architecture, and viticulture.
37. Berrendoner 2003; James 2001a, 198; Mouritsen 1998, 42.
38. Alcock 2001, 227–30.
39. Van Driel-Murray 2002, 200. Rofel 2002 labels Hardt and Negri 2000 as an example of 'Modernity's Masculine Fantasies'; many accounts of the Roman empire appear open to a similar critique. Gender critiques are relatively rare in Roman archaeology. For examples, see Scott 1998; and van Driel-Murray 2002. Dench 2005, 367.
40. Hingley 2005, 91–116.
41. James 2001a; Hingley 2005, 91–109; Laurence 2001a; Laurence 2001b; van Driel-Murray 2002.
42. Dench 2005, 134.
43. Soldiers: James 2001a; their wives and families: van Driel-Murray 2002; traders: Laurence 2001a; workers: Joshel 1992; and farmers: Haley 2003, 4.
44. James 2001a, 203; Laurence 2001b.
45. Hingley 2005, 30–48, applies the concepts of modernism and postmodernism to this debate, but also acknowledges some of the problems of applying such a perspective.
46. For example, Huskinson 2000; Laurence 1998.
47. See Iggers 1997; Gardner and Lewis 1996; Rist 1997; Shanin 1997, 66.
48. Gupta and Ferguson 2002, 75; Hardt and Negri 2000, 44–5; Knauft 2002b, 25; and Balakrishnan 2003a, xiv. This interpretation of contemporary 'empire' is not without its critics. See Balakrishnan 2000; Balakrishnan 2003b; Brennan 2003; Boron 2005; Rofel 2002.
49. Balakrishnan 2000, 3; Balakrishnan 2003a, xiv; Hardt and Negri 2000, 44–5.
50. Balakrishnan 2000, 2.
51. Balakrishnan 2003a, x. It is important to record that Balakrishnan (2000; 2003b) has considerable problems with Hardt and Negri's suggestion that multiculturalism is at the heart of empire. Hales' use of Bhabha's comments in Chapter Nine that the rejection of postmodernism only leaves a return to modernism, with its inherently imperialist logic, draws on a comparable point.
52. The accuracy of Hardt and Negri's use of classical texts is not of great concern to me in this paper, although much could be written about this topic. Nor am I too concerned about the value or the dubious ethical connotations of their idea of 'empire.' See Brennan 2003, and Boron 2005 on these issues. What I do find relevant is the way that they work ideas of ancestry into their picture of the present. Hardt and Negri appear to follow an approach that is comparable to certain classicists and classical archaeologists who have recently argued for the relevance of the classical past in the present. See Benton and Fear 2003; Hingley 2005; Toner 2002; and Willis 2007. Such a focus emphasizes the linear inheritance of what might be titled a 'discourse of domination' within Western society. See Hingley 2005, 48, 117–18. See Dench 2005, 34–5, 218–20, for the context.

53. Woolf 1997; Dench 2005, 220–1.
54. One of the readers of this chapter noted that, in the Roman world, cultural difference was also used to establish opposites in order to crush and exterminate people; heterogeneity and imperial force had a complex interrelationship. This issue is discussed further here.
55. Beltrán Lloris 1999; Woolf 1997.
56. Dench 2005; Hingley 2005.
57. Hingley 2005, 119, drawing upon Brennan 2003, 98.
58. Hingley 2005, 115–16, reviews relevant information for the relative lack of integration of various groups in southern Britain into the empire. See Isayev in Chapter Eight for additional relevant discussion.
59. Dench 2005, 35.
60. Derek Gregory (2004, 253–5), in a reflection of the writings in Hardt and Negri 2000, has stated: 'If global capitalism is aggressively *de-territorializing*, moving ever outwards in a process of ceaseless expansion and furiously tearing down barriers to capital accumulation, then colonial modernity is intrinsically *territorializing*, forever installing partitions between "us" and "them."'
61. These writings have also been particularly valuable to scholars in modern times since they could be used to define pre-Roman 'nations' and to create ideas of racial ancestry. For the context, see Hingley 2001.
62. Hingley 2005, 120.
63. Curti 2001, 24; James 2001a, 198; van Driel Murray 2002, 215.
64. Hingley 2005, 115–16.
65. Dench 2005; Woolf 1997; Hingley 2005.
66. Hingley 2005, 11. Such studies may be best undertaken in a way that utilizes all available sources of material (see Hales, Chapter Nine). Dench's impressive volume (2005, 84, and n. 149) criticizes a variety of recent approaches arising from 'the archaeologists of Roman Britain.' What some of the works that Dench briefly dismisses aim to achieve, from my reading, is to develop a less elite-focused perspective through an exploration of the material remains of past societies. While I would concur with some of Dench's concerns about attempts to write purely archaeological accounts of the Roman past (see Hingley 2005, 10–11), the elite emphasis of much of the work that derives from a focus on ancient literature (see Dench 2005, 367) requires that we examine other sources of evidence. For example, one useful source might be provided by the material information for local versions of Latin literacy. See Woolf 2002.
67. Derks and Roymans 2002, 87–134; Roymans 1996; Roymans 2004; van Driel-Murray 2002, Van Driel-Murray discusses problems with the geographical identification of the Batavians (204).
68. For the context, see Hingley 2005, 91–116.
69. Van Driel-Murray 2002.
70. Derks 1998; Derks and Roymans 2002; Roymans 1995; Roymans 1996; Roymans 2004.
71. Hingley 2005, 95.
72. Derks 1998, 55–66; Roymans 1995, 48.
73. Derks and Roymans 2002, 88; Roymans 1995, 48.
74. Derks 1998, 63–4; Roymans 1995, 49–50.
75. Derks 1998, 64–5.
76. Roymans 1995, 50–3.

77. Carroll 2003, 22; Roymans 2004, 196–200.
78. Roymans 1995, 55–8; Carroll 2001, 60–1; Carroll 2003, 28.
79. Roymans 2004, 202–5.
80. Hingley 2005, 82, 95.
81. Derks 1998, 228–30; Derks and Roymans 2002.
82. Bowman 1994a, 26–7; Campbell 2002, 30; Carroll 2001, 65; Roymans 1996; Roymans 2004.
83. Roymans 1995, 58.
84. Bowman 1994a, 26–7.
85. Derks and Roymans 2002, 87–8; Willems 1984, 236.
86. Derks and Roymans 2002, 94–7.
87. Bowman 1994b, 112.
88. Van Driel-Murray 2002, 207.
89. Bowman 1994a; Bowman 1994b.
90. Roymans 1995, 48, and 60.
91. Derks and Roymans 2002, 102; Roymans 1995, 55.
92. Cooley 2002b, 9, drawing upon the work of Woolf.
93. See the comments of Adams 2003a, 189, on the attempts of potters at La Graufesenque to become Roman, and my comments (Hingley 2005, 101) on these observations.
94. Derks and Roymans 2002, 101.
95. Bowman 1994b, 123.
96. Derks and Roymans 2002, 100.
97. Van Driel-Murray 2002, 211.
98. Haynes 2001, 71.
99. Hingley 2005, 99. There are additional examples of flexible incorporation throughout that text.
100. Van Driel-Murray 2002, 215.
101. Hodos, Chapter One; Corbeill 2001, 282–4; Woolf 2000, 887.
102. Van Driel-Murray 2002, 215. It would be interesting to try to establish the extent to which some members of the civitas of the Batavi (in addition to women) were excluded from membership of the auxiliaries.
103. Van Driel-Murray 2002, 203. For the extent to which communities in the Lower Rhine Valley were manipulated by Rome during the fifty years after Caesar's conquest, including the wholesale moving of communities, see Roymans 2004, 23–9.
104. Roymans 2004, 203–9.
105. See Hessing 2001.
106. Whittaker 1995, 21.
107. Benton and Fear 2003; Cartledge 1998a, 16–28; Hingley 2005; Settis 2006, 106–7.
108. Hardt and Negri 2000; Balakrishnan 2003a, xiii. See also James and Nairn 2006; Robertson and Inglis 2006; and Willis 2007.
109. Hingley 2005, 117–20.
110. Cartledge 1998a, 20; Hingley 2005, 3; Toner 2002, 2.

CASE STUDIES

INGENIOUS INVENTIONS: WELDING ETHNICITIES EAST AND WEST

Corinna Riva

Introduction

As recent studies on ethnicity in the ancient Mediterranean have amply demonstrated, the ways in which Greeks and non-Greeks constructed and expressed ethnic identity implicated a whole variety of contexts in which notions of 'difference' were used to define identity.[1] Difference could be articulated on the grounds of gender, social distinction, or political allegiance; while all of these factors may have been determinant in constructing ethnicity they were also highly unstable through time. Ethnic identity was therefore dynamic, particularly in situations of political instability, as was the case with Sicily.[2] In the Greek world, we now recognize that a full notion of ethnicity emerged in the classical period only, in a situation of external threats by Persians and Carthaginians, and that what had been a Greek 'aggregative' identity in preceding periods became an 'oppositional' one, as Jonathan Hall has suggested.[3] Before then, in the Archaic period, a Greek 'aggregative' identity might have worked in contexts such as Sicily where a Sikeliot Greekness was formed,[4] but not in others. In even earlier periods, namely the late eighth and seventh centuries BCE, the ethnic identity of communities of the Tyrrhenian Sea region, a space of intense cultural interaction among Greeks and non-Greeks, is hard to identify. In fact, the melting pot that was this region from the 750s BCE, when the mixed community of Pithekoussai was settled on the island of Ischia, hardly suggests a picture of a supposed Greek identity vis-à-vis others. On the

contrary, some scholars have recently spelled out 'overlap' and 'mixture' as key words for understanding the Greek/non-Greek encounter in the central Mediterranean of the seventh century BCE.[5] At this time, intercommunity contacts were likely to happen at all levels of the social scale on both sides, and aristocratic elites entertained personal relationships including guest-friendship or *xenia* relations among one another. We must envisage that in central Italy such elite relations had a considerable longevity, going back to the ninth century at least, when increasing social complexity among large communities occupying strategic coastal locations went hand in hand with growing exchange relations with the outside.[6] In this context, we must emphasize elements of commonality rather than opposition between Greeks and non-Greeks. Malkin proposes that 'a sophisticated approach to the concept [of difference] as a defining factor of identity goes beyond bipolar opposites [e.g. Greeks and the Other(s)] to look for differences within what seems the "same." '[7] Although this is quite true in general, and not just for this period, Malkin develops this approach for Archaic Campania: the space in which Greek, Etruscan, and Campanian elites met and entertained relations, he argues, was one of cultural mediation and accommodation. Neither a centre, nor a periphery, Campania is defined by Malkin as a 'Colonial Middle Ground.'[8] Campania was a shared geographical and cultural space that gave rise to a mediating culture, marked by transcultural images and values, and by shared mythical genealogies promoting the formation of collective identities.[9] These collective identities did not, however, form in a vacuum, but arose out of a long-term complexity of indigenous societies and local elites' self-definition prior to their encounter with the Greeks. Malkin explores this mediating culture by tracing the mythical genealogies that were exploited by Greeks and non-Greeks alike, and particularly, the figure of Odysseus, transcultural icon par excellence.

This Colonial Middle Ground is a refreshing approach to the seventh-century Tyrrhenian region, but is open to criticism for two main reasons. First, given the emphasis on cultural mediation and transcultural values in the Tyrrhenian melting pot, the term 'colonial' is seriously problematic. Second, we must take a further step beyond Malkin's analysis and observe fully the other viewpoint of the relation – that of the non-Greek. The transformation of the Homeric

hero Odysseus into an 'Etruscanized' figure is particularly revealing of the cultural interaction between Greeks and Etruscans, but it is mostly gauged from Greek written sources and hence is the product of a Greek perspective upon Etruscans.[10] I suggest we devote more attention to material culture, which represents the prevailing evidence at our disposal of a non-Greek perspective. This will allow us to consider the entirety of the material that Greeks and non-Greeks used in creating a mediating culture, which included material objects as well as mythological subjects. In doing so, it is crucial that we integrate material culture contextually: this entails understanding objects *both* in their immediate archaeological context and beyond, linking this context with other pertinent local contexts. As Antonaccio (Chapter Two) suggests, only by considering material culture and its full potential – objects as interactions of people but also producing relationships with themselves – can we come to a full understanding of the cultural mixture and transcultural values that this mixture engendered.

I wish to take this step by analysing an artefact and its context, as they encapsulate *both* the material objects and mythological subjects that non-Greeks exploited in entertaining a cultural dialogue with the Greeks, which ultimately served to define identities. This object is the San Paolo olpe, an engraved bucchero jug, displaying images from the Argonauts' saga, that was buried in the San Paolo Tomb, an Etruscan wealthy elite burial at Caere (650–630 BCE) (see Figures 4.1 and 4.2). This olpe tells the very story of a shared myth and the local re-elaboration of a transcultural figurative language, and demonstrates that Etruria, too, was a Middle Ground for Greek settlers and Etruscan inhabitants. While no single ethnic string may have been attached to the myth, the epic constituted an identity-building narrative for Greeks and Etruscans, respectively.

Unlike every other early Greek mythical figurative representation occurring in Etruria,[11] these Argonauts' images were not painted on a Greek-manufactured or imported vessel:[12] the canvas upon which the myth was portrayed was distinctly Etruscan. The vessel was made of Etruscan bucchero ware, and the images were not painted, but engraved in relief as if the vessel was metal-made. Engraving was, in fact, a metalwork decorative technique in which the Etruscans excelled. We may concur that this object shows the ways in which a Greek epic like the

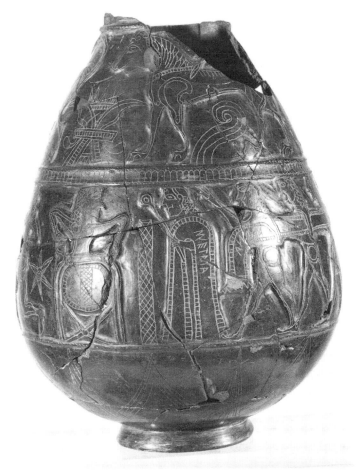

4.1. The San Paolo olpe, Medea and Jason (Copyright Soprintendenza per i Beni Archeologici per l'Etruria Meridionale; photo n. 137961)

Argonauts' saga acquired transcultural value since it was represented on an Etruscan vase, yet we must ask ourselves why the Argonauts, and not the more widely popular figure of Odysseus, were selected. The reason behind this preference perhaps lies in the specific relations that Greeks entertained with Etruscans and the motive that drove these relations. The search for mineral resources is likely to have been important. I suggest that the search for metals in the Tyrrhenian was not just a trigger to the earliest Greek encounter with Etruria, but was crucially exploited by Greeks and Etruscans alike in defining identity during the encounter, and that this is shown by the San Paolo olpe. That the Argonauts' saga was engraved on bucchero metal-imitation ware was not chance:

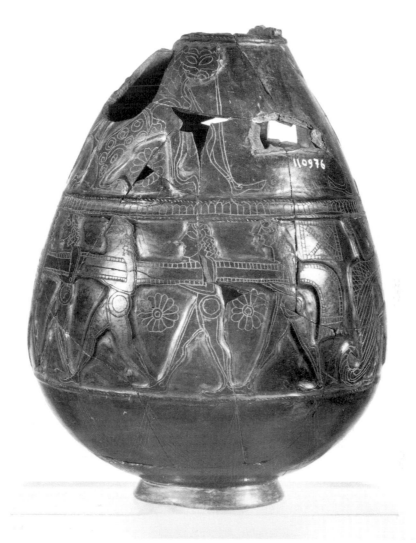

4.2. The San Paolo olpe, group of six youths (Copyright Soprintendenza per i Beni Archeologici per l'Etruria Meridionale; photo n. 202606)

either the craftsman working at the service of Etruscan elites or the elites commissioning the olpe carefully chose the myth and the medium for depicting the myth. This choice discloses a hitherto overlooked trait that, I will argue, was manipulated in the construction of Etruscan vis-à-vis Greek identity: technological innovation. This innovation involved both metallurgical skills and ceramic-working skills, which entailed the application of metalwork decorative techniques on terracotta and visually transformed terracotta into metal. Through bucchero, Etruscan

craftsmen reproduced a transcultural figurative narrative using the *techne* in which they excelled: metalwork engraving rather than ceramic painting, which they learned from Greek vase painters and/or perfected. Bucchero ware became, so to speak, a transcultural *techne*, and hence a suitable medium for depicting a transcultural narrative.[13] At the same time, this narrative, which the Argonaut epic provided, illustrated the very process of technological innovation and invention that followed the Greek/Etruscan encounter.

Hence, I will argue that technological innovation was the backdrop where Greeks and Etruscans not only met, but constructed a dialogue of cultural mediation and ultimately a discourse of Greek and Etruscan identity. The Argonauts' saga was the mythical lingua franca that allowed this dialogue and later imposed this discourse: it was used by Greeks, on the one hand, who attributed foreign and exotic origins to new *technai*, and Etruscans, on the other, who exploited their identity as technological innovators through the craftsmen at their service within a discourse of status vis-à-vis Greek and Etruscan communities. As a hybrid mythical narrative, it served an elite discourse on both the Greek and Etruscan sides, in which a process of active choice and appropriation of a Greek epic by Etruscan elites is apparent.[14]

Since the excavation of the San Paolo Tomb and the publication of the grave goods, the olpe has become famous among Italian scholars, who have interpreted it in various ways, but it has received surprisingly little attention in the English-speaking world.[15] To date, no one besides Rizzo, the excavator who published the tomb group, has attempted to place the olpe in its archaeological *and* cultural context.[16] As I have suggested, integration of both the archaeological and cultural contexts is fundamental if we are to interpret the olpe correctly. I shall therefore present and describe the olpe in its archaeological and cultural context; then I will offer my own reading of the olpe as a medium for a dialogue of identity and a discourse of status, after summarizing previous interpretations.

The San Paolo Olpe in Context

The San Paolo tomb group is located on the western slopes of Monte Abatone in an isolated position along the route linking Caere with the

port of Alsium. Underneath the monumental tumulus were two buri-
als, Tomb 1 and 2, both similar in structure to the famous Regolini-
Galassi Tomb. A long corridor, or dromos, led to the funerary chambers,
which were completely built with large stone blocks and characterized
by an ogival vault.[17]

Dated to the second and third quarter of the seventh century BCE,
hence contemporary to the Regolini-Galassi Tomb, Tomb 1 consisted
of a main chamber containing two burials and two side chambers.
Slightly more recent in date, Tomb 2 had a main chamber and one side
chamber, which was sealed off with stone blocks, hence found intact.
The single burial of this side chamber was dated to 630 BCE.[18]

Tomb 1 contained more than a hundred vessels: large impasto dolia,
or storage jars, and ollae, which were used for mixing wine and water;
Greek amphorae, including Attic SOS, Chiot, and Corinthian imports
that have been found in other contemporary Caeretan elite tombs; sev-
eral dining vessels, many of which are local impasto shapes; as well as
kylikes, chalices, and kyathoi made of bucchero. Large quantities of
Greek vessels from the Aegean islands, Corinth, and Cumae were found
among the dining equipment. In fact, Tomb 1 represents one of the larg-
est single funerary complexes of Greek imported ceramic in Etruria.
The material is mainly Proto-Corinthian in style: there are ten ovoid
aryballoi and twenty or so kotylai that are Middle Proto-Corinthian;
four pyxides and some other vessels, above all oinochoai, but also ary-
balloi of Cuman type.[19] Among these vessels, the most remarkable piece
is a Cycladic amphora of Theran manufacture decorated with a painted
bird's head, the only example found in a non-Greek context, and a type
of vessel that rarely occurs even in Greek archaeological contexts.[20]

Of the bucchero vessels of Tomb 1, two kyathoi stand out for their
figurative decoration and inscriptions. The first, dated to the middle of the
seventh century BCE, has elaborate excision and relief decoration. It belongs
to a small class of bucchero kyathoi with relief decoration that is restricted
to a few examples of similar date and archaeological context, namely
very wealthy elite burials from Caere, Monteriggioni, and Vetulonia. The
combination of two distinct decorative techniques, relief and excision, is
rare and found only on three other kyathoi, coming from two Caeretan
elite burials, the Calabresi Tomb and the Montetosto Tumulus.[21] The fig-
ures of warriors on the outer surface of the vessel are stylistically close

to Corinthian models, while the scene of the hunt between a man and beast on the inside surface is reminiscent of the decoration of Syrian ivories and Cypro-Phoenician bowls.[22] An Etruscan inscription engraved on the foot of the vessel is morphologically and graphically close to those inscribed on the kyathoi from the Calabresi Tomb,[23] the Tomba del Duce IV at Vetulonia, and Tomb 150 at Casone/ Monteriggioni. The inscription reads 'Venel Paithinas gave me,' and is a so-called gift-giving formula, also comparable to the formulae inscribed on these other kyathoi. In all likelihood, the San Paolo kyathos was produced by the same workshop that produced the bucchero ware from the Calabresi Tomb or by an artist who was very close to this workshop as an item of aristocratic gift exchange.[24] The elite tombs containing the kyathoi and arrays of comparable grave goods were placed along a very specific route that starts at Pyrgi, Caere's emporion, on the coast, and transverses through central Etruria to the metal-bearing hills: the Tumulus of Montetosto, located 4 kilometres from Caere along the Caere-Pyrgi route; the San Paolo Tomb; the Calabresi Tomb in the Sorbo necropolis at Caere, also home to the Regolini-Galassi Tomb; Tomb 150 at Casone/Monteriggioni in inland central Etruria; and Tomba del Duce (group IV) at Vetulonia in the metal district.[25] These bucchero kyathoi mark out the metal route that also mapped the Caeretan elites' personal relations with their northern neighbours.[26] This metal route is traced not via metal or Greek imported objects, but quite fittingly via vessels made of bucchero ware, which appeared for the first time at Caere in the seventh century BCE.

The second bucchero kyathos from Tomb 1 of the San Paolo Tomb has an internal relief decoration depicting the *despotes theron*/ master of animals and animals, which the excavators recognize as Syro-Phoenicizing in style and iconography.[27] Other vessels of local manufacture from Tomb 1 include two large pyxides with 'white-on-red' zoomorphic frieze decoration, and other mid-seventh-century Caeretan ceramics. Remains of precious goods, such as palm and lotus flower ivory fragments of possibly Phoenician manufacture, lay with the pottery, but any other luxury item, save the remains of a chariot, had been looted.[28]

The main chamber of Tomb 2 had also been looted: remaining objects were a bucchero kyathos;[29] a Proto-Corinthian piriform

aryballos; fragments of a Proto-Corinthian olpe that was probably decorated by the painter who also painted other vessels of the side chamber; and last but not least, the bucchero olpe itself, to which I now turn.

The shape of the olpe, a round-mouthed jug, derives from a Proto-Corinthian Transitional ceramic shape,[30] and the decoration consists of two friezes in both relief and incision (as shown in Figure 4.1). The Syro-Phoenicizing or Orientalizing style and motif of lion and panther in the zoomorphic upper frieze is reminiscent of painted friezes on Proto-Corinthian and Corinthian vases (see Figure 4.3).[31] The lower main frieze is filled by a much more complex narrative imagery consisting of three groups and an isolated figure. At the centre of the frieze stands the figure of Medea, her name inscribed, with next to her a man coming out of a cauldron. In the second group six youths carry a long cloth that is inscribed with 'kanna' (see Figures 4.4 and 4.5). Two facing boxers form the third group, and the isolated winged figure carries the inscription 'Taitale,' that is, Daidalos (see Figure 4.6). The inscriptions are all in Etruscan transliterating Greek names.

The excavators have interpreted the frieze as referring to specific episodes of the Argonauts' saga.[32] The depiction of Medea and the man being dipped in the cauldron illustrates the rejuvenation of Jason by the artful and magic crafts of Medea, as attested by later ancient sources.[33] The group of youths carrying a cloth and the two boxers are linked to a passage of an ode composed by the Greek poet Pindar, 'Pythian IV,' which narrates one episode of the Argonauts' wanderings following their enterprise in Colchis in the far eastern corner of the Black Sea: this is the games that the Argonauts attended at Lemnos, and where a precious cloth was given as the prize. The boxers, each wearing one shoe only, are also viewed as a possible reference to Jason, the *monosandalos* hero.

The intact side chamber of Tomb 2 contained about a hundred objects pertaining to a single burial.[34] Among these objects were found dozens of bucchero vases: kylikes, Latial small amphorae, oinochoai, as well as impasto vases. Among these, two ollae were inscribed 'I am of Larth Tarna,' a so-called possession formula:[35] Tarna is a gentilicial *nomen*, presumably referring to the *gens* owner of the tomb. A great many Greek imports, such as Ionian cups and Corinthian vessels, particularly Transitional Proto-Corinthian types, were deposited in this

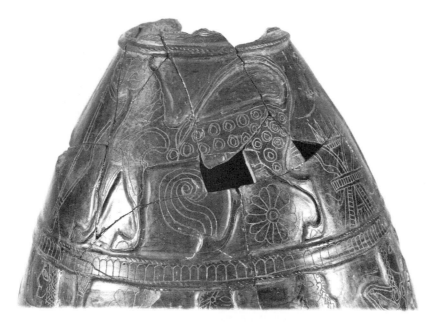

4.3. The San Paolo olpe, upper frieze, panther (Copyright Soprintendenza per i Beni Archeologici per l'Etruria Meridionale; photo n. 137964)

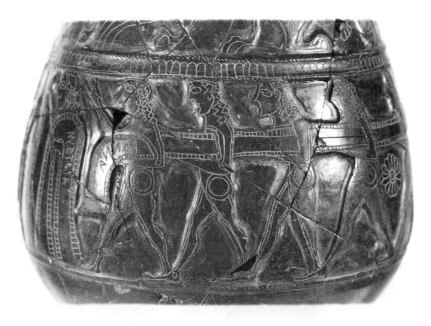

4.4. The San Paolo olpe, lower frieze, group of six youths (Copyright Soprintendenza per i Beni Archeologici per l'Etruria Meridionale; photo n. 137972)

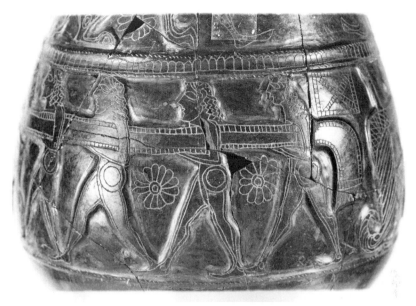

4.5. The San Paolo olpe, lower frieze, group of six youths (Copyright Soprintendenza per i Beni Archeologici per l'Etruria Meridionale; photo n. 137973)

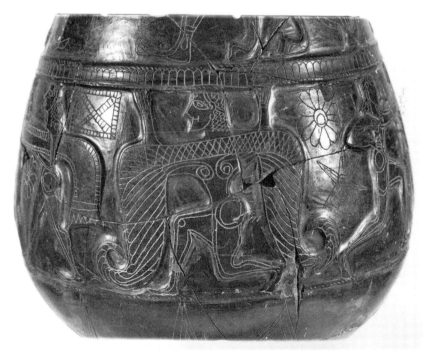

4.6. The San Paolo olpe, lower frieze, Daidalos (Copyright Soprintendenza per i Beni Archeologici per l'Etruria Meridionale; photo n. 137969)

side chamber: Corinthian vessels include some olpai of the Painter of Vatican 73 and of his entourage, and piriform aryballoi.[36] The most remarkable Greek import was not a vessel, but a laminated bronze mask, found inside a bronze basin that was located on a tufa altar in a corner of the chamber. The mask depicts almost the full figure of the Gorgon, and most probably had an apotropaic function: the holes at the ears of the monstrous face indicate that it was hanging on the wall, from which it had fallen. The object was imported from the Aegean where similar uses of these masks are well attested in sacred and civil contexts: similar bronze votive gorgoneions come from sixth-century contexts at Dreros, Sparta, Cyrene, and Corinth.[37] Other grave goods included several bronze vessels and basins, which have not yet been published.

Rarely is it possible to examine an almost complete tomb group from seventh-century Etruria in so much detail, and in this respect the San Paolo Tomb is undoubtedly exceptional. However, this is where the exception begins and ends. That the grave goods form one of the largest single complexes of Greek imported pottery in Etruria is clearly the result of the recent discovery and relatively good state of preservation of the tomb complex. It is also a stark reminder of the fragility of our interpretations of most other contemporary wealthy elite burials in Etruria, which have been victims of long-term looting and poorly recorded excavations. Despite the less-detailed knowledge we have of these other burials, nevertheless we can confidently say that the San Paolo Tomb is comparable to them, particularly those that display the greatest wealth. The tomb, for example, is very similar to the Regolini-Galassi Tomb both in the structure and content of the burials: both tombs displayed chariots and drinking and banqueting equipment. Variation between the grave goods of the two tombs is probably due to different circumstances of preservation: the Regolini-Galassi contained many more metal vessels, including silver vessels, and precious metal personal ornaments.[38] Yet, these and similar assemblages clearly belong to members of the highest elite. As far as we can see, any true variation at all between the vessels that formed the banqueting and drinking equipment of the two tombs was in style and/or provenance rather than quantity or function, and this is an aspect that one can see in other contemporary and similar elite tomb groups in Caere and

elsewhere in Etruria.[39] That vessels differed in style and/or provenance is evidence of the variety of personal and trade connections that elite groups entertained with others. The elites that owned the Regolini-Galassi, the San Paolo, and other similarly wealthy burials used the occasion of the funerary ceremony, which was essentially identical and in tune with the rituals at other contemporary less wealthy elite tombs, to display their own respective personal and trade connections. These connections, however, were not just with outsiders and new settlers, but also with next-door neighbours, particularly at Caere. Here, entertaining relations with northern Etruscan elite neighbours who had direct access to mineral resources was absolutely vital to keep up relations with Greek outsiders: the latter could not flourish without the former. Hence, showing off personal connections with *both* outsiders and next-door neighbours was a particularly strong statement of status. We can assess this clearly from the small group of inscribed bucchero kyathoi that were produced by a single workshop and given out as gifts, and, more importantly, from the strikingly regular association of bucchero and Greek imported ceramic vessels that is displayed in the wealthiest elite burials, particularly at Caere.

Unsurprisingly, there are several other aspects in the material record of Etruria indicating profound culture contact with outsiders. It is important to bear these in mind because they demonstrate tha outsiders other than Greeks were caught up in cultural mixture and intercourse. In fact, local inhabitants and outside visitors and/or new settlers would be more accurate terms with which to conceive transcultural relations in seventh-century Etruria than would Greeks and non-Greeks, if we accept that no clear notion of ethnicity, intended as an identity based on a discourse of kinship and territorial homeland, existed at this time.[40] Even when we aim to analyse Greek interaction with the Etruscans, it is still vital not to lose sight of others who were mixing in the interaction, such as Phoenicians and Sardinians. The use of inscriptions is an important indication of this mixture. The inscribed so-called Nestor's cup, found in a wealthy young male burial (720 BCE) at the San Montano necropolis on Pithekoussai, may suggest that Euboeans learned the Semitic script from Phoenicians there rather than in the east Mediterranean.[41] This famous cup must be viewed against the even earlier Greek inscription found on a Latial

impasto flask from a female cremation tomb at Osteria dell'Osa (*c.* 775 BCE), the linguistic origin of which is still uncertain, and could be Greek, Latin, or Etruscan.[42] What is more certain is that elites, merchants, craftsmen, and others in the Tyrrhenian were learning the alphabet quickly, and transforming it to suit their own language. By employing literate craftsmen, the elites were also flaunting the script as a new *techne*, as indicated by the alphabet charts that were incised on a variety of objects in Etruscan elite burials at this time, from the ivory tablet at Marsiliana d'Albegna, to the bucchero lekythos of the Regolini-Galassi Tomb and other isolated vessels that have unfortunately no provenance.[43] Appearing to be using inscriptions was a statement of status deriving from securing personal connections: the great variety of the objects inscribed and of the elite cultural contexts in which these inscriptions occurred shows that everyone who was *anyone* was flaunting the new script. The astonishingly fast pace at which the North Semitic alphabet was turned around and transformed into myriad local alphabets, including Euboean Chalkidian, further emphasizes the urgency of communicating with the outside world and of advertising the network of acquaintances and connections with that world within one's own community. The Etruscan inscriptions of the bucchero olpe, kyathos, and ollae in the San Paolo Tomb must be viewed in this context: the alphabet had already become Etruscan, but the names of the mythical figures that were being talked about in Etruscan on the olpe are distinctly Greek. The third inscription on the olpe, *kanna*, placed on the long cloth, may be the Etruscan for 'garment.' I would argue that the intention here was to familiarize an Etruscan audience who understood 'kanna' with these images and their significance.[44]

Another aspect that shows cultural intercourse with outsiders is the evidence of changes in Etruscan architecture, the result of longer and earlier contacts with non-Greek outsiders. Seventh-century architecture reveals these significant connections. The new construction technique of ashlar masonry stone blocks, displayed at the Regolini-Galassi Tomb and the San Paolo Tomb, was also adopted for other non-funerary buildings such as the defensive walls and cultic structures at Tarquinia.[45] Changing architectural plans followed the introduction of similar building techniques at elite residences across central Italy, from Ficana

in Latium, to Murlo, Casale Marittimo near Volterra, and Acquarossa near Viterbo.[46] However, small centres such as San Giovenale indicate that changes towards rectangular architectural plans were hardly an abrupt development, and cannot be explained by outside influence alone.[47] The seventh-century tholos building at Roselle, characterized by an oval layout in its interior and enclosed in a square, shows that the adoption of rectilinear stone-built structures for habitation was a slow process.[48] Funerary architecture provides clearer indicators of out-side connections. The monumental architecture of Etruscan tumulus tombs has striking parallels with contemporary funerary architecture in Anatolia.[49] Furthermore, North Syrian craftsmanship has been sug-gested for the sculptures of the Tomb of the Statues at Ceri (650 BCE) near Caere, and for the sculpted cornices of the drums that sustained the tumulus mounds at Caere.[50] In northern Etruria, noticeable changes in funerary architecture are much earlier: in the Colline Metallifere, the adoption of the burial chamber took place at Populonia as early as the end of the ninth century BCE, possibly under the impetus of contacts with Sardinia, where the use of hypogea for collective burials had been a widespread and continuous practice since the Bronze Age.[51] Similar influences from Nuragic Sardinia may also explain the later appearance of tholos tombs in the Val d'Arno such as the Montefortino, Montagnola, and Mula tholoi during the seventh century.[52]

Architecture and inscriptions are only two of the myriad archaeologi-cal indicators of the cultural intercourse between Etruscans and outside visitors and new settlers, Greeks, Phoenicians, Sardinians, and others. They illustrate well the cultural context in which to place the San Paolo Tomb and its grave goods. The tomb was the appropriate setting, where an exceptionally wealthy family group at Caere was not simply show-ing off its fortune, but was brazenly brandishing its elite connections in every single object that was held up to the funeral audience. At first sight, we may suppose that the connections with Corinth were particu-larly strong, given the enormous amount of imported Proto-Corinthian-style ceramics. Rizzo has suggested that the San Paolo Tomb is evidence of the 'earliest Hellenization of Etruria via Corinth,' also known as the 'Demaratean' phase of Archaic Etruria.[53] 'Demaratean' refers to the legend of the Corinthian aristocratic exile and trader Demaratus, who, accord-ing to the sources, fled Corinth at the fall of the Bacchiad dynasty in

657 BCE. The legend told that he arrived and settled at Tarquinia, and brought with him craftsmen who taught the Etruscans the *techne* of clay modelling for architectural terracottas and roof tiles. Debates on the concept of 'Hellenization' aside, Rizzo's interpretation of the grave goods and olpe juxtaposes the Argonauts' saga and its reference to maritime exploration for the search of metals known both in the east and west Mediterranean with ideas of invention and artisan skills, which the figure of Daidalos encapsulated. She further links this juxtaposition to the impetus that Greek contact brought to the arts and architecture of Archaic Etruria. Lastly, Rizzo sees the olpe as early evidence of the link between the Etruscans, the Tyrrhenoi of the west, and the Tyrrhenian-Pelasgi of the east from Lemnos.

I will come back to the legend of Demaratus to argue that its significance lies elsewhere than its Corinthian connections, which may be partly the product of political allegiances and ideological propaganda in later sources. Advocating strong Corinthian connections on the basis of the Greek ceramics of the San Paolo Tomb is not without its problems, since some of the vessels were Proto-Corinthian in style but had been manufactured in other places besides Corinth. Emphasizing a Corinthian commercial wave that rippled across the Mediterranean at this time might be more accurate than assuming direct connections with Corinth.[54]

Virtually all other scholars who have devoted their attention to the bucchero olpe and its figurative decoration, save for Smith, have done so with little consideration of the context of the tomb.[55] Both Menichetti and Massa-Pairault concur with Rizzo that the images refer to the Argonauts' saga, the man in the cauldron is Jason, and that the group of youths and boxers refers to the Lemnian games, as recounted by Pindar. Yet, they have gone further and argued that the occurrence of this myth in seventh-century Etruria suggests a deliberate emphasis on kingship on the part of the Etruscan *aristoi* commissioning the object.

Their argument is based on the analysis of two elements: first, the saga itself and the relationship that later sources established between the saga and the fire purification rituals taking place on the island of Lemnos; and, second, the Pindaric ode, *Pythian* IV, recounting the Argonauts' attendance at the Lemnian games, as suggested by Rizzo herself. According to the sources, the ritual tradition of fire festivals on

Lemnos, which were celebrated in honour of Hephaistos and involved potters and blacksmiths working with fire, originated from the myth of the so-called Lemnian crime.[56] The myth narrates adverse events that took place on Lemnos and ended with the return of the divine king Thoas to the island with the help of Jason and the Argonauts, and the celebration of the end of these adversities and Thoas's return with the Lemnian games. In the myth, the return of Thoas symbolizes the restoration of kingship. In fact, according to Apollonius Rhodius, Jason received the garment Dionysios gave his son Thoas, which was a symbol of royal power, from the Lemnian queen and daughter of Thoas, Hypsipyle. In Homer, the son born from the union of Jason and Hypsipyle is known as the king of Lemnos.[57]

These relations between Lemnian myth and rituals are critical to Menichetti and Massa-Pairault, who view the images on the olpe as direct reference to the Lemnian games and hence a powerful statement of royal power by Etruscan elites. Their assumptions gain strength from the Pindaric ode that also narrates the games and the giving of the garment as a prize at the games. In this ode, which the lyric poet composed in honour of Arcesilaus and the ruling family of Cyrene in the fifth century, the episode of the games is an allusion to the legitimacy of the royal house of Cyrene, and a strong politico-ideological statement to Arcesilaus's right to the throne. The mythical ancestor of the ruling family was Euphemos, a member of the Argonaut crew who arrived at Cyrene from Lemnos; in the ode, Medea herself pronounces an oracle legitimizing Euphemos's descendants to rule over Libya.[58]

Menichetti insists on the symbolism of kingship by focusing on the cauldron scene of the olpe: here, he argues, Medea rejuvenates Jason in the cauldron to a new 'royal' status through her magical crafts, and the sacrificial cooking of his body over fire invests him with a new heroic status. Menichetti does not even spare Daidalos: besides being the artisan par excellence, Daidalos is also possessor of the arts of *metis*, an important credential for royal power and comparable to the *metis* that Medea uses in rejuvenating Jason.[59] Massa-Pairault, on the other hand, examines the *monosandalos* boxers' scene, and detects in it further links to Lemnian myths and cults, particularly Kabeiric rites of initiation.[60] Her reading of the Medea and garment scenes draws our attention to the 'sceptre' that Medea is offering Jason, yet another symbol of royal power, and to the

tall object standing between the cauldron and Medea: she identifies this object as a *xoanon* or statue of the deity, and the garment scene as the *kosmesis* or adornment of the deity, an important stage in purification rituals involving the bathing and clothing of sacred statues. As creator of *daidala*, Daidalos, too, is linked to the *xoanon*, and the cauldron scene represents an instance of the initiation rites of the Kabeiroi.[61]

These hypotheses and their implications are extremely seductive, but also rest on very thin ground for two main reasons. First, their arguments rely upon later literary sources that have historical value only if viewed in their own context. The strong politico-ideological undertones characterizing the Pindaric ode's narration of the Lemnian games episode belong to the historical and political context in which the ode came to light, namely fifth-century Cyrene, a long way away from seventh-century Caere. Second, the foundations of their arguments become even more fragile because they are not buttressed by any consideration of the archaeological context of the olpe, the San Paolo Tomb complex, but are flimsily supported by the view that seventh-century Etruria was a 'princely' culture. This view, I have suggested elsewhere, is open to criticism because it is reductive of the complexities of elite behaviour in seventh-century Etruria.[62] More specifically, their assumptions fail to consider the ways in which a Greek myth was adopted and re-elaborated once it reached an Etruscan audience. To state that the olpe's images refer to a specific episode of the Argonauts' saga is not misguided per se: the images must reflect the part of the story Greek visitors told in Etruria, and, more importantly, the part of the story the Etruscans wanted to hear. However, it is far-fetched to assume that Etruscan elites had a detailed knowledge of the myth of the Lemnian crime, and, even more seriously, that they were aware at all of the allusions in the myth to symbols of kingship, which only made sense to Pindar and other Greeks who were writing in later centuries, as far as we know.[63] Finally, to imply that this very knowledge prompted Etruscan elites to choose those images seems to me too implausible.

The Argonauts and Technological Innovation

If we abandon Pindar, fifth-century Cyrene, Apollonius Rhodius, and later writers, and return instead to the cultural historical context of seventh-century Etruria and the grave goods of the San Paolo Tomb,

we may understand the significance of the olpe's images in their own context.

As I have suggested, the Argonauts' saga was one of the transcultural mythical narratives encouraging the dialogue between Greeks and non-Greeks, yet as is clear from similar instances, such as the epic of Odysseus,[64] these narratives were understood in different ways, as they were re-elaborated and exploited in local contexts. The significant allusion to explorations in search of metals that the Greeks weaved in the Argonauts' saga was clearly behind the telling of this particular story: it is important not to lose sight of the meanings the Greeks were attributing to the Argonauts in the seventh century, rather than later,[65] because they themselves introduced the Etruscans to the myth and it became a transcultural language precisely on the basis of these meanings. At the same time, the connotations that the Greeks attributed to the myth in Etruria were important to the Greeks because they also appealed to the Etruscans. Besides the Greeks' quest for metal sources, the connotations that might be particularly appealing to the Etruscans alluded to the 'invention' and discovery of new *technai*, particularly those related to metallurgy – a subtext that the olpe's craftsman perhaps exploited, and that we see in the combination of the Argonauts' scenes with Daidalos, the artisan inventor who was associated with Hephaistos from Homer on.[66]

In Greek mythology, besides maritime explorations for the acquisition of metals, the Argonauts' saga did indeed reflect a concern with the 'discovery' of the *techne* for the production of metal. This structural relationship, which the myth establishes between maritime travels and the 'invention' and development of *technai*, discloses a concern with the encounter and interaction between Greeks and non-Greeks during the travel, which is emphasized by the Greek propensity to designate metallurgical centres and mineral-rich areas with specific names. Greek mythology associated Lemnos, a stop-over during the Argonauts' explorations, with Hephaistos, forger of metals par excellence, and named the island 'Aiothaleia.' According to Hekataios, 'Aiothaleia' is identical to the name Aithale, which was given to the island of Elba, an important metal source area opposite the metal-bearing hills of northern Etruria: Elba, in fact, took its name from the furnaces for metalwork.[67] The relationship between Etruria and Lemnos is underscored by the single Greek

name Tursenoi/Tursanoi that designated them both, which we find in
Hesiod's *Theogony*. Here, it is difficult to pin down the precise meaning of
the name, which may have referred to 'pirates' and/or 'migrants'.[68] This
indicates that in the seventh century these names were not ethnic appel-
lations; instead they pinpointed metallurgical centres and mineral-rich
areas on the Greeks' metal-search map. Only later on did Tursenoi/
Tursanoi become ethnic, and probably in the fifth century; it is then
that the distinction between western Tyrrhenians and east Tyrrhenians,
referring to Etruria and Lemnos respectively, and the identification of
Pelasgoi-Tursenoi at Lemnos were created.[69]

The process of assigning ethnicity to these areas, which we find in
later sources, is revealing of the tendency by the Greeks to attribute
foreign and exotic origins to new *technai*, such as writing, and customs.
This is historicized in Herodotus.[70] The olpe demonstrates that this
tendency did, in fact, originate from the very encounters and cultural
interaction between Greeks and non-Greeks. This interaction must
have involved the exchange of new *technai* at crucial points of the metal-
searching journey, which were charted by the myth, and of which Etruria
was one. Here, Greeks and Etruscans not only learned new *technai* such
as metalwork and vase painting decorative skills from one another, but
also refined and 'invented' new *technai* as a result of this exchange. As an
innovative *techne*, bucchero visually transformed pottery into metal and
thus enabled Etruscan elites to show off shiny vessels for their ritual
practices in front of the grave. Most early bucchero vessels such as Latial
amphorae, and oinochoai were, in fact, either libation instruments or
miniature vessels, as the San Paolo olpe itself, which had a ritual func-
tion; in exceptional non-ritual contexts, such as the Lower Building of
the elite residence at Murlo, bucchero featured greatly as banqueting
equipment.[71] Technically speaking, bucchero derives from an earlier
and coarser Italic ware known as impasto, which required a reducing
firing atmosphere. The range of impasto vessels of Iron Age date shows
the process whereby craftsmen experimented with impasto firing tech-
niques and increasingly refined the clay mix until they succeeded in
producing vessels with thin, shiny and metal-like walls.[72] This techno-
logical 'invention' was stimulated by the demand by Etruscan elites for
a medium that would imitate the sought-after metal, but, at the same
time, also procured them status. Hence, elite images were particularly

rich and widely reproduced on bucchero vessels.[73] Furthermore, the earliest and finest bucchero, the so-called *bucchero sottile*, which had the closest resemblance to metal, was produced at Caere, which was quite a distance from the metal district further north, and had no direct access to metal sources except for the Tolfa Hills.[74] Yet, Caere was close to other elites further south, in Latium and Campania, and to the new settlements of Cumae and Pithekoussai, at which this new *techne* could be exhibited, and the bucchero vessels exchanged.[75]

On the other hand, Caere's elite neighbours further north could splurge on the resources that made them rich by exhibiting vast arrays of metal vessels and ritual utensils at their funerary ceremony, as indicated by the visible upsurge of metal grave goods in northern Etruscan seventh-century elite contexts. In these contexts, particularly the wealthiest ones, we find a regular funerary association of bucchero and metal vessels, and a striking absence of Greek imported ceramics.[76] The quality and stylistic variety of these metal goods show the exceptional technological achievement of northern Etruscan metalworkers, which local elites displayed at the grave.

Greek vase painters and Etruscan potters who used metalworking incision techniques on painted vessels and bucchero ware may have refined their skills from their mutual exchange. In this exchange, new *technai*, which led to 'inventions' such as bucchero or Black Figure on painted ceramics involving the use of silhouettes with incised details,[77] became one of the many channels through which distinct identities could be expressed. Bucchero ware, the product of a new transcultural or even hybrid *techne*, later acquired a distinct status as the Etruscan ware par excellence. This does not imply that bucchero became a material reference to ethnic identity. Bucchero vessels that were distinctly Etruscan in the Tyrrhenian must have acquired different connotations as they were exported to far away places while still maintaining an Etruscan look. We can see this at Miletus, where some individuals who had brought or bought Caeretan bucchero ware from Etruria in the late seventh and sixth centuries were showing off exotic goods in a Milesian context.[78] Similarly, the upsurge of bucchero imports at Greek sites in the east Mediterranean, and at Greek, Phoenician, and indigenous settlements in the central Mediterranean in the Archaic period must be viewed contextually:[79] here, among the indigenous

communities of southern France, the desire to acquire bucchero was probably influenced by the Etruscan 'signature' of bucchero because of the prestigious practice of wine drinking underlying this signature. That the Etruscans, besides the Greeks, were particularly fond of drinking activities may have been in the mind of the non-Etruscan consumers buying the vessels.[80] This does not mean that the signature determining the consumer's choice was an ethnic one. On the other hand, bucchero vessels may have carried an 'ethnic resonance,'[81] which rang more of clinking wine-drinking cups than of any clear acknowledgement of Etruscan ethnicity among non-Etruscan communities. In the context of these non-Etruscan, non-Greek indigenous communities of the Tyrrhenian Sea region, the artefacts underlying wine drinking formed a discourse of things: they aptly demonstrate that by the Archaic period wine drinking had become a hybrid cultural practice, yet the choice of bucchero drinking vessels by these consumers also reveals their keen preference for certain material cultural associations that were distinctly Etruscan.

The combination of the Argonauts and Daidalos on the San Paolo olpe reinforces the assumption that the connotation of technological innovation, which the Argonaut myth conveyed to the Greeks, also determined the choice of these images for the olpe. It is conceivable that the Etruscan elite who commissioned the olpe was also consciously selecting this very iconographic juxtaposition of the artisan/craftsman with the Argonauts, especially because this juxtaposition was articulated on bucchero ware. If this were indeed the case, it follows that the Etruscans appreciated this connotation very well, but we should not undervalue the role of the craftsman. The craftsman could have him/herself suggested this juxtaposition to the Etruscan customer, who exploited the underlying meaning of technological innovation that the images symbolized in order to articulate a dialogue of difference with his/her Greek partners. The craftsman was fully implicated in articulating this dialogue because he/she was the actual designer of new *technai* and in control of technological innovation. Indeed, by adding Daidalos on the olpe the craftsman may have exploited the opportunity of portraying the myth that was appealing to his/her rich patrons and thus promoted him/herself. The iconographic arrangement of the scene of the youth carrying the cloth on the olpe is strikingly similar to the arrangement

of the scene of the blinding of Polyphemos on the Aristonothos krater.[82] This was a painted vase that the Greek vase painter Aristonothos realized at Caere during the second quarter of the seventh century BCE.[83] The striking resemblance of these two images suggests that the scene of the krater had achieved definite fame in Etruria. The craftsman of the olpe probably sold this figurative arrangement to the Etruscan customer because this was the latest thing to show off, but was also aware of the underlying meaning of the images that the Etruscan customer wanted to convey. At the same time, the elite owner of the olpe went for this figurative arrangement because it portrayed the Argonaut myth with its connotation of technological innovation, but he/she attracted attention by sporting the better-known formula of the Aristonothos krater. However, the elite vigilantly made sure that there would be no confusion in the Etruscan audience, and had the olpe inscribed with *kanna*, the Etruscan word for garment, along with the names of Medea and Daidalos.[84] The myth engraved on the olpe was unmistakably that of the Argonauts, not Odysseus, yet upon first view the images could be overlooked and taken for the Polyphemos scene. Indeed, if we assume the engraver to be Etruscan, he/she may have copied the famous scene, but then inscribed the olpe in order to remind himself/herself of the Argonaut myth which the engraver had been commissioned to portray.[85]

In embracing this figurative narrative, the elite owning the San Paolo Tomb did not just entertain a dialogue with Greek partners. The message that the Argonaut myth conveyed had to become understandable to their Etruscan partners, the only ones who could comprehend the meaning of *kanna*, and/or other craftsmen working at the elites' service. To them, figurative language and mythical narrative were powerful statements underlying a discourse of power woven around the same theme that structured the dialogue with the Greeks: technological innovation.

If we read it in this context, the legend of Demaratus provides important clues to these suggestions. Demaratus was a trader, but in the ancient sources he is also deemed responsible for bringing to Etruria the artisan skills of painting, clay/terracotta modelling, and sculpture. He was also the father or grandfather of Lucumo, who took the name of Tarquinius Priscus, the first Etruscan king of Rome and who requested an Etruscan artisan, Vulca, active in Veii, to work on the terracotta roof

decoration of the Temple of Capitoline Jupiter in Rome. Needless to say, the ancient sources have paid considerable attention to Demaratus because of his role in establishing the dynastic line of Etruscan kingship in Rome. His legendary long-standing dynastic lineage, which was traced back to the Bacchiads of Corinth, may have served Roman writers in their objective to single out the tyrannical nature of the later Etruscan kings.[86] On the other hand, the double reference to the skills of terracotta moulding, which is concerned with the introduction of technological innovation from the outside and the transformation of the new *techne* into a distinctly Etruscan skill, has caught modern scholarly attention. Among some scholars, Demaratus has acquired preeminence, even historical truth, because the legend provides the backdrop to the Greek impetus upon the arts and crafts of Archaic Etruria. The phrase 'Demaratean phase,' in fact, suits well those who support the early Hellenization of Archaic Etruria. However, recent debates on Demaratus have concentrated on assessing the role of Greek influence on Etruscan material culture and its changes.[87] Latest research on the terracotta and rooftop tile decoration of seventh-century buildings at the settlement of Acquarossa (Ferento) near Viterbo, and at the contemporary *regia* of Murlo (Poggio Civitate) south of Siena, has shown that innovations in terracotta decoration of buildings occurred in Etruria well before the Greeks had developed roof tiles, and that there was nothing 'Greek' about them. To put it more accurately, the technical skills for, and the custom of, rooftop decoration, displayed in the extant miniature models of Villanovan huts, were indigenous to Etruria.[88] Recently, important attempts have been made to view Demaratus as evidence of the close relationship between elites and workshops in Archaic central Italy, where exclusive workshops produced images for the elites' politico-ideological consumption under their control.[89]

In the wake of these studies, I want to read the politico-ideological undertones of the message that the legend may have communicated. Demaratus is not just anybody: he is quite explicitly a member of that Mediterranean travelling aristocratic community who could afford to land on new shores and establish himself through his network of elite personal connections, and thereby promote commercial ties in the central Mediterranean. This fits well with the contemporary archaeological evidence including the San Paolo Tomb, showing

the upsurge of Corinthian imports both in Etruria and in south Italy during the seventh century. This correspondence has indeed tempted scholars to see historical truth in Demaratus and to identify him as an archetypal figure of the aristocratic trader or a metaphor for elite trade with Corinth. However, as the imports from the San Paolo Tomb suggest, Corinthian-style pottery was produced by myriad workshops outside Corinth, and at any rate we should be distrustful of dubious pots-equal-people connections.[90] The legend, in fact, fits with the archaeological evidence a little bit too well, and this may tell us that it was made to fit a historical reality in order to convey a message. If the message is no longer concerned with Greek influence over Etruria, the construct of a Hellenocentric scholarly view, then what did Demaratus bring to Etruria? He brought what I see as crucial to his aristocratic status, namely, technological innovation, the very same asset that the owner of the San Paolo Tomb flaunted on the olpe through the Argonaut myth. Demaratus could bring technological innovation precisely because of his privileged mobility, which gave him access to the finest and most sought-after craftsmen. Like them, Demaratus was a migrant, besides being a trader: his figure, in fact, merged into one aristocratic trader and craftsman, the two seventh-century Mediterranean travelling figures par excellence, and hence he demonstrates the intimate relationship that indissolubly linked the elites to the craftsmen working at their service. That the innovation had to do with some specific *technai* (terracotta and painting) is not relevant here. As we know, the Etruscans had done terracotta moulding and rooftop decoration for some time before the arrival of the Greeks and were better than them at that. What was happening in the Tyrrhenian region in the seventh century was an upsurge of innovation in a whole variety of technologies, from architectural decoration, to ceramics and metalwork, which, I have suggested, matched the intensity of cultural interaction and exchange between Greeks, Etruscans, Phoenicians, Sardinians, and others.

Through the appropriation of technological innovation, Etruscan elites acquired status within their own communities and vis-à-vis their elite partners. They claimed responsibility in promoting and generating technological innovation through the artisan who, in turn, created a whole series of visual representations disclosing an 'iconography of

elite behaviour,' and, as innovator, promoted him/herself.[91] The elite individual who chose those images was the de facto innovator.

The Iconography of Elite Behaviour

The San Paolo olpe exemplifies this dialectic interplay between artisan and elite, technological innovation and elite images. The hunting and warrior scenes that were displayed on the bucchero kyathoi of the San Paolo Tomb were also part of this elite figurative repertoire, and are found on the few other kyathoi that were probably produced by a single workshop given the similarity in the technical execution of the decoration.[92]

Some of the images underscoring the iconography of elite behaviour were also produced by vase painting, a technique that Etruscan potters learned from Greek vase painters. A distinct group of Orientalizing Etruscan painted vessels from Caere shows the technical and creative results that vase painters, active there in the seventh century, attained.[93] Their style reveals East Greek, Cycladic, and Euboean artistic influences, suggesting the hand of either Greek or Etruscan vase painters learning from them.[94] The distinctly heroic figurative repertoire that the painting displayed, including warriors in battle, scenes of warriors leaving on chariots, lions and wild animals, men with horses, and the warrior standing by a ship,[95] is comparable to the images decorating bucchero vessels. Furthermore, like the San Paolo olpe, some of these painted vessels depicted Greek mythological scenes. Of these, the best-known examples are the aforementioned Aristonothos krater and an amphora from the Allard Pierson Museum in Amsterdam showing an image that we can now safely interpret as Medea and the dragon.[96] The departure of the hero on chariot may also refer to a myth from the Trojan or Theban epic cycles. Marina Martelli has identified the Argive hero and seer Amphiaraus in one such scene painted on an amphora of the Heptachord Painter.[97] Other early figurative documents of Amphiaraus and his departure on the expedition of the Seven against Thebes, which allow her to come to this identification, are some late seventh-century bronze laminated plaques from Olympia, and the column krater TC I of the eponymous Painter of Amphiaraus from Caere itself, and now lost. The side B of this krater showed Amphiaraus and

the funeral games in honour of Pelias, the king of Iolchus, who devised Jason's expedition of the Golden Fleece. The painter executing these scenes on the krater followed the same succession of images adorning the chest of Kypselos, which was exhibited at the temple of Hera in Olympia.[98] While the funeral games and the departure of Amphiaraos for Thebes were famous subjects of Archaic vase painting, the figures of Amphiaraus and Pelias were favoured at Caere because both referred to the Argonauts.[99]

Amphiaraus was also a favoured hero elsewhere, namely at Oropos opposite the Euboean settlement of Eretria in south-eastern Beoetia. According to literary sources, Amphiaraus was swallowed up by the earth at Oropos on his exile from Thebes. Near Oropos stood a major sanctuary dedicated to the hero, who was later attributed healing power during the Peloponnesian wars.[100] In the eighth and seventh centuries, Oropos was also a metalworking centre. The industrial complex includes apsidal, circular, and rectangular structures of different building phases, the earliest of which was Late Geometric; in the late seventh century, the complex was abandoned. The largest apsidal structure, building θ, had important functions as a ruler's house, assembly hall, or even religious purposes. Remains of a small shrine, infant burials, and other evidence of sacrificial activity, show that cult and sacrifice were practised around metalworking activities. Strong links with Euboea are found at Oropos in the clay horse figurines and the pottery, including imitations of Proto-Corinthian and Corinthian vessels, as well as imports from further east.[101] This material, particularly the ceramics, is not unlike that which Etruscan and other elites acquired from their Euboean, Phoenician, and other partners being stationed or settling at Pithekoussai from 750 BCE. However, the resemblances do not cease with the pottery. On Pithekoussai, the industrial quarter at Mezzavia resembles the metalworking centre of Oropos: the buildings were similarly arranged, and at both sites the only building that was not used as a workshop was an apsidal structure containing fine ware and drinking vessels, possibly belonging to the local elite.[102] This may suggest that the Mezzavia's complex was set up by Euboeans who frequented Oropos, or Boeotians from Oropos. A final correspondence between Oropos and Etruria is suggested by Graia, the name that ancient sources attributed to Oropos. In Homer, Graia was a town of Boeotia, and Thucydides and

Strabo associated it with the town of Classical Oropos.[103] The names Graia and Graioi seem to be analogous to Tursenoi, the name for the inhabitants of both Etruria and Lemnos, and designated the metallurgical centre of Oropos. Both Graioi and Tursenoi, then, identified those points along the Greeks' metal map, either metalworking centres or metal source areas, at which people met and exchanged new *technai*. Yet, the exchange was also nonmaterial, and included transcultural values, mythical narratives, and images that were understood and accepted by all partners involved. This is shown by the diffusion of a shared heroic figurative repertoire including epic sagas such as that of the Argonauts. The apsidal buildings at the industrial quarters of Oropos and Pithekoussai demonstrate that the exchange occurred at a high level of the social scale among elites who were in contact with metalworkers and indeed may have controlled the metalworking quarter. The vessels, which displayed the elite figurative repertoire, and all the other grave goods that were buried in wealthy Etruscan burials, show the equally exclusive social arena in which the exchange took place in Etruria.

Yet, if Tursenoi and Graioi denoted the exchange locations at which these people met in the seventh century, they began designating people in later centuries when they became ethnic names. This reveals the tendency of Greek mythology to attribute foreign and exotic origins to new *technai* that is found again in Herodotus, where we have a non-mythological presentation of ethnea 'learning' skills and customs from each other.[104] What began as a simple process of 'calling each other names' among Greeks and non-Greeks during the encounter ended as the process of ethnonimity. The Greeks were not the only ones to construct ethnicity through names; non-Greeks, too, exploited these names for defining collective identities. Hence, Graici became the collective name by which the western Tursenoi identified all the subsequent newcomers from the Aegean.[105] These appellations of future ethnic identities originated from the crucial points along the Mediterranean metal route. However, as Herodotus demonstrates, it was not the exchange of metal and other material goods that was significant, but the exchange of technical knowledge, including writing, and this was a stimulus to technological experimentation and innovation. In this cauldron of technological exchange and cultural mixture, craftsmen serving local demands and needs developed distinct styles

and types. These are the very categories that today we often simplistically study as markers of ethnic identity with little attention to the complexities of how both material and non-material objects came to be used for defining ethnicity.

Conclusion

I have examined the San Paolo olpe and its archaeological and historical context in order to show the ways in which material and non-material objects were used to create both a discourse of things and a mythological discourse that were deeply intertwined with one another in a setting of cultural mixture following the encounter between Greeks and Etruscans in the Tyrrhenian Sea region in the eighth and seventh centuries BCE.

In this setting, the Argonauts' epic depicted on the olpe and other artefacts in Etruria was introduced by the Greeks as a mythical narrative encouraging a dialogue with non-Greeks, and was woven around the very connotations to which the epic alluded: the search for mineral sources and, more importantly, the discovery and invention of new *technai*, particularly those related to metallurgy. The epic soon became a transcultural narrative as it was re-elaborated and understood in Etruria in order to suit local purposes and meanings. Hence, while the epic constituted a lingua franca for cultural mediation between Greeks and Etruscans, it was also exploited by the Etruscans in a discourse of status and prestige vis-à-vis their own communities and neighbours. Furthermore, because of the epic's allusion to technological innovation, a discourse of things involving the invention of new *technai* and the production of innovative and sophisticated objects was woven around the mythological discourse. Later on, after the sixth and certainly in the fifth century, the myth was reinterpreted and acquired different meanings, and this is shown by the preference for specific episodes of the epic in Etruscan and southern Italian vase painting.[106]

The dialogue of cultural mediation between Greeks and Etruscans, which both these material and non-material discourses encouraged, also constituted the arena for defining places, people, and their identities, which ultimately were to become ethnic.

Acknowledgements

Ideas discussed in this contribution were presented at research seminars at the Department of Classics at the University of St. Andrews and the Department of Archaeology at the University of Exeter, and I benefited from precious feedback on both occasions. I am indebted to Robin Osborne and Peter van Dommelen for reading the text thoroughly and offering invaluable insight and suggestions. Emily Kearns has also extended important help and proffered interesting comments on Herodotus. Any errors or flaws are entirely my own.

Notes

1. Hall 1989; Hall 1997; Malkin 1998; Malkin 2001b; Shepherd 2005, 115–36.
2. Antonaccio 2001, 113–57.
3. Hall 1997.
4. Antonaccio 2001. Though even in Sicily aggregative identities were contested on many grounds and in a variety of contexts and chronological phases.
5. Malkin 2001a, 14.
6. These momentous changes occurred following the end of the Bronze Age: Pacciarelli 2000. According to the chronological framework recently proposed, the Bronze Age/Iron Age transition has been set at c. 950/925 BCE: Pacciarelli 2005.
7. Malkin 2001a, 14.
8. Malkin also defines the field of Greek colonization as Middle Ground (see Antonaccio, Chapter Two).
9. Malkin 2002.
10. Malkin 2002.
11. For example, the Chigi olpe: Arias, Shefton, and Hirmer 1962, 17, 275–6, pl. IV, 16; Rasmussen 1991, 57–62; Aristonothos krater (see below); the Tragliatella oinochoe: Martelli 1987, 271, no. 49; Menichetti 1992; Menichetti 1994; and the slightly later François vase from Chiusi: Menichetti 1994. An exception is a seventh-century Etruscan red impasto pithos depicting the blinding of Polyphemos, held in the J. Paul Getty Museum.
12. We do have examples of later fifth-century Greek vessels in Etruria depicting images of the Argonauts: e.g., an Attic red figure hydria from Vulci (*LIMC*, 'Iason' 62), and an Attic red figure kylix from Caere (*LIMC*, 'Iason' 32): Pontrandolfo and Mugione 1999.
13. Although production of bucchero ware continued in later centuries in and outside Etruria, the metal-like appearance of the earliest seventh-century bucchero vessels, which Etruscan craftsmen succeeded to create, remained unparalleled.
14. Antonaccio in Chapter Two.
15. Rizzo and Martelli 1993; Menichetti 1995; Massa-Pairault 1994; Smith 1999; Rizzo 2001; Bellelli 2000–3.
16. With the exception of Smith 1999, whose analysis of the olpe could not, however, benefit from the publication of the tomb group.
17. Rizzo 2001.

18. Rizzo 2001.
19. Parallels of these Proto-Corinthian vessels come from various sites: those of Cumaean manufacture have also been found at Cumae, Pithekoussai, Satricum, Pontecagnano, Tarquinia, as well as in other Caeretan tombs. A few other parallels also come from Corinth: Rizzo 2001, 168–70.
20. Outside Thera, other parallels for this vessel come from Aegina, Delos, Naxos, Samos and Cumae. Not a vessel for export, it is mainly restricted to Cycladic contexts, yet it found its way to Caere along the route via Rhodes as a prestige object. No parallel is known from any Greek settlement of Magna Graecia: Rizzo 2001, 167 and 168.
21. From chamber II of the Tumulus: Dore Marchesi and Minarini 2000, 207, no. 223.
22. Rizzo 2001, 166–7.
23. Sciacca 2003; Sciacca 2004; Sciacca 2006–2007.
24. Sciacca 2003, 116.
25. The San Paolo Tomb is on the Bracciano-Settevene road from Caere at the junction to Ceri, on the way to the sea. For the Regolini-Gallassi Tomb, see Sciacca and di Blasi 2003. For Tomb 150 and Tomba del Duce, see Dore Marchesi and Minarini 2000, 315, 320 nos. 433, 434; Sciacca 2004, 35, n.53. The burials from Caere (San Paolo, Calabresi, Montetosto) also shared a similar monumental structure (built tomb with dromos) – although nothing is known of the original structure of the Calabresi Tomb.
26. The similar inscriptions on the kyathoi from the tombs of San Paolo, Calabresi, 150/Casone at Monteriggioni, and del Duce at Vetulonia indicate even more explicitly the personal relations existing between the owners of these tombs. On aristocratic gift-exchange in Etruria, see Sciacca 2006–2007.
27. Rizzo 2001.
28. The ivory fragments were probably decorations from wooden boxes, as attested in other Etruscan elite tombs with similar grave goods (Rizzo 2001). The chariot remains are not mentioned in the most recent publication of the tomb group, but are cited in the catalogue of Emiliozzi 1999.
29. Dated between the second and third quarter of the seventh century, with parallels found exclusively at Caere: Rizzo 2001.
30. The shape of the San Paolo olpe is very similar to the shape of the Chigi vase. As a ceramic form, the olpe was invented at Corinth, but is clearly derivative of a metal shape: Rasmussen 1991, 58.
31. Cook 1997, 52–7, fig. 6.
32. Rizzo 2001.
33. Euripides, and Lycophron's *Alexandra*. Yet, the episode is known in the *Nostoi* and in Simonides: Pontrandolfo and Mugione 1999, 329. The rejuvenation of Jason by Medea is also depicted on later Attic vessels found in Etruria: *LIMC* 'Iason' 59–62. Of these, the Attic red figure hydria from Vulci (no. 62) depicts the scene with a white-haired older man, not to be mistaken for Aeson thanks to the inscription besides the man, which designates him as Jason: Pontrandolfo and Mugione 1999, 330, n. 5.
34. Skeletal remains were recovered on a small pebble bed: Rizzo 2001. The laying of a funerary bed made out of pebbles is also attested from the slightly earlier Tomba della Capanna at Caere.
35. The gentilicial *nomen* Tarnas occurs again at Caere in the fourth century BCE: Rizzo 2001, 174.

36. Rizzo 2001, 165. The hand of this vase painter is also found on vessels from other elite tombs at Caere.
37. Rizzo 2001, 173.
38. No ceramic was found in the cella and the righthand-side niche of the Regolini-Galassi Tomb: Pareti 1947, 245. The metal vessels from the San Paolo Tomb have not yet been published.
39. Pareti 1947 drew parallels between the Barberini, Bernardini, and Regolini-Galassi Tombs respectively. Less wealthy elite burials also displayed similar grave goods for banqueting and wine drinking.
40. Antonaccio in Chapter Two.
41. Sherratt 2003, 233. Similarly, it may have been on Pithekoussai rather than the east that the Greeks first came into contact with the custom of the *symposion:* Murray 1994, 54. Sherratt's (2003) important study on the reintroduction of writing in Greece convincingly argues that the adoption of the Semitic script to write Greek was an expression of the language as a fundamental element of Greek identity in the Mediterranean. In a context of cultural mixture the ways in which the Semitic script was used to express different dialects underlay the variety of emerging collective identities that made the Tyrrhenian region a cultural melting pot.
42. Bietti Sestieri, De Santis, and La Regina 1989–1990; Ridgway 1996.
43. Such as the bucchero cock-shaped vessel from Viterbo: Pandolfini and Prosdocimi 1990, 22–3. Other alphabet charts from known contexts include: a red impasto Latial large amphora from Tomb 4, Monte Campanile, Veii, and a painted local aryballos from Tomb 863, Casal del Fosso, Veii, both tomb groups being unpublished; the bucchero amphora from the Monte Aguzzo Tumulus at Formello, Veii, which was exceptionally inscribed with two sets of alphabet charts, a gift-giving inscription with both the names of the gift-giver and recipient, as well as the craftsman's signature: Pandolfini and Prosdocimi 1990, 24–6, no. I.4, tables V–VI; Bagnasco Gianni 1996, 133–4, no. 15.
44. The Greek labelling of human figures and objects on the François vase would have served a similar function: de la Genière 1999; yet the writing on this vase would have been helpful only to those who had prior knowledge of the stories depicted on the vase: Osborne 2007.
45. Bonghi-Jovino 1986, 93–111; Bonghi-Jovino and Chiaramone Treré 1997.
46. For Ficana, see Pavolini 1981; Rathje 1983; Stopponi 1985. For Murlo, see Phillips Jr. 1992; Stopponi 1985, 64–68, 74–98. For Casale Marittimo, see Esposito 1999; Torelli 1999. For Acquarossa, see Östenberg 1975; Stopponi 1985, 41–64; Wikander and Roos 1986, 40–72.
47. Steingräber 2000.
48. Donati 2000, 32.
49. Naso 1996.
50. Colonna and von Hase 1984; Naso 1998.
51. Bartoloni 2000, 27–9; Bartoloni 2003, 57–63; Lo Schiavo 2000.
52. Bartoloni 2000, 27; Bartoloni 2003, 65.
53. Rizzo 2001, 165.
54. See Ridgway 2006, 33–4, on the presence of Corinthian vase painters and potters on Pithekoussai.
55. Massa-Pairault 1994; and Menichetti 1995. Both, however, wrote before the tomb group was fully published. Smith 1999 is an excellent attempt at considering the cultural context of the olpe but his analysis unfortunately lacked knowledge of the grave goods.

56. According to Hellanicus, the Sinties of Lemnos invented fire and the forging of metal weapons: Burkert 1970, 3.
57. Homer *Il.* XXIII, 747; XXI, 41; VII, 468; XIV, 230.
58. Menichetti 1995, 277, 278.
59. Menichetti 1995, 279–80.
60. Massa-Pairault 1994, 448–9.
61. Massa-Pairault 1994, 463.
62. Riva 2006.
63. Even if we concede that such allusions may have been known among the Greeks as early as the seventh century, it is still unlikely that they would have been understood by an Etruscan audience in such detail.
64. Malkin 2002. Interestingly, analysis of Pindar's *Pythian* IV has led scholars to note the parallel between Jason's encounter with the dragon in the ode and Odysseus's defeat of the Cyclops, and emphasize the intertwining between the stories of the Argonaut and Odysseus at an early date: "the crossing over between Odysseus (or Odyssean characteristics) and Jason in *Pythian* 4 doubtless lay to hand in the poetic and mythical material (perhaps mostly oral) long before Pindar." Segal 1986, 15–16.
65. The link between metals and Colchis as reflected in the story of the Golden Fleece also points to the early search and/or trade of precious metal ores by the Greeks in the Black Sea region where Armenia and Caucasus, not Colchis as Strabo had noted, were rich in metal sources from a very early date. Boardman 1999 [1964], 245; Braund 1994.
66. Frontisi-Ducroux 1975. Homer calls artful crafts *daidala* and associates them with Hephaistos; after Homer, Daidalos continues to shadow Hephaistos: Morris 1992, 99. An eastern origin for a Late Bronze Age Daidalos is attested by Ugaritic and Mycenaean sources, and this reflects the nature of Aegean relations with the Levant that involved mobile craftsmen, especially metallurgists: Morris 1992, 99–100.
67. De Simone 1996, 42–3. Aithalides is furthermore the name of an Argonaut.
68. De Simone 1996, 55–6.
69. The olpe is therefore important early evidence for the links that Greek mythology established between Lemnos and Etruria: de Simone 1996.
70. Emily Kearns, personal comment. See further the invention of coinage attributed to the Lydians (Herodotus 1, 94), of military accessories attributed to the Carians (Herodotus 1, 171), and of the calendar and religious customs that the Greeks adopted from Egypt (Herodotus 2, 4, 43, 50, 59).
71. At Murlo, the bucchero finds are dated within the last quarter of the seventh and the first quarter of the sixth century: Berkin 2002.
72. Bucchero has fewer inclusions than impasto and the intermediate clay was impasto buccheroide, which characterizes the kyathos from Monteriggioni. Potters may have experimented with refining the clay mixture after seeing other ceramics that were characterized by particularly refined clay. The purer clay allowed the potter to produce vessels with thinner walls. Yet, *bucchero sottile* also required specific firing settings, which involved an even lower oxygen firing atmosphere as well as a specific type of furnace that allowed the potter to reach this atmosphere. That production of *bucchero sottile* ceased from the middle of the sixth century suggests that the technique of *bucchero sottile* was soon forgotten, giving way to a standardized production of *bucchero transizionale* and *pesante*: Gran Aymerich 1990; Acconcia 2004.

73. Gran Aymerich 1999.
74. Workshops at other centres have been hypothesized to be the place of manufacture of *bucchero sottile* vessels found in northern and inland Etruria. However, these sites' products are characterized by less refined clay and firing than Caeretan ones, suggesting that technological skills had only been partially transferred from southern coastal Etruria: Sciacca 2004, 35, n. 54; Acconcia 2004, 288.
75. From Pithekoussai, bucchero vessels may have reached the east Mediterranean.
76. Riva 2000, ch. VIII.
77. Rasmussen 1991; Cook 1997, ch. IV.
78. Miletus has now produced the largest quantity of Etruscan bucchero ware in the whole of eastern Greece: Naso 2006. We know from some inscribed examples that bucchero vessels, mainly kantharoi, dedicated at Greek sanctuaries, particularly Ionian sanctuaries, were transported and/or given by Greeks.
79. Bucchero imports come from Samos, Megara Hyblaea, Syracuse, and Selinous in Sicily, Massalia, Carthage, Tharros on Sardinia, and non-Greek settlements and oppida in the Languedoc and Provence: Gras 1985, 490–8; Renard 1979; Gori and Bettini 2006; Bonghi-Jovino 1993.
80. At indigenous sites in southern France we find a consistent combination of bucchero kantharoi and Etruscan wine amphorae among imported pottery: these communities also practised wine drinking out of Etruscan vessels, and may have particularly liked the Etruscan look of their drinking habits. Cf. Dietler 1997; Dietler 2006.
81. Antonaccio 2001, 125; Antonaccio in Chapter Two.
82. I owe this insight to Peter Wiseman.
83. *LIMC* 'Odysseus/Uthuze' 56. A contemporary red impasto pithos from the J. Paul Getty Museum shows Odysseus blinding a seated Polyphemos, and a large wine jug in the centre of the scene: Snodgrass 1998, 96, fig. 38. Another scene of the blinding of Polyphemos is found on a Caeretan hydria of 520 BC: *LIMC* 'Odysseus/Uthuze' 57; Hemelrijk 1984, 36–7, no. 20. See Dougherty 2003 for a reading of the Aristonothos krater that focuses on visual bilingualism and multiculturalism within a Greek colonial discourse; see Izzet 2004 for a sophisticated analysis of the blinding of Polyphemos in Etruria and the inscription on the krater.
84. *Kanna* may correspond with the Greek *agalma*, whose meaning is analogous to *ornamentum:* Rizzo and Martelli 1993; the reading by Pugliese Carratelli 1994, 364, of *kanna* as *kauna* also suggests the meaning of garment. Cf. Belelli 2000–2003 for an alternative view of kanna as a borrowing from the Greek κανναβις, interpreted as hemp, the material of a ship's sail.
85. If Greek, the engraver may have inscribed *kanna* to fulfil the patron's wish to familiarize his/her Etruscan audience with the myth.
86. In reality the debate on the relationship between Demaratus and Roman kings rests upon the 'Hellenization' of Rome as a politically correct "désétrusquisation" of early Rome: Poucet 2000, 164–5, n. 112; Ridgway 2006, 41.
87. Smith 1998; Ridgway and Ridgway 1994.
88. Ridgway and Ridgway 1994, 7; Ridgway 2006, 33. Interestingly, the evidence from Acquarossa further shows that such decoration was not in use purely on aristocratic or religious buildings, but was also used in less aristocratic private houses.

89. Smith 1998; Glinister 2003.
90. The Corinthian connection is, however, sustained by philology: all the names of Greek gods and heroes in Etruscan derive from the Doric dialect of Corinth, indicating that the Etruscans learned Greek myth from the Corinthian telling of stories: Osborne 2007, 89.
91. Smith 1998, 47.
92. Sciacca 2004, 33–6. However, some scholars have now attributed a northern Etruscan manufacture to the kyathoi from Monteriggioni and Vetulonia: Sciacca 2004, 35, n. 54.
93. Martelli 2001. Unfortunately, these vessels, from old museum collections, lack an archaeological context, although it is reasonable to presume that they all came from wealthy elite burials that were looted.
94. Martelli 2001 argues that the iconographic themes of these vessels further reflect these specific influences.
95. The warrior by a ship is a unique scene and is painted on an amphora of unknown provenance from the Antikensammlung of the University of Erlangen, assigned to the Argive Painter. The neck of this amphora shows a warrior in two distinct scenes: in one he is standing with a horse, but in both he is represented with a ship: Martelli 2001, 4.
96. From the so-called Painter of Amsterdam: Martelli 2001, 7.
97. From a private American collection: Martelli 2001, 6.
98. Burr Carter 1989; Schefold 1992, 183–95.
99. Carpenter 1991, 168, figs 266–8.
100. Schachter 1981, 19–26.
101. Blackman 1996–1997, 14–16; Mazarakis Ainian 1997, 100–1; Mazarkis Ainian 1998. Earlier contacts with Lefkandi in Euboea going back to the end of the tenth century have been found in an excavated area east of the metalworking centre of Oropos, which has produced Euboean pottery and a bronze cheese grater not unlike those found in Lefkandi's graves.
102. Mazarakis Ainian 1998, 201–3. Apsidal buildings were common in the Aegean at this time, but both at Oropos and Pithekoussai the presence of such a building not used as a workshop in a metalworking quarter is significant. At Oropos, building θ was the largest structure within the entire metalworking quarter.
103. *Il.* II, 498. Mazarakis Ainian 1998, 210–14.
104. Emily Kearns, personal comment.
105. Blackman 1996–97, 16.
106. For a detailed analysis of the use and changing meaning of the Argonauts' saga in Italy through the fourth century BCE, see Pontrandolfo and Mugione 1999.

SHAPING MEDITERRANEAN ECONOMY AND TRADE: PHOENICIAN CULTURAL IDENTITIES IN THE IRON AGE

Michael Sommer

For their neighbours, the cities of the Levantine coast were inseparably associated with long-distance trade. The Hebrew Bible pays tribute to Tyre's 'merchants who behaved like princes.'[1] Cuneiform documents from the Neo-Assyrian period provide us with vivid accounts of Phoenicians who pursued their commercial activities even while their city was besieged by Assyrian troops.[2] Egyptian texts give evidence of the Phoenician rulers' shrewdness when it came to selling raw materials onto the emerging markets of the Iron Age. And the Homeric epics portray the people from the Levantine coast as highly skilled craftsmen, but ethically ruthless traders who earned their living by travelling about in their round ships, selling and buying large quantities of commodities.

Trade invariably requires interaction with others. The purpose of this chapter is to explore how this interaction may have affected the projection and reception of the social identities of the traders. This Iron Age world was a world in transformation, transformed not least by long-distance trade, which turned a Mediterranean surrounded by isolated peripheries in the early Iron Age into the turntable of intercultural and commercial exchange it was in the Archaic period. The people the Greeks called 'Phoenicians' were one of the driving forces of this process, which shaped – this is our hypothesis – their own as well as their neighbours' cultural identities.

But who were the people who inhabited cities like Tyre (Sur), Sidon (Saida), Byblos (Gubla) and Arados (Arwad), all situated on the coast of

present-day Lebanon and Syria? The Greek texts, starting with Homer, apply two ethnonyms to them: sometimes they are called 'Sidonians' (Sidones) and sometimes 'Phoenicians' (Phoinikes). Phoenicians in its variations (Phoinikes, Phoenices, Poeni, Punici) is thus a term applied exclusively by non-Phoenicians – Greeks and Romans – to label others.[3] The ethnonym, probably derived from *phoenix* (purple red), has been adopted by modern scholarship – rather *faut de mieux*: the few extant Phoenician texts – inscriptions mostly of a commemorative character – do not mention any collective ethnonym; nor do the Assyrian and Egyptian texts, or the accounts of the Hebrew Bible, though the Old Testament sporadically refers to the inhabitants of the Levantine coastal cities as 'Canaanites,' a rather vague term generally applied to the urban population of Bronze Age Syria, but still in use in Late Antiquity, as St Augustine tells us.[4] Inferring from the texts, one is inclined to believe that the individual city was the chief horizon of identity for its inhabitants.

In this chapter, I investigate, specifically, the relationship between how ancient authors received the identity of the Phoenicians as sociocultural populations, and the projection of that identity (or those identities) by the Phoenicians themselves through the material culture they traded. Focus will be on the Phoenician east, that is, the Levant, but the 'colonial' adventure of the Phoenicians in the west can hardly be ignored. The bulk of the archaeological evidence comes from outside the Levant, and this raises the first methodological issue: to associate a given group of findings with a collectivity we know of only from texts produced by others inevitably ends in aporia. This leads to a second methodological issue: identity and alterity – the expressions of 'otherness' – are usually merely two sides of the same coin.[5] If we want to grasp Phoenician identity at all, we have to consider the texts as well: not as 'evidence,' but as narratives reflecting constructions of alterity circulating among their neighbours. Therefore, we cannot but begin with Homer.

Homer's Phoenicians

In the Homeric epics, the identity of the Phoinikes is seemingly unproblematic: Homer's Phoenicians are sailors and shrewd merchants who,

after crossing the Mediterranean, visit the Greek mainland and the islands to trade trumpery: 'Thither came Phoenicians, men famed for their ships, greedy knaves, bringing countless trinkets in their black ship. Now there was in my father's house a Phoenician woman, comely and tall, and skilled in glorious handiwork.'[6] Thus begins the story of the herdsman Eumaios, who, being the son of a king, was kidnapped by Phoenician merchants. The Phoenician woman, who worked in the household of Eumaios's father and who played an inglorious part in the kidnapping, was from Sidon.

Whereas in the *Iliad* and *Odyssey* the Phoenicians enjoy a rather dubious reputation as shifty, acquisitive tradesmen, the Sidonians are introduced as the skilled producers of fine luxury items, such as the garments that Hekabe, Hektor's mother, gets from her bedroom when preparing for a procession: 'But the queen herself went down to the vaulted treasure chamber wherein were her robes, richly broidered, the handiwork of Sidonian women, whom godlike Alexander had himself brought from Sidon, as he sailed over the wide sea on that journey on which he brought back high-born Helen.'[7] Sidonians were also the producers of a prestigious krater, which Achilles offered as a reward in a sprinting contest: 'a mixing bowl of silver, richly wrought; six measures it held, and in beauty it was far the goodliest in all the earth, seeing that Sidonians, well skilled in deft handiwork, had wrought it cunningly, and men of the Phoenicians brought it over the murky deep, and landed it in harbour.'[8] The passage highlights the perceived division of labour between the Sidonian craftsmen who produced valuable goods like luxury garments and precious vessels on the one hand, and the more generic 'Phoenician' carriers on the other. Homer's puzzling reference to 'Sidonians' – along with 'Phoenicians' – suggests that the question of Phoenician identity is more complicated than it seems.

Another episode featuring the Phoenicians as protagonists is the pretended story of Odysseus's life, told to the swineherd Eumaios by the hero in disguise. The 'Cretan Odysseus,' having returned home from the Trojan War, 'then to Egypt did my spirit bid me voyage with my godlike comrades, when I had fitted out my ships with care.'[9] Upon their arrival in Egypt, despite Odysseus's warnings, the comrades 'set about wasting the fair fields of the men of Egypt; and they carried off the women and little children.'[10] Odysseus's companions are massacred

by the Egyptians, but the hero himself is spared by the king, who hosts him. 'But when the eighth circling year was come, then there came a man of Phoenicia, well versed in guile, a greedy knave, who had already wrought much evil among men.'[11] The Phoenician takes Odysseus with him to Phoinike. There, the man persuades him to join a commercial enterprise to Libya: 'having given lying counsel to the end that I should convey a cargo with him, but in truth that, when there, he might sell me and get a vast price.'[12] They are shipwrecked, however, and Odysseus escapes to the land of the Thesprotians.

The story is purely fictional, of course: a fictitious narrative embedded in an epic that itself is fiction.[13] But it is meant to be plausible both to Eumaios and the audience of the epic. The story points to an idiosyncratic maritime entrepreneurship that merges trade, piracy, looting, and mercenarism. Individual entrepreneurs form companies for joint operations. In such a business, ethnicity hardly matters. The *Odyssey*'s account presents long-distance trade as largely multicultural. This multiculturalism – as will be seen – is reflected in the archaeological record from various parts of the Mediterranean: in the commercial exploration and colonization of the Mediterranean west, Greeks and Phoenicians interacted closely. In other contexts, ethnicity mattered absolutely: artefacts were labelled 'Phoenician' due to their perfection, value, and prestige; people in recognition of their craft and skills, but also because of their notorious greed for profit. When the *Iliad* and the *Odyssey* were cast into written form, stereotypes about Phoenician behaviour were already easily at hand; the construction of the Phoenician 'other' had just begun.

When we approach the Phoenicians through texts like the *Odyssey*, fabricated by their neighbours, they act as a homogeneous, monolithic group. The literary alter egos of the inhabitants of places such as Byblos, Tyre, and Sidon feature clear-cut markers that make them distinct and serve as 'identity cards' wherever they emerge. When viewed through the archaeologist's spectacles, however, the Levantine traders appear radically different: what we can trace in material culture is not the distinct monolithic collectivity portrayed in the narrative sources, but a highly hybrid class of merchants whose ethnic identity is equivocal, whose cultural borders seem to be blurred. The two perspectives are not necessarily contradictory and mutually exclusive, but can be

regarded as complementary:[14] the construction of alterity through the narratives provided a framework for the Phoenicians to be assigned a place in the wider, 'global' world of the Iron Age Mediterranean (and possibly even helped them to find their own identity as 'Phoenicians' – an example of one of the paradoxes of globalization noted by Hodos in Chapter One), whereas their ability to adapt to other customs, values, and systems of communication enabled them to fit into cross-cultural discourses of status and prestige. But unlike in the Roman world, for which Hingley (in Chapter Three) argues 'heterogeneity becomes a binding force of imperial stability,' hybridity in the Iron Age was not a constituent of formal empire, but of a rather informal economic supremacy that involved a high degree of centrality and connectivity in the Mediterranean networks of trade and exchange. In many respects, this echoes Antonaccio's heuristic discussion in Chapter Two, where she argues for hybridity arising from encounters among peers; in this case, it is the merchant class rather than a purely elite one.

Again, the Homeric epics are literature, not history. But they echo the horizon of experiences of people in early Archaic Greece. From a Greek perspective, the Phoenician sailors came from a distant coast of the Mediterranean of which one knew, in that period, relatively little. The *ethnikon* 'Phoenicians' may have meant, at that stage, little more than sailor merchants, who brought exotic goods (made by Sidonians), who spoke an exotic language, and who behaved in exotic ways. We should be extremely cautious when associating with such concepts a particular material culture or specific artefacts or material remains.[15] The methodological flaws and risks of such constructions of 'archaeological cultures' have been observed repeatedly elsewhere,[16] and indeed are discussed throughout this volume,[17] so need not be discussed here in detail. That Homer's Phoenicians are a literary construct and not an accurate ethnography of the Levant goes without saying.[18]

But my aim here is not to reconstruct a particular, historical ethnicity, nor indeed to prove Homer wrong. I am concerned with cultural identities and how they are mirrored in the material evidence. As Hingley has suggested with regard to the paradigm of Romanization, modern concepts and models, be they explicit or implicit, usually derive from classical texts whose entire weight is then imposed on the material records. By doing so, they reduce the 'variety of cultural experiences' to

fit their categories, which in a sense is legitimate, but highly unbalanced (see Chapter Three). No study of the Phoenicians can ignore textual sources, but rather should take them as what they are: not 'evidence' in the proper sense, but 'narratives' created for all kinds of purposes, including handing down information. An alternative narrative can be constructed, however, by examining the material evidence in the Levant and colonial diaspora from a *longue durée* perspective. Such a narrative better accommodates the generalizations of the texts alongside the specific, and often varied and problematic, material culture patterning in localized contexts than do current models that emphasize only one of these elements. In individual cases it is often impossible to decide whether an artefact recovered in the Mediterranean west has been brought to the site by Levantine traders from the east, produced locally by manufacturers from the Levant, or crafted by local producers emulating Levantine models. The gradual shift from a Phoenician commercial and colonial network towards a hierarchic, hegemonic quasi-empire in which Carthage played a key role makes matters still more complicated, for while a Carthagocentric scenario is implied in ancient sources, this is difficult to map materially.[19] Even at a basic level, the material record alone provides no clue whether a site was a Phoenician or a Punic foundation – or whether it was an indigenous settlement where people from the Levant lived or to where they brought objects from the east. The archaeological record from the Levantine cities themselves does not add much to the puzzling image from the west: for the most part, these sites are overbuilt by modern structures; Sidon and Tyre, the main Phoenician coastal cities, are still thriving Phoenician harbour cities, the latest military conflicts notwithstanding. This makes the small town of Sarepta (Sarafand), with its remarkable industrial quarter, the only Phoenician site that has been properly excavated.[20] Thus, in contrast with Greek examples from this broad period (see Antonaccio on Sicily in Chapter Two), there is little from the Phoenician homeland that can be used as a basis for comparison with material from the Phoenician diaspora.

From Byblos to Carthage

The Phoenician coast stretches roughly from Arados (Arwad) in the north, in present-day Syria, to Dor (Tel Dor, Khirbet el-Burj) in the

south, in modern Israel. Geography was a decisive factor at all times: since the dawn of history, this part of the Levantine coast was oriented towards the west. The coast itself, with numerous promontories, peninsulas and offshore islands, provided ideal conditions for seafaring, whereas the fertile, but restricted coastal plain allowed for little more than small-scale subsistence farming. The coastal alluvium was cut off from its hinterland by high mountains: Mount Lebanon rises to more than 3000 metres.[21]

In the early Iron Age, urban centres began to sprout along the Phoenician coast. Byblos gained independence from the Egyptians, who had up till now dictated the terms of economic interaction and negotiated new terms of trade for the exportation of raw materials, cedar wood in particular, to the Nile delta. Tyre and Sidon soon outflanked Byblos and began to rival with each other for regional hegemony. Tyre won the race by a canvas: the city established commercial relations with the rural hinterland and, increasingly, with the Mediterranean west, from where it obtained raw materials and slaves. A number of biblical narratives picture the flourishing Phoenician port, its immense wealth and ample commercial network: the books of Kings report the contribution of Hiram, the king of Tyre, to Solomon's temple projects and the commercial joint ventures of Solomon and Hiram, who sent their ships to the far-flung shores of Tarshish (Spain) and Ophir (possibly Nubia).[22] Ezekiel 27 tells us about Tyre's trading partners and the commodities exchanged.[23] To be sure, such evidence needs to be seen in its narrative context, and it is almost impossible to unravel the texts' manifold chronological confusions; but there can be little doubt that, by the eighth century BCE, Tyre was a 'hot spot' of trans-Mediterranean trade. Politically, the city had subdued the southern part of the Phoenician coast, including Sidon.[24] Curiously, the city with its mainland possessions was known as the 'kingdom of the Sidonians.'

In the meantime, the system of interstate anarchy was replaced by renewed imperial hegemony. Expanding westward, the Neo-Assyrian Empire reached the Mediterranean under Tiglath-Pilesar III (745–727 BCE). Even though it annexed most of the Levantine states and deprived Tyre of most of its mainland possessions, Assyria never achieved more than a loose suzerainty over the city, which for its part benefited economically from the Assyrian aristocracy's demand for

luxury goods. The Assyrian royal inscriptions boast of repeated victories over Tyre, but in fact a number of attempts to take the island by siege failed. The city was still unconquered when Nebuchadnezzar II put it under siege for no less than thirteen years (585–572). Shortly after the conquest, the Tyrian monarchy ceased, and the city temporarily became a republic.[25]

Tyre and the other Phoenician cities retained a high degree of autonomy under Persian rule, when Sidon became the capital of a satrapy. The Levantine coastal cities provided the backbone of the Persian fleet during the wars with the Greeks. In August 332 BCE, Alexander the Great conquered Tyre, which he had to besiege. Because its inhabitants were reluctant to let in the Macedonian army,[26] the king enslaved the entire population and garrisoned a Macedonian unit within the walls. The dam Alexander built when besieging the city still connects the old town of Tyre with the mainland. With Alexander's conquest, the Phoenician cities lost their political importance for good, but they continued to be major hubs of the trans-Mediterranean long-distance trade. Phoenician cities carried on issuing their own silver coins well into the Roman period (58/59 CE), and bronze coins until the third century CE. This numismatic evidence stands out from other local eastern, 'pseudo-autonomous' coinage by showing no reflection whatsoever of the arrival of Roman imperial rule in 64 BCE.[27]

The Rise of a Commercial Class

The coins struck by Roman Tyre bear eloquent witness to the city's distinct civic identity, matching similar evidence from Greek cities. Tyre issued shekels (tetradrachms) with the head of the city god Melqart and an eagle. The bronze coins likewise displayed Melqart and the Phoenician legend LSSR (of Sur = Tyre). Melqart was the one deity that embraced everything the Phoenician metropolis stood for. He was the travelling god par excellence who congenially embodied the daring commercial spirit of Tyre, 'whose merchants are princes,'[28] and its maritime orientation. Not surprisingly, the god's *interpretation Graeca* was Herakles. Melqart seems to have appeared first in the tenth century BCE and is epigraphically attested from the ninth century BCE

onwards, thus representing at least some sort of religious continuity of more than 1200 years.[29]

The god's very name (*mlkqrt* = 'king of the city') suggests that he was regarded as the divine ruler of the city, similar to Yahweh, the lord of Israel, where the spheres of politics and religion merged into theocracy. After Moses, core elements of politics (the 'law,' 'covenant') became constituents of the relationship between humans and the god.[30] Whereas in the Bronze Age states, the king, and the bureaucracy of the palace centres, appeared as representatives of the divine world, in Israel, God's own people, political institutions – the previously omnipotent king included – were completely marginalized by the primacy of religion. Tempting as it is to take Israel's theocracy as a model for nearby Tyre,[31] things appear to have been quite different there.

To be sure, by this period the Phoenician kings lacked the prominent position their Bronze Age predecessors once had occupied.[32] In the Phoenician epigraphic record, which is basically limited to royal tomb inscriptions, they become visible mainly in their religious roles, as priests of the city god, builder of temples, and, in the broadest sense, as guarantors of divine justice on earth and mediators between the human and the divine worlds.[33] The Greek, Hebrew, Egyptian, and Assyrian traditions add further details (the king as supreme justice, diplomat, military leader, city founder, builder, and dispenser of economic resources), but it is self-evident that external views and assumptions account for much of this image of an almighty king.[34]

A narrative handed down by Flavius Josephus portrays the origin of the cult of Melqart as an intentional foundation act: 'When Abibalos [Abibaal] died, his son Eiromenos [Hiram] succeeded him in kingship.... He built the great place [Eurychoros] and put up a golden column in the Temple of Zeus. He also went and cut wood on Mount Lebanon for the roofs of the temples; he pulled down the old temples and built new ones for Herakles [Melqart] and Astarte; and he was the first to celebrate the awakening of Herakles in the month of Peritius.'[35] This is legend, of course, but the account, not included in the biblical narratives on Tyre, is likely to have a Phoenician source. Under the auspices of a political theology that is theocratic, such a deliberate choice in favour of particular gods is hardly conceivable.[36]

There is, however, a second possible explanation for the gradual disappearance of the king from the political stage. The analogy in this case is not Israel, but Hellas. In early Archaic Greece, the monarchic institutions were gradually replaced by the community of the free and the equal, the polis as an autonomous commonwealth of citizens.[37] A major role in this process was played by military innovation, namely the rise of the phalanx constituted by citizen soldiers who demanded their share in political participation.[38] Lacking a comparable importance, the army's place in the Phoenician cities was taken by another pressure group: the merchants.[39] In the Levantine societies of the Bronze Age, merchants had been economic agents depending on the great institutions of palaces and occasionally temples.[40] In the Iron Age, the involvement of such institutions in the exchange of commodities seems to have dropped drastically. The report of Wenamun and the biblical account of Solomon and Hiram's joint commercial enterprises are the latest – external – pieces of evidence testifying a direct and major role of Phoenician kings in trade.

Instead of being representatives of a palace carrying out administered trade 'embedded' in reciprocity and mutuality, Homer's Phoenicians appear as economically independent entrepreneurs who operate on their own behalf, at least beyond their homeland. Nonmonetary intermediate trade and the supply of high-value, low-bulk luxury items is their base of existence in the wider Mediterranean: a service the provision of which depends on some rudimentary understanding of market principles, namely the fluctuation of prices according to supply and demand. An image consistent with this evidence is depicted by Ezekiel's 'lament over Tyre': a city having established a commercial network through the importation of raw materials and agricultural products from the periphery of the system and the production and supply of high-value finished goods. No mention is made of the 'state' or any palace institutions being involved.[41]

The importance of individuals for Tyre's long-distance trade is also highlighted by Neo-Assyrian cuneiform documents. The 'contract' between the Assyrian king Esarhaddon (680–669 BCE) and Baal, king of Tyre, – in fact a loyalty oath regulating the duties and privileges of Tyre within the Assyrian sphere of hegemony – mentions 'ships belonging to the people of Tyre,'[42] undoubtedly merchant vessels that were the

property of individual ship owners. Other Assyrian documents report that merchants from Tyre pursued their business unhampered by political adverseness when the city was besieged by Assyrian troops around 720 BCE.[43]

It is only logical that such economic independence from institutions that previously had dominated the economic sphere brought about a demand for political participation. In contrast to any other contemporary society, the vast majority of Tyre's inhabitants depended directly or indirectly on long-distance trade. It was not only the merchants themselves who were involved, but also the producers of luxury items destined for exportation. Even the pottery industry of the nearby town of Sarepta catered for external markets, producing an immense surplus of ceramic vessels. This coastal town in the vicinity of Tyre was small but featured a high degree of functional segregation between dwelling and industrial areas. The pottery industry was the domain of individual workshops, run by private (and literate) craftsmen, who thus had their share in Tyre's long-distance trade: apparently, the potters from Sarepta produced the packing material for many of the liquid goods Tyrian merchants shipped overseas.[44] Their economic key role nourished a strong feeling of class solidarity among the Phoenician traders that could be converted in the virtual monopolization of political power by a merchant oligarchy. Isaiah's 'merchant princes' of Tyre was no hollow phrase: it was these merchants who, in the Iron Age, took over political power from the royal palace as the Phoenician city's pivotal institution.

Civic Identity

The oligarchic character of the Phoenician city-state is best documented for Carthage, although, like Athens, Carthage may be an exception rather than the rule. Nevertheless, it provides at least some indication of civic structure, and while it would be incorrect to suggest that political structures in Phoenicia and its diaspora were replicated and remained unchanged over time, there are a number of characteristics that may be viewed as shared ideologically, even if not identical in practice. It is also the case that, for the authors and readers of the Greek and Latin literary sources that shape our own view of the city, Carthage represented

the intrusion of the dangerous and alien eastern civilization into the western Mediterranean.[45] The city had a people's assembly (ˊlm), which could decide political issues, but only if the sufets (the chief magistrates) and the ḥˋdrm (the council or senate) disagreed or summoned the assembly.[46] This suggests a preponderance of the oligarchic institutions, even though for Polybios the Carthaginian constitution ranks among the 'mixed' ones, with a balance between monarchic, oligarchic, and democratic elements.[47] But the body of citizens seems to have been rather restricted: when Scipio Africanus conquered Carthago Nova (Cartagena) in 209 BCE, according to Polybios,[48] he immediately restituted full freedom to the *politikoi* (citizens), whereas he only promised it to the *ergastikoi* and *cheirotechnai*. Craftsmen, we may infer, were not citizens in the full sense.[49] Thus, there was a strong sense of civic identity in Carthage, but not everyone participated in full citizenship.

The merchants did, however. The second Roman-Carthaginian contract, dating from the fourth century BCE, determined that Roman merchants trading in North Africa or Carthaginian Sicily should be treated like Carthaginian citizens – and vice versa.[50] The offices and access to the senate were restricted to the wealthiest citizens[51] – and the most promising way to acquire wealth in a city like Carthage, which largely depended on long-distance trade, was commerce. This makes the merchants the most likely candidates for an urban elite that ruled over Carthage and its empire.

For the Phoenicians in the Levant, there is far less evidence. But the concept of citizenship seems to have been exclusive rather than inclusive in the East, as well. At the climax of its power, Tyre controlled a formidable territorial state, which included not only other Phoenician cities (Sidon) and smaller urban settlements of a predominantly industrial character (Sarepta), but also large stretches of mountains and farmland, most prominently the fertile Jezreel Valley in Lower Galilee. Here, and in the hills of Upper Galilee, fortifications and settlement patterns seem to indicate that Tyre was in firm control of the area. Burials, however, reflect a more diverse situation. Cremation and inhumation occur next to each other, in contrast to the Phoenician coastal cities where cremation dominated.[52]

It would be pointless to identify the different burial styles with specific patterns of ethnicity, but cultural diversity on the fringes of the

Tyrian territory is as such significant and sets apart the Phoenician city-state from the Greek polis, which culturally as well as politically was closely integrated. The 'kingdom of the Sidonians' was, in this respect, an empire *en miniature* rather than the unity of city and territory that was represented by the Greek polis. This may suggest that, though there are obvious parallels between the Phoenician and the Greek city, the 'Sidonians' represented a restricted urban elite that ruled over a politically and socially less privileged, ethnically and culturally diverse periphery. It may further imply that the 'Sidonians' monopolized political power in their kingdom.

As in later Carthage, there may have been some collective participatory institutions in the Levant. In the Near East, especially in Syria and in northern Mesopotamia, tribal assemblies and councils of the elders added a participatory element to the centralized societies as early as the Early Bronze Age.[53] Such institutions may have survived into the Iron Age, but there is little evidence for them before the Achaemenid period. During the uprising of the satraps (366–360 BCE), when Sidon also rebelled against Persian rule, according to Diodoros,[54] 100 *symbouloi* (council members) were sent to Artaxerxes in order to negotiate the terms of surrender. The 100 may well have been members of a kind of *boule*, or council of the elders. When Alexander approached Tyre in 332 BCE, the city sent envoys to the Macedonian king to negotiate peace. Any agreement was, however, subject to ratification by the people's assembly.[55]

There is better evidence for magistracies. After Tyre had surrendered to Nebuchadnezzar in 572 BCE, *dikastai* (sufets) replaced the kings as eponymous officials for a number of years.[56] There is no evidence for sufets in Tyre before that date, but their existence may be inferred by the fact that Tyre's colony, Carthage, seems to have been governed by sufets from its foundation in the late ninth or early eighth century BCE onwards.[57] In Carthage, at least in later years, the sufets were annually elected eponymous officials. Josephus's *dikastai* held irregular terms, but they were certainly eponymous and also may well have been elected.

In the inscription on his sarcophagus, Eshmunazar, who ruled the city of Sidon under Persian suzerainty in the fifth century BCE, boasts of having received the towns of Dor and Ioppe from the Great King and of 'having added them to the territory of his country, to be possessed

by the Sidonians for ever.'[58] The Persian king, entangled in concepts of monarchic and dynastic rule, had given the towns to the king of Sidon; Eshmunazar, for his part, added them to the country of the Sidonians. The notion of the city as the collectivity of a body of citizens also looms behind the famous Athenian *proxenia* decree for Straton, 'king of the Sidonians':[59] the king is declared *proxenos* of the Athenians – and every single citizen of Sidon with him. It is the collectivity of the Sidonians who benefit from the privileges vicariously bestowed on their king.[60] There is hardly any document that better bears witness to the Greek and Phoenician civic identities being, in principle, compatible.

Networking the Mediterranean

Though the individual city or city-state was obviously the most prominent reference point for civic identity in Phoenicia, there were other circles to which collective notions of belonging could be attached. Economic activities and interests shared together with people with similar cultural and linguistic backgrounds inevitably create strong bonds of solidarity. We know nothing about the composition of the ship's crew that kidnapped the young Eumaios, but its members were certainly tied together by a marked team spirit. Several individuals jointly owning a ship and sharing the risks and profits of long-distance trade – this is the model, provided by the trade companies of the early Hanseatic League in the European Middle Ages,[61] which best fits Homer's descriptions of Phoenician trade.

Such a sense of a common bond must have existed on a much larger scale, too. Here starts the story of the Phoenician expansion in the west, which has been the subject of much scholarship in recent times.[62] People from the Levant sailed to the coasts of the Mediterranean and beyond and some of them stayed overseas, settling down in or in the vicinity of indigenous villages and towns. This process, which took place from the tenth century BCE onwards, resumed earlier contacts between the Levant and the west (including the Aegean) in the Bronze Age. Archaeologically, the easterners in the west are difficult to detect. In Cyprus and the Aegean, the period is marked by a massive spread of 'Oriental' artefacts and therefore labelled 'Orientalizing': imported bichrome and later red-slip wares, which were often used as containers

for liquids; prestige goods such as engraved silver and bronze bowls, jewellery, and ivory decorations of furniture; local pottery with motifs borrowed from Near Eastern models, local imitations of Oriental jewellery, and so on.[63] Even though the presence of people from the Levant is attested by the Greek literary tradition (e.g. in the myths around Kadmos who became the founder of Thebes), it is often difficult to decide whether the objects found, such as those in the tombs of Lefkandi on Euboia, dating from the eleventh to the ninth centuries BCE, arrived there as gifts, were imported from Cyprus or, since the ninth century BCE, from the supposedly Greek *emporion* in Al Mina on the Levantine coast, or produced locally by Phoenicians or Greeks – or indeed reached Euboia by a variety of ways.[64]

In another case, we can be more certain. In Italy, the importation of 'Oriental' artefacts started slightly later, in the tenth century BCE. The link with the Levant seems to have been particularly strong at Pithekoussai (Ischia), supposed to be a 'key Greek site'[65] by most scholars. The settlement on Monte Vico dates back to the middle of the eighth century BCE. At the foot of Monte Vico was a necropolis where different types of burials have been revealed by archaeologists. Most of the adults were cremated and buried under small stone tumuli, whereas children and some adults, probably those of humble social rank, were buried in pit inhumations. Most of the pottery found in the necropolis seems to have been imported from Greece, but there is also a high concentration of artefacts from the east, namely the Levant and Egypt: 36 serpentine scarabs from North Syria or Cilicia, small amulets, Egyptian scarabs, one bearing the cartouche of Pharaoh Bocchoris (ruled 720–715 BCE), perfume containers produced in North Syria and by Phoenicians in Rhodes, and finally a number of Phoenician amphorae.[66]

These objects, however, cannot prove the permanent presence of people from the Levant on the island. Most noteworthy, therefore, is the find of an amphora of Greek production from the middle of the eighth century BCE, inscribed with a West Semitic inscription indicating that the vessel was used as a measure. The amphora, containing also a steatite scarab, was reused for the burial of an infant. Next to the baby, its mother, a brother or sister of eight years and a second infant were buried, all cremated. The inhumed body of a fifth person (a slave?) has been found nearby.[67] Doubtless, the individuals cremated

in accordance with Greek burial rites all belong to the same family. As the amphora was imported from Greece, but inscribed locally, it is believed that the buried family members were Semitic-speaking, most likely of Levantine or Cypro-Phoenician origin. Thus, these people from the eastern Mediterranean had come to the west and had adopted customs we believe to be Greek.[68]

This evidence sheds some light on places like Pithekoussai. Rather than more or less homogeneous 'colonies' settled by people sharing all the same ethnic and cultural background, they were neither 'Greek' nor 'Phoenician' nor 'indigenous,' but multicultural hubs of long-distance trade attracting individuals in search of commercial opportunities and profit chances. Such cosmopolitan entrepots of long-distance trade lined the shores of the eighth century Mediterranean, from Al Mina in northern Syria to the coasts of the Aegean, Italy, and the western Mediterranean.[69] The 'Phoenician' settlements in southern Spain seem to follow roughly the same pattern: in places like Toscanos in present-day Andalusia, burial rites associated with Phoenicians (cremation) co-existed with inhumation. This is not enough evidence to suggest that the colonizing group was multiethnic in itself, but it could indicate some degree of cultural diversity.[70]

Thus, following the discussion by Antonaccio in Chapter Two on the Middle Ground model, settlements like Pithekoussai, but also Al Mina and Toscanos, may also be regarded as hybrid Middle Grounds, for they existed in a sphere where ethnic and linguistic origins hardly mattered in comparison to the opportunities they had to offer to new settlers, among which were surely economic ones.[71] Planted sometimes on virgin soil, sometimes in the vicinity of existing settlements, and inhabited by a mix of people of whom some came from distant places, they created a hybrid space for the interaction of individuals bearing with them all the distinct traditions, customs, dress codes, diets, languages, and beliefs Mediterranean shores had to offer, and merged into something new with traits that were mutually understood. Long-distance and migration created, in the Iron Age Mediterranean, 'a "third space", marked by the fusion of cultural elements drawn from all originating cultures, but resulting in a configuration in which these elements, though never equal, can no longer be disregarded or restored to their original forms, since they no longer exist in a "pure" state but have been permanently "translated." '[72]

Greek 'colonization' has long since been described in similar terms: as a process involving the use of force and violence against 'natives' in the beginning, leading however to a rather smooth integration of indigenous people into the *kosmos* of the Greek poleis, resulting in hybridization on both sides[73] and the adoption and inclusion of non-Greeks into the aetiological universe of Greek myth.[74] Neither 'Greek' nor 'Phoenician' identity in the Iron Age was hermetic, monolithic, or compact: both groups were protagonists in the establishment of a trade diaspora of outposts,[75] the driving force behind which was the search for economic opportunities. Even though the Levantines came probably first, both they and the Greeks formed part of *one* network with a high degree of connectivity in both directions and a common material culture, the 'Orientalizing' style.[76] The concept of a trade diaspora with individual actors as protagonists of cultural exchange and transformation – as opposed to diffusionist concepts of cultural change,[77] as well as hierarchic centre-periphery models such as the 'world system' concept[78] – bears the advantage of analytical flexibility. Instead of over-simplifying by imposing modern notions of ethnicity and 'national' identity on ancient societies, it takes into account the puzzling complexity of cultural identities.

All this is not to suggest that 'Greeks' and 'Phoenicians' became indistinguishable. Greeks and Levantines both retained distinct identities: at least from the Greek point of view the Phoenicians were clearly the 'others,' though possibly not as foreign as other 'barbarians.' But there are also marked differences we can trace back in the material cultures. Niemeyer has recently pointed to the sculptural revolution that happened in Greece, but left the Phoenician sphere virtually unaffected, the home country as well as the 'colonial' diaspora.[79] Only later, from the fifth century onwards, did the Phoenicians adopt Greek techniques of stone carving and start to produce free-standing sculpture and sarcophagi in considerable quantities, such as the sarcophagus of Eshmunazar from Sidon.[80]

The Phoenicians' apparent reluctance to excel in fields which are – to us – emblematic of classical art, has devalued their artistic production in the eye of the modern beholder. Phoenician art has been repeatedly dismissed as eclectic, epigonic, and 'elusive'[81] – a judgement that strikingly contrasts with the Greeks' pronounced esteem. But it was

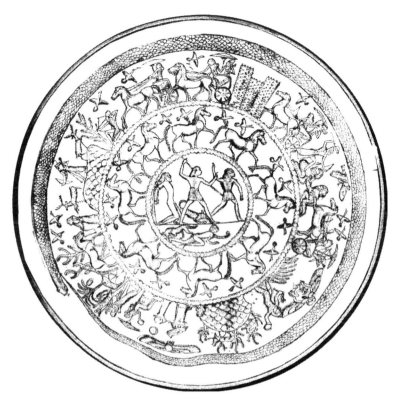

5.1. Phoenician silver patera, Villa Giulia, Rome (Drawing: S. Grice, after Gehrig and Niemeyer 1990, fig. 23)

hardly a lack of artistic capability that caused the Phoenicians to focus on the 'minor' arts, such as ivory carving, faience and glass making, seal engraving and the production of metal vessels. The Phoenicians were masters of 'portable art,'[82] and quite deliberately so. The products of their craftsmanship were designed for a 'market' stretching from the Assyrian Empire to the Columns of Herakles. Phoenician ivories, metal bowls, and glass amulets were as mobile as the Phoenicians themselves. They were made of precious materials and hence convertible into the value and prestige scales of various societies. Less convertible than material value is iconography, which can transcend the borders between cultural systems only if the recipients have a clue to the semantic code used.

Exemplary of the problems iconography raises are the low metal bowls of the patera type, of which many examples have been found in the Near East and the Mediterranean.[83] Heterogeneous in style and theme, they

all feature two rather simple iconographic patterns: one monoscenic mode of representation, which freezes a sequence of actions into one 'still'; and an episodic variation, in which a sequence of scenes is depicted, with recurring characters and objects (see Figure 5.1).[84] The grammars and vocabularies of the episodic representations can be deduced from the context. A beholder who lacks the cultural code will have far more difficulty with the monoscenic representations, although these prevail in the corpus of extant Phoenician bronze and silver bowls.[85]

How could Greeks, Assyrians, and Egyptians understand the Phoenician bowls' iconography? How could the artefacts serve 'to define the status of local aristocracies as an élite,'[86] if the 'target groups' found it hard to get a clue to their meaning? The answer is quite simple: the Phoenicians catered for small, wealthy elites in assertive societies and these societies all shared a highly militarised, aristocratic system of values. The themes depicted on the bowls appealed directly to members of a military aristocracy, no matter to which polity they belonged: hunting, war, festivities and the relationship between the human world and the divine were the key themes recurring on the bowls.[87]

The iconography of the Phoenician paterai is characteristic of the artistic production of a mobile society focused on the production for foreign 'markets' and foreign 'customers.' It reflects *their* demands and should not be mistaken for an expression of the producers' own cultural 'identity.' 'Portable art' is therefore an appropriate label for the artefacts in question: they carried a simplified inventory of Near Eastern visual art towards the west. Their apparent eclecticism and stereotypic triviality, often criticised by modern scholars, are in fact a reflection of the Phoenicians' versatility and their genuine ability to cater for the demands of others.

The artefacts imported from the Levant were indeed objects of much fascination in Archaic Greece and a major stimulus for Greece's own artistic development. The krater set out by Achilles bears eloquent witness to the esteem in which the Greeks held Phoenician metal work. Even more striking is the famous 'shield description' in Book 18 of the *Iliad*: 'About the other city there lay encamped two hosts in gleaming armour, and they were divided whether to sack it, or to spare it and accept the half of what it contained. But the men of the city would not yet consent, and armed themselves for a surprise; their wives and little

children kept guard upon the walls, and with them were the men who were past fighting through age.'[88] Cities put under siege belong to the standard motifs of Phoenician paterai. Another passage is literally a word-for-word quote of a scene typically depicted on Phoenician bronze and silver bowls, the fight between wild animals and hunt: 'Two terrible lions had fastened on a bellowing bull that was with the foremost cows, and bellow as he might they haled him, while the dogs and men gave chase: the lions tore through the bull's thick hide and were gorging on his blood and bowels, but the herdsmen were afraid to do anything, and only hounded on their dogs; the dogs dared not fasten on the lions but stood by barking and keeping out of harm's way.'[89] Other recurring themes on the paterai are music and dance, also taken up by Homer in the text.[90]

Such themes were popular in the Bronze Age Aegean already and can be found on many Mycenaean vases. In the Dark Ages they still represented a notion of a commonly shared background among elites, cross-culturally, from Etruria to Mesopotamia. Whether in the Aegean this idea of 'Mediterraneanism' was a reflection of continuity between the Bronze and Iron Ages or indeed resurrected by the influx of Levantine goods, is secondary. What is decisive is the fact that Phoenician art tapped into common themes and that, therefore, it appealed to the well-to-do in the Aegean as anywhere in the Mediterranean and beyond. Reading Homer's ekphrasis of the shield, we can observe how Levantine images modelled after ancient Mediterranean archetypes penetrated Greek imagination: when the *Iliad* was composed, they already had found their ways into peoples' minds. Though the object in question is a shield, not a bowl, the parallels to the iconography of Phoenician paterai are more than obvious.[91] Once more, the evidence of Phoenician material culture points towards a diasporic, as it were 'cosmopolitan,' collective, identity, which complemented the strong sense of civic identity that was undoubtedly there, as well. The notion of belonging to a coherent social class, bound together by commercial spirit and economic interest, divided and alienated the Levantine merchant aristocracy – Homer's Phoenicians – from the vast majority of their home towns' populations, but at the same time it connected them to the many nodes of the Mediterranean network in which they played such a decisive role.

Conclusion

The model presented here – a cluster of various interlaced circles of cultural identity, be they civic, social, or diasporic – is only one way to tackle the manifold problems Phoenician identities pose. I have not attempted to address the difficulties arising from the slow and apparently smooth process that, in the late sixth century BCE, transformed the open network of the Iron Age Mediterranean, to which the Phoenicians had contributed so much, into a space controlled by few powerful polities: the Persian Empire in the east, a handful of Greek poleis in the Aegean, and first of all Carthage in the southern and western Mediterranean. The transition from network to hegemony, and later from hegemony to empire inevitably brought about changes in the cultural identities of the people inhabiting the Mediterranean coast, which, for the Punic West at least, are almost impossible to trace, given the scarcity of the written and the problematic nature of the material evidence.

The ancient texts themselves present generalizations of the Phoenicians; emic Phoenician identities are not distinguished. As such, the etic perspective we have from ancient literary sources may be considered as a kind of global reception of who the Phoenicians were. A more nuanced perspective may be gleaned from the traded items of Phoenician material culture that were popular with other Mediterranean populations. The Phoenicians, themselves, understood the sociocultural and commercial values of such objects as ideas of culture, and they manipulated this perception of themselves held by others to their own commercial advantage. This is shown here by the example of the paterai. Yet concurrently, such trading activities also served to reinforce Phoenician identities among themselves, especially the identity of the merchant class, expressions of which are not as apparent from other ancient sources. In some respects, therefore, the rise of the merchant class represents a development in Phoenician society that may be regarded as the hybrid result of global engagement. As such, this case study blends the models of globalization and hybridity, as outlined in Chapter Three by Hingley and in Chapter Two by Antonaccio, to reveal their close interrelationship.

The open, trade diaspora network, which dominated the Iron Age and was established and maintained to a large extent by Levantines,

people from 'Phoenicia,' but which also involved Euboeans, Phokaeans, other Greeks, individuals from Asia Minor, North Syria, Egypt, and Israel/Judaea, not to mention indigenous people from all parts of the Mediterranean, laid the ground for the 'classical' Mediterranean where all regions interacted with each other and secluded isolation was henceforth impossible. Their achievement makes the Phoenicians – in the perspective of a very *longue durée* – the true protagonists of 'Mediterraneanism,' for which Peregrine Horden and Nicholas Purcell have made such a strong case.[92]

Acknowledgements

This essay is dedicated to the memory of Hans Georg Niemeyer (1933–2007).

Notes

1. Isaiah 23:8.
2. Saggs 1955, no. 2715.
3. Prag 2006, esp. 7–29, with an in-depth discussion of the epigraphic evidence. See also Isayev, Chapter Eight, on the labelling of Lucanians by outsiders.
4. Augustine, *Ad Rom.* 13.
5. See the contributions in Essbach 2000; and Gehrke 2004.
6. Hom. *Od.* 15, 415–18, trans. Samuel Butler.
7. Hom. *Il.* 6, 288–90, trans. Samuel Butler.
8. Hom. *Il.* 23, 741–4.
9. Hom. *Od.* 14, 246–7.
10. Ibid., 263–4.
11. Ibid., 287–9.
12. Ibid., 296–7.
13. Kullmann 1960; Latacz 2003 [1985]; Latacz 1985.
14. On the concept of hybridity in archaeology, see Sommer 2005b, 402–8; Hodos 2006, 13–18; van Dommelen 1997, 309. On hybridity and the related concept of créolité in general, see Hall 2003a; Hall 2003b; Bhabha 1994.
15. Coldstream 1982; Markoe 1985; Markoe 2000, 143–69; Moscati 1975, 99–152; Moscati 1992, 65–71; Sommer 2005a, 84–96.
16. Jones 1997.
17. See especially chapters in this volume by Antonaccio; Hales; Hodos; Ilieva; Isayev; and Riva.
18. Garbini 1980, 127–8; Winter 1995.
19. While the concept of a Carthaginian empire has been deconstructed by recent scholarship, Carthage nevertheless maintained a significant presence in the activities and interactions of the Phoenician diasporic communities of the central and western Mediterranean. Fuller discussion lies beyond the scope here. For further details see Aubet 2001 [1993], 185–217; Garbini 1980, 125–50;

Huss 1994 [1990], 4–38; Moscati 1988c; Moscati 1992, 132–7; Sommer 2005a, 122–7; van Dommelen 2002.

20. Pritchard 1978.
21. Aubet 2001 [1993], 12–16; Sommer 2000, 37–40; Fisher 1978 [1950], 375–6; Mensching and Wirth 1977, 209–12; Moscati 1988b; Vaumas 1954, 217–33.
22. 1 Kings 5–6, and 10:11.
23. Liverani 1991.
24. Aubet 2001 [1993], 77–118; Sommer 2000, 97–9; Sommer 2004, 237–40.
25. Katzenstein 1973; Sommer 2005a, 179–90.
26. Arrian, *Anab.* 2.24.5; Polyb. 31.12.11–12.
27. Acquaro 1988, 464–6; Destrooper-Georgiades 1995, 157–60; Millar 1993, 288.
28. Isaiah 23:8.
29. Bondì 2005; Bonnet and Xella 1995, 327–28. This is not to suggest that ritual and religious practices remained unchanged throughout this time, but some characteristics retained a resonance. See also Bernardini and Zucca 2005.
30. Assmann 2002, 46–52; Assmann 2006 [1992], 81–2.
31. Garbini 1980, 58.
32. Bondì 1995b, 295.
33. Donner and Röllig 1962, nos. 13, 14; nos. 10, 14, 15, 16; nos. 4, 6, 10.
34. Sommer 2000, 240–1.
35. Josephus *AJ* 8.146.
36. Sommer 2001, 72–3.
37. Meier 1994 [1993]; Meier 2001 [1980], 108–81; Snodgrass 1980. On the rise of the occidental city in general, see Weber 2005, 923–1033.
38. Hansen 1993; Raaflaub 1997; Raaflaub 1999; Raaflaub 2005.
39. Bondì 1995a, 349; Brizzi 1995, 304–6; Sommer 2000, 249–53; contra Ameling 1993, 169–76, who emphasizes the importance of the military, at least in Carthage.
40. Liverani 1988, 546–52. Aubet 2007, in general.
41. Ezekiel 27:4–25.
42. Watanabe, Reade, and Parpola 1988, 5.
43. Saggs 1955, no. 2715.
44. Pritchard 1978, 113.
45. See, among many possible others, Miles 2004.
46. Huss 1994 [1990], 333–4.
47. Polyb. 6.43.1.
48. Polyb. 10.16.1; 17. 6.
49. Bondì 1995a, 348–9; Gschnitzer 1993, 192.
50. Polyb. 3.23.
51. Arist. *Pol.* 2.11.
52. Balensi and Herrera 1985; Briend 1980; Prausnitz 1962. On burials in general, see Teixidor, Gras, and Rouillard 1989, 215.
53. Jacobsen 1943; Liverani 1976, 284–5; Postgate 1992, 81–2.
54. Polyb. 16.45.1.
55. Arrian. *Anab.* 2.15.6: *koinon*; Curt. Ruf. 4.3.21: *contio*.
56. Josephus *Ap.* 1.157.
57. Huss 1994 [1990], 334.
58. Donner and Röllig 1962, no. 14.
59. *IG* II² 141.

60. Gschnitzer 1993, 196–7.
61. Dollinger 1998 [1964], 17–24; Friedland 1991, 31–71; Schildhauer, Fritz, and Stark 1982 [1974], 28–74.
62. Botto 1995; Bunnens 1979; Niemeyer 1982; Niemeyer 2002; Niemeyer 2003b; Niemeyer 1995; Sommer 2005a, 113–43.
63. On Syro-Phoenicizing or Orientalizing motifs, see Riva, Chapter Four. See also Gubel 2006; Aubet 2006; van Dommelen 2006b.
64. As gifts, see Boardman 1999 [1964], 272; imported, see Bonnet 1995, 656–7; Niemeyer 2004; produced locally, see Coldstream 1982; and other ways, see Lemos 2005, 54.
65. Boardman 1999, 276.
66. Cerchiai et al. 2004, 40–1; Hall 2007b, 99; Teixidor et al. 1989, 144–5.
67. Teixidor et al. 1989, 145–7; Amadasi Guzzo 1987, 23.
68. Ridgway 1992, 111–18. This is not to suggest that generally people at Pithekoussai buried in diverse manners or with non-Greek objects must have been of different, non-Greek, ethnicities; rather, the suggestion is specific to this individual example.
69. Lehmann 2005, 84–6; Lemos 2005, 57.
70. Niemeyer 1990, 52–4.
71. For recent discussion of these case studies, with bibliography, see, e.g. Aubet 2001 and Sagona 2004 (Toscanos); Hodos 2006 (Al Mina and Pithekoussai).
72. Hall 2003a, 30; see also Berg and Mair 1999; Gehrke 2004; Waldenfels 1999.
73. Antonaccio 2001; Hall 2002, 90–124; Hall 2007b, 257; and see Antonaccio, Chapter Two.
74. Malkin 1998, 207–9.
75. E.g. Stein 2002. For the Phoenicians, specifically, see Aubet 2001, 350–1.
76. Sommer 2007.
77. E.g. 'Romanization': see Hingley, Chapter Three.
78. Kristiansen 1998; Sommer 2004; Woolf 1990.
79. Niemeyer 2003a, 202–3; Niemeyer 2007, 14; see also Markoe 2000, 150.
80. Markoe 2000, 150–2.
81. Harden 1971 [1962], 171.
82. Markoe 2000, 150.
83. Markoe 1985.
84. Markoe 1985, 60–4.
85. See, for comparison, Riva, Chapter Four.
86. Niemeyer 2003a, 205.
87. Sommer 2002, 218–20.
88. Hom. *Il.* 18. 509–15.
89. Hom. *Il.* 18. 579–84.
90. Hom. *Il.* 18. 603–7.
91. Revermann 1998, 31–2.
92. Horden and Purcell 2000, esp. 522–3.

CHAPTER SIX

SAMOTHRACE: SAMO- OR THRACE?

Petya Ilieva

Although several official excavations have been held on the 'island of Nike' during the last two centuries, bringing to light a considerable amount of archaeological evidence, debate over the identity of the Greek apoikists of Samothrace continues. Discussion of the origin of the Greek settlers of the island over the past 100 years has resulted in two main theories: that they were from either Aeolis or Samos. Interestingly, the same well-known archaeological material and ancient literary sources have been used by scholars on both sides of the debate.

The present approach to the problem aims to set the finds from Samothrace in the context of archaeological data from Thrace and East Greece as an attempt to look for the possible origin of the island's inhabitants according to their material record (see Figure 6.1). A direct link between group identity (ethnic, in this particular case) and material traits has been a matter of debate in very recent years, since ethnic identity has been said to be a social construct that may not be materially manifested.[1] Yet, if the study relies on defining criteria of ethnic identity *only* as common kinship, language, religion and/or the primacy of written or spoken discourse (often an elite one, as Antonaccio underlines), and excludes the archaeological record, then much of the past (pre- or nonliterate) remains unidentifiable.[2] Although we cannot rule out the strength of a criterion such as language, for example, it is not always a diagnostic 'magic wand,' and when evidence for the language used by communities is available, it might complicate the entire picture, as the case of Samothrace demonstrates. Despite the general denial of the

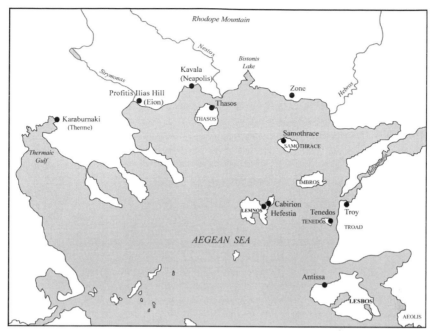

6.1. Map of the North-Eastern Aegean showing the distribution pattern of G 2–3 ware (Drawing: S. Grice)

culture-historical approach of regarding artefacts as diagnostic criteria of ethnicity, it has been recognized nevertheless that 'certain cultural forms and artefacts may sometimes actively serve as *indicia* of ethnic identity.'[3] While it is generally correct that not all material culture expresses ethnic identity, it is exactly the field in which to search for what Antonaccio defines in Chapter Two as the 'discourse of things.' Proposing that 'humans' ability to associate a thing with some other place gives it one of the criteria for ethnicity: an original homeland,' she provides a strong operative tool for exploring diagnostic artefacts as identifying indicia. It is especially fruitful when applied to mixed cultural contexts, such as those familiar from the Greek *apoikiai*,[4] where the permanent settling down of Greek-speaking newcomers and their co-existence with the natives creates what she designates as hybrid cultural development.[5] The approach I follow is based on the attempt to identify the original homeland, as far as possible, of material (and associated ideas) from Samothrace that may have served as ethnic indicia, thus tracing different elements observable in the material record of the island and their gradual 'hybridization.' This material record has been examined with regard to three main cultural unities, each with a different 'original

homeland,' which are, more or less, overlapping in chronological and contextual terms: Thracian, Aeolian, and Samian.[6] This circumstance requires defining criteria for recognition of contact (whatever it is) and presence, based mainly on contextual analysis of 'non-local' artefacts. As Waldbaum suggests, a broad 'range of cultural considerations, including preferred shapes of pottery, shapes intended for special uses, inscriptions, and other elements of material culture such as architecture and burial customs'[7] gives a solid ground for defining presence and not just incidental or regular contacts. The case study of Samothrace indicates, however, that although part of the material record illustrates that a hybrid cultural context developed after the foundation of the *apoikia,* some other 'non-local' (in terms of original homeland) artefacts suggest a different mode of interaction on the island, one of contact with neighbouring regions that did not result in a synchronous establishment of *apoikiai.*

The Pre-Greek Inhabitants

The ancient literary tradition generally agrees that the pre-Greek population of the island was of Thracian origin.[8] It seems that they are the first ethnic group among the diverse inhabitants of Samothrace who are identified by name and, following Jones's formulation of ethnic groups where emphasis is laid on shared culture,[9] they can be connected to part of the material record, traceable in finds from the Sanctuary of the Great Gods, probably in the South Necropolis, and in other recently identified sites outside them (Vrychos, Mandal' Panaya, Porta) (see Figure 6.2).[10]

The existence of a Thracian element can be illustrated by certain monuments and finds whose original homeland is recognizable in southern Thrace. Most plentiful is ceramic evidence, represented by a particular class of handmade ware (see Figure 6.3). It relates to the Early Iron Age pottery *koine* of south-eastern Thrace, sharing common features of shape and decoration, although it does not find exact parallels with the Thracian assemblage. When considered in context as well as in broader cultural setting, this distinct part of the indigenous material assemblage emphasizes similarities with recognized homeland features, and differences with later colonial expressions, therefore playing a functional role as a diagnostic element that reflects pre-Greek identity during the discussed period.[11] The chronological framework of the Samothracian handmade ware stretches

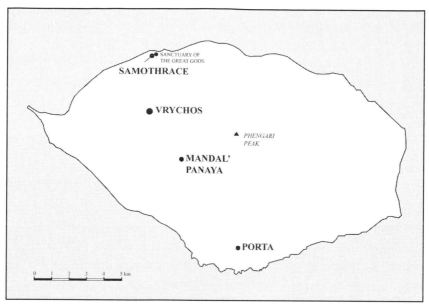

6.2. Map of Samothrace with the archaeological sites mentioned in the text (Drawing: S. Grice, after Matsas and Bakirtzis 2001, fig. 2)

from the eleventh century until the eighth/ seventh centuries BCE, and its appearance is usually taken as an indication of the arrival of a Thracian element on the island. At present, this ceramic category is known from the settlement sites on Vrychos hill and in the locality of Porta,[12] from a votive deposit in a *bothros* (pit) in the Sanctuary of the Great Gods,[13] and through different, mainly surface, finds from various sites on the island, including the open-air sanctuary at Mandal' Panaya.[14] Of all these sites, the settlement at Vrychos, which is characterized by the existence of a *peribolos* wall encircling a considerable area,[15] is the only one that has been subject to archaeological exploration. Unfortunately, the absence of a clear stratigraphic sequence (including permanent building remains)[16] limits the possibility of contextualizing the material more precisely, although the building complex may be recognized as domestic.

The decoration and shapes of the pottery, the only class of material artefact from the site, are best paralleled in the Early Iron Age assemblages from the mainland coast of Thrace opposite Samothrace. Some of the cup shapes found at Vrychos are well paralleled in the deposit from the Sanctuary of the Great Gods (Hall of Choral Dancers, ex Temenos), where they are dated by imported ware to the seventh century BCE,[17] and in finds from the open-air sanctuary at Mandal' Panaya.[18] The shared

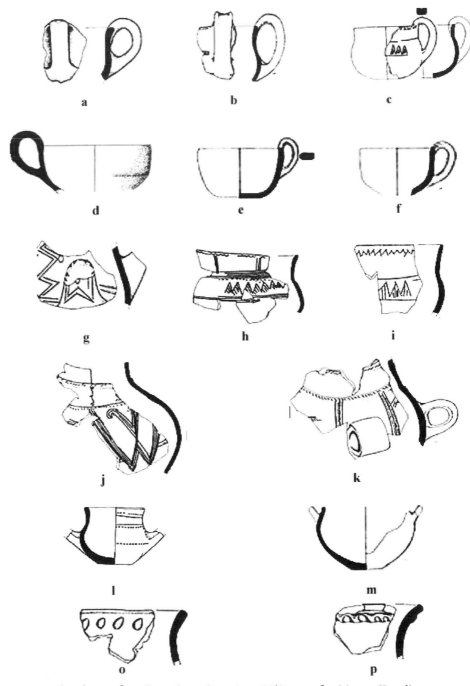

6.3. Handmade ware from Samothrace (Drawings: P. Ilieva: a. after Matsas, Karadima, and Koutsoumanis 1993, fig. 1; b. after Matsas, Karadima, and Koutsoumanis 1989, fig. 1; c. after Matsas 2004, fig. 12a; d. after Lehmann and Spittle 1982, fig. 76; e. after Matsas 2004, fig. 14a; f. after Matsas 2004, fig. 14a; g. after Matsas et al. 1993, fig. 1; h. after Matsas 2004, fig. 12a; i. after Matsas 2004, fig. 15; j. after Matsas 2004, fig. 12b; k. after Matsas 2004, fig. 12a; l. after Matsas 2004, fig. 15; m. after Matsas 2004, fig. 14a; n. after Matsas 2004, fig. 16; o. after Matsas 2004, fig. 16)

characteristics between the ceramic assemblage from Samothrace with that of Aegean Thrace suggest that a local variety of the Early Iron Age handmade ware of south-eastern Thrace was developed.[19] Among the vase shapes are recognizable one-handled cups, jugs, deep bowls, kantharoid and krateroid shapes, amphorae and storage vessels, the last usually being decorated with applied, roughly executed plastic bands with nail and/or finger imprints. The general morphological and decorative style of the vessels from Samothrace and the littoral zone of Aegean Thrace gives ground for defining certain basic differences between these and those of inland south-eastern Thrace, and suggest a kind of regional development.[20] It could be summarized, as far as possible from the mainly partially preserved ceramics, that fluid, S-like profiles of the vessels predominate in the coastal area and Samothrace, in contrast with the more carinated shapes of hinterland Thrace, where emphasis was put on the junctions between different parts of the body. One of the basic decorative ornaments of the Early Iron Age pottery from Thrace, the channelling, has been executed in quite different ways. While inland it is represented by well-shaped, deep grooves, in the Aegean littoral they look more like shallow incisions, often with some space between them. The most diagnostic feature of this pottery, the big, horn-like projections that give the name 'bukelkeramik,' familiar from inland Thrace and Troy VIIb2,[21] are also a matter of different treatment. In the coastal variety, they are closer to a 'button' shape, projecting only slightly from the wall to form a kind of relief, but not a 'classical horn.' An obvious preference for incised decoration (geometric, with a limited number of linear ornaments), instead of the rich stamped one developed in the hinterland, can also be mentioned as a distinctive feature of the Aegean Early Iron Age ceramic repertoire.

In sum, the ceramics from Samothrace and from the opposite coastal sites form a local variety distinctive from the pottery of inland Thrace, to which they are, however, related. The shared stylistic characteristics between the Samothrace ceramics and those from the opposite shore indicates that the island had close relations with the littoral zone, which became its peraia after the establishment of the *apoikia*, prior to the coming of the Greeks, and reflects a regional development rooted in a complex background.[22]

The considerable importance of the settlement at Vrychos for the Early Iron Age on Samothrace may be additionally underlined through the

existence of five megalithic tombs (dolmens) located in close proximity to it, on the slopes of the hill.[23] In other words, it is a rare example of both funerary and domestic contexts connected to a single site.[24] The tombs belong to the dolmen tradition that was popular during this period in south-eastern Thrace (including modern south-eastern Bulgaria, north-eastern Greece, and north-western Turkey). The Samothracian examples are built with local, quite hard stone that is difficult to work; the tough nature of the stone could explain their specific form: massive, roughly rectangular slabs that look more like natural, unworked stone are used for the construction of the walls and covering. The Samothracian single-chamber dolmens are simpler than the more elaborate two- and three-chambered constructions known from south-eastern Bulgaria, but they do not differ in their general outlook or building techniques.[25] Like the dolmens from the mainland, the Samothracian examples are adapted to the locally available building material. This phenomenon is observable among many Thracian dolmens: examples from Rhodope Mountain (on both sides of the modern Greek-Bulgarian border at its summit) use thinner, better fitting slabs, for the local building stone is softer, sandier, and easier to work.[26] It is unclear if tumuli covered the Samothracian dolmens, as is usual in Thrace, for no traces of them have been preserved, but the survival of medium-sized unworked stones encircling some of the dolmens, perhaps serving as a *peribolos*, implies that tumuli may have once existed. At present, Samothrace represents the most southerly extent of megalithic dolmen burials.[27] The appearance of grave monuments typologically identical with examples from the internal territories of south-eastern Thrace is particularly suggestive, in addition to the already discussed ceramic repertoire's similarities to coastal Thracian assemblages, of a Thracian-related culture prior to the arrival of Greeks.

Not all foreign goods or practices can be viewed as indicative of the presence of new people, however.[28] The distribution of other classes of material culture, such as fibulae, for example, suggests that trade may provide a better explanation for their presence than the assumption that they serve as ethnic indicia. I have discussed elsewhere in detail the distribution of fibula types, including the so-called Thracian type, in the littoral area of Aegean Thrace, the Troad, and Samothrace.[29] The distribution pattern of the so-called Thracian type, in particular, in the

north-eastern Aegean littoral suggests that towards the end of the eighth century or beginning of the seventh century BCE, Samothrace came into more active contact with neighbouring regions than in the preceding centuries of the Early Iron Age, although many of the examples may have a sixth century date (such as those from the South Necropolis) and therefore belong to the period by which the Greek *apoikia* was already established.[30] In this case, the fibulae could have been used by Greeks and Thracians simultaneously. Thus, they hold no specific ethnic identification value. This example highlights the necessity of considering contextual characteristics when attempting to relate material culture to ethnic identity. Undoubtedly, when analysing artefacts with wide circulation and/or trade value, it becomes nearly impossible to identify the cultural identity of the final user, particularly in the case of utilitarian goods such as fibulae. It is perhaps not fair, either, to maintain a static interpretation of such goods or an interpretation divorced from their sociohistorical contexts. The absence of reliable evidence for a precise chronology of the fibulae limits the possibilities of setting them with any certainty in a sociocultural context, that is, to define whether they belong to a period before or after the Greek settling. Even if we are able to prove that they were in use after the establishment of the *apoikia*, they may be at best an example of an advanced stage in the process of 'hybridization.' In other words, by this time, the original homeland of the artefact can no longer be viewed as indicative of an ethnic identity, as the objects could have been appropriated by all the residents and thus may no longer have been regarded as exclusively Thracian.

A group of 'non-Greek' votive inscriptions from the Sanctuary of the Great Gods may also be attributed to this pre-Greek 'cultural unity,'[31] as well as examples from the open-air sanctuary at Mandal' Panaya, and in the area of Apollo temple in the Samothracian *apoikia* Zone on the Thracian shore,[32] where the presence of non-Greek inscriptions in a Greek cultural context remains unique in the greater Thracian region. The identification of the language of the inscriptions as Thracian, although utilizing the Greek script, is widely accepted and usually taken to be evidence of the so-called lingua sacra known from Diodoros 5.47.3 as the liturgical language of the cult in the Sanctuary of the Great Gods. As the problem of the identification and decipherment does not concern us here, one fundamental question that these inscriptions raise within

the prism of the present study is whether and by how much the use of a written alphabet by one language to express a different spoken language can serve as a cultural marker, especially when preserved only as a short votive inscription. The nature of the inscriptions, the date of their appearance,[33] the vessels on which they were executed,[34] their context,[35] and the adoption of the foreign practice of inscribing a dedication, a popular practice in the Greek world, clearly indicate a mixing of local tradition with that of the Greek newcomers[36] that is among the chronologically earliest indicia for the beginning of the process of hybridization. Thus, any attempt to identify the dedicants as local Thracians who adopted some Greek practices, or as Greek settlers who adopted the local spoken language must remain inconclusive. The adoption by the Samothracians of the practice of writing using the Greek alphabet to express their spoken language is a substantial act considering that the mainland Thracians did not share the Greek tradition of writing at this time. The earliest discoveries from Thrace include an inscribed golden ring from the first half of the fifth century BCE found in a grave in Plovdiv district,[37] and the inscription on a vessel from Duvanli necropolis dating from the second half/end of the fifth century BCE.[38] They support the interpretation that the Samothracian and Zone examples are among the earliest that mark the gradual penetration and adoption of the practice of writing in the wider Thracian region, most likely resulting from contact and co-existence with Greeks.

If we assume that the inscriptions under discussion are dedications by Greeks, then the question arises as to why the Greeks felt it necessary to use a foreign language as a mediator for their contact with the gods. In fact, the popular explanation for this phenomenon is that the non-Greek language was in use by the autochthonous population of the island and was also used as a lingua sacra by the Greeks.[39] This does not help to identify the dedicator's ethnic affiliation and perfectly illustrates that even a strong criterion such as language may not always function as a sign of ethnicity. The very appearance of such a cultural element in the early years of the *apoikia*, when the formation of a hybrid context was still in process, is indicative of the adaptation of existing local practices by the newly arrived Greeks. It may be viewed as resulting from what Hall defines as 'aggregative' ethnicity rather than from an oppositional mode in a colonial context.[40]

Finally, an early pithos inhumation of a young man in the South Necropolis (S252)[41] could be considered relevant to the argument. On the basis of the unusual treatment of the cranium, the top of which was split away and the top of another human cranium placed in the grave,[42] it has been assumed that the grave is most probably non-Greek and therefore that of a local Thracian.[43] It may not have been the only such burial, but the nature of the preservation of the early graves from the South Necropolis renders it impossible to assess any further.[44] This particular burial, however, is situated in the Greek polis cemetery and included a karchesion, a vessel that was popular in the Troad and Aeolia from eighth century BCE until the end of the sixth century BCE, as stratified contexts with karchesia elsewhere indicate (to be discussed). Although the grave contains an inhumation, which contrasts with the predominant contemporary cremations in the South Necropolis,[45] without the specific feature of post-mortem mutilation it would be impossible to distinguish it from the 'Greek' ones, especially when one considers the presence of the karchesion.[46] The unusual treatment of the cranium finds an interesting 'continuation' in other examples of bodies with post-mortem mutilation from the South Necropolis, although they belong to the Early Roman period.[47] Evidently the practice remained archaeologically 'invisible' in the predominant cremations of the sixth and fifth centuries BCE, and it is not attested in the Hellenistic period graves of the South Necropolis. If one set the evidence from the 'unusual graves' in the South Necropolis of Samothrace in the context of the wider Thracian region, however, it could support a Thracian-related origin of the practice, thus providing an original homeland for a rite recognized in a hybrid cultural background. Post-mortem mutilations, or, more correctly, burials in non-anatomical order appear often as a characteristic feature of the burial practice in the Thracian lands from the Bronze Age continuing during the Iron Age.[48] It has been recently demonstrated that during certain periods (fifth to second centuries BCE) and in some areas (Rhodope Mountain) this practice appears more often.[49] The persistence of such 'non-Greek' rites in the South Necropolis of Samothrace gives a notion of common descent, as Antonaccio defines it in Chapter Two.

The grave under discussion, illustrating a combination of context (the cemetery of the Greek *apoikia*, which according to the written sources is Ionian), grave equipment (the karchesion that implies a

connection with Aeolia) and disturbance of the anatomical order of the body (a Thrace-related custom), together with other Samothracian features, such as the presence of Thracian-type fibulae and the use of the Greek alphabet to express a local language, all serve to illustrate the nature of hybrid cultural development at a time after the establishment of the *apoikia*. It seems that, chronologically, all these examples belong to the period immediately following the foundation of the polis (late seventh/sixth century BCE), when the origins of different elements are still traceable, albeit with difficulty, and before the process of hybridization has changed them to form eventually the picture of the 'Samothracian' Greek identity.

The Aeolian Connection

The next chronological 'cultural unity,' in terms of its appearance in Samothrace, is the Aeolian horizon. This is marked by the presence of finds that link the island directly with the area of the nearby Troad, and Aeolia more generally. Results from the systematic archaeological exploration of the Sanctuary of the Great Gods and the South Necropolis suggest to Lehmann that the Samothrace *apoikia* was founded c.700 BCE by a group of settlers from Aeolia.[50] This opinion was supported by the then earliest epigraphic evidence from the Sanctuary, which is a fragmentary inscription from the middle or third quarter of the fourth century BCE containing some Aeolisms and *koine* forms.[51] Fraser argues that it records a Samothracian decree because the first letters of the polis name are Σα-, and there is no Aeolian city with those initial letters. He acknowledges that it could be a decree of another city for a Samothracian citizen.[52] As Graham observes, however, the city of Samothrace could have been named in a decree of another city that was inscribed at Samothrace, which weakens an argument in favour of an Aeolian element on the island.[53] Graham, himself, argues that the colonists were Samian and arrived during the first half of the sixth century BCE.[54] Reference to the month of *maimakterion* on another stone inscription implies an Ionian presence in the polis, although it has been argued that the Aeolian influence nevertheless predominates.[55] It is noteworthy, however, that the patron goddess of the Samothracian polis is Athena, who was also the patron goddess of most Aeolian cities.[56]

Ceramic material from the Sanctuary, the city itself, and the South Necropolis further supports the notion of a strong Aeolian-related complex of artefacts, particularly the homogeneous group of subgeometric pottery called G 2–3 ware (see Figure 6.4).[57] In addition, a limited quantity of Aeolian gray ware and examples of karchesia,[58] found in the Sanctuary and the South Necropolis, strengthens Lehmann's arguments in favour of the Aeolians being the first Greek-speaking colonists on the island.[59] The contextual analysis and the distribution pattern of G 2–3 ware around the North Aegean coast, however, indicates its value as a trading commodity, thus implying the possibility for an alternative, commercial explanation surrounding its appearance on Samothrace,[60] although it is taken to be a north-east Aegean Greek product. The analogy with the situation on Thasos and its peraia[61] gives rise to the suggestion that the appearance of G 2–3 ware on Samothrace may indicate a pre-colonial phase, when contacts with the north-eastern Aegean were strong but did not include Greek settlement. Thus, the fine vases of the G 2–3 group should not be taken as a sign of permanent Greek presence on the island, at least during the first half of the seventh century BCE. Rather, they may indicate the activities of local inhabitants who dedicated these luxury vessels in their sanctuary. Such an interpretation does not confront the assumption that these wares were shipped by Greeks as part of their trading activity in the north-eastern Aegean.[62]

The identification of a group of pottery with a place of manufacture[63] puts us in danger of oversimplifying the Greek colonizing movement and the extent of ancient Greek trade and seafaring skills. On the other hand, it is exactly this pottery group that is best comparable with the literary sources that discuss the mythological relation between Samothrace and Troy, Aeolia and Lemnos, the earliest of which might be attributed to the sixth century BCE.[64] Although it has been noted that the archaeological material by itself does not allow identification of peoples and spoken languages,[65] the contextual and chronological position of this ware and the absence of firm material analogues to the previously mentioned criteria for permanent Greek presence on Samothrace in the first half of the seventh century BCE[66] gives rise to the assumption that these objects, products of a Greek cultural environment, were used in a pre-colonial phase in a local manner. Their presence at this time does allow

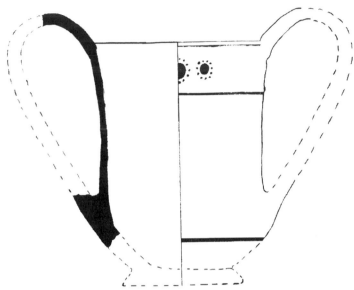

6.4. Sessile kantharos of G 2–3 type from the Sanctuary of the Great Gods, Hall of Choral Dancers (previously Temenos) (Drawing: P. Ilieva, after Matsas and Bakirtzis 2001, fig. 15)

us to set Samothrace within the network of connectivity developed in the north Aegean in the Late Geometric and Early Archaic periods, rendering it part of the Early Archaic cultural *koine* of the region. Taking into consideration the connection with the Troad developed in the literary sources, we are reminded that Pseudo-Skymnos defines the inhabitants of Samothrace as 'Τρωας όντας τω γένει' (*Troas ontas to genei*, or of Trojan stock), adding that later when the Samians helped them in time of famine they accepted 'συνοικους' (*synoikous*, translated as settlers, but closer to co-habitants, as syn- implies somebody one is living with, i.e. mixed habitation) from Samos.[67] Being a material, and chronologically the earliest manifestation of the locals' taste for luxuries, this pottery group mirrors an already structured network of 'primarily economic, or…broadly cultural'[68] relations in the north-eastern Aegean into which Samothrace was integrated. This process of interaction creates a broader cultural identity, in material terms, of the pre-Greek Samothracians, which removes them from the Early Iron Age context of Thrace and marks the beginning of a gradual mixing and overlapping of traditions that will find a final expression later in the very hybrid nature of Samothracian Greekness.

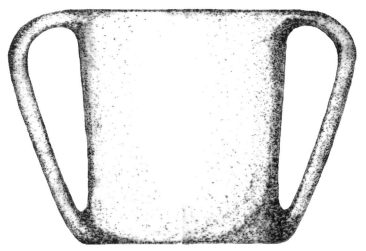

6.5. Restored karchesion from Samothrace (Drawing: P. Ilieva, after K. Lehmann 1998, fig. 74)

As mentioned already, karchesia were found in the South Necropolis and in the Sanctuary of the Great Gods,[69] and the use of the shape on the island seems to belong to the period between the late seventh and end of the sixth century BCE (see Figure 6.5). The shape has been found in north-western Anatolia – the Troad and Aeolia – as well as on the islands of Tenedos, Lesbos, and Lemnos, on Thasos, at inland Thrace, at the village of Dolno Sahrane, and along the western coast of the Black Sea, at Apollonia Pontica.[70] This specific variety of the kantharos shape comes mainly from cult contexts, and it is generally accepted that it was used for libations. Its distribution pattern confirms, in addition to other, already mentioned categories of finds, that Samothrace was an active member of the network of relations and exchange that developed in the littoral and island territories of the north and north-eastern Aegean in the Archaic period and supports the view that the island became a part of this culturally related area. It indicates, also, that the contacts between Samothrace and Aeolia continued after the foundation of the *apoikia*, but from the viewpoint of its cultural connotations, this vessel type belongs to the 'Aeolian horizon.' The evident preference given to the shape illustrates, as does the case of G 2–3 ware, the Aeolian connection in the mosaic of the Samothracian colonial material identity,[71] but in contrast to G 2–3 ware, the karchesia seem to belong to a slightly later, advanced stage

in the formation of this new local identity when the third element is already present.

The entire material assemblage suggests that the local population of the island interacted with the north-eastern Aegean, especially the Troad and Lemnos, during the Archaic period. It reflects the interaction of the inhabitants of Samothrace (pre-Greek as well as Greek apoikists, already in co-existence with the former) with a North Aegean economic and broadly cultural network that results in recognizable aspects of the material culture, at least during the Archaic period. Undoubtedly, the literary tradition and material record associate Samothrace with Aeolia, but a permanent presence of Aeolian apoikists as early as the first half of the seventh century BCE is difficult to substantiate clearly from the archaeological record. The appearance of artefacts whose style originated in the wider Aeolian area complicates further the picture created later by the mixing of local Thracian and Ionian Greek elements, adding one more element to the process of mutual assimilation from which emerges the new idiom of colonial Samothrace.

Trying to Identify the Samians

Far more numerous are the artefacts dated from the end of the seventh/early sixth century BCE onwards[72] from the South Necropolis, the Sanctuary of the Great Gods, and that at Mandal' Panaya. Many of these are taken to be the archaeological reflection of the literary tradition of the Samian origin of the Greek colonists on Samothrace,[73] which finds its origin in Antiphon.[74] For instance, Graham, arguing in favour of the Samian origin of the apoikists, relies upon Antiphon, as well as the Aristotelian politeia of the Samothracians,[75] and Pseudo-Skymnos,[76] whose text, however, combines both the Samian and Aeolian traditions. Graham interprets Herodotus's tale of the Samothracian ship in the battle of Salamis as support for the Ionian origin of the Samothracians.[77] The only doubt about this Samian tradition was raised by Strabo, who says that the story was created by the Samians to gain glory for their island.[78] Graham suggests, however, that Strabo's source was not Apollodoros, but Demetrios of Skepsis, whose arguments are based on a 'combination of pedantry and local patriotism,' and thus Graham rejects the reliability of his information.[79]

Graham has also questioned the archaeological arguments for an Aeolian origin of the Samothracian settlers. As mentioned earlier, he suggests that the decree in Aeolian dialect, which Fraser argued was Samothracian, was issued by some other city mentioning the polis of Samothrace. He argues that the pottery group G 2–3 is not a Greek product,[80] adopting Beschi's view that the Samothracian examples belong to the Lemnian variety of the group,[81] and that Lemnos had been inhabited by pre-Greek Tyrrhenians at this time, as suggested by Thucydides.[82] Instead, he interprets reference to an eponymous basileus attested on the inscribed lists of theoroi and initiates from the Sanctuary of the Great Gods[83] as complementary to Herodotus 3.59, who cites an event of Samian history '*epi Amfikrateos basileuontos.*'[84] Finally, script on the famous sixth-century relief with the figures of Agamemnon, Talthybios, and Epeios has been described by Jeffery as 'a fine example of eastern Ionic lettering,'[85] and Fredrich earlier relied on it as evidence supporting the tradition for Samian colonization.[86]

These might also be supported by a fragmentary inscription dated to the last quarter of the sixth century BCE in the museum of Samothrace, recently identified by Clinton and Dimitrova. It contains the name *Onesim[os]* in Ionian dialect and is taken by the authors as an additional argument supporting the Samian origin of the Greek settlers of the island.[87]

The remainder of the archaeological record of the South Necropolis, the Sanctuary of the Great Gods, and the open-air sanctuary at Mandal' Panaya, however, poses a number of questions regarding whether or not such clear-cut ethnic identities can be assigned.

The Archaic-period finds of the Sanctuary of the Great Gods do not provide any indication of the origin of the Greek settlers. With the exception of the karchesia, which have already been discussed, only the few Attic black figure vases and fragments of pithoi with stamped relief decoration are recognizable imports;[88] most of the ceramic assemblage is plain ware that is most likely of local manufacture after East Greek prototypes, like the one-handler.[89] The dedicated objects in Mandal' Panaya show a clearer link with East Greece, especially the collection of kylikes,[90] the anthropomorphic example in the shape of a woman's protome,[91] and terracottas whose artistic style associates them with Late Archaic East Greek examples.[92] Although their East Greek character

is generally not doubted, it is almost impossible to interpret them as directly illustrating a connection with Samos since similar products were manufactured all over the Aegean basin, where they were in circulation as trade goods deprived of ethnic resonance. Thus, the relationship between the literary and archaeological data is not so clear-cut.

The South Necropolis of Samothrace likewise demonstrates a number of features that do not support the Samian tradition. Cremation is the dominant burial rite during the sixth and fifth centuries BCE in the South Necropolis. With the exception of one complete and five partially preserved clay sarcophagi, and inhumation grave S252, discussed earlier, there are no other inhumations in the South Necropolis during this time that are attested by archaeological remains. The excavator assumed the existence of additional, destroyed inhumation burials,[93] but even these would have been few in number in comparison with the cremations and pyre places recorded along the torrent where the cemetery developed. Only one inhumation, Archaic in date, was recovered from the North Necropolis: T12, a child inhumation in an SOS amphora.

By contrast, in the North and Western Necropoleis of Samos during the Archaic period (seventh and sixth centuries BCE), clay and stone sarcophagi of different types, inhumations in grave pits, graves cut in the rocky terrain, and burials in amphorae set in natural rock slits were common features.[94] Cremation was also practised on Samos, but it was much less common. This rich variety of grave types used for inhumation that co-existed with cremation is not exceptional for the East Greek world or for the Ionian *apoikiai* on the North Aegean coast.[95] However, the South Necropolis of Samothrace demonstrates quite a different model, with conservatively applied uniform burial practices during the sixth and fifth centuries. While one might argue that the restricted size of the cemetery necessitated cremation rather than inhumation burials, it is worth remembering that inhumation burials were interred in the same area from the fourth century BCE until Roman times.

The grave goods from the South Necropolis also pose a number of questions about the identity of the deceased. Two groups of finds are very suggestive in this respect. The first one consists of eight bronze phialai, and the second includes fifty identifiable fibulae (plus an unknown number of very scorched and distorted examples). The

unusually high number of phialai is worth noting when one takes into consideration that they have been found in the polis cemetery and not in the Sanctuary of the Great Gods. With the exception of the North Necropolis of Corinth, where only three examples that are morphologically close to the restorable Samothracian pieces have been found,[96] phialai were more common among rich burials in the Archaic-period necropoleis of Macedonia and Iliria, which did not belong to settlements organized after the Greek polis model. At least six bronze phialai are known from Sindos and one is recorded from Trebenischte; several have been found in the western Balkans, and two in northwestern Thrace, in a grave in the territory of the village of Sofronievo and in the village of Nefela. The closest and most interesting parallel, however, is the necropolis of Assos, where 15 per cent of the grave urns were covered with bronze phialai. Some of them are morphologically extremely similar to the Samothracian ones – shallow and broad with an almost flat base.[97] In contrast to Assos, the Samothracian examples were most probably part of the pyre equipment, or somehow used in the cremation ceremony, because they are very scorched, badly preserved, and warped.

It is difficult, too, to find parallels to the second category of finds, the fibulae, exclusively in Samos. Rather, their distribution pattern, number, and typological variety find better similarities in the cemeteries in the Troad and the opposite Thracian coast.[98] In addition, luxury goods, such as faience and glass vessels, silver utensils, and fittings for vessels of other materials, are also part of the grave equipment.[99] In contrast, similar dedications are extremely rare in the Sanctuary of the Great Gods, especially during the Archaic period. The East Greek origin of the South Necropolis finds is evident but, as they were luxury items that were traded all over the Mediterranean, they cannot serve as explicit indicia for the apoikists' identity. Thus, the numerous ceramics and fibulae that show more localized contacts suggest that the relationship between Samothrace and Ionia was not the dominating one.

The greatest quantity of material evidence of this phase comes from the South Necropolis and consists mainly of vases. Two striking features are immediately observable: first, the only clearly definable category of Archaic ceramics is represented by Attic imports and a few Lemnian stamnoi; second, there is an apparent absence, at present, of East Greek

painted pottery styles such as Wild Goat, Fikellura, Ionian Little Masters, rosette bowls, and other styles. Similar conclusions cannot be drawn from the ancient town, as such levels have not yet been reached in excavation. It is likely, however, that these patterns may be replicated in the settlement, since, while one might expect that if East Greek pottery were imported widely into the settlement then it would be likely to be interred in the graves alongside the other imported wares,[100] the same standard of assumption should apply in the reverse scenario (lack of imports).

The multiplicity of vase styles in the South Necropolis consists of Klazomenian amphorae identifiable as Enmann and Knipovitch classes, imitations of Attic horsehead amphorae and C cups, decorated and undecorated amphorae, the last combining morphological and stylistic features of different ceramic classes,[101] and long-necked jugs. The excavator assumed the same foreign place of origin for many of these, and local production for some. The general impression is that all the amphorae from the South Necropolis look as if they are products of potters who knew well and could imitate Attic and North Ionian prototypes and combined characteristic features of both in a single vase,[102] reinforcing a connection with the North Ionian ceramic tradition. It would be misleading, however, to view them as imports, or specifically as Klazomenian, elements of whose black figure style can be easily recognized in the Samothracian examples;[103] rather, they are better characterized as of a broadly Ionian style, or Ionicizing, and are more likely to be locally manufactured. However, this is not to say that they were produced by an existing pottery workshop on the island, but it is possible that they were manufactured in the temporary establishment of a travelling potter's workshop. Travelling potters working away from home are archaeologically well attested in the Archaic period in the Aegean basin and south Italy,[104] and the possibility for the existence of such a model of production on Samothrace should not be ruled out. Generally the Archaic-period ceramic assemblage from the South Necropolis finds closer parallels to styles produced in North Ionian and Aeolian centres. Any attempt to find parallels with the ceramic assemblage known from Samos fails at present.[105] It is worth remembering that ancient literary traditions suggest that colonists from Aeolia, Ionia, and Attica established their settlements in the neighbouring Hellespontine area, and sometimes jointly.[106] This is the region where the earliest Athenian colonial interests are attested and where we hear of

the struggles with Mytilene for Sigeion, and the story of Miltiades I and the Thracian Dolonkoi. It might be assumed that, with such a diverse demographic picture, apoikists would bring their own pottery traditions, which then developed into regional varieties based upon the ceramic classes known from home, resulting in the emergence of new, eclectic types. In this respect, the hybrid culture of this area is the probable candidate for the creation and inspiration of the discussed types known at present exclusively from the South Necropolis of Samothrace.

The very hybrid nature of the archaeological finds from Samothrace (South Necropolis, Sanctuary of the Great Gods, and the sanctuary at Mandal' Panaya) reflects, at best, the presence of Ionian settlers, but it does not indicate any direct association with the ancient tradition that identified the apoikists of Samothrace as specifically Samian. It is difficult to find any confirmation of explicitly Samian traditions in the burial customs or religious practices, either, especially when compared with traditions on Samos itself. This last aspect of mother city and *apoikia* relations raises a number of questions in this case. The sanctuary of Hera on Samos was a source of international fame during the Late Geometric and the Archaic periods. The Heraion attracted dedications from all over the known world: Cyprus, Egypt, Phoenicia, Syria, Phrygia, Assyria, Urartu, and the Caucasus area, continental Greece, and the western *apoikiai*.[107] Presumably, Hera was important to the Samians, themselves, as well. It is puzzling, then, if the settlers on Samothrace were Samian, that they did not continue to worship Hera alongside the local cult they adopted. Despite the fact that it was quite common for colonies to worship a different set of gods when compared with those of the mother city, one would expect the apoikists to preserve, even on a small scale, worship of the goddess whose sanctuary 'at home' was famous throughout the Archaic world.[108] It is interesting, also, when taking into consideration that the Samian merchants in the emporion of Naukratis established a Heraion for the worship of their patron goddess,[109] that the written sources and the archaeological record on Samothrace do not preserve any trait that would imply the existence of a Hera cult on the island. Furthermore, if the apoikists were Samian, why did the Sanctuary of the Great Gods not acquire architectural features common at this time on Samos? It should be borne in mind that in the Samothracian *apoikia* Zone, an architecturally formed sanctuary of Apollo was functional in the sixth century

BCE and a fragmentary preserved kouros was found in its territory,[110] features that are missing in the Sanctuary of the Great Gods at that time. Regarding the peculiarities observable in the Archaic period finds from the Sanctuary of the Great Gods and the absence of surely attested relevant architectural remains, it might be assumed that they mirror a kind of response of the Greek settlers to specific local conditions, or reflect a relationship between the Samothracian polis and the local inhabitants. It is, most likely, related also to the nature of the Sanctuary and the pre-Greek roots of the cult, definable as *inherited sacredness*,[111] which is absent, for example, in the Zone, where the apoikists organized their sacred space in a recognizably Greek way.

If we accept that there was settlement by Samians, then we must look for the nature of this settlement, since the establishment of a sizeable group of Samians in a new location, implied by the term *apoikia*, does not appear to be supported by the archaeological record. The identification of the Ionian settlers of Samothrace as Samians could explain the vagueness of the material evidence to some degree, if only their appearance on the island is placed out of the intentional foundation of an *apoikia*. The vagueness of the material evidence for specifically Samians makes more sense if the Samians were not part of an intentional pro-active political act to establish an *apoikia*, but rather were a population seeking refuge on the island. It is known that some Samians were forced to escape their homes, and it is likely that they would have settled on Samothrace, but not because they intended to established an *apoikia*, which is generally a product of the polis as a community of citizens (even if the *apoikia* is established by an individual leading a group of people). The reason for such a viewpoint might be found in the same literary sources that support the Samian origin of the settlers. Antiphon, for example, states that they '*katokisthesan de anagke, ouk epithymia tes nesou*' (they were settled by necessity, not by desire of the island), and this necessity is explained in terms of the Samian tyrants expelling Samians who arrived on Samothrace because '*leian labontes apo tes Thrakes*' (having taken booty from Thrace). Aristotle explains the establishment of the settlement in a similar way: the Samians had been expelled – '...*Samioi katokisan auten ekpesontes tes oikeias*' ('Samians settled it, when they had been expelled from their home country').[112] Pseudo-Skymnos defines the settlers of Samothrace as 'mixed' and calls the Samians '*synoikous*' of the local inhabitants.[113] The

only author who uses the term *'apoikous'* when mentioning the Samians is Strabo,[114] who indeed rejects the Samian tradition.[115] Their Samian origin did not necessarily mean that their connection with Samos was strong, hence it is difficult to recognize explicitly Samian features in the material record of Samothrace. A similar example mentioned by Herodotus is extremely useful in this respect. According to the story, when the Samian enemies of Polycrates finally had to leave Samos, they exacted booty from two places and then settled at Kydonia in Crete, where, among the temples they built, there was one to the local goddess Diktynna.[116]

If we trust the written sources that relate the appearance of the Greek settlers on the island to the need to abandon their homes on Samos, then the establishment of the *apoikia* could hardly be recognized as a product of the Samian polis.[117] Indeed, it was the necessity to escape, probably, some political troubles at home, that forced them to settle on Samothrace. This might explain to a certain degree the apparent absence of clear-cut material connections between both islands and the absence of a preserved 'memory' of the oikist of the Samothracian polis.[118]

The archaeological record indicates Ionian presence on Samothrace in addition to the local inhabitants and probably some Aeolian settlers (after the late seventh/early sixth century BCE), but there is no explicit relation with Samos itself, whose position as a mother city needs additional consideration. Despite the presence of material originating in Ionian artistic circles, the relationship between Samothrace and the cultural *koine* of the north-eastern Aegean continues to be well attested for a period of almost a century after the establishment of the polis until the Persian Wars.

Conclusions

Mixture and overlapping characterize the crystallization of Samothracian colonial 'Greekness,' but it is still possible for us to trace those elements, initially different in origin, that define the notion of 'original homelands,' and to advocate that behind the cultural unities recognizable in the Archaic period material record of the island one could recognize different unified groups of people.

The material assemblage of the island prior to the seventh century BCE is quite homogeneous and identifiable as culturally belonging to the Early Iron Age *koine* of south-eastern Thrace, confirming the ancient

literary tradition surrounding the ethnic identity of the pre-Greek inhabitants of Samothrace. By the beginning of the seventh century BCE the island evidently came into more intense contact with neighbouring areas, especially the Troad and Aeolia, where Greek-speaking populations were already in co-existence with local inhabitants. These locally oriented relations resulted in the appearance of recognizably 'foreign' artefacts, such as G 2–3 ware. The fact that this ware was dedicated in the Sanctuary of the Great Gods probably reflects a kind of taste for luxuries used in a local manner, rather than a permanent Aeolian Greek settlement process on the island during the first half of the seventh century BCE, which is not supported archaeologically to date. Despite the fact that one could hardly speak of Aeolian settlement on Samothrace, this is the region with which the island continued to be strongly culturally related in terms of the material record and mythical tradition during the Archaic period, even after the establishment of the *apoikia*. By that time, Samothrace had become an active member in the structured network of economic and cultural relations that had developed in the north-eastern corner of the Aegean. Thus, Aeolia played a considerable role as an 'original homeland' for certain groups of artefacts (or their know-how) from Samothrace that, alongside the local and the Ionian Greek elements, shaped the hybrid nature of Samothracian identity.

By the end of the seventh/early sixth century BCE, with the Greek apoikists (presumably of Samian origin) there appeared artefacts that are broadly Ionian in style but not explicitly related to Samos. Their unparalleled Ionicizing features imply a certain level of hybridization even before their appearance on the island. The literary evidence as well as the material record dating from the initial phase of the *apoikia* imply an 'aggregative' model employed in the shaping of Samothracian Greekness. It seems that the Ionian settlers adapted themselves to the local environment quite quickly and simply, as contests arising from conflicts with the indigenous population are not evidenced on Samothrace and her peraia. By contrast, the already discussed specifics of the Samothracian material record, like the appearance of votives combining local language with Greek alphabet, indicate that the formation of a modus vivendi with the natives that was not based on oppositional valuation had taken place. The written sources implying that the Greeks settled on Samothrace from necessity to escape political troubles at home provide a sufficient

explanation for the evident absence of explicit material culture relations with the mother city. It seems that the actions of the Samian Greeks on Samothrace were structured by their status. Arriving as political refugees, they were partly deprived of the notion of kinship with the mother city and probably more open to accept aspects of local culture.

From the mutual assimilation of customs, traditions, and artefacts originating in the areas already discussed (Thrace, Aeolia, and Ionia) there emerged a new culturally 'hybrid' identity of the Samothracian polis visible in the material culture, where the modern 'look' registers them in active interaction, while at the same time they had already started to lose their initially diagnostic features.

While certain traits characterizing the three cultural/regional streams are generally recognizable in the finds of the Archaic period, that is, immediately after the foundation of the polis, their subsequent merged development into a hybrid, new colonial context disables any attempt to adopt such a methodological approach with regard to the finds dating from the next century onwards. The process can be especially well illustrated with the development of the Sanctuary of the Great Gods, where the mixing of traditions resulted in the creation of the most famous mystery sanctuary of the Hellenistic world, by which time the last indicium for ethnicity – the local, non-Greek language – had disappeared.

Notes

1. Hall 1997; and see Antonaccio, Chapter Two.
2. Hall 1997, 142, express this position explicitly when saying that 'it is, therefore, hopeless to believe that archaeological evidence can *identify* ethnic groups in the past.' The discourse of things as reflecting identity, suggested by Antonaccio, is another perspective that allows the involvement of the archaeological record in the discussion.
3. Hall 1997, 132, with discussion and further bibliographic references.
4. Preference for the Greek term *apoikia* instead of the Latin-derived 'colony' has been given in the text because of the difference in the sociohistorical, economical, and cultural background (Osborne 1998).
5. Although the term 'hybrid' is extremely biological, as Antonaccio notes in Chapter Two, it is still a useful term.
6. This method of analysing diagnostic artefacts under cultural unities according to their (or their prototypes') original homeland shows explicitly the difficulties in the attempt to untangle a hybrid culture into its original elements. The case study of Samothrace with the three cultural unities as defined in this text provides an excellent illustration of Malkin's suggestion (2001a, 14) that 'overlap and mixture rather than contrast are key words' when trying to discuss, understand, and define phenomena originating in colonial context.

7. Waldbaum 1997, 6. Although her study concerns the presence of Greeks in the East, her theoretical approach matches perfectly the study of the phases of Greek appearance and settling in Thrace to which Samothrace belongs during the Early Iron Age.

8. Lewis 1958; see also Burkert 1993, 178-91. Herodotus famously connects the Samothracian Mysteries with the mythical Pelasgoi, implying their presence on the island (Hdt. 2.51). The Pelasgians continue to defy any material identification, and their status remains more rooted in mythology. They are, therefore, excluded from consideration in the present study.

9. Jones 1997, 84.

10. Lehmann and Spittle 1982; Dusenbery 1998; Matsas 2004. As Hall argues (2002, 19), 'literary evidence will normally constitute the initial point of departure in any analysis of ancient ethnicity.' And although the narrative marks the 'departure,' it could hardly complete the entire picture without crossing it with the discourse of things.

11. For the role that material culture plays in reflecting identity, see Hodos in Chapter One and Antonaccio in Chapter Two; see also Antonaccio 2001, 125.

12. Matsas, Karadima, and Koutsoumanis 1989, 607-17; Matsas 2004, 227-57.

13. Lehmann and Spittle 1982, 317-83.

14. Matsas, Karadima, and Koutsoumanis 1993, 647-55.

15. There are a number of sites with *peribolos* walls from the territory of Aegean Thrace, too (for example, at the Chlomo, Vouvos, and Odondoto peaks of the Ismar Mountain, as well as one at Asar Tepe, Ergani: see Triantaphyllos 1990). Whether these walls had a defensive function, at least in those cases where an Early Iron Age date might be assumed, and how these settlements should be defined require discussion based upon well-stratified and well-excavated sites, which are sadly absent at present. See Efstratiou 1993, 135-71; and Ilieva 2006a, with relevant bibliography.

16. The only exception is a small part of stone walling belonging to a building of, probably, circle, oval, or apsidal plan. See Matsas 2004, 240, fig. 11.

17. Lehmann and Spittle 1982, 383, figs. 73-82.

18. Matsas et al. 1993, 647-55.

19. Triantaphyllos 1990, 311; Efstratiou 1993, 142; Nikov 1999, 35.

20. For a more detailed discussion of the characteristic features of the Early Iron Age pottery from Aegean Thrace and its relation with the neighbouring areas, and for further references, see Ilieva 2006a.

21. Schliemann 1880; Schmidt 1902; Blegen, 1958; Köpenhofer 1997, 296-353.

22. By this I mean that important factors such as the local ceramic assemblage during the Late Bronze Age and the mutual influences with the neighbouring area west of Nestos valley (East Macedonia, in modern Greek terms) during the Early Iron Age should not be ruled out.

23. Moutsopoulos 1989, 246-79; and most recently Matsas 2004, 234-6.

24. One might also include the recently discovered so-called megalithic grave from the Krimniotissa locality, which is near the settlement at Porta. Although it is not a real dolmen, its construction shares general traits of the megalithic tradition. See Matsas 2004, 236, fig. 8.

25. See further Fol 1982, 263-390.

26. Triantaphyllos 1981, 61-4; Kulov 1991, 73-86.

27. In contrast with Morris 1998, 47, who claims that the rite is unknown south of the Rhodope range.

28. The use of the term 'foreign people' here is relevant if one thinks of them as a new element that appears on the island during the Early Iron Age, i.e. they are foreign to the Bronze Age background.

29. Ilieva 2007; Kilian calls these fibulae 'Thracian type' to highlight his view that Thrace was the most probable place of origin of the type. Caner accepts this in his classification of fibulae from Asia Minor: Caner 1982, 49–50. For the characteristics and distribution of the type in southern Thrace, see Gergova 1987, 24–31.

30. Thracian-type fibulae are known from the open-air sanctuary at Mandal' Panaya, too, where Greek activity is attested from the sixth century BCE onwards (Matsas et al. 1993, 648; Matsas 2004). The excavators of the site, for example, suggest an eighth-century date for this material, which corresponds with the general chronology of the type in Thrace; thus the excavators have dated the material by association with its homeland chronology, and implied a pre-Greek context for its appearance in the concrete site (Matsas et al. 1993, 648). Because the safety pins do not have a precise stratigraphic context, however, it is impossible to advocate with any certainty whether they mark a dedication by a local inhabitant that chronologically precedes Greek settlement on the island, or belong to a later date, by which time they could be that of a Greek or other co-existing group.

31. The term does not imply any chronological notions as the inscriptions appeared on the island from sixth century BCE onwards, i.e. after the Greek arrival. See Bonfante 1955, 101–9; Lehmann 1960; Graham 2002; Ilieva 2007.

32. Matsas 2004, 227–57; Tsatsopoulou 1989, 585, figs. 8, 9.

33. These inscriptions appeared in the sanctuary from the sixth century BCE onwards, i.e. after the Greek arrival on the island. The earliest examples of Greek inscriptions go back to the mid-fifth century BCE, and by the end of the fourth century they finally replace the non-Greek ones: see Lehmann 1960; Graham 2002, 252–4.

34. All are on Greek-type wheelmade shapes that date from the beginning of the sixth century BCE, coinciding with the appearance of permanent Greek settlers.

35. The sanctuary was initially used in local worship, as the mythical tradition suggests; see Burkert 1993, 178–91.

36. On the other hand, the same practice is well attested on the neighboring island of Lemnos, which the mythical tradition and the archaeological finds connect with Samothrace (see Lewis 1958; Graham 2002, 255), and where the Greek alphabet was used to express the Tyrrhenian language. There is, however, an important difference between both islands in this aspect: the Lemnian inscriptions appear in contexts that predate the establishment of the Athenian cleruchy on the island, while the Samothracian inscriptions appear in relation to the arrival of Greek settlers.

37. Georgiev 1979, 224–5.

38. Filow 1934, 64–5, fig. 81. In Plovdiv district, different contexts (settlement structures, necropoleis) and artefacts give reason for suggesting permanent Greek presence at least from the end of the second quarter/mid-fifth century BCE: Ilieva 2006a.

39. Lehmann 1960, 9–12.

40. See Hall 1997, 32–3; 47–51, for comment on Hall's model of 'aggregative' and 'oppositional' ethnicity. See Malkin 2001a, 9, for the 'oppositional' example

of the Greek community of Naucratis set in politically centralized context. And see Antonaccio 2001, 115, for the concept of 'aggregative' Sikeliote Greekness.

41. The excavator Dusenbery dates the grave as 'probably Classical' (Dusenbery 1998, 744), while Graham suggests a revision between the late seventh and end of the sixth century BCE based entirely on the chronology of the karchesion shape (Graham 2002, 247). Following Dusenbery, he defines the karchesion found in the grave as G 2–3 in fabric (this pottery classification will be discussed in more detail later in the text). Love does not attribute it to this particular class of ware, although she recognizes the general resemblance in the technique and clay structure between both groups (Love 1964, 207). Graham's dating becomes doubtful because if we accept this particular karchesion as belonging to the G 2–3 class, then this would mean a considerably earlier date in the first half of the seventh century BCE, with a possible widening of the chronology in the second half of the century. But a sixth-century BCE date is almost impossible for the Aeolian variety of the G 2–3 ware, to which the Samothracian exemplars seem to belong. By contrast, if we accept a sixth-century date for the vessel, then its attribution to the G 2–3 ware is hazardous. Taking into consideration the general outlook of the Samothracian G 2–3 ware and the appearance of certain pottery groups of sixth-century date with probably local origin whose fabric is tightly related to that of G 2–3, suggesting a kind of limited, local continuation of the technique (Ilieva 2006b), it is more likely that the karchesia on Samothrace have a date between the late seventh and end of the sixth century BCE, as Graham suggests, but that they do not belong to the G 2–3 group. This is the most probable date for the grave under discussion.

42. Dusenbery 1998, 410.

43. Dusenbery 1998, 744; Graham 2002, 247.

44. The South Necropolis covers an area less than 300m² and was reused for centuries. When, in the fourth century BCE, the predominant burial rite became inhumation, the sixth- and fifth-century cremation burials were almost entirely destroyed. Graham correctly observes that 'these circumstances make it impossible to associate all the material found with specific graves' (Graham 2002, 245). It is also unclear whether the earliest surely datable grave goods are relevant to the initial phase of the cemetery or not, because some of the ceramics and fibula types suggest a date earlier than the second quarter of sixth century BCE, which has been proposed as the initial period for the entire cemetery, judging by the earliest datable Athenian imports (see Dusenbery 1998, 701–47). This means that some of the artefacts found in the South Necropolis without direct association with Attic imports could belong to graves preceding the second quarter of sixth century BCE that were subsequently destroyed and whose characteristics remain unclear. Judging from the non-Attic artefacts found in the South Necropolis, an initial date for the cemetery in the late seventh/early sixth century BCE looks preferable and may inform a revised chronology of the Greek arrival on the island and the establishment of the *apoikia* (for further discussion and additional arguments, see Ilieva 2006a).

45. Although cremation is the predominant burial rite in the South Necropolis until the fourth century BCE, the finds there of one entirely preserved clay sarcophagus and fragments of another five that likely date from the first half

of the fifth century BCE indicate that inhumation also existed (Dusenbery 1998, 1138–43). A child's inhumation in an SOS-amphora found in the North Necropolis of the polis confirms the observation (Karadima and Koutsoumanis 1992, 677–9). The excavators suggest a wide chronological range between the seventh century and the first half of the sixth century BCE for this grave, revised by Graham to the second quarter of the sixth century BCE, thus indicating that the early graves were not exclusively restricted to the South Necropolis (Graham 2002, 245–6).

46. This vessel is found usually in cultic contexts, and literary evidence indicates it was used in cult practice (Love 1964, 204–22), although it is found also in non-cult contexts, which suggests that further consideration of the shape's function is necessary (see Polat 2004, 215–23).

47. Dusenbery 1998, 35–9. Indeed, all of them are known from graves dating from the Early Roman period (first century BCE), the late date of which gives strong reason for Graham to reject them as possible parallels with S252 (Graham 2002, 247).

48. For detailed discussion, see Georgieva 2003, 313–23.

49. Georgieva 2003, 314.

50. Lehmann 1952, 19–44; 1998, 19.

51. Fraser 1960, 21, N. Graham 2002, 237.

52. Fraser 1960, 21–2.

53. Graham 2002, 238.

54. Graham 2002.

55. Fraser 1960, 21, N 5; 3.

56. Most probably, the sanctuary of Athena was situated in the upper part of the polis in the Ai-Giorgis locality (Lehmann 1998, 19; Karadima 1995, 487–97), as suggested by stone decrees of the Hellenistic period from this area and the results from limited trench excavations conducted in 1995 (Karadima 1995, 490).

57. Lehmann and Spittle 1982, 315–94. Some fragments were found during limited excavations in the Ai-Giorgis locality of the ancient city, and its appearance there is extremely important (Karadima 1995, 490). The lack of stratigraphic and positional contexts renders it difficult to discuss them in great detail, but their location in the area of the later Athena sanctuary suggests a possible cult deposit of earlier date.

58. Love 1964, 204–22.

59. Lehmann and Spittle 1964, 242.

60. Ilieva 2007.

61. The same pottery has been found in the ancient city of Thasos (Bernard 1964; Gimatzidis 2002), in the Early Iron Age necropolis at Kastri on Thasos (Koukouli-Chrysanthaki 1992) and in the Thasian peraia, in Neapolis and Eion (Koukouli-Chrysanthaki 1992, 574; 1993, 687) in contextual and stratigraphic locations that support a pre-colonial date for its appearance there. Therefore, it has been interpreted as evidence for trade relations developed in the north Aegean in the late eighth/early seventh century BCE, indicating that the Thracian inhabitants of Thasos were familiar with products originating in the northern Aegean prior to the arrival of the Parian settlers.

62. This hypothesis is more plausible than the alternative of the Phoenicians as the leading traders in this area during the pre-colonial phase, which Graham claims (Graham 1978), since the Phoenicians remain archaeologically

unattested in this region, and there is little else to substantiate a claim for their presence here as traders (see also Tiverios 2004, 295–306).

63. Evidence for production of G 2–3 pottery at Troy (Momsen, Hertel, and Mountjoy 2001, 169–211), combined with the vessels' stylistic features, as well as chemical analysis of some of the Samothracian examples, suggests the Troad as the most probable place of origin for the ware (Karadima et al. 2002, 157–62; Matsas 2004, 227–57), or at least for the clay, and supports the probability that the Troad, if not Troy itself, may have been one of or the main manufacturer of the Samothracian pieces. Nevertheless, alternatives are still possible. The Samothracian kantharoi show close stylistic and morphological resemblance to some of the Lemnian examples, correctly pointed out by the Italian archaeologists working on Lemnos (see Beschi 1996, 23–50; Messineo 2001, 123). That Lemnos was a centre for production of G 2–3 ware alongside Troy and that it was in contact with Samothrace during the Archaic period is certain and indicates a possible relation between particular ceramic groups (including G 2–3 ware) of both islands.

64. For a full list of the ancient sources, see Lewis 1958; and Lehmann and Spittle 1964, 237–41, with three more additions in Burkert 1993, 178–91.

65. Burkert 2002, 37.

66. Although the absence of systematic survey of the ancient town leaves the question open.

67. Ps.-Skymn. 690, 695.

68. See Antonaccio, Chapter Two.

69. Lehmann 1962, 117; Lehmann and Spittle 1964, 132; Dusenbery 1998, 744.

70. For Tenedos, Lesbos, and Lemnos, see Bayne 2000, 141–2, fig. 51, 1–3, 57, 6–7; Utili 1995, pls. 38, 685, 686, 690, who prefers the Homeric name *depas amphikypellon*; Blegen et al. 1958), 254, fig. 291; Polat 2004, 215–23; Arslan and Sevinç 2003, 241–46, figs. 16, 6.4, 6.5, 6.6; Lamb 1932, figs. 1, 12a,b; Acheilara 1987 (1992), part B2, 482, plate 289γ; Beschi 1996, 34, 43; for Thasos, see Love 1964, 204–22, summarizing the data known to date, as well as at Enos (personal observation); for Thrace and Dolno Sahrane, see Getov 1965, fig. 5b. Nikov, in preparation. The chronology of the shape in the Aeolian sites proposed by Bayne ranges between the eighth and early sixth centuries BCE (see Bayne 2000, 141–2, with full reference to the places where it has been found). The revision suggested by Beschi, based on the chronology of the destruction level caused by the Persian attack on Lemnos (see Beschi 1994, 31–7; 1996, 23–50; 2003, 303–49; 2005, 963–1023), changes it to the end of the sixth century BCE, and evidence from Lesbos confirms his opinion. The examples found in the Artemision of Thasos have been dated to between the early seventh and early sixth centuries BCE (Love 1964, 212). Two entirely preserved examples found in Troy have been dated to the first half of the seventh century BCE (Blegen 1958, 254, fig. 291, 36.696, 38.1243), while those from the Assos cemetery have a general chronology in the seventh and sixth centuries BCE (Utili 1995, figs. 38, 685, 686, 690). Three vases found in the Early Iron Age necropolis of Tenedos predate 600/580 BCE (Arslan and Sevinç 2003, 241–6, figs. 16, 6.4, 6.5, 6.6), and the Daskyleion example belongs to the seventh/early sixth century BCE (Polat 2004, 215–23). The vases found in Apollonia Pontica belong to sixth-century BCE contexts (Nikov, unpublished), while the chronology of the one from inland Thrace is disputable (late fifth/early fourth century BCE, according to the excavator (Getov 1965, 205–7, fig. 5b). For a proposed revision

to the end of sixth/first quarter of the fifth century BCE, see Ilieva 2006a, with discussion.

71. For a colonial identity as a kind/function of collective identity, see Malkin 2001a, 3, and mainly Antonaccio 2001, 113–59.

72. As discussed, the date of the earliest material in the South Necropolis, and hence its beginning, has been assumed by the excavator to be no earlier than the second quarter of the sixth century BCE, based upon association with Attic imports. The chronology I have suggested is based upon other material in the South Necropolis (fibulae, ceramics) that predates this time and is not found in association with Attic imports (Ilieva 2006a). In this assessment, the date of certain categories of finds, like fibulae or Lemnian stamnoi, might go back to the end of the seventh/beginning of the sixth century BCE, suggesting that this was the time of the foundation of the *apoikia*.

73. Fredrich 1909, 25; Graham 1982, 117; 2002, 221–60.

74. *FrGH* 548 F5a.

75. *FrGH* 548 F5b.

76. Fr. 690–695.

77. Graham 2002, 233–4, on Hdt. 8, 90.

78. Strabo 10.2.17.

79. Graham 2002, 237.

80. Graham 2002, 238.

81. Beschi 1996, 40–1.

82. Thuc. 4.109.4.

83. Fraser 1960, N 22. The earliest of the lists known to date belong to the mid-third century BCE, although it might be, as Fraser points out, due to 'chance survival and destruction of records, or to the fact that these particular lists were not inscribed on stone before that date' (Fraser 1960, 14).

84. In fact, it was Felix Jacoby who noticed for the first time the existence of *eponymous basileus* on both islands (*FrGH* IIIb, 281, n. 43).

85. Jeffery 1990, 299.

86. Fredrich 1909, 25.

87. Dimitrova and Clinton 2003, 235–9; Matsas 2004, 229, n. 21.

88. The style of the scenes on both known fragments of this ceramic category suggests a Thasian origin for the stamping tool, which is usually an engraved cylinder that was rolled on the clay surface. The use of this type of stamp for relief decoration became a rule from the second quarter of the sixth century BCE in the Cyclades, North Ionia (including both of the most prominent production centres – Chios and Klazomenai) and Thasos (Semantoni-Bournia 1992, 38–9; Semantoni-Bournia 1996, 1011–29; Cevizoğlu 2004, 187). Most likely, the Samothracian vessels, which were probably pithoi, were locally manufactured on the island, although this cannot be confirmed given the absence of chemical analysis of the clay. It should be mentioned that the style of the Thasian relief ware is characterized by a number of East Greek elements that are well paralleled in the architectural terracottas of North Ionia. Thus, it seems that a connection with East Greece has been mediated through Thasian workshops.

89. Representatives of this shape are known from the Hall of Votive Gifts (Lehmann 1962, 120–1, 127), the Altar Court (Lehmann and Spittle 1964, 173–5), and South Necropolis (Dusenbery 1998, 741–2). For a general comment on the shape, see Lehmann and Spittle 1964, 233–7. The vessels are

characterized by an inward lip, flat disc base, and one handle, as the name suggests. This group of vessels, which Love defines as probably of local origin, follows imported East Greek prototypes and differs markedly from the Attic varieties of the shape (see Sparkes and Talcott 1970, 124–7).

90. Matsas 2004, 230. The shape is often defined as an 'Ionian cup,' but as Cook and Dupont note, 'these so-called Ionian cups were probably made widely in southern workshops, not only of Ionia; in Aeolis too' (Cook and Dupont 1998, 129). From this viewpoint, they could not act as indicators of an exclusive connection with Ionia, since they could equally be Aeolian products.

91. Fredrich 1909, 23, fig. 1. This piece together with terracottas and miniature marble statuettes were gathered in the locality of Mandal' Panaya by the Samothracian doctor and scholar N. Fardis prior to 1892 (Fredrich 1909, 23–8; Matsas et al. 1993, 647–55). His collection was first described by Kern (1893, 381), and later some of the finds came to the Museum of Art in Bonn and illustrations were made of them that were published by Fredrich (1909, 23–8), but the exact number and the nature of all the artefacts in the collection is uncertain.

92. Matsas et al. 1993, 650.

93. S245-1, XS-535, XS-536, XS-537, XS-538, XS-539; Dusenbery 1998, 1138–43, 410, 744.

94. Tsakos 1968, 388–90, pl. 392–6; Tsakos 1970, 417–18, pl. 351–2; Gercke and Löwe 1996, 120–9; Tsakos 2001, 451–66.

95. For general discussion of the Archaic burial rites and grave types in East Greece, see Philipp 1981. On the island of Chios were found stone sarcophagi and clay examples, entirely preserved, and a mass of undecorated fragments of Klazomenian type and also with relief decoration. In the Rizari cemetery of Chios town, dated to the late seventh century BCE, next to four lidded sarcophagi were found eight cremation burials in pithoi and amphorae set around a pyre (Hunt 1945, 31–2; Lemos 1997 with reference to the archaeological exploration on the island). Although the evidence from Archaic Lesbos is quite incomplete, it seems that similar types of burials were employed: sarcophagi, inhumations in clay urns in coexistence occasionally with cremations (Spencer 1995, 294, with bibliographic reference). At Klazomenai, cremations coexisted with inhumations in sarcophagi, amphorae, pithoi, in cist graves (although rare), and simple pits during the seventh and sixth centuries BCE (Hürmüzlü 2004, 77–95). Similarly, in the cemetery of Pitane during the seventh and sixth centuries, cremations were in coexistence with inhumations in sarcophagi (stone or clay), pithoi, amphorae, and other vessel types, as well as in simple pits (Iren 2003, 3, with bibliographic reference). The necropolis of Gryneion reveals a similar picture, with cremations and inhumations in sarcophagi and different types of urns (Hürmüzlü 2004 with bibliographic reference; Iren 2003 with bibliographic reference). Not essentially different is the situation revealed in the Archaic necropolis of Assos, where cremations and pyre places were found together with inhumations in cist graves, amphorae, pithoi, and sarcophagi (Utili 1995, 110–41). For the diversity of burial practices and grave types in Abdera, see Koukouli-Chrisanthaki 1994; Skarlatidou 2001. The situation in the Chian Maroneia and in the Aeolian Enos, the two most influential Greek poleis east of Nestos valley, is not clear because of the lack of corresponding archaeological finds dating to the Archaic period. While the cemetery of the Samothracian *apoikia* Zone

has been excavated, it remains still unpublished, but the preliminary reports indicate the existence of different grave types, including burials in pithoi and amphorae, stone and clay sarcophagi, cist graves, and simple pits cut in the bedrock, together with cremations (Tsatsopoulou 1990). It is interesting that even in this case, the burial pattern in the *apoikia* differentiates from that of the mother city, Samothrace, being closer to the East Greek examples already given.

96. Blegen et al. 1964, 179, pl. 81.
97. For Sindos, see Vokotopoulou 1985, 51, 111, 137, fig. 222; for Trebenischte, see Filow 1927, 78, fig. 93; for western Balkans, see Mano-Zisi and Popović 1971; for Sofronievo, see Nikolov 1965, 167–8; for Nefela, see Torbov 1993, 37, n. 22; for Assos, see Utili 1995, 114, pl. 3, C VIIIFst, no. 3, no. 58, no. 17, no. 26; pl. 4, no. 37, pl. 5, no. 44, no. 2; pl. 6, no. 13, pl. 8, no. 2, pl. 3, C VIIIFst, pl. 4, no. 37.
98. The situation in the South Necropolis is strongly reminiscent of the Late Geometric and Archaic necropolis on Tenedos (Arslan and Sevinç 2003, 223–49). A considerable number of fibulae have come to light from these graves that are analogous to most of the Samothracian examples. The same types are also well known from the necropolis of Thymbra (see Caner 1982, 20–1, with comments on the problems regarding the identification of the site, which Thiersch describes as Thymbra when registering the finds from there). It is worth mentioning, too, the similarity to the grave equipment from the Archaic cemetery at the village of Micro Doukato (Triantaphyllos 1984, 179–207), and with fibulae found in an Early Iron Age grave from the cemetery of the Samothracian *apoikia* Zone (Vavritsas 1967, 89–95, pl. 70β; Daux 1967, 733, fig. 9).
99. Dusenbery 1998, 1063–5, 1143–4.
100. Compare with Dusenbery 1998, 701–47.
101. Some of the Samothracian amphorae without decoration remind one of Milesian Fikellura shapes, for instance in relation to the broad, almost spherical body and flattish shoulders, although they differ in their double lip.
102. The amphorae of the Knipovitch class and the imitations of Attic horsehead types are exceptions as their features clearly identify them and differentiate them from the other amphorae under discussion, whose eclecticism makes their place of origin uncertain. Among these last is, for example, a group of amphorae called black figure lion amphorae, which consists of five vessels with different shapes united by a common decorative pattern: panels enclosing standing, roaring lions, some with their heads turned back (Dusenbery 1998, 712–15), and whose style recalls that of the Gorgon Painter (see Moore, Philippides, and von Bothmer 1986, 75–7). In the Dusenbery's group of Decorated Amphorae, one could recognize vases decorated with a scale pattern on the body and palmette finials on the neck, a style that strongly recalls that of the Late Archaic Klazomenian black figure vases (compare Özer 2004, 207), but the shapes to which this decoration was applied are diverse.
103. For the Klazomenian black figure pottery, see Cook and Dupont 1998, 95–107, and most recently Özer 2004, 199–217.
104. Tiverios 1989, 617–18; Coulié 2002, 208–10.
105. This statement might be illustrated if one compares the ceramics from the West Necropolis of Samos (Gercke and Löwe 1996, 24–89) and these from the Heraion (Walter 1968; Walter-Karydi 1973) with the far more modest and less diverse Samothracian examples.

106. Undoubtedly, the leading role in the colonization of the region belongs to the Aeolian settlers, who established *apoikiai* all over the Thracian Chersonesos, moving north-east to the Hebros delta, where they founded one of the strongest poleis of Thrace: Enos. In contrast, Ionian activity in the area is very restricted, being limited to the Milesian Limnai and Kardia, which was a joint enterprise of Miletus and Klazomenai. In the mid-sixth century, Miltiades the Elder settled Athenians in Kardia and established new settlements on the Thracian Chersonesos (Roebuck 1959, 109–11; Boardman 1999 [1964]; Graham 1982, 119–21; Isaac 1986, 148, 159–95; Loukopoulou 1989; Tsvetkova 2000, 431–62; Tsvetkova 2000/2001, 23–34). We should not forget the influence of Abdera, and the recently suggested possibility that an additional wave of Klazomenians settled there together with Teans after the invasion of 546 BCE (Ersoy 2004).

107. Kilian-Dirlmeier 1985.

108. Even in the cases of 'particularistic polis migrations' (Malkin 2001, 8), such as that of the Phoceans and Teians in the face of the Persian threat, cults known from home were transferred and deities worshipped in the new places. For examples, see Malkin 2001a.

109. Kyrieleis 1993, 125–53.

110. Tsatsopoulou 1989, 583; 2001, 20.

111. Contra Malkin 1987, who claims that the decision of the apoikists as to where to place their sacred areas did not depend on indications of local native cults. Although the statement for the non-Greek origin of the Samothracian cult might be controversial, especially with regard to the fact that all the philological sources are products of a Greek cultural environment, thus giving a picture transformed through Greek 'eyes,' it is indeed the mythological tradition that makes Samothrace belong to the non-Greek world (Burkert 1993). The bothros where G 2–3 pottery was found together with animal bones indicates, also, cult activity in this same place prior to the foundation of the *apoikia*, which implies that when the Greek settlers arrived they found an already functional place of worship where the Sanctuary later developed as an architectural complex.

112. Lewis 1958, nos. 40, 41; Graham 2002, 232.

113. Fr. 679–680, 690–695, see Lewis 1958, N 58.

114. Strabo 10.2.17, see Lewis 1958, N 42.

115. Because of the fact that most of our literary sources were written much later than the time they speak of, their limitations as a tool and the interpretative difficulties with them are generally recognized.

116. Graham 2002, 255, on Hdt. 3.57–59

117. The emergence, development, and spread of the polis is directly associated with the Greek colonization of the Archaic and Classical periods, which originates in the polis as a form of social organization and 'should be seen … as … its very formation and development' (Malkin 1987, 1).

118. The only source on this matter is Strabo (10.2.17; Lewis 1958, 42), who mentions Tembrion, who was indeed the founder of the Ionian Samos, thus creating Strabo's confusion. See Graham 2002, 236.

THE BIG AND BEAUTIFUL WOMEN OF ASIA: ETHNIC CONCEPTIONS OF IDEAL BEAUTY IN ACHAEMENID-PERIOD SEALS AND GEMSTONES

Lloyd Llewellyn-Jones

This chapter analyses images of women found on what are commonly termed 'Graeco-Persian' seals – a series of distinctive scaraboid seals and gemstones that date to the period of the early- to mid-fifth century BCE and the fourth century BCE. They are generally thought to have their origins in workshops in Achaemenid Anatolia, that is to say in the satrapies of Asia Minor.[1] In attempting to locate something as specific as the iconography of body image in the Graeco-Persian glyptics, we must also engage with much larger issues, in particular with the impact of ethnocultural consciousness expressed in the material culture of Achaemenid Asia Minor. I draw on a model of hybridity that is very well articulated by Carla Antonaccio in Chapter Two, a model that allows the more nuanced exploration of the ways in which these seals express an Anatolian vision of female beauty mediated between both 'Greek' and 'Persian' traditions and that adds up to something rather more than the sum of their parts, that is to say rather more than simply 'Graeco-Persian.' This model of hybridity is attractive in allowing us to move beyond the essentialist and traditional binary notions of Greece and Persia as mutually antithetical entities, notions that have severely restricted attempts to discuss cultural interaction in western Asia Minor.[2] Antonaccio acknowledges that the growing interest in the Persians over the last decades represents the 'vanguard' of scholarly

interest into 'The Other,' one of the earliest recognitions of diversity in the ancient world.[3] I wish to offer a double measure of classic 'Otherness,' however, by concentrating not only on Persians but specifically on Persian *women*.

The picture is not a simple one: the sociocultural and ethnic mix of Anatolia during the Achaemenid period was excessively complex since the area was a curious, yet rich, hodgepodge of clashing, merging, and stand-alone cultures. The material evidence (ranging from public architecture, tombs and tomb art, to jewellery and seals) reveals that for a period of more than two centuries mainland Greek culture rubbed shoulders with the lavish court cultures of central Iran. At the same time, indigenous elite cultures of the many and varied regional centres of Anatolia were amalgamated with the Graeco-Persian mix. Collectively, they created a rich new culture of art and architecture specific to, but not shared by all, the urban elites of Asia Minor.[4]

In this respect the term routinely employed in scholarship to locate the place and period – Graeco-Persian – is limiting and restraining; simply reversing the idiom to Perso-Greek gets us nowhere.[5] The notion that the indigenous cultures of Achaemenid-controlled Asia Minor can be explained away as part of the titanic East–West, Greek–Persian dichotomy is unreasonable. Following Jonathan Hall's model, however, ethnicity is expressed through cultural indicia such as language, religious belief and practice, fashion, and so forth.[6] Moreover, as Hall emphasizes, material culture is an obvious extension of the very same cultural indicia. In that case, we can observe that Achaemenid Asia Minor had its own peculiar cultural identities actively shaped through its rich artistic and creative tradition. Yet the language of (or at the least of a certain kind of) scholarship cannot accommodate this, and Graeco-Persian remains the common tag for describing the material traces of a hybrid society rich in its (marginalized) local cultures.

The glyptics I consider here reflect on the pleasures of life in the courts of Asia Minor – either satrapal courts or the courts of the indigenous rulers of the area. The subject matter of the gems has often enticed scholars to interpret them in a predictable way (as a visual aspect of the East–West dichotomy, evidence for the 'otherness' of Persian life), and routinely to gloss them with readings stemming from Orientalist attitudes towards Eastern artefacts, arising from colonialist discourse. In other words, we

read the scenes as a picturesque exoticism in which the East is not so much a place as a topos of references and characteristics, as famously propounded by Edward Said.[7] John Boardman suggests, for instance, that the seal stone images have 'more than a hint of the Raj' about them, showing Persians 'somewhat corrupted by the Hellenized natives.'[8] He also suggests that the scenes display the 'civilizing' of the East with the introduction of Greek cultural tastes and mores.[9] Whether we should view the Persian occupation of Asia Minor through the focus of an imperial Raj *mentalité* is debatable, but to interpret the glyptics merely as a bastardization of the purely Greek and the wholesomely Persian is certainly wrong.

Carla Antonaccio warns of the dangers of casually defining material cultures as simply Greek or even non-Greek while ignoring the problems of identifying ethnicity or even more specific localizations. Certainly the seal stones of Anatolia are usually classified simply as Persian ('the court style'), Greek ('the Greek style'), or Graeco-Persian ('the mixed style'). But is this appellation of 'styles' appropriate for the study of the Achaemenid-period gems and seal stones?[10]

Margaret Miller's sophisticated analysis of Athenian attitudes towards imported *Perserie* – dress and textiles, drinking cups, fans, and parasols – has sharpened and advanced our understanding of the nuances of applying cultural tags to material artefacts. She has demonstrated how the Attic Greeks assimilated Persian luxury goods into their own cultural vocabulary to such an extent that within an Athenian context the Persian-crafted (or inspired) goods can no longer be thought of as wholly Persian nor specifically Athenian; they are something unique to time and place. We might call them Athenian versions of Persian originals, but because of the context in which they are used (usually with a shift in gender usage) the items cannot necessarily be identified as Persian at all.[11] Similarly, I suggest the seal images discussed here are not Greek, nor Iranian, nor Graeco-Persian. Instead they are distinctly localized: they are 'Persian-period Anatolian,' and this is how I shall refer to them here.

I want to go further than solely identifying the various ways in which ethnic identity and material culture converge. I want to use the archaeological finds, in this case the seals, to attempt to identify something completely intangible: cultural conceptions of localized female beauty. In a way I am dealing here with what might be termed the archaeology

of taste, specifically expressed through differing localized conceptions of aesthetics focused on the female body image. In my case study, it is through the female image that 'localness' is expressed, just as in the grave reliefs of Roman-era Noricum examined by Hales in Chapter Nine, in which women appear to wear 'local' dress. On the seal stones, male iconography is conspicuously conformist: men are either wholly Greek or wholly Persian in appearance. Men are represented as bearded and bare-chested – wearing *himatia* or belted *chitōn*s – if they are Greek; if they are Persian they wear longsleeved tunics (*kandys*) and trousers (*anaxarides*) with a turban (*kidaris*) headdress. Localized ambiguities of identity are thus to be found in the female image – and especially in relation to dress, hairstyles, and body shape. Whether this is a result of the modern viewer expecting to see 'otherness' in the female image is open to debate. It could be that concepts of the female were more fluid in antiquity and that the multiplicity of female 'types' in ancient art reflects the multivalent readings of female beauty across ancient cultures.

In ancient cultures an individual's beauty was generally thought of as innate – one was either beautiful or not; one was born with beauty or without it. Beauty could not (by and large) be created.[12] But is beauty just in the eye of the beholder? It is recognized that cultural differences affect what defines beauty and what stimulates enjoyment in a person who looks at or contemplates a 'beautiful' individual.[13] The evolution of allure has seen to it that whenever we attempt to analyse beauty in a global context it becomes clear that taste and diverse attitudes towards beauty make the task nigh-on impossible. Global attitudes towards height, skin colour, and weight are in a constant state of flux.

But does it mean that when we say something is beautiful, or when we record an image of beauty in art or literature we are recommending to others that they should take delight in it too? Beauty, of course, may be intersubjective. However, as Umberto Eco notes, by codifying beauty in art we also make it objective.[14] Certainly Kant argued that if we think something is beautiful, we want everyone to agree with us. If that is the case then what we find beautiful must be a reflection of a mix (to a greater or lesser extent) of individuality and group socioethnic consciousness.[15] By adopting this standpoint as our theoretical framework, we might learn much about a society, including a past society, from what it finds beautiful. Taste becomes a strong symptom of cultural self-awareness.

In this chapter I will attempt to explore the all-encompassing questions of ancient cultural interaction and hybridity through a localized question of taste and perceptions of female beauty. I will explore how Anatolian seals and gemstones construct a vision of ethnic identity as culturally specific as any message advanced by the major architectural structures of Achaemenid Asia Minor. However, before I can examine the minutiae of the glyptic evidence, it is important to contextualize the bigger picture of cultural interaction within Asia Minor in the Late Archaic period and throughout the Classical era.

Achaemenid Asia Minor

Prior to Achaemenid sovereignty, several regions of Asia Minor were already under the strong cultural influences of Greece. The Carians and, later, the Lycians and Phrygians had adopted an alphabetic script based on Greek letter types. The Lydians adopted many elements of Greek culture, and scores of Lydians spoke Greek fluently.[16] Likewise, many Carians were already bilingual by the late sixth century BCE, a fact attested by the literature of Scylax and Pigres of Halicarnassus. According to Diodorus, the populations of the cities of Asia Minor were bilingual, speaking Greek and one of the many local languages.[17] Personal names are a clear indicator of the cultural hybridity experienced in Asia Minor at this time and testify to a high degree of mixed marriage: while Herodotus may have borne a Greek name, the names of his father – Lyxes – and of his uncle – Panyasis – were purely Carian.

The ethnic mix of Asia Minor increased with the steady encroachment of Persian power from the reign of Cyrus II onwards. Plutarch later reflected that the penetration of Persian customs into Ephesus threatened the city with 'complete Barbarization.'[18] Large Iranian colonies sprang up in Cappadocia, where relief decoration in stone shows a heavy borrowing of Persian styles in art and architecture, and in Lycia where local elites quickly began to adopt Persian names. In the Classical period it is not unusual to find Anatolian elites bearing such Persian names as Mithrapata, Artembares, and Mithridates. One remarkable Lydian tombstone records that the grave belonged to Hlasitini (a Lycian name), the son of Megabates (a Persian name filtered through Greek transliteration).[19] In fact, tombs display some of the best preserved

evidence of this ethnic fusion, especially visible in the painted figures of the Graeco-Lydian burial complexes of Aktepe, Harta, and Karaburun. Here, *realia* such as dress, cosmetics, hairstyles, equipment, and technology show the almost seamless blurring of Greek, Persian, and local cultural styles.[20]

Under Achaemenid rule Asia Minor was divided into a series of satrapies, each with its administrative capital and all with somewhat indistinct borders.[21] With its coastline bordering the Aegean Sea, Anatolia was of primary importance to the Great King seated on his throne in the Persian heartlands. This fact is attested by the appointment of members of the royal family as satraps throughout Asia Minor. The newly founded city of Daskyleion (modern Ergili near Bandirma in north-western Anatolia), for instance, formed the seat of government in Hellespontine Phrygia, and was successively governed by brothers, uncles, cousins, or sons of the monarch. Sardis, the famed capital of Achaemenid Lydia, was always administered by a satrap drawn directly from the royal family. In turn, the satrapal courts of Asia Minor modelled themselves on the royal court at the centre of the empire, with many of the rituals of royalty enacted around the figure of the satrap himself, who represented the Great King in absentia. While the military responsibilities of the satraps were of foremost concern, the cultural importance of satrapal courts should not be underestimated, especially regarding the ethnic mix encountered in them, since the domains of the satraps could contain Persians, local elites, and foreigners drawn from across the empire.[22]

How much of an impact did the Persian presence have on local ethnic culture, or at least on local *elite* ethnic culture? It is difficult to tell. It is worth noting Sancisi-Weerdenberg's warning that our search for the meaning of empire has been 'mostly confined to phenomena that betray an Iranian influence, to artefacts of a typical or hybrid Iranian provenance, to changes in the titulary and in the onomastica derived from the Iranian vocabulary. Iranian "traces" are, however, not the only kind of evidence which can lead us to detect the impact of the Persian empire.'[23]

There are several important issues to keep in mind here. Indigenous Persians from the Iranian heartland were of course spread throughout the empire, where they were occupied in all sorts of roles ranging from the highest governmental positions to the lowliest military posts. However, the demographic spread of Persians was not consistent throughout the empire at any given time, so that concentrations

of ethnic Persians varied from location to location. The Persian aristocracy (and royalty in particular) grew in number throughout the Achaemenid period and this must have had a direct implication on the social order (especially so on social stratification). Nevertheless, it must be conceded that, in much of the empire, elite Persians cannot have made up a very high percentage of the population. The satraps and their courts, the 'ethno-class dominante,' as Sancisi-Weerdenberg puts it, with their ties of personal familial loyalty to the Great King, actually made up only one aspect of a wider picture of administration. Native-born individuals acted as governors, administrators, and officers under the observation of Persian nobles.[24] Indigenous local monarchs, princelings, and other dignitaries were often allowed to maintain positions of authority under the jurisdiction of satrapal courts. In effect, therefore, there could be two court systems simultaneously operating in one satrapy: one a facsimile of the court of the Great King; the other a localized court system. This latter court system may have followed local time-honoured traditions with, perhaps, an increasing blend of Persianization becoming apparent over successive generations of Persian subjugation.

Many areas of the Persian Empire saw the growth of what can be termed a 'polyethnic elite.' Certainly, in regard to Asia Minor, the ethnic blend within court cultures is a notable feature of the Achaemenid period and lasted well into the Hellenistic period too. This is an important point to observe because, as Dusinberre argues, it 'demonstrates the degree to which local cultures adopted Iranian customs and blended them with local habits, rather than merely taking on the appearance of foreign traits to curry favour with barbarian despots.'[25]

Seals and Gemstones

Of the material culture available to us from Achaemenid Anatolia, it is the corpus of seals and seal images that provides the richest evidence for an investigation into ethnocultural identity. Clusters of *bullae*, the lumps of clay moulded around cord into which the seals were pressed, have been excavated at only a few locations throughout the empire (and most are piecemeal finds at best). At Daskyleion, a rich collection of seals, gems, and sealings has been found (Kaptan's inventory includes 185 seals on 406 *bullae*), and has considerably advanced our understanding

of the complexity of the culture and society of Achaemenid Asia Minor.[26] However, the pieces in this find do not necessarily provide us with an answer to how the polyethnic elites constructed themselves culturally.[27]

Nevertheless, it is commonly recognized that seals and seal imagery were important features of Persian cultural and political expression; as such Herodotus correctly ascribed seals a common usage throughout the Persian Empire.[28] Seals were small and were routinely worn as items of jewellery, either as rings or as necklaces. The subjects carved on them in intaglio were only readily intelligible in impression on clay or wax. The seals, or at least their impressions, conveyed authority and could sanction action and expenditure since they belonged to individuals (but also to offices) who can be identified as royalty, satraps, civil servants, and merchants. While the seal itself remained with the owner, the objects sealed by merchants, officers of state, or royalty could and did travel far and wide. The seal impressions discovered at Persepolis and various sites across the length and breadth of the Achaemenid Empire eloquently demonstrate how far they actually did travel. It can be argued, therefore, that the seals come close to providing us with the universal iconographic medium that we need for a study of common imagery within the vast geographic layout of the Persian Empire. The seal imagery is, consequently, of tremendous importance to the historian of the Achaemenid period. The iconography often reveals the widespread cultural contacts made within the empire through style and decoration. This is especially true in regard to Egypt and the eastern Mediterranean.

It is beyond my scope here to attempt to trace the sweeping chronological, geographical, or stylistic changes within the iconographic make-up of the glyptics. Instead I focus on the particulars of iconography within the gems' pictorial schema. Boardman has meticulously examined the manufacture and use of the Anatolian seals and has suggested several important hypotheses for our understanding of the iconographic make-up of the gems. Their source of origin, for example, has been suggested partly by their distribution, which occurs mainly within Anatolia itself, though they also travelled far west to Italy, north to the Black Sea, and east into Central Asia and India. The seals are predominantly Greek-style finger rings carved with images that, in stylistic inspiration, may be singularly Greek, homogeneously Iranian, or an amalgamated localized Anatolian style. They are crafted for the most

part in blue chalcedony, the most popular material for seal carving in the Greek mainland studios too.[29]

Furthermore, Boardman suggests that while it is not viable to say whether any of the seals were *specifically* cut by Greek artists, the style and, in particular, the choice of subject matter can be said to have been inspired by both the work of Greek craftsmen and the themes of Greek art.[30] It is obvious that the seals belong to a heavily Hellenized environment. More specifically, they were probably created for and utilized by the Persian and Persianizing courts of Asia Minor or even by the dignitaries of the semi-independent kingdoms of Anatolia, and perhaps even by the luminaries of the Syro-Phoenician coastal city-states.[31]

An examination of the iconographic layout of individual seals reveals important factors that contribute to Boardman's thesis: in battle scenes between Persians and Greeks, for example, the Greeks are always shown as the vanquished foe. In one example a Persian cavalryman lances a naked Greek.[32] In another the Great King himself kills a naked hoplite, representing, perhaps, the king's rule over the entire Greek people (or at least his anticipated hold over the western Greeks).[33] Such precise images make the ideological, cultural, and political sphere of the gems obvious to understand. This is certainly true if we compare the seals to more familiar, widely dispersed Greek-made artefacts, such as Attic vases, which, in particular, highlight Greek military success over Persians and sometimes emphasize the point by equating martial prowess with sexual aggression and physical domination of the weak and effeminized *barbaroi*.[34]

While the ideology of Persian political, military, and cultural superiority predominates in the theme of the seals, nevertheless in terms of artistic style and flavour there is a heavy Greek influence. Foreshortened human and animal figures, some three-quarter faces, some frontal faces, and naturalistic renditions of poses, anatomy, and dress all point to a Hellenic cultural sphere.[35] It has been noted that some of the Greek subjects show a highly developed familiarity with Greek myth, suggesting a direct Greek intervention. One important seal impression, possibly found in India, shows the naked Greek demi-god and hero Herakles resting his right foot on the carcass of the Nemean lion. The nymph Nemea offers him sustenance from a jar as Eros flies overhead to crown the nymph with a garland (see Figure 7.1). This curious seal depicts an

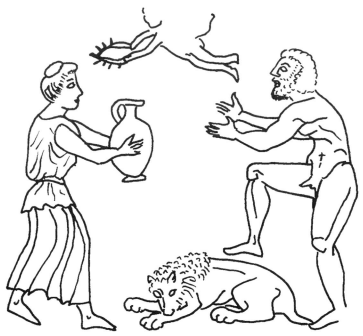

7.1. Herakles and the nymph Nemea, detail from blue chalcedony scaraboid (Drawing: L. Llewellyn-Jones, London, British Museum, after Boardman 2001, pl. 856)

uncommon subject in the wide genre of myths surrounding the great Greek hero, and for Boardman the Herakles glyptic is emphatically 'an example of a gem offering an unfamiliar variant on a common story, and the more interesting for its being a Greek work in the Persian Empire.'[36] But what is the origin of the seal? It might be considered a direct Greek import from a mainland workshop. Perhaps it is the work of a Greek craftsman resident in Anatolia, or the work of a Persian craftsman resident in one of the satrapal cities or towns. It may be the product of a local Anatolian artist picking up on the Greek styles commonly seen in some of the monumental and minor arts of Achaemenid Asia Minor as well as in objects imported from mainland Greece.[37]

If the distinctly laissez-faire subject matter found on many seals is inspired by examples from Greek artworks, this will have an impact on our perceptions of the decidedly Hellenized behaviour of the patrons who actually commissioned or acquired the seals. Without doubt, the scenes on the gems – of Persian women with their menfolk, with their children, and with their dogs, or even of Persians relaxing, drinking, and dancing – are very much in the spirit of Classical

Greek art. But they are decidedly not Persian; in Achaemenid art such plebeian subjects are rare. The art of central Iran tends to concentrate on court scenes of audiences and tribute bearers, or of heroic images of monarchs fighting ferocious beasts and reconfirming Achaemenid world order. Even the small glyptics crafted in the 'court style' (and no doubt used by the Great King and his relatives) echo the theme of the heroic king. There is no room in the court arts of Iran for the minutiae of daily life scenes.[38] Such images do not serve the purpose of reflecting dynastic glory. The Anatolian seal images are far removed from the artistic ideologies promoted by the official centralized art of the Achaemenids, as Boardman makes clear:

> The Greek artists invented a number of motifs which must have appeared startling to Persians in the provincial western courts, who had been used to the more formal treatment of divine or royal motifs on their seals. The innovations reflect not only the utterly different atmosphere of Greek art, with its realism and observation of natural forms and action, but also to some degree the real influence of the Greeks.... Dogs scratching themselves or animals coupling must have been as common sights in Persia as in Greece but it took Greeks to find subjects like this suitable for portrayal. No doubt in Persepolis too Persians leaned on their spears while their women played with their children and their dogs, but these were not the motifs for an easterner's art.[39]

We might ask some pertinent questions of this undoubtedly remarkable material: do we have in the seals a skewed Greek view of Persian culture? Do the glyptics provide an accurate observation of Persian habits? Or is it more a matter of elite Persians reviewing themselves through Greek iconographic conventions? And if so, then why? Are elite Persians regarding Greek artistic mores as superior to their own iconographic conventions? Or are they simply 'going native' and enjoying the artistic (and other) freedoms of being so far removed from the dogmatic centre of rule? Is this simply a matter of elite cultural consumption, elites surrendering themselves to the lure of the exotic West, or are we witnessing here the hybridity discussed by Antonaccio, a genuine merging of iconographical and stylistic traditions reflecting and invigorating the dynamics of social and political interaction? Or perhaps the theories of globalization expounded by Hingley (Chapter

Three) and Hodos (Chapter One), in which increasingly 'global' styles
and iconographies paradoxically lead to fresh avenues for expressions
of 'localness,' might be more appropriate. How far is ethnic identity,
in terms of localized indigenous tradition and culture, represented
within the seals' designs? Let me try to pin down some hypotheses.

Comparanda 1: Attic Iconography

Given the rich cultural and iconographic crossovers encountered in the
gems, I believe that, to decode the glyptic iconongraphy, it is viable to use
a methodological framework based on the type of scholarship formu-
lated (and continually refined) over the past twenty years for the reading
of the iconography of Greek minor arts – in particular Attic vase painting.
Recent scholarly approaches to the study of the representation of Athenian
women, for example, are certainly of use in unlocking the gender-loaded
codes of the seals' imagery. Both genres systematically share artistic and
cultural devices and schemes.[40]

Much attention, for example, has been given to the idea of a Greek pot
having several consecutive narrative meanings. The physical handling
and revolving of a vase or cup in a pot-user's hands can trigger a narrative
sequence encoded on or in the object – a narrative that is sometimes delib-
erately and clearly rendered by an artist but, more often than not, is left
ambiguous, and open to a viewer's individual interpretation.[41] Interestingly,
a sense of narrative can be read into certain seals from Anatolia too. This
is certainly evident in those multi-surfaced gems classified as 'pyramidal'
or 'pendant' seals. Like a Greek vase, these seals allow the viewer to rotate
the object and to construct a story. On one example (a four-sided carne-
lian pendant seal), a seated man in Persian dress (a satrap?) is approached
by an armed guard, then by a woman holding a rhyton (drinking horn)
and a garland, and finally by a shorter (and possibly younger) girl hold-
ing a rhyton and a phiale. Perhaps representing members of the satrap's
family or court (all wear Persian costume), these standing figures face and
process towards the seated man, requiring us to rotate and view the seal in
a certain order.[42] Of course, although most seals are flat scaraboids with
all conception of narrative necessarily contained on one side of the inta-
glio, nonetheless, the iconographic composition is often rich, and scenes
can be densely packed with incident and detail to create a narrative.

So, at the most basic level of cultural interdependence, we can say that Attic pottery and Anatolian seals invite either narrative interpretation or, at least, visual interaction. Can we go further? A short case study of the representation of one type of glyptic genre scene might help.

Comparanda 2: Representing Women

Women feature prominently on the Anatolian-made seals and gemstones, certainly when contrasted with the paucity of images we have of women from the Iranian heartland itself.[43] Some glyptic scenes (narrative or otherwise) share a common cultural theme in terms of iconographic representation: the interaction of human figures or of human and animal figures. Collectively, these suggest a fluid interdependence of subject matter and inspiration between mainland Greece and the Anatolian satrapies.

Images of lone women in Persian dress form a high percentage (as much as 60 per cent) of the seals' iconographic make-up, suggesting perhaps that there was a ready market for female jewellery in the form of seals, or at least that the female figure was a popular one with clients – either male or female (see Figure 7.2a).[44] Females seated on a variety of low stools or chairs are common; some wear crowns, diadems, or tiaras, perhaps indicating noble status.[45] Occasionally a seated woman wears a long, full, pleated veil and interacts with figures around her. One interesting gem is carved on both sides with images clearly echoing Athenian genre scenes (see Figure 7.3). The front of the gem depicts a veiled woman playing the harp – an iconographic trope of both the Near East and of Greece – while in the company of her pet Maltese dog. Incidentally, the Maltese breed is the house-pet par excellence of Athenian women, and certainly the most popular type of dog depicted in the so-called 'gynaikaion scenes' on Attic vases.[46] The back of the gem represents the same woman in the company of a diminutive male figure (a child or slave) while holding a bird on her hand. From the scale it looks like a rook or even a hawk, but this is unlikely; the artist has simply scaled-up a pet songbird, which is utilized in the same way as is found in the Greek images (see Figure 7.4).[47] What we have in these glyptic scenes is, therefore, a highly idealized and overtly romanticized take on life within the (imaginary?) 'women's quarters,' just as in Attic gemstones and vase painting.[48]

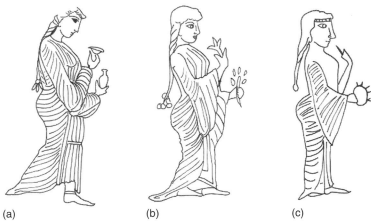

(a) (b) (c)

7.2. Women in eastern dress. (a) Woman in Persian dress, detail from bluish chalcedony scaraboid; (b) Woman in Achaemenid court robe with lotus and flowers, detail from cornelian scaraboid; (c) Woman in Persian dress with floral wreath, detail from chalcedony hemi-spheroid (Drawings: L. Llewellyn-Jones: a. New York, Metropolitan Museum of Art, after Richter 1956, pl. 22. 133; b. and c. London, British Museum, after Boardman 2001, pl. 879 and pl. 903)

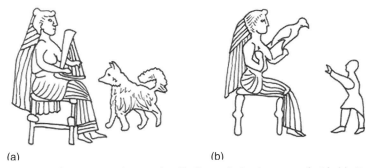

(a) (b)

7.3. Seated woman and pets, details from chalcedony scaraboid. (a) Front: woman with harp and Maltese dog; (b) Reverse: woman with bird and child (or slave) (Drawing: L. Llewellyn-Jones, Boston, Museum of Fine Arts, after Boardman 2001, pl. 964)

There are several scenes on the gemstones that could be classified as 'domestic' – that is to say scenes showing women occupied in traditional feminine skills, such as spinning or weaving, or else beautifying themselves, caring for infants, or even reading or playing musical instruments.[49] To find a Persian context for such images is difficult, and these 'domestic' scenes, can be classified as a *wholly* Greek genre. As such, the scenes are rendered in a very Greek manner, with – most typically – a man in the company of a single woman. Both subjects, however, are dressed in Persian costume. The woman, for her part, is often

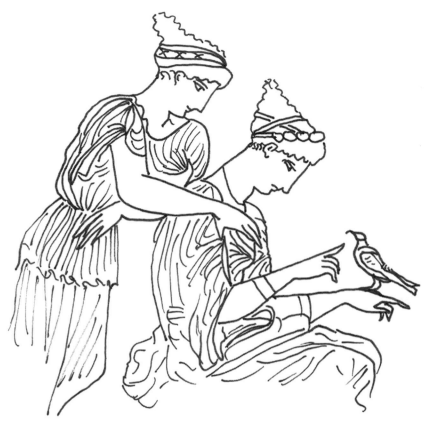

7.4. Women with a songbird, detail from Attic epinetron by the Eretria Painter
(Drawing: L. Llewellyn-Jones, Athens, National Museum)

the active partner in the scene, ministering to the needs of her male
partner and providing him with comfort by offering him an unguent
bottle or a phiale of wine (see Figure 7.5a). In one scene a man stands at
ease with his arm around the waist of a woman 'in a pose of un-oriental
familiarity,'[50] which surpasses in its depiction of relaxed male-female
intimacy almost anything found in a purely Attic context, too. Taken
as a whole, the iconography of the seals strongly suggests that marital
harmony is being conscientiously emphasized. This idea is given impe-
tus by other iconographic scenes of mother-child interactions, which
also come to the fore in ways that clearly echo Greek 'family' genre
scenes.[51]

The most interesting of the 'domestic' scenes shows a woman offer-
ing a cup to an armed man who stands opposite her, a spear in his
hand (see Figure 7.5b). Such an image can readily be compared to the

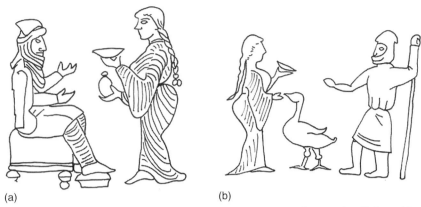

(a) (b)

7.5. Domestic scenes. (a) Woman administering to a seated man, detail from blue chalcedony scaraboid; (b) Departure of the warrior – Graeco-Persian style, detail from chalcedony scaraboid (Drawing: L. Llewellyn-Jones, Oxford, Ashmolean Museum, after Boardman 2001, pl. 880; Baltimore, Walters Art Gallery, after Boardman 2001, pl. 892)

so-called Departure of the Warrior scenes commonly found on Attic black figure and red figure pots from the late Archaic period through to the late fifth century BCE.[52] In the Greek compositions the scene typically shows a heroic young warrior (sometimes a mythological figure) armed and ready to leave the domestic sphere for military action. He is sent off to war by close members of his family in different line-ups according to the artist's composition of the scene. The soldier's mother and father are frequently represented, but it is more usual for the artist to depict the farewell between a husband and wife. This detail was no doubt meant to call to mind such classic moments of Greek epic poetry as Hector of Troy's farewell to his wife Andromache for the last time before he meets his death on the battlefield.[53]

Certainly the Anatolian gem portrays the same moment of leave taking. Here, however, the Persian warrior, leaning on his spear, is fully clothed in a Median riding habit, his mouth swathed in the cloth of his *kidaris*. In the Greek Departure of the Warrior scenes the wife often extends a ritual phiale towards her spouse. The artist of this seal envisages the Persian wife performing the same ceremonial act in honour of her husband. Greek scenes often include detailed symbolic devices within the narrative such as a large water bird – a goose, swan, or heron – standing at the middle of the composition in between the married couple. Once more, in the Anatolian glyptic we find the Greek motif repeated.

In the Attic-made scenes, the presence of the water bird, not always to scale, transcends any pretence at rendering an accurate 'daily life'

scene and suggests that the artist is drawing on the symbolic aspect of the bird. According to Sian Lewis's perceptive readings of the Greek Departure Scenes, the water fowl symbolizes the constancy of the woman who waits at home while her man is away from the domestic sphere, fighting.[54] The symbolism of such a scene certainly becomes apparent on an item like a seal, since such gems were the personal items of individuals who might wear them on a daily basis. It is difficult to assign a gender to the owner of a seal bearing such an image, but one might interpret its symbolic value in two ways: either it is the forget-me-not of a soldier on duty or it is a love token for the wife at home. The theme of separation and constancy applies in both cases.[55]

What we have in this particular seal image, of course, is a very Greek depiction of the bond between a husband and wife, and not necessarily a Persian take on marriage at all. After all, Greek writers remind us that among Persian royalty and nobility, polygamy was practised, with a man having several consecutive wives and numerous concubines: we know that this practice was certainly followed in the court of Pharnabazus,[56] the most important and influential of the Anatolian satraps, and it would be logical to suppose that other satraps and nobles followed suit and kept up the Persian tradition. But in the Anatolian glyptic evidence there are no images that can be identified as a single man enjoying the company of several wives or concubines to confirm the idea.[57] On the gems, Greek-style monogamy is the norm.[58]

The Body Beautiful: Greek or Persian, 'Graeco-Persian' or Anatolian?

Having considered some of the common representational themes found in Attic vase painting and the Anatolian seals, I want to turn now to some specifics of the iconography, namely the body-image of the women of Asia Minor. I will decode the use made of the female body shape in the gems by comparing representations with examples found in Greek art, utilizing recent methodologies for reading the iconography of Greek vase paintings and the minor arts.

Pausing to reconsider the image of the nymph Nemea on the Herakles seal from the Punjab (Figure 7.1), it is easy to see that as far as pose, body, and dress are concerned, she is represented in a typically Greek fashion. Nemea's figure is well proportioned; she is slim-hipped and full breasted; she wears an arm-exposing linen *chitōn*; her hair is bound

up in a fillet. The nymph resembles, to all intents and purposes, many such women on Greek gemstones or pottery of the Classical period.[59]

Turning now to a sole figure of an Anatolian woman, however, several notable differences become apparent straight away (see Figure 7.2). In terms of dress, the woman wears an Achaemenid court robe. Essentially a large bag-shaped tunic made from what appears to be fine pleated linen, the gown is caught into a sash at the waist, with the excess fabric pulled out of the waistband to create elegant loose 'sleeves.'[60] The skirt of the garment is folded in such a way that pleats are brought forward to a central waterfall of cloth. A small train drags on the floor, but the skirt is pulled up high enough at the front to reveal soft slippers or boots. The Persian wears a very un-Greek hairstyle of a single plait or braid hanging low down her back; it is intertwined with tassels or pom-poms for decoration. This hairstyle is not attested in any other visual source than the seals, where it features predominantly.[61]

The most striking feature of the image, however, is the woman's physical build: the Persian woman is of ample build, and in this she shares a common physique with other women on the Anatolian gems, who are uniformly buxom. The women are *always*, without exception, depicted with full breasts and, most conspicuously, very large buttocks, which are given particular emphasis by the drapery of their robes, which seem to cling to their ample fat. This steatopygic fatness is the most notable feature of the representation of women on Anatolian gems. Steatopygia, however, is not attested in any of the (albeit scarce) representations of women elsewhere in the empire. Two beautiful Achaemenid ivory female figurines from the Phoenician coast, for example, cup their small breasts in their upraised hands, but their figures are decidedly lacking in curves otherwise.[62] The Persian noblewoman adopting the 'hand-over-wrist' prayer gesture on a limestone plaque has full breasts but in no way can she be considered fat.[63] The three female figures depicted on a cylinder seal carved in the Iranian court style each wear an Achaemenid court robe, the drapery of which is arranged in the same style as that found in the Anatolian gems.[64] Yet besides some emphasis on the breasts, the three female figures have flat buttocks and hips and are, again, decidedly lacking in curves. This would suggest that the images of curvaceous women on the Anatolian glyptics are atypical of the way in which women are represented in the arts of the rest of the empire.

But what can be done with this observation? What, moreover, do the existing images suggest about the physical make-up of real Persian or Anatolian women? Steatopygia is understood as an unusual accumulation of fat in and around the buttocks of women. As commonly reported by early European explorers, it was a condition found among the women of the Hottentots of Central Africa, where it was interpreted as a mark of supreme beauty and desirable fertility, since the condition begins in infancy and is fully developed on the first pregnancy.[65] The discovery of the famous Neolithic figures in stone and ivory (the so-called ice-age Venus figurines) indicates that the steatopygic trait was revered and desirable in a woman from a very early period, although it is not feasible to imagine that all women looked this way. It is possible, however, that the association between fatness, fertility, and desirability continued into the Bronze and Iron Ages too. Thus while the Anatolian seal images tell us very little about the reality of the physical appearance of the women of Hellenized Persia, in terms of gender ideology they are loaded. In some of the examples on the Anatolian gems, the obsession for a large build is so pronounced that in the iconography the buttocks almost form a shelf of flesh, suggesting that these images must attest to at least a localized fetish for the ample, Rubenesque, woman. In the Anatolian seals, beauty is expressed through fleshy abundance because fatness denotes enviable fertility (see Figures 7.2, 7.5). The Greek Hippocratic corpus emphatically makes that association, highlighting for historians and archaeologists of the Greek world the dichotomy between the physical reality of women's lives and the artistic ideal that the communities created.[66] Robert Garland has suggested that when judged from the scarce osteo-archaeological evidence and our knowledge of the somewhat inactive and secluded lives of many women of various poleis, most Greek women would have had a tendency to run to fat and that it is only an artistic conceit that depicts them as slim-hipped, flat-bellied, and boyish.[67]

In the Greek artistic imagination, a figure must not be too fat or too thin.[68] This causes imbalance and complication of line, after all. In *The Nude*, Kenneth Clark alludes to a red figure cup from the mid-fifth century BCE on which four men are represented: on one side, two buff athletes are shown throwing the discus and javelin. They are muscular and solid and lithe. On the other side, separated from the action, is a fat young man seen in profile, with a big belly, turning his back on

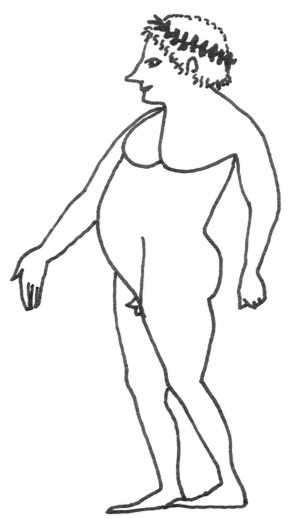

7.6. Fat youth, detail from Attic red figure krater (Drawing: L. Llewellyn-Jones, London, British Museum, after Clark 1956, fig. 17)

the games (see Figure 7.6).[69] Next to him is a skinny youth facing the athletes, but seeming to pull away as far as he can from the action. The reading of the jar is unambiguous, as least as far as Clark is concerned: both fat and thin, he correctly adjudicates, are at odds with the ideal of vigorous male beauty.

But what of women's beauty? On the whole, Greek artists tend to depict women with slight builds. In one titillating scene, for instance, two women are shown anointing their bodies with perfume. They are lithe, almost masculine in the outlined contours of their bodies, almost

boyish in the narrowness of their hips and the flatness of their stom-
achs.[70] It has been noted that the vision of the ideal female body in Greek
art (prior to the mid-fourth century BCE) takes the ephebic body as its
model and simply adds rudimentary breasts to the torso to create the
biological sex of the figure.[71] Nevertheless, other images of women, espe-
cially in the short-lived genre of blatantly pornographic vase paintings of
the Late Archaic and Early Classical periods, are ample in their fatness. It
has been suggested that these women are old prostitutes, denigrated by
society and misused and abused by groups of their young clientele, who
are frequently shown in an orgiastic frenzy, beating them with slippers or
simultaneously penetrating them orally and anally.[72] Sexual humiliation
is undoubtedly the theme of these images, but nevertheless, the scenes
seem to depict the male erotic fantasy of mature women actively parti-
cipating in lively sex, their fatness adding to their sex appeal. Throughout
most of human history, fat has been thought to be the best feature of the
female body, the most desirable and beautiful stuff of all.[73]

The 'Big and Beautiful Women' of Asia Minor

Maybe the indigenous women of Anatolia, or the Persian (or Greek)
women who settled in Asia Minor operated under a set of rules in which
big was beautiful. From the seal images we can say with confidence
that ethnic taste aspired to that body image and artists were there-
fore content to depict their women as ample and buxom. No doubt
in real life some women, those of high social status perhaps, were fat.
Certainly, it is worth recalling Xenophon here, as he plunged deeper
into the Persian Empire during his mercenary career, being concerned
that, 'if we once learn to live in idleness and luxury, and to consort
with the beautiful and big [kalai kai megalai] women of these Medes
and Persians, we may, like the lotus-eaters, forget our way home.'[74]

　　What, though, is meant here by Xenophon's term megalai? Recently,
scholarship has come to the conclusion that Xenophon cannot be talk-
ing about the beautiful fat women of Asia, but the beautiful tall women
of the Persian Empire. For Christopher Tuplin, 'the women are megalai
not because they are fat…but because height is a mark of beauty and of
presence appropriate to an imperial people.'[75] Robin Lane Fox suggests
that no Greek mercenary would want to be reminded of the short dumpy

woman he left at home and that, therefore, to Greek eyes, the women of
Asia were uniformly tall and beautiful.[76] Something more than, and less
than, scholarship is at work here. Judging from the iconographic repre-
sentations, height is not the issue at all. If these gems show us the kind of
women that local ideology found beautiful, then the women Xenophon
was encountering in Asia were fat and beautiful – and not just fat, but
really fat, ample indeed. That is the correct reading of *megalai* in this con-
text. The argument that only height can give these women sex appeal or
dignified presence devalues the beauty of the soft fleshy bodies depicted
in the seals and says more about contemporary taste in female physique
than Classical-period taste in body image. It must also be remembered
that Xenophon was not describing the physically active women of the
Scythians alluded to in the Hippocratic *Airs, Waters and Places*, but the
refined ladies of the Anatolian satrapies, whose daily regime extended
little beyond the rigours of weaving on a loom or plucking at the strings
of a harp.[77]

The secret of sex appeal, it has been suggested, lies at the waist, or, to
be more specific, the waist-hip ratio calculated by dividing the waist mea-
surement by the hip size. The smaller the waist in relation to the hip, the
more desirable a woman is seen to be.[78] The waist, after all, is one of the
distinguishing human features; no other primate has one. The waist is a
defining human characteristic. As Klein succinctly puts it, 'a fat ass makes
us human.'[79] In the Anatolian seals, the belting of the Achaemenid female
robe and the organization of its pleats emphasizes such a diminutive
waist and glories in the swell of the breasts and, most obviously, the but-
tocks and hips. By their physiques the women of the seals are defined as
undeniably sexual. The women of Asia are beautiful because they are big.

In the Greek world, art historians studying female sculpture, such
as Attic korai, or representations of women in vase paintings, have a
multitude of Greek texts (epic, lyric, dramatic) to examine when try-
ing to assess the relationship between representation and ideals of
actual physical beauty.[80] Other than Xenophon, frustratingly we have
no indigenous Persian or Anatolian literary sources that can be evalu-
ated to glean a conception of female beauty or sexuality. So the ques-
tion of how the images of fat women relate to localized conceptions of
beauty remains open. It is worth speculating, though, that even ideal
images can be based in reality if they depict appearances correctly at any

given time or place. As Mary Stieber has explained in relation to korai, 'this is a beauty which exists independently of idealization, a natural, as opposed to an unnatural beauty, an *ideal* beauty perhaps, but not an *idealized* beauty.'[81] The seal stones of Asia Minor depict a very specific ideal beauty unique to time and place, and this is where their unique importance lies.

It is well recognized that representations of the sexes in Greek art exploit the architectural and erotic possibilities of the curve at the buttocks and hips.[82] Blatantly erotic vase paintings, however, go one step further and fetishize the posterior in order to show anal intercourse between a man and woman.[83] In the Anatolian seal imagery there are similarly a few intimate scenes of a Persian and his lover – be she wife, concubine, or courtesan – in the same act. Given the obvious penchant for fleshy buttocks in Achaemenid Anatolia, it is no surprise to find a similar fetish for *coitus a tergo* (see Figure 7.7a).[84] In the Near East such scenes, frequently found in Assyrian and Babylonian contexts, have often been interpreted as having a religious significance, but the gemstone scenes are decidedly secular, reminiscent of many such examples in the Attic repertoire.[85]

However, only one sex scene is depicted in an overt Greek style: a large bed accommodates a young couple in the midst of lovemaking (see Figure 7.7b). The young woman, with large breasts, and wearing her hair in a simple plait, reclines on a pile of cushions and supports her weight on her arms, while her legs (with their slippered feet) are hooked over the shoulders of her lover, who grips her behind her knees and kneels on the bed in order to penetrate his lover. There is a certain realistic innovation here. The kneeling position of the youth is not usual even in Greek representations, but, as Boardman notes, the girl's legs in the air recall Lysistrata's injunction to her followers to 'lift their Persian slippers to the ceiling.'[86]

The debate over the secular or sacred context of the sex scenes can have an impact on our understanding of both the Greek and Anatolian examples: what exactly is the sexual act being practised here: anal or vaginal intercourse? What, if any, are the repercussions of either sexual act as to the status of the woman represented? Is she a wife or a prostitute? In many of the seal representations, the penetrated woman holds a mirror and often glances backwards at her lover, leading Boardman to surmise

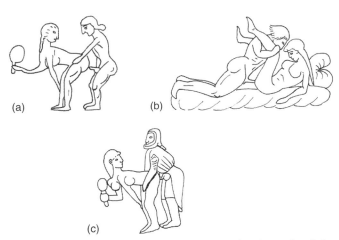

7.7. Sex scenes. (a) Coitus a tergo: woman with mirror, detail from chalcedony scaraboid; (b) Greek-style sex scene between a Persian man and woman, detail from chalcedony scaraboid; (c) Coitus a tergo with a clothed man and a woman with mirror, detail from scaraboid (Drawings: L. Llewellyn-Jones, Munich, Münzensammlung, after Boardman 2001, pl. 298; Boston, Museum of Fine Arts, after Boardman 2001, pl. 862; Malibu, J. Paul Getty Museum, after Boardman 2001, pl. 1065)

that these scenes are 'thoroughly secular.'[87] But how then are we meant to interpret the mirror? Is it a woman's symbol designating her as housewife or as whore? On one seal a man remains fully clothed while penetrating a naked woman (see Figure 7.7c). Do the clothes indicate that he is visiting with a professional woman or is he initiating an intimate act of lovemaking at home? There is another layer of interpretation to be explored here, beyond the scope of the present study, in which issues of aestheticism and narrative become intertwined. The bodies of the women participating in the *a tergo* sex scenes demand cultural contextualization in order for the specifics of the sex act – the fetishization of the posterior – to be understood.

Conclusion

This brief investigation into the images of women on the Anatolian seals augments the understanding of the bigger and complex intercultural relations in operation in Asia Minor during the Classical period. Recent and important work undertaken by Miller on the Athenian use of Persian imagery in art and other forms of fashionable *Perserie* has required a reevaluation of sociocultural relations in the Graeco-Persian world, especially in terms of gender ideology.[88] Likewise, while it might

be possible to characterize some elements of that interaction as the desire of Greek and Persian elites for the exoticism of their antithetical 'Others,' the ways in which Greek artistic traditions are manipulated on the seals from Achaemenid Asia Minor tell a much more nuanced story of acculturation, one that might look something more like hybridity. An examination of the seals demonstrates that the cultural interaction was very much a two-way process. The Persians adopted and adapted Greek artistic styles and scenes to their own specifications as readily as the Greeks adapted Persian art, architecture, or items of dress. A study of the imagery of gender, then, works in harmony with and expands on the ongoing analysis of the Greek writings on Persian women, and develops the groundwork already undertaken on the representation of women in gender ideology in indigenous art and literature of Greece.

But another sphere of ethnic cultural interaction exists at a much more localized level, in which the unequal power balance between those inter-acting influences might lend itself more to Hingley's model of globaliza-tion (see Chapter Three). This is where the importance of the seal stones becomes clear. The iconography of the Anatolian seals reveals that cultural and ethnic interrelations existed not only on the level of high culture, but in the minutiae of life at other levels of society too. Hingley observes how elites of various socioethnic backgrounds were often involved in a series of cultural and political interactions that prompted them to define their identities in very original ways. Much the same perceptive observation can be made for the elites of the Persian Empire. In regard to Achaemenid Anatolia, a very localized elite ethnic identity, filtered through the dom-inant cultures of Greece and Persia, reflects itself in the least tangible of materials: conceptions of ideal beauty. The specific body images of women found on the Anatolian gems are highly representative of how the cultural blend of Achaemenid Anatolia operated at all levels. The gems operate at a localized level to contextualize a specific cultural attitude to a body 'type' and a related conception of beauty. At the same time, the gems demon-strate the hybrid interaction of several identifiable cultures, each with its own individual artistic and sociocultural agenda.

But the tiny seal images display more: they reveal something of how the Persian Empire operated as a whole, just as Hingley's Batavian exam-ples shed light upon the workings of the 'global' Roman Empire. The Persians recognized their own centrality, but identified the key players

in the make-up of the empire as a whole (the great land masses of Egypt, Babylonia, and Anatolia in particular). Yet the Persians also acknowledged that within these great historic states lay something more distinctly localized, more intimate, and more culturally specific. The success of the Persian Empire lay in the ability of its central authority to recognize the multiplicity of levels of national and local identities within the vast geography of its borders. It could therefore implement successfully a system of government (the satrapies) that identified, explored, and utilized the diversities. Unfortunately, textual evidence from the Achaemenid period does not supply us with a convenient Persian 'handbook' of good government. Scholars may lack a written source that specifically sets out the Great King's governmental policy, but the material evidence often speaks eloquently of how the imperial centre interacted on national and local levels throughout the empire. As Antonaccio reminds us in this volume, texts alone do not completely encompass the lived experience of antiquity. Words alone cannot give us the full picture of a society's ideological and cultural make-up. The tiny gems and seal stones from the satrapies of Asia Minor give an invaluable insight into the lived experience of elite inhabitants of a section of the Persian Empire. They also articulate the principles that propelled the governance of the empire as a whole. By offering evidence of a rich artistic tradition that demonstrates Antonaccio's conception of cultural hybridity, the seal stones of Achaemenid Asia Minor, and the very localized Anatolian vision of female beauty contained in them, focus our attention on the way in which the Persians integrated themselves into their empire. In the framework of the globalization model, the seals use wider dominant cultural conventions to look inwards at a specific, 'local' culture. But they operate on a different axis too: within Hingley's frame of interpretation, the gemstone images of women also operate outwards as global projections. In this, the seals are a demonstration of cultural integration on an empire-wide scale and they are part of an empire-wide material demonstration of an effective *Pax Persica*. In this regard the remarkable depictions of the big and beautiful women of Asia speak louder than words.

Notes

1. For an investigation of seals, their chronology, and imagery, see Richter 1956; d'Amore 1992; Boardman 1999 [1964], 106–7; Boardman 1994, 42–6; Boardman 2000; Boardman 2001 [1970]; Dusinberre 1997; Kaptan 2002;

von der Osten 1931. For a discussion of the function of seal images gener-
ally, see Merrillees 2005; and Garrison 2000. On the Anatolian satrapies and
the cultural interactions of the province, see Kaptan 2003; Bakir et al. 2001;
Casabonne 2004; Dusinberre 2003.

2. Antonaccio, Chapter Two, suggests that this is why more recent studies of
other models of cultural interaction and acculturation have been focused on
the Greeks' western colonies.

3. For the Persians as the ultimate 'Other' to the Greeks, Cartledge's observa-
tions remain particularly focused and perceptive: see Cartledge 2002 [1993].
For a more recent appraisal, see Hall 2006, 184-224.

4. See Dusinberre 2003.

5. See Kaptan 2002, who opts to use the term 'Persianizing' over 'Graeco-
Persian.' Does this mean we can only read the localized art of Asia Minor in
either an Attic or Iranian frame of reference?

6. Hall 2002; and see Antonaccio, Chapter Two.

7. Said 2003 [1978]. See Hodos, Chapter One, for a more extensive discussion of
the effects of colonialism on archaeological thought.

8. Boardman 2000, 170.

9. Boardman 2001 [1970], 324.

10. Boardman 2001 [1970] uses these categorizations routinely.

11. Miller 1997.

12. See, for example, Llewellyn-Jones 2002b; Kampen 1996; Garland 1995. Much
of relevance is also to be found in Cohen 2000.

13. See Hersey 1996; Botting and Botting 1995; Morris 2004.

14. Eco 2004.

15. Kant 2000 [1790].

16. See Hdt. 1.94, who notes that Lydian manners and habits were identical to
those of the Greeks. For evidence of the widespread use of Greek see Xen.
Anab. 1.26-31.

17. Diod. Sic. 12. 60. 3-5.

18. Plut. *Lys.* 3.

19. Neumann 1968, 180.

20. Özgen and Öztürk 1996, 31-47.

21. The satrapies of Anatolia included, at one time or another: Armenia, Greater
Phrygia (separated into eastern and Hellespontine Phrygia for the purposes
of administration), Lydia, Caria, Lycia, and Cilicia. For the nature of the
Anatolian satrapies, see Briant 2002, 65-7.

22. On the Persian satrapal system, see Briant 2002, 390-4, 656-77.

23. Sancisi-Weerdenberg 1990, 264.

24. Sancisi-Weerdenberg 1990, 269.

25. Dusinberre 2003, 10.

26. Kaptan 2002.

27. Many questions relating to the Anatolian seals are shared by studies of jewel-
lery from the same area. See Williams 2005.

28. Hdt. 1.195.

29. See comments in Boardman 2001 [1970], 303-27. Of course, the cylinder had
long been the preferred seal type for Mesopotamia, ideally used to seal rectan-
gular inscribed tablets. But in the Classical period, and in the empire rather
than in the Persian heartland itself - where the cylinder remained popular -
sealing was more regularly done of rolled papyrus, requiring only an imprint

over a knot (*bulla*). For this, a stamp seal or finger ring was more suitable, though a cylinder could be used. For comments on the increasing popularity of stamp seals in the Classical period, see Merrillees 2005, 15.

30. Boardman 1994, 44. Schmandt-Besserat 1978, 47, is too cavalier when she states that the seals under investigation were 'executed by Greek artists at the request of Persian clients.'

31. Boardman 2000, 152–74.

32. Boardman 2001 [1970], pl. 881; Boardman 1994, pl. 45c: Rome, Villa Giulia. For further examples, see also Boardman 2001 [1970], pl. 1062: New York, Rosen Collection (the style is almost entirely Greek) and Schmandt-Besserat 1978, 48, fig. 52: Pierpont Morgan Library (a cylinder seal in style). A fine example comes from a chalcedony scaraboid from the Oxus treasure (BM ANE 124014; found in Tadjikistan): coming from what has been identified as a Greek workshop it shows a clothed Persian warrior subduing a recumbent naked Greek hoplite. See Curtis 2005, 121, fig. 9.

33. Boardman 2001 [1970], pl. 849. Once Arndt, A1410.

34. For a good discussion of Greek military/sexual dominance over the eastern barbarians, see Cartledge 1998b. See further discussion in Hall 1989.

35. These are all values, of course, we would associate with Classical art, values themselves generated by and encouraging sociopolitical as well as aesthetic aims (contrast Clark 1956 ch. 2, with Stewart 1997 ch. 4).

36. Boardman 2001 [1970], 311. See also Boardman 1994, 46–7 and Boardman 1969, 596.

37. See Boardman 1999 [1964], 84–109; Boardman 1994, 21–48; Boardman 2000. For a good discussion of Attic vases in the Achaemenid Empire, see de Vries 1977. The iconographic image of Herakles in this pose with an attendant nymph is only otherwise known from a metope at Olympia and from a sealing from Ur. See Boardman 1994, 325, n. 56.

38. See the classic study by Cool Root 1979, which provides full coverage of the Achaemenid iconographies listed here.

39. Boardman 2001 [1970], 324.

40. For interpretations of women in Attic art, see especially Lewis 2002; Blundell 2002, 143–69; Reeder 1995; Llewellyn-Jones 2002b; Llewellyn-Jones 2003.

41. For the use of narrative on Attic vases, see Lissarrague 1987; Lissarrague 2000. See also Stansbury-O'Donnell 1999; and Small 2003.

42. See Boardman 2001 [1970], 317, fig. 294: Once Arndt. However, other Anatolian cylinder, pyramidal, pendant, or cube seals show no real sense of narrative at all; they simply display a series of unconnected human figures, male and female – Greek and Persian. See Boardman 2001 [1970], 315, fig. 289, pls. 861, 876, 906.

43. On the rarity of images of Achaemenid women in Iranian art, see Brosius 1996, 84–7; Cool Root 2003, 27–9.

44. Women standing alone are depicted in the following seals in Boardman 2001 [1970], pl. 283: New York, Met. 133; Boardman 2001 [1970], pl. 854: Berlin F 181; Boardman 2001 [1970], pl. 879: London BM 434 (this is also presented as colour pl. 2) (The same image is depicted in Goldman 1991, pl. 26); Boardman 2001 [1970], pl. 903: London BM 433 (For this image see also Goldman 1991, pl. 25; Richter 1956, 34 no. 133, pl. 133 and Schmandt-Besserat 1978, 47, fig. 50). See further Goldman 1991, pls. 24, 28, 27, 31.

45. See, for example, Boardman 2001 [1970], colour pl. 4: London BM 436. Boardman 2001 [1970], pl. 966: Cambridge. Boardman 2001 [1970], pl.

990: Munich A 1421. For the same image see also Goldman 1991, 96, fig. 32. Boardman 2000, 155, pl. 5.3: London BMWA (Oxus Treasure). Von der Osten 1931, fig. 103: New York. Met. 86.11.43. For the Oxus Treasure woman see also Goldman 1991, 87, fig. 5. The woman on the Oxus Treasure ring wears a mural crown, which, as far as can be known, appears to be the headdress of royal Achaemenid women and has its origins in Assyrian royal iconography. However, it is difficult to assign this figure to a royal female and the ring probably depicts a noblewoman, perhaps of a satrapal court, suggesting that the crenellated crown was worn by female royalty and nobility. In this I follow Daems 2001, 46.

46. Boardman 2001 [1970], pl. 964: Boston 03.1013 (front). See also Goldman 1991, pl. 23. For the image of the female harpist on seals from the Greek mainland, see Boardman 2001 [1970], pl. 600: Leningrad; and Boardman 2001 [1970], pl. 472: unknown location. For the image of female harpists in Near Eastern (Assyrian) art, see, for example, Reade 1983, 68, pl. 102 (the banquet of Ashurbanipal). For debates surrounding the Attic 'women's room' scenes, see Lewis 2002, 130–71; for the Maltese dog in Attic art, see Lewis 2002, 19–20, 159–61.

47. Boardman 2001 [1970], pl. 964: Boston 03.1013 (back). For Greek seal images of women with pet birds (or symbolic magical birds like the iunx), see Boardman 2001 [1970], pl. 759: Tarentum. For the same motif in Attic vase painting, see Oakley and Sinos 1993, fig. 129: red figure epinetron by the Eretria Painter. Athens, National Museum 1629. On songbirds as pets, see Lewis 2002, 161–3.

48. See Lewis 2002.

49. Applying such a tag is not without its problems. See Lewis 2002, 135–8, on the problem of using the term.

50. Boardman 2001 [1970], 316 and pl. 891: London BM 436.

51. See, for example, Boardman 2001 [1970], pl. 891: London, BM 436 (reverse). It depicts a woman holding a lotus bud and offering a toy (a rattle?) to a young child. For comparative scenes in Attic art, see Lewis 2002, 14–20; Garland 1990, 144; Neils and Oakley 2003.

52. See Reeder 1995, 154–60; Llewellyn-Jones 2003, 100, fig. 109.

53. Homer, *Il.* 6. 467–74. For the role of the mother in the scenes, see Lewis 2002, 38–42.

54. Lewis 2002, 163–6.

55. Boardman 1999 [1964], 105, argues that 'the subjects [on the seals and gemstones] are mainly explicable by the probability that the gems were worn by women.' I would prefer a more fluid interpretation as to the sex of the owners, wearers and, indeed, users of the seals.

56. On Persian concubinage, see Brosius 1996. On the concubines of Pharnabazus, see Xen. *Hel.* 3.1.10.

57. See, for example, Ctesias 44; Hdt. 1.135. See further Brosius 1996, 35–7.

58. Only once, around 413 BCE, did the Athenians permit men to take two wives. This was a pragmatic solution to the fact that so many young Athenian men had died during the Sicilian disaster that there was a surplus of unmarried Athenian women. For details, see Ogden 1999, xxvi–xxvii.

59. See Lewis 2002; and Boardman 2001 [1970] passim.

60. A good discussion of the Achaemenid female robe is provided by Goldman 1991.

61. Most women in Achaemenid art, certainly from the Iranian heartland, wear either veils (which obscure the hair) or else adopt the 'pageboy' coiffure of tight curls and ringlets. See Daems 2001, 44.
62. Caubet and Gaborit-Chopin 2004, 78, pl. 82; Stucky 1985, 7–32.
63. Brosius 1996, 85.
64. This is probably a royal audience scene representing court women, possibly three generations of royal women. See Amiet 1977, 440, pl. 821, 456; Briant 2002, 253 fig. 37(b). Possibly from Susa, but perhaps found in the Levant; opinion is divided.
65. Steatopygia is a genetic trait that seems to have been widespread in Eurasia during the icy pleistocene until around 10,000 years ago. It is a way of storing fat reserves (energy) for hard times. Steatopygous mothers had a better chance of surviving through winter with their children. On the image of steatopygia, see Gilman 1986. For the Venus figures and their relationship to the bodies of real women, see Duhard 1990, 241–55; Duhard 1991, 552–61.
66. For the issue of fatness in Greek medical thought, see Pinault 1993.
67. Garland 1995, 120. See further Llewellyn-Jones 2002b, 193–4, n. 24.
68. On the ideal proportions of the male and female sculpted figure, see Stewart 1997, 86–107.
69. Clark 1956, 24, and fig. 17.
70. Kilmer 1993, pl. R207.
71. Llewellyn-Jones 2002b.
72. Kilmer 1993, 104–07, pl. R518.
73. On the issue of fat beauty, see Klein 1996; Braziel and LeBrosco 2001.
74. Xen. *Anab.*3.2.25.
75. Tuplin 2004, 156.
76. Lane Fox 2004b, 202.
77. *Airs, Waters, Places*, 19–21. See comments in Pinault 1993.
78. See Botting and Botting 1996.
79. Klein 1996, 37.
80. On the korai, see Stieber 2004; and Keesling 2003.
81. Stieber 2004, 140.
82. See Stewart 1997, 86–97.
83. Kilmer 1993, 44–5, n. 35, 82–6, 114–17, 182–3. See also Stewart 1997, 161–7.
84. Boardman 2001 [1970], pl. 298: Munich A 1432 (missing); Boardman 2001 [1970], pl. 906: Paris BN 1104.
85. For Near Eastern evidence and debates, see Leick 1994, 50, pl. 6; and Assante 2002, figs. 1–3. For the Greek artistic evidence and debates, see Younger 2005, 123–5.
86. Boardman 2001 [1970], 311. See also Ar. Lys. 229.
87. Boardman 2001 [1970], 317.
88. See Miller 1997.

CHAPTER EIGHT

UNINTENTIONALLY BEING LUCANIAN: DYNAMICS BEYOND HYBRIDITY

Elena Isayev

To understand how a sense of belonging was articulated and negoti-
ated in the past, especially by those who did not leave their own writ-
ten record, we have to accept that most of the evidence we have will
give us an external perspective. This is the case whether the outsider is
an ancient author in whose narrative the specific group is discussed,
or the scholars, we who try to recognize patterns of choice from the
remains of the lived experience in the material record. Essentially, the
indicators of identity that we extract are not those by which the group
in question consciously intended to be recognized. In the rare instances
where we have direct statements of self-perception – the so called 'real'
identity, for example in the epigraphic record – we cannot assume that
these can be mapped onto identities that are attributed and recognized
externally, even where markers such as the ethnic labels appear to be
the same.

 The aim of this study is to highlight the tension between the contex-
tual usages of a particular ethnic term, along with its implied perception
of an identity, and how specific cultural networks may have functioned
on the ground. The creation of such constructs as the Lucanians – a
name given to the people who occupied the mountainous landscape
of south-west Italy – is a result of both internal and external processes.
Ancient authors employ such terms (often from a distance of time and
space) as literary shorthand to create and distinguish different groups.
In so doing they also provide the reader with a recognizable package
complete with the necessary characteristics, which act as a reference

point to evoke a particular response. Ancient narratives, therefore, rely on such identities being viewed as static, and ideally regionally bounded, without allowing for change over time. The evidence of material culture challenges such notions of apparently stable and coherent 'ethnic' units. Instead, the image is one of fluidity and dynamism, which is readily accepted in current scholarship and strongly highlighted in studies focusing on imperial and colonial encounters. Such investigations, represented in this volume particularly in Antonaccio's and Hingley's chapters (Two and Three, respectively), form part of an ongoing discourse about models of cultural hybridity and local–global dichotomies.

What has received less attention is the relevance of these concepts outside of imperial and colonial settings. Malkin's application of the 'Colonial Middle Ground' model to the ancient Mediterranean region[1] is challenged and expanded by Riva (in Chapter Four) to include Etruria and bring attention to the larger context of cultural interchange into which colonial encounters are placed. Fourth-century Lucania, too, may qualify as such a crucible of interaction. The material record provides evidence of coexistence between rapidly changing global trends and more persistent traditional local/regional features. But to argue that we are witnesses to the creation of a mediating culture, an 'in between space' of the kind suggested by Malkin for Archaic Campania and Sicily, would be dangerous.[2] For, in articulating who or what it was mediating between, we would need to assume the existence of static units outside such a temporal and geographic juncture, along the same lines followed by ancient authors. As Hales points out in Chapter Nine, cultures and identities are not 'end products' but are always shifting and acclimatizing to new circumstances. There is no doubt that some places more than others were prone to dynamic interaction – prominent poleis, mineral-rich regions, large sanctuaries, harbour areas, and other major trade route zones may be some of the more obvious candidates. Lucania, however, does not neatly fit any of these models, and yet it still had the features of a Middle Ground, in the sense of being both a centre and periphery that hosted diverse cultural trends while operating independent sociopolitical units.

It would be difficult to argue that this situation was the direct result of encounters with an incoming 'other' or encroaching hegemonic

regimes, although colonies and threats of empire did exist at this time. Rather, the evidence suggests that the interaction, which exhibits characteristics associated with 'hybridity,' is an ongoing trend rather than a uniquely isolated episode. As van Dommelen articulates in his critique of Bhabha's initial conceptualization of the phenomenon, while hybridization usefully denotes a process of interaction and negotiation between various social groups that underlies cultural mixtures, the theoretical flaw of cultural hybridity is that it is based on the presumption of the existence of pure cultures.[3] A further concern is that it is difficult to argue for the creation of a 'new' social space in light of a specific type of contact, since the dynamism of any cultural process is always creating new spaces. A colonial or imperial encounter would affect such a trend, and perhaps expand, shrink, shift, or redirect the contact pattern and the key players in it, but it does not necessarily create it. In light of this it would seem that what needs explaining is not so much the existence of a Middle Ground, a context that can easily be applied to Lucania, but rather places that cannot be defined as such, and those points in time and space where there is evidence of stagnation, and where such dynamism is lacking.

Focusing on ancient Lucania before Roman hegemony, I seek to explore the landscape where these issues converge. I will begin with an overview of the period when the term Leukanoi first made its appearance in literary texts. The image created by ancient authors will then be weighed against conscious statements of self-perception from the region, which on the whole show a preference for community- as well as locality-based identity. In the final section, an examination of cult practices, especially at the sanctuary of Rossano di Vaglio, will exemplify how cultural spheres overlap in what are unintentional dynamic identities that reach into wider, more global frameworks. In so doing I question the extent to which we should be seeking convergence between the textual and material domains, which are the result of significantly diverse formation processes.

Lucanians in Ancient Narratives

The earliest surviving textual reference to a group called the Lucanians is in a speech given by the orator Isocrates to the Athenians in 355 BCE.

In a general tirade about the disorganized handling of state affairs in Athens, he states, 'We Athenians, despite our noble inheritance, are more willing to share it with any who want to than are the Triballians and Lucanians to share their ignoble inheritance.'⁴ This implies that while these two groups were typical barbarians they still had the sense to keep foreigners out. Isocrates' choice of these peoples, one on the southernmost coast of Italy and the other almost at the opposite end of the Mediterranean in Thrace, is not surprising. Triballian contacts, often hostile, with the Greek colonies on the Thracian coast, are noted by the late Republican author Diodorus Siculus.⁵ Their ability to attack and defeat Philip in 339 BCE on his return from the Danube exemplifies the strength of their forces and organization. Athenians would have been well aware also of activities in southern Italy. Lucanian alliances with Syracuse in Sicily and, especially, the ongoing wars with the Greek colony of Thurii, set up by Athens in the fifth century BCE, are recorded by a number of ancient authors.⁶ Isocrates' throwaway comment about them indicates that they were terms for politico-military units with which Athenians would have been familiar, and ones that could be used to inspire a stereotype of 'ignoble' people. Such a characterization would fuel the threat of spreading barbarism, a topos that was prevalent in the writings of the period, and is particularly evident in Isocrates' other work, the *Panegyric*, published in 380 BCE.⁷ It shows that communities, known to the Athenians as the Triballians and, more for our interests, the Lucanians, had significant enough power to have made their mark, and were, therefore, in a position to be insulted in Athens at a time when they were at the height of power.

Authors writing before the fourth century BCE who show interest in the south-west region of Italy, especially for the period we define as prehistoric, refer to the populations by different names: Oenotrians, Ausonians, Chones, and Opici; the term Leukanoi is not familiar to them. From Hecataeus's work, all that remains is a list of peoples and cities he identifies as Oenotria.⁸ Herodotus also refers to the region as Oenotria and mentions it only in passing, noting that a new city, Elea, was founded there by the Phocaeans from Rhegium.⁹ Thucydides gives a more detailed picture, stating that the Opici drove the Sikels out of Italy.¹⁰ But this does not mean that he had access to privileged information. The ejection of the Sikels is also noted by Antiochus of Syracuse,

but according to him it was the Oenotrians who were the aggressors; and he adds a further complexity by stating that the Opici were also called the Ausones.[11] Both ancient and modern authors have been keen to explain the changes in terminology in terms of population movements attributed to migrations and conquest.[12] But this assumes the existence of stable ethnic units to which these labels can be attached. It is more likely that the very confusion that prevails in the ancient narratives is a reflection of the fluidity and the constantly shifting nature of overlapping boundaries and group definitions over time.

From the fourth century BCE there are two other references specifically to Lucanians. One is in the *Periplous* of Scylax, dated to the midfourth century BCE, which includes the Leukanoi among the groups who inhabit the south Italian coast.[13] The other is an excerpt from the Tarentine writer Aristoxenos, quoted in Porphyry's *Vita Pythagorae* 22, who notes that among those who came to Pythagoras were Lucanians, Messapians, Peucetians, and Romans.[14] The term Lucanian appears not to have been widespread in this period nor in the third century, although that is surprising since later sources tell us that there was intense military activity in the region: the Pyrrhic Wars followed by the Hannibalic campaigns. In fact there is only one surviving textual reference to the Lucanians from the third century: Leonidas Tarentinus, as part of his dedicatory epigrams, notes that Lucanian spoils were offered to Athena by Agnon.[15] The dedication was probably a result of victories in the campaigns of Tarentum and Cleonymus against Lucanians and Romans in 303 BCE.[16] It could be argued that there are few surviving texts where there would have been a focus on the Lucanians, but Musti's studies have shown that the term does not appear to have been used by authors such as Timaeus and Ephorus, who would have included the region of ancient Lucania within their narratives.[17] This suggests that the term developed gradually.

By the third century BCE, at least for the purpose of indicating military groupings, the terminological distinction between Samnites, Lucanians, and Bruttians appears to have been more firmly drawn. These three names, representing groups based in central and south-west Italy, appear separately from 282 BCE in Rome's list of their triumphs, the *Fasti Triumphales*.[18] However, this may reflect late Republican use of the terms that were then projected back in time to complete the list.

The subjugation of Lucania as a region, along with Samnium, is also noted in the epitaph on the sarcophagus of Scipio Barbatus.[19] But here, too, the date is problematic, for although the sarcophagus is dated to the mid-third century BCE, it may be that this particular inscription was only added a generation later, when the tomb was clearly still in use by the descendants.[20] If so, it would have coincided with the end of the Hannibalic War, when for the first time there are remains of the most direct evidence of self-perception in the form of coins that exhibit the name Leukanoi. But the use of the term here is also not straightforward, and we will return to it later in the section on coinage.

Only in the texts of the second century BCE is there a more articulated use of the terms Lucania and Lucanians, and a significant increase only in the latter half of the first century BCE, ironically at a time – in the aftermath of the Social War – when the term may have had little meaning other than as an administrative regional designation. Most of the history of Italy is pieced together from texts written in the late Republican and early Imperial periods, texts that are primarily interested in describing campaigns and alliances with different Italic groups, which are presented as large, definable, and cohesive ethnic units for the purposes of the narrative. External observers' use of collective labels, such as Lucanians, initially may have been to signify occasional federal or military groupings, but later became shorthand, 'umbrella' terms for the inhabitants of the separate regions of Italy. From other forms of evidence it is difficult to show that an identifiable and unified group such as the Lucanians was a historical reality from the fourth century BCE, or when, if ever, they would have conceived of themselves as an ethnic unit. This does not mean that the name had no meaning for the groups and individuals it was intended to represent; it is just that we should not expect to be able to isolate who they were, and in what context they would have subscribed to that identity.

Numismatic Evidence and the Touta

From the region of ancient Lucania (see Figure 8.1), which encompasses modern Basilicata, parts of Campania south of the Sele river, and a section of Calabria north of the river Lao, self-defining labels are primarily found on coin evidence. Most of these represent local sociopolitical

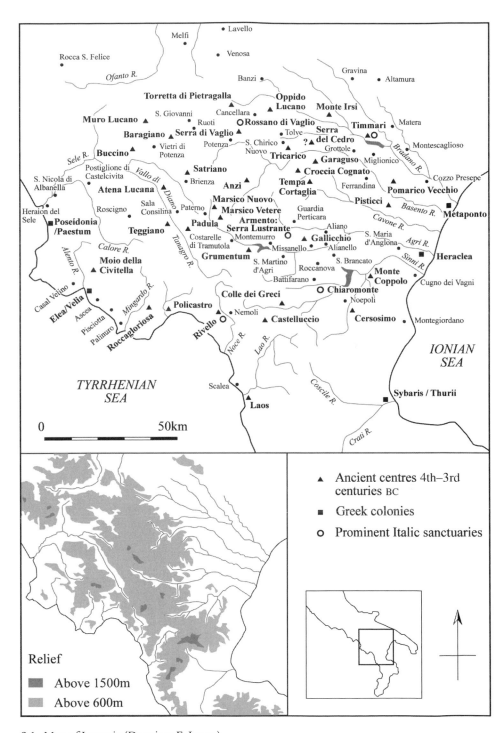

8.1. Map of Lucania (Drawing: E. Isayev)

groupings, some of which have been identified with specific settlements. The earliest Italic issues from the region, which circulated alongside the coins minted by the Greek colonies, date to the sixth and fifth centuries BCE. These include the following legends, all using the Greek script: PAL/MOL,[21] associated with Palinuro-Molpa on the cape of Palinuro,[22] near the ancient river Melpes;[23] SIRINOS/PYXOES,[24] which may be a joint issue by Pyxous, the later Buxentum, and Sybarite Siris II; AMI,[25] which is thought to represent the Aminaioi of Thessalian origin, whose settlement has been identified with Timpone della Motta, near the river Crathis; SO,[26] perhaps to be associated with the Sontini mentioned by Pliny,[27] or Sanza in the Vallo di Diano; SERD,[28] which has been identified with the Serdaioi, who appear on an inscribed bronze tablet from Olympia that records a pact of friendship between the Serdaioi and the Greek city of Sybaris with her allies, including Poseidonia, whose settlement/s were probably situated on the Tyrrhenian coast between Vibo and Poseidonia.[29] These coin issues make no obvious reference to any overarching ethnics, nor to any that are used by ancient authors to describe large groups of people in this part of Italy. Coins in this period do not appear to have been the medium for the expression of such identities either in the Italic or the Greek sphere. Instead they represent smaller sociopolitical groupings, perhaps based around specific places, while other issues with double names may commemorate the union, possibly a synoecism, of previously distinct groups. The question, which is difficult to answer beyond speculation, is: what else was the distinction based on, other than a different physical location?

This proliferation of small Italic coin mints in the region had significantly decreased by the following period. From the fourth century BCE, in Lucania, apart from the Greek colonies, we only have evidence that the site of Laos, which is known from a number of ancient texts,[30] struck its own bronze issues, with the legend LAINON, in the Greek alphabet.[31] There is no direct information from other sources to suggest why the site chose to mint its own independent coinage. It is probable that these small denominations were intended primarily for internal use and circulated locally along with coins minted by other authorities, especially those of the Greek colonies. The main audience for the LAINON issues would have been the population of the city itself, hence it was not necessarily intended as a declaration of communal identity to the outside

world.[32] We may assume that the identity it did display was locally based around the physical settlement.

It is not until the late third century BCE, at the time of the Second Punic War, that the ethnic Lucanian appears on coins.[33] These are mostly bronze, some of a Punic standard, which the Carthaginians probably used to pay their allies,[34] and hence they are closely related to those of Metapontum and the Bruttii in the same period.[35] That the name was a loose self-attribution, and possibly one initiated externally may be suggested by the fact that where the full legend appears on the coins it is spelled in two different ways: initially in Oscan, using the Greek script, LOUKANOM, and later in Greek LUKIANWN. The two languages, Greek and Oscan (an Italic language used by communities in the central and southern parts of the peninsula), appear interchangeably on inscriptions in Lucania from the fourth century BCE, hence it is not surprising to find both used on the coins. What stands out is the use of the ethnic itself. In the context of the Second Punic War the use of the term 'Lucanian' signifies some form of military grouping, as a number of those who joined Hannibal chose to be united under the name Leukanoi. But such a union need not have included all the Italic settlements of the region, and the ancient sources note that some of them continued to be allied to Rome. The broader identity, Leukanoi, in this instance, had a significance beyond those that may have operated on a more local level. Notions of ethnicity may not have had much relevance for the purposes of this grouping. Nor did all those from the region who resisted Rome necessarily fight under the Lucanian banner. There is a small number of coin issues found in the area of Volcei, modern Buccino, just north of the Vallo di Diano, with the legend FELEX(A), in Oscan, which are believed to be the coinage of that community during its 'revolt' against Rome (216–209 BCE).[36] Howgego, in reference to the Imperial period, questions the extent to which a public medium such as coinage is the place to look for opposition to Roman rule.[37] In the case of Volcei, we may argue that the very act of choosing to mint one's own coins in a time of conquest may in itself signify autonomy, if not direct resistance, of the kind that was much more deliberate in the Italian coinage of the Social War of 90–87 BCE.[38]

The coins struck during the Second Punic War are part of a bigger overall increase in coin mints in this period, which is similarly noted

in Spain, where the need to pay troops and allies also led to new issues by cities, and to names of some ethné appearing for the first time.[39] The persistence of local city mints alongside those displaying names of more overarching cultural or regional identities, such as the Leukanoi, suggests that groups could choose whatever they felt represented them best at any one time. We have no way of knowing to what extent the Volceians also subscribed to being Lucanian, and whether any of their men would have fought as Carthaginian allies and received payment in coins containing the Lucanian ethnic. But the scenario makes it difficult to argue for the existence of static cohesive units that could be mapped onto specific regions as implied by the use of ethnic names in ancient narratives.

The ties along which boundaries were formed may be better understood by considering the Oscan term for the largest sociopolitical grouping – the touta or tota – which is attested in the epigraphic record in the central Apennines, Umbria, and also in Lucania.[40] From these contexts it would appear that it could be used to represent either an individual community,[41] or a combination of these that may form a unified people.[42] While there is some overlap with the terms nomen and populus in Latin, they are not exact substitutions, partly because the Latin terms also change over time.

From Lucania there are two instances where the term touta is used. The earliest is a dedication on an olla from Castelluccio, dated to the sixth century BCE: 'toutikes dipoteres,'[43] written in what may be early Oscan, using the Achaean alphabet. Its meaning is generally taken to be an offering made to the deity, dipateres (Jupiter?), of the community – toutikes.[44] There is no indication as to what the name of the 'community' may have been, nor does it give us any sense of the constituency of the group, which could have been as small as the population of one particular settlement. The other instance of the term is on a fragmentary lex (law) inscribed on a bronze tablet from the fortified settlement at Roccagloriosa, dated to c. 300 BCE.[45] Here, as it appears as part of a legal formula, its use is more generic, while again the name of the 'community' itself is not given. Side 'B' of the tablet, line four, reads: '…[p]oust touteikais aut…,' similar to the Latin: 'post publicas aut.'[46] From this context alone it is unclear whether this law would bind just the members of the settlement at Roccagloriosa, or a much larger grouping to which the city belonged.

A similar ambiguity lies behind the name Utiana, which appears on dedications from the fourth to the third centuries BCE at the prominent sanctuary at Rossano di Vaglio, situated in what was a densely populated part of Lucania.[47] The term always appears in association with a deity, most often Mefitis – Mefithi outianai[48] – and in this context its function may be similar to that of the toutikem in the earlier dedication on the olla from Castelluccio. Utiana may have been the name of a specific touta, as suggested by Lejeune,[49] but even if that is the case we are still left wondering whether it represented one settlement that used the cult site, or a conglomerate of those for whom the sanctuary was a central focus. Some support for the latter comes from two factors: first, there is no other such name noted on inscriptions from Rossano di Vaglio; and, second, the nature of the material from the sanctuary indicates that it was a central focus for a relatively large catchment area, which would have included several settlements.

The use of cult sites for meetings and festivals where group memberships were reaffirmed is well attested in the Italian context. Latin communities gathered at common shrines, and annually on the Alban Mount for the celebration of the Feriae Latinae,[50] and participation in this festival was a key feature of belonging to the group of the nomen Latinum.[51] For communities in Etruria, the shrine of Voltumna may have served a similar purpose, as Livy describes how representatives met there for deliberation and treaty making.[52] In Umbria, a unique text, the tabulae Iguvinae, records the ritual ceremonies for the purification of the Iguvine poplo,[53] and also includes lists of banished communities.[54] Touta, nomen, and poplo represent units of membership with intentionally created frameworks of belonging that could be delimited along sociopolitical as well as other boundaries. Notions of ethnicity and culture can serve as important tools to underpin and promote the cohesion of these groups and to guide their action. But it is questionable to what extent this process leaves traces in the material record, and also whether we can recognize these traces. While we can identify patterns that suggest distinction, it is much more difficult to show that these can be traced along the same lines as implied by the terms and names from the epigraphic and literary records.

The Material Record of Cult Practice in Lucania

Moments of conquest, colonization, and imperial intervention are usually the focus of studies trying to capture changes in the material record. In such contexts differences between cultural trends are more likely to be magnified, reflecting responses to external pressures and the need to strengthen boundaries under threat. These can also be accompanied by sharp visible breaks, and the influx of foreign objects and practices, which may be the result of new directives and exchange networks. Antonaccio's discussion of cultural and ethnic hybridity (Chapter Two) is therefore most relevant to this context, where there is a recorded intense meeting of cultures. But outside it, ascertaining what constitutes those elements that make up the hybrid state is a much more ambiguous process, because of the multidimensional nature of the cultural spheres that operate concurrently. Under what circumstances would a culture be identified as not being hybrid is perhaps another way of articulating the problem. A snapshot of the material evidence from Lucania, and particularly from the sanctuary at Rossano di Vaglio, exemplifies how these overlapping spheres may have functioned, and also the subtle interplay between local choices and global networks.

Cult sites provide an ideal landscape for such an investigation since some of them had a significant role in sociopolitical gatherings and acted as intercommunity forums, encapsulating to some extent what has been termed the 'third culture.'[55] Their physical setting may be partly used to determine their roles. In Lucania, these appear to fall into three types: within settlements; extra-urban – usually small and in association with a particular site; and large rural complexes that seemingly function in an autonomous capacity. Rossano di Vaglio is one of a number of sanctuaries in the region that belong to this final category.[56] It is situated on a mountain plateau of the Potentino, in the midst of a significant number of fortified settlements that flourished in the fourth century BCE, the period when the cult site was built. The importance of the site may be ascertained from its monumental structures, the high quantity and quality of the material deposits, accompanied by a large number of dedicatory inscriptions, and also its long life span of at least two centuries beyond that of any of the surrounding fortified centres, most of which were abandoned by the end of the third century BCE.

This material record can be used to exemplify how elements of distinction were combined with participation in wider-reaching frameworks by focusing on two aspects of cult practice: the choice of architectural models, and the pantheon of deities that were given cult at the site.

From its inception in the fourth century BCE, the sanctuary at Rossano di Vaglio was conceived along monumental lines. Of the other known public buildings from Italic settlements in Lucania, none is comparable in size, or in scope of the material remains. However, the sanctuary is substantially smaller than the prominent public and cult areas associated with Greek colonies in this period, which also differ in their structure and layout. The cult complex at Rossano di Vaglio (see Figure 8.2) consists of a large rectangular paved courtyard (21m x 37m), approached through a substantial stepped entrance, and bordered by rooms fronted

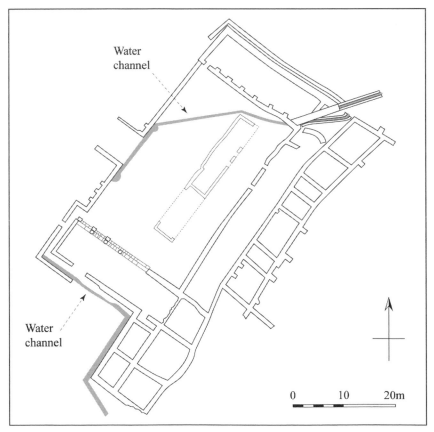

8.2a. Sanctuary at Rossano di Vaglio (Drawing: A. Wainwright, after Adamesteanu 1992, 63, fig. 111)

8.2b. Sanctuary courtyard at Rossano di Vaglio looking south from the entrance steps (Photo: E. Isayev)

by porticoes on three of its sides. Within the paved area was an altar (4.5m x 27.25m), and a series of water channels with two collecting basins, which may have also served as fountains. Rebuilding and further monumentalization of the site took place at the end of the third and through the second century BCE with the addition of rooms, columns, and marble statues.[57] Some of these key features are also characteristic of other sanctuaries in the region. The combination of an open space with surrounding rooms and porticoes, and the prominence of water channels are particularly well attested at the other substantial Lucanian cult site at Serra Lustrante (see Figure 8.3), and to varying degrees at the smaller sites of Chiaromonte S. Pasquale, S. Chirico Nuovo loc. Pila, possibly Colla di Rivello, the south-west sanctuary at Torre di Satriano, as well as in inner-city cult areas at Pomarico Vecchio and Roccagloriosa.[58] Another notable feature of all these sites is the absence of substantial temples or any other large monumental buildings.

Temple structures had a different role within cult practice at these sites. All these sanctuaries, except for Rossano di Vaglio, have remains

of small shrines in the shape of temples, varying in size from 1m x 1m to 3m x 3m. These must have formed the focus of ritual, as suggested by their prominent positioning and by what may have been procession routes leading to them, delineated by paved, and at times porticoed, pathways (particularly well preserved at Serra Lustrante) (see Figure 8.3). These shrines were votive depositories. They must have been systematically emptied and the objects placed in pits, many of which are known

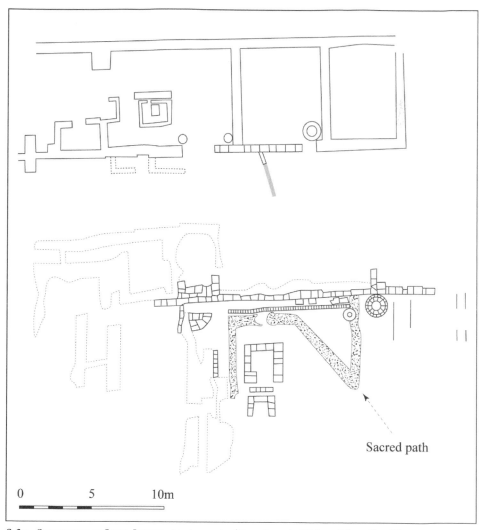

Sacred path

0 5 10m

8.3a. Sanctuary at Serra Lustrante, Armento (Drawing: A. Wainwright, after Bianco et al. 1996, 194)

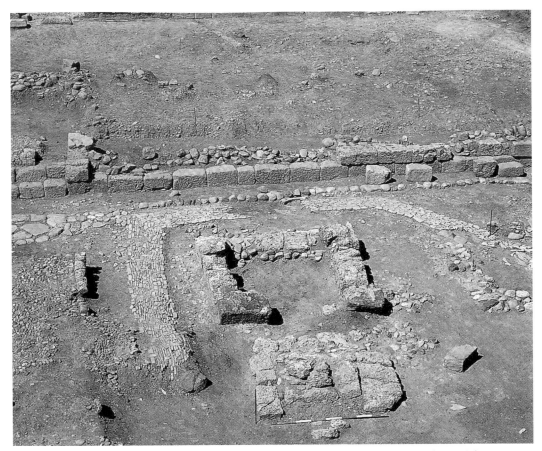

8.3b. Shrine and sacred path at the sanctuary at Serra Lustrante, Armento (Copyright Bianco et al. 1996, 194)

from these sites. Ritual activity at the sanctuaries also took place in the rooms that surrounded the courtyard, as indicated by remains of sacrifices and votive pits. They may have been used also for communal banqueting, as suggested by the remains of both fine dining wares and coarse wares.

Some have argued that the layout and structure of the sanctuaries in Lucania are modelled on house forms.[59] Domestic buildings within settlements in the region, which on the whole lack any prominent definable public areas such as an agora or a forum, may have had multiple roles and could be used as public spaces. At the fortified centre at Roccagloriosa, the large house, 'Complex A,' seems to fulfil this purpose (see Figure 8.4).[60] It has a number of rooms (some with clear evidence

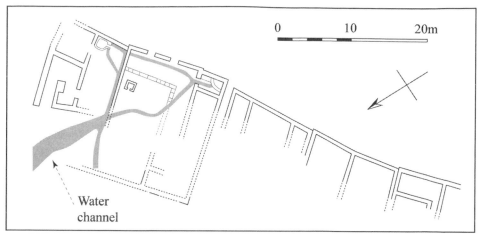

8.4. House 'Complex A' with shrine, at Roccagloriosa (Drawing: A. Wainwright, after Fracchia and Gualtieri 1989, 223, fig. 5)

of domestic activities) around a large courtyard, measuring circa 60m², which contains within it a shrine and a substantial votive deposit with a variety of offerings, including imported fine wares.[61] These features, which are not typical of other domestic buildings at the site, suggest that its worshippers extended beyond the immediate family that occupied the house.

The choice not to use temple structures should not be seen as a reflection of an inability either to create or to fund such buildings. In Lucania, wealth was invested elsewhere. Remains of large fortification walls, sophisticated drainage systems, and settlement layouts, as well as high-quality objects (including gold crowns) are found in both cult and tomb deposits.[62] Nor is there any evidence of cultural isolation. From ancient texts and imported material we know that there were close relationships with Greek colonies and other groups who made use of temple structures. Furthermore, examples of domestic architecture, technology, and town planning from the region show that the latest fashions were enthusiastically incorporated. This phenomenon is also outlined by Horsnaes in her careful study of the funerary trends in north-western Lucania from the sixth to the fourth centuries BCE. By demonstrating the diversity in the forms of contact had by different parts of the region, she highlights how inappropriate the

term Hellenization is in describing the much more interactive relationship between the Greek and Italic communities.[63]

The choice to continue using a certain type of architectural model for cult sites in the fourth and third centuries BCE needs to be seen as deliberate and stemming from traditions connected with a particular form of cult practice in the region, which may be distinct from those in the surrounding areas. A similar phenomenon of maintaining traditional-form structures for religious practice has also been noted in Sicily. Hodos has shown that despite the adoption of a number of Greek ideas of urbanization, from building styles to city layouts, religious buildings continued to be circular, which was the building form prior to Greek colonization.[64]

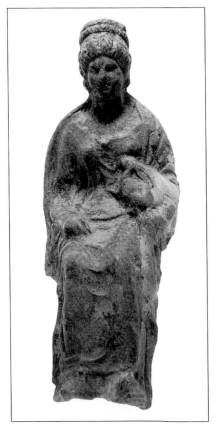 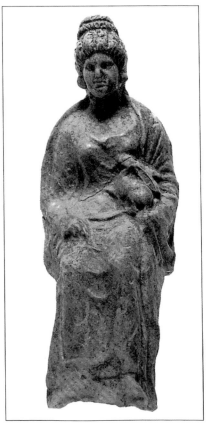

8.5. Terracotta votive statuettes from the sanctuary at Serra Lustrante, Armento (Copyright Bianco et al. 1996, 270, cat. nos. 3.44.4–5)

This is not the case for other aspects of cult practice in Lucania during this period. The nature of the votives as well as the dedicatory trends follow similar lines to those with which we are more familiar from the Greek colonial context. Pottery, full size or in miniature, and terracotta figurines are the most prominent votives (see Figure 8.5). Some of these were produced locally, as indicated by the presence of kilns near cult sites. Other examples are identical to votives found at Greek sanctuaries, and were either imported or made in situ using the same moulds, possibly by itinerant craftsmen.[65] Such votives are deposited alongside more precious objects, including bronze statuettes, coins, jewellery, armour, and larger statues in metal or marble. This combination of features should be sufficient to identify the pantheon of deities worshipped at the sanctuaries in Lucania, and yet they remain elusive. Terracotta female figurines have at times been associated with Hera, Demeter, and Persephone. Such votives are considered to be evidence for rituals destined for chthonic divinities, particularly, as is typical at cult sites in Lucania, when found in relation to water and springs, which are often seen as entrances to the underworld. However, this would not necessarily explain the presence of miniature armour and male figurines, or the bronze statuette of a draped lion skin from the sanctuary at Serra Lustrante.[66] At this site, such votives, and also a significant number of vases with Herakles imagery, have led to the designation of the site as a Herakles sanctuary. But how, then, do the numerous loom weights, some clearly of a votive nature, which are abundant at Serra Lustrante, match this label? From the material evidence, it would appear that deities worshipped at the sanctuaries in Lucania belonged to a wide-ranging pantheon; some of them are recognizable from, or share characteristics with, those better known from the Greek sphere.

Direct evidence for specific deities who received cult is most abundant in the epigraphic record from the sanctuary at Rossano di Vaglio. The inscriptions, dating from the fourth century BCE to the first century CE,[67] written in Oscan, Greek, and the latest ones in Latin, clearly indicate that the main deity worshipped at the site was Mefitis, the one who is named as Utiana on some of the dedications. She appears to have embodied similar characteristics to those associated with Demeter and Kore, including chthonic attributes and also fertility. On dedications she is cited as aravina (related to the working of the

land)[68] and caprovina (a derivation from capra – she-goat).[69] Mefitis was not the only one to receive cult at the sanctuary of Rossano di Vaglio. Dedications were made to a significant number of other deities including Jupiter, Herakles and Mamers,[70] but they do not all hold the same status as Mefitis. Lejeune notes that the phrasing of these dedications implies that, other than Jupiter, who is listed on equal terms with Mefitis, the other deities are either at the sanctuary under her patronage, or as guests, to whom she is a hostess.[71] It is unclear whether Venus, who is mentioned in one of the later inscriptions, should be considered as a separate deity related to Mefitis, or is meant to be equated to her.[72] There is no such clear evidence for deities who received cult at other sites in Lucania; Rossano di Vaglio remains exceptional for the quantity of inscriptions that have been preserved. We may deduce that

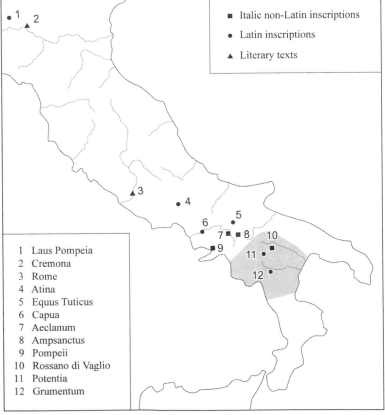

■ Italic non-Latin inscriptions

● Latin inscriptions

▲ Literary texts

1 Laus Pompeia
2 Cremona
3 Rome
4 Atina
5 Equus Tuticus
6 Capua
7 Aeclanum
8 Ampsanctus
9 Pompeii
10 Rossano di Vaglio
11 Potentia
12 Grumentum

8.6. Distribution of references to Mefitis in textual and epigraphic sources (Drawing: E. Isayev, after Lejeune 1990, 44–7, fig. 2)

Mefitis would have been prominent at other sanctuaries in the region, judging by the similarity of both the votive assemblages and key cult features described here.

From a variety of other sources we do know that Mefitis was worshipped at a significant number of sites throughout Italy, and particularly in the south-west of the peninsula (see Figure 8.6).[73] The main site of her cult may have been the sanctuary at Rocca S. Felice, which lies near the sulphur pools in the Valle d'Ansanto in Hirpinia, a region to the north of Lucania. If anything resembles the entrance to the underworld, then this would be it; even today, skeletons of animals killed by the noxious fumes lie scattered across the site. While springs and caves were often associated with underworld deities, clearly this place was distinctive, and it was noted by ancient authors, including Cicero, Pliny, and Virgil.[74] Mefitis also had a place of worship near the Esquiline hill in Rome, which may have been introduced either in the early Republican period or the third century BCE.[75] The two instances of her cult in the north of Italy, at Laus Pompeia, and Cremona,[76] date to the late Republic or early Imperial period, and were probably brought there by Italian veterans from the south of the peninsula. If there was a way of proving this last point, it could tell us more about the part played by Mefitis in the colonial construction of a sense of belonging.

The evidence for the multiplicity of deities who received cult in Lucania as well as the nature of the cult complexes themselves do not allow for a straightforward connection between cult and identity. On the one hand, the structural forms prevalent in the sanctuaries would suggest a cohesion in the methods of cult practice in the region, where there appears to have been a conscious choice not to use the temple form of building. However, this cohesion, or any sense of a regionally distinct culture, is not represented in the choice of deities worshipped at these sites. Mefitis, the main cult figure at the largest known Italic sanctuary in Lucania, at Rossano di Vaglio, is also an important deity in the central-west region of Italy, particularly in Hirpinia and Campania. Herakles may reflect connections with Greek centres, but not necessarily, as he was a prominent figure of worship, and part of the imagery of a significant number of cult sites throughout Italy from an early date.[77] Other less well-known deities, such as Mamers, are associated

primarily with the central Apennines. Cultural ties between this area and Lucania are also echoed in the use of the Oscan language across both regions. Different trends are suggested by the votive assemblages, however, and appear to follow yet another pattern, one that reflects southward-looking communication networks with the surrounding Greek coastal areas, with sometimes identical terracotta votives being used in the fourth and third centuries BCE in Greek and Italic sites. The nature of cult practice in Lucania is at the very least hybrid, even before Roman hegemony. It can even be argued that the combination of trends from different parts of the peninsula and further afield are enough to give the region Middle Ground status.

With Roman infiltration, we would expect a change in the cultural patterns. The provenance and nature of votives indicate that there was a significant increase in connections with areas to the north of Lucania at the end of the Republican period, which may be in part attributed to a shift in the direction of supply networks.[78] In the epigraphic record, there is evidence of an infiltration of Latin formulae and language. Other ties, particularly with central Italy, were not as prominent, especially following the Social Wars, and the use of Oscan after these campaigns is rare. Nevertheless, Mefitis appears both in Rome and in the north of Italy even as late as the Imperial period, when there are signs of rebuilding and continuity of worship at some of the cult sites in Lucania, and also at the Mefitis sanctuary in Hirpinia at Rocca S. Felice. From observing the trends and transformations of cult practice in the region, it would be difficult to argue that a state of cultural hybridity is somehow a development of an otherwise homogeneous condition. Cultural processes are by their very nature dialogues between new and ongoing trends – hence they can only ever be hybrid. For such a concept to be useful, we would need to have a sense of what a non-hybrid culture would look like, or, for that matter, a non-Middle Ground inhabited landscape. Even if examples could be produced, it would be difficult to ensure that any physical or temporal boundaries that were imposed on them were not artificial. An alternative way to make them meaningful is to assume that hybridity and aspects that define a Middle Ground environment are the norm rather than the unique. Then we can consider whether the essence of such entities is different in a conquest-imperial context in terms of the pressures and choices that inform and affect the cultural dialogue.

Conclusion

What does this evidence tell us about the inhabitants of the region of ancient Lucania? Were they or did they think of themselves as Lucanian? The simple answer to this would be: some of them, at certain times, and depending on who was asking. But even such a response undermines the foundations on which ethnic labels, as they appear in the ancient narratives, are based, as they are dependent on stable and definable coherent units, for which there is no support in the material or the epigraphic record. We have no way of knowing whether the worship of Mefitis was at all important to maintaining any form of ethnic identity. The sphere in which Mefitis was worshipped reaches well beyond the region that was ancient Lucania, as it is articulated in ancient narratives. We may go so far as to speculate that the sanctuary at Rossano di Vaglio was a central meeting point, and its prominent remains would suggest that those who met there may have used it as a way to establish group membership. But how large was the group? Did it encompass the whole of Lucania, groups outside the region, or primarily the settlements in the vicinity of the Potentino, with others only allowed in by invitation as guests or ambassadors? The only group name that survives in the epigraphic record from the site, if in fact it does represent a touta, is Utiana, a name not mentioned in either ancient narratives or in the numismatic evidence. The names on the coin issues are primarily local, the exception being the appearance of the Lucanian ethnic during the Second Punic War, a label that, as I have suggested here, may have been encouraged externally. From the patterns within the remains of material culture, what does feature is a shared form of cult practice, apparent in the architectural form, which seems to be particular to the region, but not exclusive to it. However, other cultural trends clearly link into spheres that either extend north into the central Apennines or look south towards the Greek colonies.

In many ways, Hall's warning of the fallacy of conflating regional cultural distinctiveness with ethnic distinctiveness[79] has been heeded and alternative approaches are exemplified by many of the contributors in this volume. But it needs to be probed further by asking whether we can even talk about regional cultural distinctiveness. The cultural trends are

not contained within regions, but span them or exist only in some of their localities. This being the case we also need to reconsider Hingley's critique (Chapter Three) of the idea that Rome enabled regional integration. Rome did enable integration on some levels, but we should be cautious of thinking about it in regional terms, since Rome was largely responsible for creating and cementing regional boundaries, particularly at the time of Augustus. These boundaries were in the minds of the post-conquest authors who, when writing about past events, projected them back in time, and in so doing infused them with ethnic labels. It is also difficult to talk about cultural regions, since trends are not contained by physical boundaries, nor should we be trying to establish physical community boundaries by turning to the material culture. So the fallacy is double – not only that of ethnic units but also that of regions. Terrenato is right in saying that ethnicity is a modern fixation that is not a useful category,[80] and perhaps neither is regionalism. We are in danger of supplanting the ethnic labels with those of regions for the purpose of our own narrative. But then how do we write narratives if we cannot talk about some form of solid entity, at least notionally? How can a Derridean dilemma, of deconstructing to the point of non-existence, be avoided? The framework of thinking in physical units is partly the result of the nation-state mentality that has inspired the local–global debates, centred on false dichotomies of homogeneity and heterogeneity.[81] Perhaps an alternative approach needs to stem from Anderson's observations about the nation as an imagined community.[82] This would mean starting with questions, already being addressed by Aristotle, as to how communities were imagined in the ancient past, and considering ways in which material culture can be employed in furthering such an understanding, especially in light of how identities are used, exhibited, and transformed as part of that process.

Notes

1. Malkin 2002, 151–81; see the critical analysis by Antonaccio, in Chapter Two.
2. Campania: Malkin 2002. Sicily: Malkin 2004, 341–64.
3. van Dommelen 2006b, 138–9.
4. Isocrates, *De Pace* 49–50.
5. Diod. Sic. 15.36.
6. Diod. Sic. 14.100.5–102.3; Strabo 6.1.13, 263.
7. Asheri 1999, 362–3.

8. Hecataeus of Miletus, Fr. 64–71; 89; 160, in *FGrHist* 1.
9. Hdt. 1.163–67.
10. Thuc. 6.4.5.
11. Fr. 555F9 in *FGrHist* 3: Strabo 6.1.6, 257; Fr. 555F7: Strabo 5.4.3, 242.
12. Isayev 2007, 11–21.
13. Scylax *Periplous* 12.
14. Aristoxenos Fr. 17 Wehrli.
15. Leonidas Tarentinus *Anth. Pal.* 6.129; 6.131.
16. Mele 1995, 111–29.
17. Musti 1988, 59 and 63.
18. *Inscriptiones Italiae* XIII.1, 72–5.
19. *CIL* I.2, 6–7; Dessau *ILS* I.1.
20. Wachter 1987, 301–42; Courtney 1995, 40–3, and 216–20.
21. Rutter 2001, 108, nos. 1105–6.
22. Greco 1990, 43.
23. Pliny *HN* 3.72.
24. Rutter 2001, 143, nos. 1722–7.
25. Rutter 2001, 124, nos. 1356–7.
26. Rutter 2001, 144, no. 1728.
27. Pliny *HN* 3.98.
28. Rutter 2001, 142–3, nos. 1717–21.
29. Meiggs and Lewis 1988 [1969], no. 10; Greco 1990; Arnold Biucchi 1993, 1–3; Van Effenterre and Ruzé 1994, 175–7, no. 42.
30. Hdt. 6.21; Strabo 6.1.1, 253; Diod. Sic. 14.101–2.
31. Rutter 2001, 176–8, nos. 2289–2309.
32. Butcher 2005, 145, considers a similar trend in relation to provincial coinage.
33. Rutter 2001, 129–30, nos. 1450–8.
34. In the same way as they did in Spain: Ripollès 2005, 79–94.
35. Siciliano 1996, 237.
36. Rutter 2001, 122, nos. 1341–5.
37. Howgego 2005, 1.
38. Rutter 2001, 55–7; Pobjoy 2000.
39. Ripollès 2005, 80–81.
40. Apennines: Dench 1995, 135–37; Umbria: Bradley 2000, 181–82.
41. Letta 1994, 387–406.
42. La Regina 1981, 129–37.
43. *ST* Ps 1 (Ve 186).
44. Arena 1972, 322–30.
45. Gualtieri and Poccetti 2001, 187–275.
46. Gualtieri and Poccetti 2001, 239–40, and 262.
47. *ST* Lu 15; Lu 9; *RV*-22, *RV*-45: Lejeune 1990, 17–19.
48. *ST* Lu 15.
49. Lejeune 1990, 36–7.
50. Livy 32.1.9; 37.3.
51. Cornell 1995, 294–5.
52. Livy 4.23.5–7; 4.25.6–8; 5.17.6–8; 6.2.2.
53. The Latin populus: Sisani 2001, 216; Bradley 2000, 181–3.
54. *ST* Um 1, Ib.16–17; VIb. 53–54, 58–59; VIIa. 11–12, 47–8.
55. Hodos, Chapter One.

56. Adamesteanu 1990; Adamesteanu 1992; Adamesteanu and Dilthey 1992; Adamesteanu and Lejeune 1971; Nava 1999, 704–6.
57. Denti 1992a; Denti 1992b.
58. See entries for specific sites in Isayev 2007.
59. Fracchia and Gualtieri 1989, 217–32.
60. Gualtieri 1993, 325–45.
61. Fracchia and Gualtieri 1989.
62. Isayev 2007, 41–7.
63. Horsnaes 2002, 94–103, and 132.
64. Hodos 2006.
65. Miller Ammerman 2002.
66. Russo Tagliente 1995.
67. Lejeune 1990, 11–14.
68. *ST* Lu 33; Lu 34.
69. *ST* Lu 32.
70. Jupiter: *ST* Lu 35; Lu 6/7; Herakles: *RV*-58: Nava and Poccetti 2001, 95–122; Mamers: *ST* Lu 36; Lu 28.
71. Lejeune 1972; Lejeune 1975, 320; Lejeune 1990, 16–18 and 56–9.
72. *ST* Lu 31; Lejeune 1990, 15, 58–9.
73. Lejeune 1990, 44–7; Radke 1965, 211–12.
74. Cicero *Div.* 1.79; Pliny *HN* 2.208; Virgil *Aen.* 7.563–571.
75. Varro, *LL* 5.49; Festus, p.476.13; Coarelli 1998, 185–90.
76. For Laus Pompeia, see *CIL* V 6353; for Cremona, see Tacitus, *Hist.* 3.33.
77. Lulof 2000, 207–19.
78. Isayev 2007, ch. 4.
79. Hall 1997; Hall 2002.
80. Terrenato 2005, 59–72.
81. Hardt and Negri 2000, 44.
82. Anderson 1991 [1983], 6.

CHAPTER NINE

TRICKS WITH MIRRORS: REMEMBERING THE DEAD OF NORICUM

Shelley Hales

Introduction

Funerary art is an interesting sphere in which to consider ancient identity and debates about where to locate that identity. As Ewald puts it, here is the point where the rotting body is swapped for a permanent, artificial *imago*, where inner identity is turned to the public, to become all surface, to give way to the commemoration of enacted and represented identities as expressed in visual and material culture.[1] Similarly, it is the moment of death that 'finishes' identity by putting a stop to the contingencies and variations practised through the winding circumstances of life.[2]

Funerary monuments combine epigraphic testament (where some might locate 'real' identity), with the performative (the act of commissioning and erecting the artefact, the rituals of the funeral), and the represented (iconography). I want to focus on one iconographic element, the mirror, and use it as a glass through which to explore the ways in which the examination of funerary imagery might contribute to the search for ancient identities.

The Grave Altars of Klagenfurt

My subject is a series of grave altars from the settlements of the Roman era around the Austrian town of Klagenfurt, centring on Virunum and Flavia Solva, a Vespasianic *municipium* to its north-east (see Figure 9.1). Virunum was the capital of the province of Noricum, which

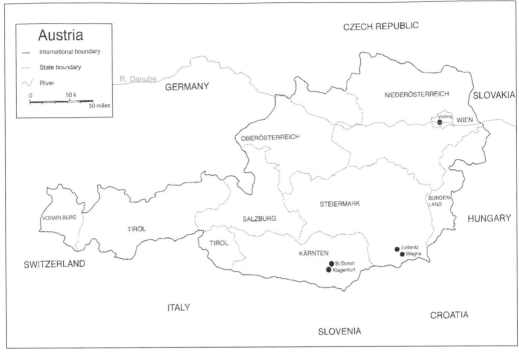

9.1. Map of Austria (Drawing: S. Grice)

was annexed by the Romans in 16/15 BCE. Early Roman traders settled on the Magdalensberg, a pre-existing settlement high on the hill over the Zollfeld. Under Claudius, the Magdalensberg was evacuated for a site on the plain, Virunum, which became a municipium and the home of the procurator. Most of the grave stones here would have been lined up along the main road, a major north-south trade route, leading out of town. Three come from St Donat, a villa site on the main road just to the north. The apparent peace and prosperity traditionally attributed to the area in the early empire has been credited with the evolution of both a strong upper class and thriving 'Norican culture,' an imagined, cohesive culture the existence of which is surmised from literary references to the regnum noricum, a kingdom or tribal coalescence of Celts. These references have allowed later scholars to impute some kind of pre-existing identity to the population that fits the territory of the Roman province.[3]

Some grave altars now survive in the Landesmuseum at Klagenfurt, while a great number can be found incorporated into walls of local

buildings. They date from roughly the middle of the first century to the mid-second century CE and feature Latin inscriptions on the front, while the sides bear reliefs that show, on one side, women holding mirrors out to the viewer (see Figure 9.2). They are dressed in clothes usually described as 'local' – a long under-dress covered by an overgarment, which is hooped up by a girdle and fastened by two large wing brooches on the shoulder. Their hair falls to just above shoulder length and is rolled at the bottom. They usually hold other toilet items in addition to the mirror:

9.2. Grave relief: maiden with mirror and work basket, Klagenfurt (Copyright Landesmuseum Kärnten)

baskets, caskets, jugs, or towels. In several examples, the female figure is counterbalanced on the other side of the altar by a male figure holding a stylus and tablet. The best preserved examples come from Flavia Solva, and these show how the individual reliefs from Virunum must have been assembled. A long rectangular marble relief found on the Zollfeld and now in the museum at Klagenfurt does not conform to the altar form but does demonstrate clearly the relationship between iconography and epigraphy. It was dedicated to Gaius Tertinius Statutus, who had served as an *aedile*, by his wife Catrona Severra, who had built the monument for herself and her 'marito optimo' (see Figure 9.3). To the left of the inscription, in a separate and isolated frame, stands the male figure, wearing a long, loose-armed tunic, holding up a rectangular tablet, with bundles of scrolls near his feet. To the right a female stands in a posture that itself vaguely mirrors that of the male. She holds up a mirror in place of his tablet and has what appears to be a towel in her lowered left hand. This monument gives us the opportunity to explore how the iconography, and specifically the device of the mirror, might be understood in terms of creating the identities of Catrona and Gaius; as Piccottini says, to remind viewers of their status and their need for representation.[4]

Garbsch's inventory of gravestones from Noricum includes at least twenty-four images of mirror-wielding 'maidens,' the greatest concentration (eleven) coming from Kärnten, including six from the area immediately around Klagenfurt. The other dense area is Steiermark, the district immediately north-east of Kärnten, which accounts for another ten of the images. Six of these are attributed to the area around Leibnitz, in the general area of Flavia Solva.[5] Only seven of these examples preserve an inscription. Catrona's husband was not the only *aedile* represented. An

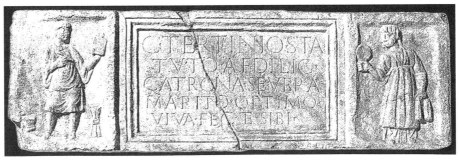

9.3. Grave relief of C. Tertinius Statutus and Catrona Severra (*CIL* III 4867) (Copyright Landesmuseum Kärnten)

aedile of Flavia Solva, L. Gautius Finitus, also made an altar for himself and his wife. Two dedicators explicitly declare their status as freedmen. Six inscriptions commemorated married couples, perhaps strengthening the association of the mirror and stylus with gender roles. One example, from Wagna, and therefore presumably Solva, was dedicated to just one occupant, Claudia Iucunda, aged twenty-three.

In all cases where the details are traceable, the mirrors conform to two types popular in the Graeco-Roman world: the round mirror with a handle and the compact or '*Klappspiegel.*' At least one, now in the Landesmuseum, further confirms its classical pretensions by its decoration – as the female figure holds up the mirror to the audience, we see not our own reflection or that of the dead woman but the face of the gorgon (see Figure 9.2).[6] The appearance of the gorgon in this context also seems to fit practices around the classical world. Medusa's association with reflection suits her well to mirrors, and her and the mirror's association with the funerary sphere suit her to tomb iconography.[7]

One of the oddest and most interesting aspects of these grave altars is that scholarship has long decided that the figures portrayed on them do not represent the dead but their dependents, generally their slaves.[8] This popular perception of the altars leads to the assumption that, in their present form at least, they do not preserve the likenesses of the dead. This may not have been the case in their original form. It is considered possible that the significant number of roundels containing double portrait busts, which might be interpreted as married couples, might have once surmounted the grave altars.[9] This idea is perhaps supported by comparative evidence dragged into the debate from the neighbouring province, Pannonia. Pannonian grave stelai often feature reliefs of a male and female dependent (generally depicted conducting sacrifice) flanking the main picture field of the busts of the commemorated couple. The difference in status between women on Pannonian stelai and those wielding mirrors on the Norican altar reliefs is said to be seen in the headgear (such as the veil) and jewellery, especially the torc, worn by the Pannonians. Where depicted in full length they may also appear seated, perhaps again implying status, though it should be noted that, like the Norican figures, these Pannonian women often carry domestic objects, in the case of the pictured relief, probably intended to be spinning items (see Figure 9.4). Likewise, within the Norican examples,

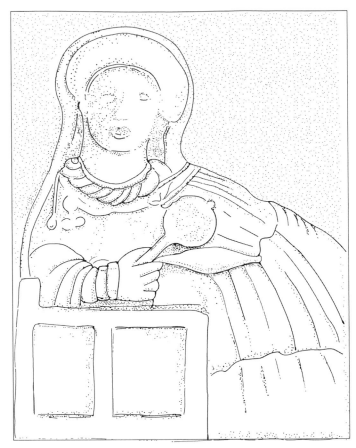

9.4. Grave relief of Bozi: woman with torc and spinning items, Ercsi (Zollfeld-Virunum) (Drawing: S. Grice, after Mócsy 1974, pl. 12c)

the difference in status between the 'women' in the roundels and the 'girls' on the altar reliefs is usually explained by the former's headgear and cape (seemingly indicating a role or presence beyond the house?) and, often, jewellery. It is, however, by no means necessary to presume that all the altars were fitted with such appendages, since other alternative toppings, such as pyramids, are also well attested in the material record.[10] Instead, we might want to consider to what extent the reluctance to see the dead in these unglamorous 'maidens' is actually an interesting reflection of our own expectations of 'Roman' women, particularly the kind of women who were married to civic magistrates.

So what do these grave altars tell us about the Noricans who dedicated them, and what kind of identities do they reveal to us? First, we might look to the written testament: the inscriptions through which

the dead apparently 'speak' to us, offering us their names, occasionally occupations, often their ages, and more implicitly perhaps a signal of their ethnic origins. All our examples had become Roman in as much as they were Roman citizens, though the number of men and women with the same family name, for example Q. Pompeius Eugamus and Pompeia Venusta, and the two couples explicitly declaring themselves as freedmen, would suggest for most a recent arrival to the citizenship. While their family names appear to tie them, however loosely, to traditional Roman practice (e.g. Pompeius, Antonius), personal names, such as Samuda, or Catrona, are usually described as 'local' or 'Celtic.' The general practice here, of course, is to suggest that it is the Samudas and Catronas who reveal their true identity, the Roman names simply showing the adoption of Roman habit, like a costume. But the epigraphy goes beyond this; the adoption of Roman names and of Latin as the language with which to name themselves shapes the very way these people present themselves. The information they purport to give of themselves, however factual, is entirely bound by Latin epigraphic practices – they say all the right things about themselves and add all the correct conventions.[11]

In this respect, the material evidence also implies burial and commemoration conforming to Roman commemorative practices: the commissioning of a monument, its apparent location along the main road, and its form. Schober suggests that the grave altar, originally from Rome, actually reached this region from Aquileia, where grave altars were popular. Several seem to share iconographic similarities, suggesting a significant amount of contact and influence between the area and northern Italy.[12] That the form must be understood in regional terms rather than in terms of a global imposition of funerary types is verified by some of the wider regional differences in commemorative practice between Noricum and Pannonia, where stelai become the preferred monument type, apparently under the influence of soldiers stationed in the province.

The iconography, too, suggests a pattern of local identifications and expressions of difference. The grave stelai and altars show distinct but interlinked practice – both often show a male/female pair, though on the stelai they are more often than not engaged in sacrifice rather than in 'toilette' or literary activities as at Noricum, and also are shown in direct relation to a male-female couple. Garbsch's research into the

graves of Noricum and Pannonia was conducted precisely for the pur-
pose of investigating the distinctive female dressing habits of these prov-
inces.[13] Though he stresses the 'local' nature of these outfits, we should
be wary of using them as evidence of 'native' dress, since how these cos-
tumes relate to 'pre-Roman' practices (and it would be difficult to say
when this time would be, since trade links and cultural influences had
been going on for so long) and what melange of influences themselves
resulted in those 'pre-Roman' practices is, of course, impossible to say.
Garbsch worked to show that while there are clear similarities between
the two provinces, there are also very distinct differences, particularly
in headgear.[14] However, it is important to notice that other differences
also distinguished groups within Noricum, while similarities existed
between different areas of both provinces.[15] Moreover, familiar Norican
elements, such as the brooches found in graves in free Germany, sug-
gested to Garbsch a healthy trade with Noricum and a much wider distri-
bution of costume accessories, though perhaps worn in different ways.[16]
In fact, these complex relationships reiterate the futility of expecting
local, colonized identities and traditions to conform to the artificially
imposed territories of Roman provinces. The men and women who we
now see as Norican or Pannonian may have had little else in common
other than that they were all caught within the same borders imposed
by a new Roman world.

The convention of the mirror, too, is not confined to Noricum, though
it appears rather differently in neighbouring areas. A third-century
grave relief from Gallia Belgica shows a seated woman surrounded by
four slave girls bearing the kinds of objects seen in Noricum, including
a jug and a mirror. A woman contemplating her mirror also appears on
a grave altar from Aquileia, though it bears little direct iconographic
or stylistic similarity to the Norican examples.[17]

These grave altars demonstrate how provincial practices were caught
up in local networks that refused to follow the borders of empire or
provinces. These practices were as much about expressing difference
from other 'Roman' groups as apparent 'integration' with Romanness
(a Romanness that itself was learned from other neighbours, themselves
'Romanized/hybridized').[18] By themselves, of course, none of these dif-
ferent elements guarantee 'identity,' but as a peculiar assemblage born
of a fusion of material and visual objects and associations, they do

constitute a lived culture, through the medium of which Catrona was attempting to communicate an 'identity' for herself and her husband.[19] But how does such a peculiarly 'local' cultural assemblage relate to the epigraphic identities recorded on Catrona's relief? In investigating this question, we might adopt the mirror as our guide.

Mirrors and Gender

Although she (or her suspected slave girl) and her neighbours, who commemorated themselves in their roundels, may look very 'local' in terms of their dress, it is also the case that, just as presenting themselves according to Latin epigraphic practice entailed not only a new language but also a way of presenting family relationships and personal status, the adoption of portraiture practices and funerary forms likewise channelled self-representation into tropes designed to convey certain sets of values.[20] Although Catrona Severra may have had little conception of the fact, her mirror linked her grave iconography into a much wider and long-lasting iconography of women and their mirrors. Mirrors appear in funerary contexts on many grave reliefs from across Asia Minor, but in a particularly interesting way on two from Laodikeia and the Tembris Valley. In both cases, a couple is shown in the same dress and pose, the mirror appearing not in the hand but as a floating motif between their portraits.[21] While we might rightly want to steer clear of the idea that provincial art simply emulates metropolitan art forms of the imperial centres, it is still the case that looking at other mirror images (and the strategies employed by those who have considered them) might offer possibilities for looking at Catrona through her mirror.[22]

Most discussions of the relationship between mirrors, women, and identity have been conducted through the medium of gender studies. Wyke's survey of women and mirrors, for example, brings together the aforementioned Gallic relief of a woman surrounded by her maidservants with the Projecta casket (a fourth-century vanity case from the Esquiline treasure, which features both Venus and a mortal woman doing themselves up in mirrors), precisely to conclude that, in both instances, the mirror acts as 'an honorific, although limited, summation of Roman women's lives and social status either as consumers or producers of beauty processes.'[23] In this model, gender identity (with the

attendant general concepts of feminine grace) becomes an all-important, common experience that appears to take precedence over other issues. Those concepts of feminine grace, as expressed in Greek and Latin literature, repeatedly configure female beauty in terms of shine and reflection, a sign of their roles as living mirrors.[24] In the language of engendered seeing, woman becomes an object, reduced to body and reflective surface, divided from, and a mere reflection of, the cerebral world of men (a divide we might choose to recognize in the mirror and scrolls that stand for Catrona and her husband on their grave relief).[25] In our case, then, both Catrona's act of commemoration and the symbol of her mirror might tell us of her capacity to see herself as object or image, even as the *imago* itself may well be missing. In terms of identity, the mirror and the relief is the point where nature becomes culture, where 'real' inner identity is created as a surface, public object.

The ability and, indeed, necessity of women to construct and to perform images of themselves placed them in clear opposition to the 'natural' state of masculinity.[26] Wyke notes how such a construction allowed them to be quickly unmasked – citing the satirists who take us behind the scenes where slimy potions drip off hideous faces.[27] Similarly, Roman and Christian moralists were quick to condemn mirror-using women.[28] Here, the gorgon on the mirror in our second relief (see Figure 9.2) takes on an extra importance. The outcome of looking into the mirror is the creation of a cosmetics mask, like that of the Medusa.[29] The idea of woman as Medusa is played on in Lucian's *Imagines*, where Panthea is described as being as captivating as the gorgon.[30] The turned-out Medusa image might suggest this possibility. While women looking in their mirrors, like the woman on the Aquileian relief, have the effect of containing the women in their own space, the turned-out mirror has the effect instead of creating a woman who might look back at the viewer, who might attempt to impose herself on the public sphere. The gorgon head might suggest the lure of the viewer to meet her eye and to become trapped between the woman and her mirrored image.[31]

In this model, Catrona becomes embroiled in an integrated myth of womanhood that spans the geographical and chronological range of antiquity. But is that all that the mirror does here? After all, the grave is for her husband as well. In the Asian reliefs, the fact that the mirror

appears between both partners might suggest that the fear of the construction possibilities of mirrors goes beyond the female sphere.

Mirrors and Romanness

Satirists and moralists writing during the century or so in which the Klagenfurt reliefs were produced spared even less the men who dared to use mirrors to invent their beauty. They are nothing but surface appearance, in danger of becoming trapped in the mirror they revere.[32] The much-cited Senecan parable of Hostius Quadra, who lived out his sexual fantasies in a bedroom lined with mirrors, might imply that the whole business of mirror gazing was unnatural and perverse.[33] His mirrors not only allowed him to watch his degradation from all angles, but also, because the mirrors were deliberately distortional, to see the various members magnified to improbable proportions.[34] Hostius's antics show that such distortion might have held considerable attraction to mirror users. The mirrored walls of his bedroom allowed him to reinvent himself and his lovers to the extent that it was said that he might as well have commissioned a portrait of himself and his lewd actions. This brings us back to the parities between reflected and sculpted/painted images, and reminds us that the parallel was not simply one of illusionism but also reflected the mirror's creative possibilities; the images produced in mirror surfaces were often seen to be on a par with those generated in bronze and marble by sculptors and in words by orators and writers. Mirrors and images, then, do not give you who you are but the work of art you might be.

But as much as mirrors facilitated such artificial reinvention, they also, like art itself, were praised for their clarity and mimetic values, simultaneously wielded as revealer of truths and tools of trickery and (self)deception.[35] The manipulative possibilities of pleading the veracity of mirrors while presumably relying on their distortional powers perhaps led Seneca himself to promote his *De Clementia* as a mirror of the reasonable character of his tutee, Nero.[36] The real power (and indeed danger) of the mirror was precisely the opportunity it afforded to change the image of whoever stepped in its sights under the protest that it merely offered a true reflection. In this sense, they could not only reflect but actually aid in the creation, manipulation, and *memoria* of *personae*.

The possibility of fashioning the self through the production of images stresses the visual and performative aspect of identity creation. Concepts of performativity have gained considerable ground in recent discussions of social and political behaviour in Rome. While the idea of theatricality has proved popular with regard to explaining behaviour in certain ritual contexts, particularly the *convivium*, other investigations have opened this discussion more broadly to investigate performance as a principal embedded in Roman society.[37] Nero no longer stands accused of playing the actor but rather of making explicit the performative turn of elite behaviour.[38] Concepts of Roman manliness are said to have contrasted themselves with the feminine and the effeminate by parading manhood as a natural state even while recent studies have exposed the very construction of that natural pose.[39] Recent revisitations of masculinity have stressed its performative nature and the necessity for Roman men to make the leap from natural to cultural manhood. The very performative nature of Roman identity made those affecting such an identity constantly open to attack. The gap between natural and contrived was constantly employed as a political tool. While the example of Hostius seems farfetched, it is merely one end of a scale of rhetorical attacks that claim to expose the constructed personae of enemies – to show their apparently innate Romanness to be nothing but posturing or else to accuse them of adopting some other set of poses or costumes (which would usually be classed as effeminate and/or alien).[40]

In such a world, the ability to reflect on and invent identity, and the power to impose the resulting image on an audience through living performance, sculpture, or literature were crucial. The parallel between self-representation through such creation and identity has been vaunted by Henderson, among others. Like performativity, such constructions might be seen to be influenced by debates in sociology and critical/cultural studies that have increasingly divorced 'identity' from an inner sense of self and stressed the contingent and outward-looking nature of identity as something that responds to circumstances and contexts and might be described as always unfinished.[41] Sociologists and anthropologists have tended to read identity as something invented through discourse, both within communities and as a reaction against others.[42] Bhabha conceives of identity as constituted in representation, promoting representation

from 'a second order mirror' held up to reflect what already exists.[43] As a result, cultural identity is never a natural essence of an individual or a society; it is always posturing and politicized.[44] Bhabha's point might seem useful here, if only, yet again, to stress how useful is the concept of the mirror as a thinking tool for theorizing identity making.

In Rome itself, the lifetime practice of self-invention might lead to this final portrayal. The most Roman of Romans is susceptible to this – Augustus's last act is to look at himself in the mirror, perhaps to see himself as the *imago* he is about to become.[45] As with reflections, these images, passed off as true likenesses, were rhetorical inventions by nearest and dearest that would persist as a reflection of the deceased well into the future. The funerary sphere at last allows the individual to demonstrate a finished identity, as death brings an end to the posturing of life.

The ability of imagery, particularly in the funerary sphere, to turn identity entirely over to a public, culturally located realm (while at the same time relying on a sense of the personal) might be seen to underlie the importance of the grave altars of Virunum and return us specifically to the exploration of provincial identity. Following a tradition recognizable across the West, Catrona, like many of her neighbours, erected her gravestone while she was living: 'viva fecit.'[46] The strategy afforded her the weird experience of seeing herself commemorated for posterity, creating an odd tension between a living, unfinished or unreconciled individual and the finished identity of the commemorated corpse. For Catrona, like the others who chose this route, these two would intersect for the rest of her life. She was able to see herself, just as in her mirror, as a finished product, one that allowed no gap between inner, 'real' identity and performed/presented identity. The declaration of 'real' identity is seen to be a performative trope in itself, particularly when confined to the funerary sphere, pressed into a highly standardized form of epigraphic Latin, the ritual of death and commemoration, and the visible manifestation of local visual and material culture.

It cannot be coincidence that much of the sniping about mirrors comes from Roman Stoics, like Seneca, who had a philosophical and political investment in demanding the fixedness of identity and character, safeguarding their sense of superiority by insisting everybody else stayed exactly who and where they were. Seneca further naturalized his own constructed stance by dismissing the mirror itself as an

inversion of nature.[47] He and his fellow moralists, ensconced in Rome, could apparently afford to scorn the mirror (though as we have seen, he used the metaphor of the mirror rather shamelessly in other works). It is interesting, in this respect, that Seneca makes his attack on mirrors a status as much as a gender issue as he spits contempt for the daughters of freedmen with their mirrors, making clear that mirrors cause a social as well as physical transformation.[48]

In this model, the mirror of the Norican grave altar does not simply serve as a gender-specific tool in contrast to the stylus of the male figure, but stands together with it as a tool of self-fashioning. Perhaps this is also where the gorgon's head comes in, emblazoned on the mirror thrust out at us in our second example. Vernant contends that Medusa might be the doorkeeper of the dead, her stare diverting the living's eye from what they cannot ever see – the dead.[49] At the same time, of course, the art of the funerary sphere is precisely the art of making the dead visible, but only as *imago*, turning the dead, or even the not quite yet dead, into stone.

Mirrors and Provinces

While the literary evidence from Rome might appear to offer useful models for avenues of investigation into Gaius and Catrona's construction of themselves and their genders, it does, of course, also stress the distance between Seneca's Rome and early second-century Virunum. However, if they were only ever intending to present themselves on a local platform, their complex place in a web of local, regional, and imperial cultural manifestations also bound them to an imperial stage, and it is in seeking avenues with which to investigate that bond that the mirror might serve its use. Perhaps that negotiation can be seen in the active transformation offered by the mirror itself, in providing and foregrounding the frame through which different identities might be mediated.

It is important here to understand that most of the sociological attempts to understand and define identity and its relationships to representation have grown in substantial part out of attempts to theorize the challenges of postcolonialism, multiculturalism, and displacement. It is a commonplace of these studies to associate the preoccupation with forging identities with loss or crisis of old identifications.[50] Postmodern ideas have grown out of a fear that the fracture

of colonialism and globalization have rendered unworkable modernist binary notions of self/other, us/them, themselves agents of marginalization, and have turned instead to the plural and hybrid.[51] Indeed, that choice has been rather enforced by the exposure of the limits of modernist, psychoanalytical terminology, for example, when applied by Fanon to Arab Algeria.[52] Fanon's experiences also remind us that identity manipulation might be considered a necessity rather than a luxury in strategies of provincial image making. In the course of the twentieth century, colonial discourse, most famously Fanon's understanding of colonization as the imposition of a white mask, has often used the metaphor of mirror and mask to understand the colonial experience.[53]

In order to function on the world stage, individuals have to learn to articulate and mobilize different identities as the occasion demands, identities that have to be demonstrated through performance and (re)presentation.[54] But, while these new identities might be enforced by violent upheaval and political suppression, 'hybridity' and 'liminality' have also been thought of as providing a creative impulse, as groups and individuals seize opportunities to manipulate the imposed mask or to look through the crooked mirror for the purposes of their own self-invention.[55]

Such identities have proved attractive as models for antiquity. The inhabitants of the Roman Empire, too, were affected by their part in a Roman world bigger than they could ever experience, and found themselves moving in new circles and facing new experiences, all of which commanded different identities.[56] The interest in applying these kinds of models to the Roman Empire is played out particularly in recent reexamination of the performance of 'Greekness' during the Second Sophistic, or in recent escalation of interest in characters like Lucian, whose own complex ethnic/cultural/social identity seems to be reflected in his work by the crooked mirror he holds up to literary and artistic tradition in an attempt to redefine the world.[57] The use of such a crooked mirror allowed those who wished to take part in the empire to do so. And for those with ambitions to succeed or in some cases to survive, there would be little choice but to channel these differences into recognizable faces. So prevalent was the ability to reflect on oneself that it is precisely as masters of words and mirrors that the inhabitants of Noricum depict themselves. Even in the purported absence of their portraits, the mirror and the Medusa mask not only make the dead

of Virunum visible but demonstrate their ability to wield and control these powerful media. In return, the transformative powers of mirror and mask provide an identity with which to confront the world.[58]

Just as these modes of interpretation move away from essentialism towards cultural interplay, they also make it harder to sustain ideas of acculturation and hybridity in their old forms, since both imply the coming together of two closed, 'finished' cultural products, in our case presuming that Catrona is the result of a Roman and a Celtic Norican identity clashing.[59] But cultures, and the identities of the people living within and across them, are not end products; they are always shifting and acclimatizing to new circumstances.[60] The search for origins, for the ultimate source of Catrona's ethnicity, dress, or grave form that is exemplified by the studies we surveyed at the beginning of this chapter, turns out to be rather fruitless in this atmosphere. As has been recognized, there is no set package of 'Romanness' (however much Roman authors tried to create a shorthand for an essence of Rome), but rather Romanness was the sum of its ever increasing parts.[61] Everything that happens within the boundaries of empire, however unconvincing, is 'Roman,' whether it is later interpreted as acculturation, hybridization, resistance, or hyphenation. After all, to the Germanic peoples on the other side of the Danube, Noricum was Rome. While Catrona's efforts may look decidedly proto- or even un-Roman, her efforts at self-representation as a Roman citizen added to the debate about what Roman was – and what she added, repeated, and performed became part of an expanding concept of Romanness, shining a mirror back on the 'centre.'[62]

Of course, such attitudes that swing the focus from the experience of self to an invention of multiple selves, shifting identity from ethnic origins to cultural behaviours, have not been popular on all fronts. Dench has been particularly harsh on the use of postmodernism and its emphasis on negotiation and multiculturalism, which she locates particularly with the analysts of material culture. Postmodern ideas of pluralities are credited with instituting an 'anything goes' mentality of a sharing, caring empire.[63] As correctives to such positive assumptions, Hingley calls for a more explicit recognition of the brutality of empire, and Mattingly reminds us of the narrow remit of the Roman experience we find in the pursuit of 'Roman' material culture.[64]

However, there are certainly ways in which heterogeneity and hege-mony can coexist. Emphasizing the process of cultural identity making through negotiation and local manipulation, and the possible socio-political inclusivity of recognition arising from such invention does not at all underestimate the political and military might of Rome. Even a province like Noricum, touted as one of the most peaceful, found itself decisively annexed and occupied following the uprising by some of its tribes during the Alpine Wars, and the real nature of Rome's relations with its provinces is shown by their abandonment when things got tricky on the northern frontier.

Bhabha recognizes that the concept of 'multiculturalism' envisaged by Western liberalism does not somehow lift us from our Western perspec-tives, as is demonstrated by our inability to cope with other visions of mul-ticulturalism and attempts to dissent from our own ideal. In other words, multiculturalism itself can be understood as a dominant force's attempt to shape the world.[65] It is perhaps from this perspective that we might be able to rescue something of the postmodern for antiquity, not by way of proposing a master plan of empire but by suggesting a possibility for investigating and understanding the varieties of the Roman experience, in which various possible modes of encountering Rome might achieve a loose vision of consensus, while also encouraging differences between dif-ferent constitutive elements of empire, and between ruled and ruler. At the same time, by appearing to set more store by culture than ethnicity, empire might be understood as removing the certainties of 'real' identi-ties, also thereby breaking down resistance by disrupting old solidarities.

As in Rome, but perhaps more decisively, the enabling effect of perfor-mance and representation and the promise of mirrors could be thrown back in provincial faces in the most brutal way at any time. Mack's rein-terpretation of the *gorgoneion* as a symbol of viewers/patrons' conquest of Medusa, rather than their defeat by her, is a reconfiguration that relies precisely on patron and viewer being the dead white males of clas-sical Athens, where both maker/patron and viewer share a viewpoint (he does not stray into the inequality of processes of production).[66] But how does that work out in terms of an unequal relationship? When the patron is a provincial woman and the perceived, central (simultane-ously non-existent and all-pervasive) eye is a Roman imperial male? Of course, this extreme inequality was usually bypassed; even the highest

official of the province, the procurator, was often a man of non-Italian origin.[67] The one moment this eye, in the temporary incarnation of Marcus Aurelius, did pass by on his way to the Marcomannic front, he probably never gave Catrona's monument a second glance. If he had, he might have had the same reaction as many later investigators: Severra with two rs indeed![68] Catrona's efforts, when put on this stage, can only be failure, reducing her title to 'Catrona Severra (*sic*)' just as, in terms of its 'linear' style, peculiarity and paucity of costume, the iconography might be described as 'Roman maid servant (*sic*).'[69]

To surrender yourself as image is to surrender yourself to the eyes of others, in what Mack calls 'visual consumption' and to invite (mis)recognition.[70] From this point of view, the emphasis on performance and appearance belies the accusation of 'anything goes' since it is actually difficult and demanding, particularly because it wipes out the reliance on certainties or 'real' identities. By relying on the images of mirrors and scrolls, these grave altars expose the workings, both validating and undermining their owners' efforts. In this model, what condemns Catrona to provincialism is not her own representation but the very act of being looked at by/from the centre (whether that vantage point is claimed by ancient contemporaries or modern academics). It is at this point that the ambiguity of the gorgon comes into play – it can be turned to or against its implied owner or viewer. If the real prize is to manipulate the enforced mask as self-representation, the loss is to have that mask confirmed as such by the eyes of others.[71] However, the exaggerated suspension and framing of Catrona's presence does not only invite speculation about how other viewers see her and interpret her 'self'-expression. The direct confrontation with the mirror and mask must also reflect back on the viewer's own 'self'-construction and positioning. It is not only Catrona's identity at stake here – even the most aristocratic 'Roman' viewer, born and bred on the Palatine or Esquiline, would have to confront the constructed nature of his Romanness.

Plutarch advised his readers to beware the flatterer, a creature easily exposed by his attempts to mirror his victim. He is to be avoided since, in that act of reflection, he will pass his falseness back to the victim, who will be lost in the mirror.[72] While emulative behaviour might be seen as one of the enabling practices of empire, it was also presented

as a fear of 'natural' Romans.[73] While apparently offering a system of adaptation, inviting cultural mimicry, they could expose that 'imitation' at any time.[74] This perhaps is a privilege of the 'centre' (or a good way of asserting 'centrality') – to seize the position of nature, either to expose the made-upness of others or to reveal their 'natural' barbarity (i.e. the centrally and latterly constructed myth of Celticness).[75] If 'real,' or ethnic, identity is to play a part in this model, it is here, at the point when the 'centre' can whip out the retort that gives the illusion of being irrefutable.[76]

This leads us to an aspect of the Virunum monuments where gender and ethnic, central and provincial, perceived and conveyed identities might, by virtue of accident but nevertheless effectively, intertwine. Many commentators have noted that it is precisely in the female costume that local 'tradition' appears to persist. Various explanations have been offered: the process of becoming Roman (particularly through army service) induces in the men good taste that diverts them from their old, loud stripes into tunics and subdued cloaks, while their parochial, stay-at-home wives retain their weakness for pattern and bling; Roman men marry local women but allow them to retain their old wardrobes.[77] Others might be tempted to class this as resistance that respects a 'Celtic tradition' of the high social status of women. However, it is also surely a sign of the locus of imperial interest in its provinces – it is the men who must be forced into compliant costumes, whether cuirassed or togate. Women may be allowed to swan about in barbarian guise.[78] There are plenty of parallels for wives and lovers allowed to parade in flamboyant costumes that their men would not dare touch. The fashion for, say, Persian umbrellas among fifth century BCE Athenian women or Antinous's Dionysus or Osiris costumes left them vulnerable to being slapped down as much as such exotica raised them up.[79]

Modern Mirrors

The perceived absence of the recipients themselves, at least in the preserved part of the grave altars, invites us to contemplate ourselves in the apparently empty mirror offered from the past. But have we inherited control over or are we entrapped by the Medusa? Hingley, in Chapter Three, twice

uses the metaphor of the mirror to explain the way we search for the present in the past. The Klagenfurt mirrors offer an excellent opportunity to reflect on our own cultural identities and the ways in which we fashion ourselves in the light of the 'Romanization' of northern Europe.

The account of Noricum in the 1921 guidebook to the Klagenfurt Landesmuseum stresses its inhabitants' lives of dignity and well-being; Noricum had been the most advanced Celtic nation and enjoyed constructive relations with the Romans, who had annexed the area peacefully. It was not Romans but aggressive Germans who had disrupted the good life. Such conceptions, not peculiar to this publication, involve overlooking both the uprising and subsequent punishment.[80]

Thirty-odd years later, this positive picture of the area's Celtic heritage took on new acuity as Austrians struggled to found a cultural and ethnic heritage for a country that was negotiating independence following World War II, during which Anschluss had entailed its complete disappearance. In 1951, four years before the State Treaty was signed, an article in the journal *Carinthia* traced the Celtic roots of Noricum. Through an account of Celtic material culture, the author carves out an Austria that is neither Germanic nor Slavic. The Celts made their greatest achievement, the regnum noricum, on Austrian soil, and the reassertion of the 'Celticness' of the people can be found in the Medieval period, during which the Celtic combined with the Christian. Our girl with the Medusa mirror, meanwhile, demonstrates the continuity of Celtic identity during the Roman era.[81] The conclusions are particularly interesting since the emergent state authorities had made clear that it would be culture that would forge a sense of unity amongst a politically and ethnically diverse people.[82]

The assertion of a Celtic population, so enthusiastically proposed in *Carinthia*, had a very particular, regional resonance. The journal had started in 1811, its name referring to the area of the Habsburg empire, which since the end of World War I has been split into two, becoming Kärnten in Austria and Koroška in Slovenia. Like many areas divided by the postwar treaties, the division was artificial and painful. Many Slavs still live as a minority in Austrian Kärnten, their presence already acknowledged and contained in the State Treaty, and their ethnic and cultural identity still a matter of some contention.[83] It would seem that the mirrors of Virunum continue to cast a strong reflection.

Notes

1. Ewald 2004, 230.
2. See Suleri 1995, 174–75, talking of self-portraiture and autobiography.
3. Isayev, in Chapter Eight, emphasizes the difficulties of extrapolating pre-Roman 'local' traditions from the perspective of Roman-imposed units, such as the province. Roman rule obliterates conquered peoples' pasts as well as their presents and futures.
4. Garbsch 1965, cat. 81.7; Piccottini 1996, 86.
5. These numbers are not exhaustive. They represent the grave altars that are explicitly attributed with mirrors in Garbsch 1965. It should be noted that Garbsch's inventory (136–63) is chiefly concerned with costume rather than props. Three other examples come from Tirol, Niederösterreich, and Oberösterreich. An updated list can be found in Pochmarski 2004.
6. Garbsch 1965, cat. 30; Egger 1921, 40.
7. See, for example, Zahlhaas 1975, 60–2. Balensiefen 1990, 169–70, notes that the mirror itself may have had explicitly funerary associations.
8. Pochmarski 2004, 166–74, considers the identities that have been attributed to these female figures. Almost all commentators consider them to be subservient to the deceased, either slaves or daughters, and Pochmarski attempts to separate the two types. The assumption of slavery is traced back to Diez 1953. Garbsch 1965, 11, does not consider them to be slaves.
9. Kremer 2004, 147–59, discusses the funerary monument types of the area and explores the contributions they might make to conceptions of 'local' identity.
10. Schober 1923, 177–82.
11. Fanon 1968 [1952], 17–62, notes that language is one of the most effective masking tools a colonizing power inflicts on its colonies, limiting the ability of the colonized to express themselves in any other form than that prescribed by the ruling power. See also Goldman 1995, 120–1.
12. Schober 1923, 183–225, esp. 209, 221–5. Now overtaken by Kremer 2004.
13. Their peculiarity or 'locality' is demonstrated through comparison with the body and costume types discussed by Alexandridis in Chapter Ten.
14. A clear division can be seen in terms of props, with the Pannonian girls being preoccupied by sacrifice, and the Norican ones with dressing and washing. In this respect, the Norican figures might be more closely linked to those appearing on Aquileian grave altars, though their dress is distinctly different from their Italian neighbours: see Garbsch 1965, 10–11. Gabelmann 1987, 299, also points out that the grave altar reliefs of Aquileia seem to show the dead rather than servants.
15. For instance, while the 'maidens' of Noricum and Pannonia are easily distinguished in terms of props, dress habits are very similar, with the exception of north-west Pannonia, where the girls wear an armless overgarment with a broader girdle, headgear, and even jewellery: see Garbsch 1965, 4–10. The most localized peculiarities seem to lie in hat types (interestingly the part of the outfit that Garbsch identifies as the most obviously un-Roman). His conclusion is that Virunum is more 'Romanized' than Flavia.
16. Garbsch 1965, 128–32. He also notes that the wing brooches are generally more popular in examples from the north, and that the southern parts of both provinces seeming increasingly to prefer double knot brooches: 119–20.

17. Gallia Belgica: Wyke 1994, fig. 1. Aquileia: Ferri 1933, fig. 572. Gabelmann 1987, 296–9, demonstrates that the image of the mirror/hairdo preoccupied woman is popular across the northern provinces in the second and third centuries.

18. Garbsch 1965, 126, suggests that the group identities expressed in Norican costume are on the scale of 'local' rather than 'tribal' or 'ethnic.'

19. Here following Antonaccio (Chapter Two) that material culture can be constitutive of identity.

20. Von Hesberg 2008 discusses the appearance of 'local' women in funerary contexts in the provinces immediately to the west of Noricum. Although they are dressed in what we might assume are local fashions, he stresses that their clothes and poses conform very closely to Roman conceptions of decorum and status. He notes how one woman strikes the pose of one of the Herculaneum woman types, showing an intriguing and complex reception of and insertion into the traditions investigated in Alexandridis's Chapter Ten. I am very grateful to Henner von Hesberg for allowing me to read this paper ahead of publication.

21. Buckler and Calder 1939, no. 24, pl. 6, no. 365, pl. 63.

22. Mattingly 1997a, 11 warns against assuming that provincial art always looks directly to central models.

23. Wyke 1994, 142.

24. Apuleius *Met.* 2.9. Ovid *Medic. Faciei. Fem.* 67–8. See also Martial *Epig.* 11.50; Ovid *Am.* 2.17.7–10; Propertius 3.6.10. Aphrodite shared these translucent properties: *Hom. Hymn.* 5.84–88, 161–6, 172–5. Vernant and Frontisi-Ducroux 1997, 102–3; Richlin 1995. McCarty 1989 provides a full account of the role of the mirror in ancient literature.

25. Ovid, *Ars Am.* 3.113–28; Horace *Odes* 1.19.6. Wyke 1994, 138.

26. Their close association with mirrors is stressed in the *Anth. Pal.* 6.1; 6.18–20; 6.211.

27. Wyke 1994, 146–8. Wyke and Richlin 1995 stress the performative nature of femininity, a state achieved only through the medium of the mirror and the mask of cosmetics. See also Vernant and Frontisi Ducroux 1997, 53–71.

28. Seneca had much to say about mirrors: *QN* 1.15.7–8, 1.16.8, 1.17.4–10. The Greeks had also associated mirrors with the East. Eurip. *Or.* 1111–13, *Hec.* 925. Clement of Alex. *Paid.* 3.2.11; Tertullian *De Cult Fem.*

29. Richlin 1995, 185, opens with this comparison.

30. Lucian, *Imagines* 1.

31. This is supported by the substitution of a gorgon for an expected mirror image elsewhere in Roman art: for example, see Elsner 2000; and Platt 2002, 92–4. Both offer readings inspired by Lacan. In a modern context, Armstrong 1989 offers some interesting observations of the ways in which the mirror might disrupt the Lacanian construct of the male gaze.

32. Statius *Silv.* 3.4.93–98; Martial *Epig.* 9.16. See also Aulus Gellius *NA* 6.12.5; Juvenal *Sat.* 2.99–100; Macrobius *Sat.* 3.13.4.

33. Seneca *QN* 1.16.1–16. Bartsch 2006 provides an alternative reading of this episode, concentrating on the philosophical implications of the mirror.

34. In a rather familiar Roman trope of role reversal, it takes his slaves to act as the moral voice, to recognize his barbarism, and to kill him.

35. Vernant and Frontisi Ducroux 1997, 155–76, discuss this paradoxical nature of the mirror.

36. Sen. *De Clem.* 1.1.
37. Bartsch 1994; D'Arms 1999, 301–19. The concepts of performativity and theatricality are presented in Parker and Sedgwick 1995, 1–18; and Davis and Postlewait 2003, 1–39.
38. Huskinson 2000, 100, moves the idea of performativity to a broader discussion of Roman identity. In Chapter Two, Antonaccio alludes to the concept of performed identities in a different context.
39. One of the ways in which such constructed ideas of manliness could be verified as 'natural' was through the application of such emergent sciences as physiognomics, which stressed the importance of appearance and deportment. See Gleason 1995, 55–81; and Barton 1994, 95–131.
40. Corbeill 2002, 182–215, explores the deliberate exploitation of this trope. Wyke 1994, 145, notes that the feminine was used as metaphor in oratory for the use of Greek techniques and flourishes, creating a triangle of woman/foreign/made up.
41. Henderson 2002; Hall 1990, 222; Steyn 1997, 1.
42. See, for example, Caiuby-Novaes 1997, ix–xvii, and Strauss 1969, 9–14.
43. Rutherford 1990b, 236.
44. Hall 1990, 226.
45. Flower 1996, 60–127, on the role of these funerary imagines; and 256–69, on their survival in the period of the Klagenfurt monuments. Suet. *Aug.* 99.
46. This reminds us that social status is not only conveyed by the (lack of) portraits standing in for the individual but also the very act of erecting the grave altar. Alexandridis (Chapter Ten) also notes the performance of erecting monuments.
47. Sen. *QN.* 1.15.7–8, 1.16.8, 1.17.4–10.
48. Sen. *QN.* 1.17.9. Freedmen, of course, were also enthusiastic funerary commissioners.
49. Vernant 1991, 111–50, esp. 121, 141–2, 153. In a Lacanian model, identification, the point at which the subject recognizes him/herself in the mirror, is also a kind of death, where the self becomes exteriorized representation. Zahlhaas 1975, 60, insists that the Klagenfurt Medusa has nothing to do with the mirror on which it is depicted. Riva (Chapter Four) mentions gorgoneia used in seventh/sixth century BCE funerary contexts.
50. Mercer 1990, 43; Hall 1992, 275; Steyn 1997, 4. Porter 2001, 84–5, recognizes this in the case of Pausanias.
51. Rutherford 1990a, 9–27; Steyn 1997, 1–6. Pajaczowski 1997, 101–12, discusses how Europeans are having to reinvent their old viewpoints of self and others.
52. Young 1990, 188–9.
53. Fanon 1968 [1952]. For another example, see Hallesten 1995, 76.
54. See, for example, Diawara 1995, 202–11, on the importance of performance, and Caiuby-Novaes 1997, xv, on self-representation, also noting that this puts more stress on the cultural sphere as the locus of 'identity.' Featherstone 1995 probes this relationship further.
55. Hall 1992; Steyn 1997, 1–6; Henderson 1995, 2–5.
56. Webster and Cooper 1996, 1–17, and Mattingly 1997b, 7–26, provide commentary on how such approaches have allowed us to look at the 'peripheries' of empire.
57. Goldhill 2001, 19–20; Whitmarsh 2001, 269–305. On Lucian, see Porter 2001, 90; and Branham 1989, 167–72, 213–15.

58. Mack 2002, 571–604, provides a reappraisal of the role of the material manifestation of the gorgon, precisely as a tool that the viewer/commissioner can appropriate and manipulate. Bhabha 1994, 52–7, provides a modern comparison, with his conception of the 'evil eye.'

59. Though Dench 2005, 292–7, points out the limits to this apparent inclusive attitude: the Aethiops. The inability to incorporate the black African perhaps should be taken into account when declaring the Roman empire as a more inclusive model of empire than the modern European empires. In these empires, most discourse is precisely predicated on the polarities of white colonizer/black colonized. Fanon 1968 [1952] is the most obvious example here. Interestingly, while the heterogenity of Rome has been a popular idea for some time now, the heterogeneity and 'unfinishedness' of other groups, such as Celts, has been less readily recognized. See Webster 1996a. Like early anthropologists, we continue to search for untouched tribes. See Hardt and Negri 2000, 124–6.

60. For a crosscultural comparison, see Cauiby-Novaes 1997, 1–16.

61. The absence of a straightforward material definition of what is Roman has been underscored in many places – for example, Mattingly 1997b, 17; Hingley 1996, 41–7.

62. Woolf 1998, 11, suggests the idea of the 'debate.'

63. Dench 2005, 4–35. The complex relationship between antiquity and postmodernity is hinted at in Featherstone 1995, 81. While Dench and others accuse peers of using postmodernity to impose on antiquity, Featherstone uses antiquity (specifically the Roman empire) as a mode through which to chart an origin for his own concept of postmodern identities. Vout 2003, 201, also worries about an 'anything goes' scholarship. Similar reservations have been expressed in other disciplines, e.g., Mercer 1990, 55–6. However, Bhabha (Rutherford 1990b, 218) expresses the fear that the rejection of postmodernism leaves only a return to modernism, an intellectual position that is inseparable from the stances of imperialism and colonialism. See Featherstone 1995, 1–14; Hardt and Negri 2000, 69–113.

64. Hingley, Chapter Three, and Hingley 1997, 81–102. Mattingly, Chapter Eleven, and Mattingly 1996, 49–69.

65. Bhahba (Rutherford 1990b, 208). Hardt and Negri 2000, 137–59, also see the exploitation of hybridity as a main feature of the success of empire, and suggest that it is the 'winners' of empire who generally encourage multiculturalism. Sardar 1997 writes of the difficulties of achieving a hybrid/multicultural identity.

66. Mack 2002, 593–8.

67. Alföldy 1974, 79–81.

68. Is this a moment, as Hingley (Chapter Three) suggests, in which integration ends in exclusion – in which Catrona's efforts to master a Roman name are exposed?

69. See Alföldy 1974, 140, on the nature of 'Norican' art.

70. Mack 2002, 578. The idea of womanhood might be a case in point. What appears to be a common conception foregrounds some vague commonalities but disguises deep, local differences.

71. Goldman 1995 discusses how Dubois and Fanon theorized black subjugation to the white mask and recommended resistance through such manipulation. The success of this strategy was later played out in terms of Algerian

resistance: by assuming white masks (in this case, by removing the veil), Arab women were able to take weapons past French checkpoints. See Fuss 1994.

72. Plutarch *Mor.* 53a.

73. A minor example: when criticized for his lavish villas, Lucullus's retort is that his freedman neighbour has a huge pile and that someone of his own aristocratic status should be able to exert his superiority over such upstart behaviour. Cicero *De Leg.* 3.13.30.

74. Fanon 1968 [1952], 21–42, notes this as one of the tensions of the colonial experience. The colonizers simultaneously insist that the colonized act like them while emphasizing that they can never be them.

75. It is possible for that centre of natural manhood to lie elsewhere: look at moments when a Greek author explicitly shows Vindex the Gaul acting as avenger to the effeminate, alien nature of Neronian Rome (Dio 63.22.1–6). O'Gorman 1993 provides an excellent discussion of moments when Romanness might be located in barbarians. On constructions of Celticness, see Webster 1996a, and James 1999a.

76. Dench 2005, 222–97, illuminates how 'ethnicity' still lurks behind declarations of ancient identities that have been recently understood as cultural/performative.

77. Garbsch 1965, 3; Kenner 1951, 570–1. Egger 1921, 15–17, believes conservative female dress and many cults are the only local traditions surviving under the Romans. Kremer 2004, 153–6, offers a more theoretical analysis of these gender differences.

78. Webster 1997b, 170–5, cites this as part of two possible readings for the prominence of the Celtic female in the syncretic gods of Roman Britain. Kenner 1951, 581–2, speaks of how the grave reliefs show gender equality in Celtic society. As von Hesberg 2008 stresses, a wider Roman audience, however, would be acquainted with the Celtic female in a less flattering context – the trophy, in which defeated provinces are personified by the feminine. The intersection between gender and culture in terms of identities under empire is clearly a rich source, here also represented by the earlier mentioned female resistance fighters in Algeria. See Fuss 1994.

79. On the Attic fashion for *Perserie*, see Llewellyn-Jones, Chapter Seven, and Miller 1997. For Antinous' costumes see Meyer 1991, 231–5.

80. Egger 1921, 1–19.

81. Kenner 1951. His conclusion (593) reminded readers that, although the Celts were now lost, they were not dead because Austrians lived with their inheritance and, most importantly, that modern Austria had grown from their greatest creation (*ihrer größten Schöpfung*), the regnum Noricum. The Vienna correspondent to *The Times*, 3 January 1950, expressed similar thoughts, promoting the similarities between the ancient and modern female costumes of Austria. Mattingly 1996, 55–6, talks about how the French, too, have been able to construct a positive narrative of the Celts' Roman occupation experiences.

82. Bushell 1996a provides a useful introduction to the ways in which culture was deployed to create an Austrian sense of Western, Christian nationhood. Hall 1992, 293–7, theorizes such impulses.

83. Barker 1996, 42 quotes Article 7 of the State Treaty, which deals with the minorities of Austria. See Barker 1984 for a more recent (outsider's) perspective on the question of the Slovenes of Kärnten.

NEUTRAL BODIES? FEMALE PORTRAIT STATUE TYPES FROM THE LATE REPUBLIC TO THE SECOND CENTURY CE

Annetta Alexandridis

The question as to whether and how material objects can be interpreted as markers of identity or identities seems to be easy to answer when one analyses portrait statues. In contrast to ceramics, for example, the primary purpose of these artefacts was to represent individuals, which means they had to be in some way recognizable as such. The problem of how to interpret these 'materialized identities' nevertheless remains a complicated one.

The erection of a portrait statue and the effect it had was the result of a number of different individual agencies and perceptions and their interaction: the sculptor's or producer's, the commissioner's or purchaser's, the honoured person's and the beholder's to name the most important ones. So, in every single (inter)action, different identities would be at work.[1] They influenced the external aspect of the object, the portrait statue, be it in terms of its style, quality, size, material, and its display, as well as in terms of perception of the piece.

In a specific context we might be able to get a more complex idea of the interactions and the identities that were effective, but in any case we will never be able to reconstruct these identities other than in an idealized form.[2] Individual agencies aside, how much and which parts of these identities are due to more general or collective factors of one or more other natures, such as gender, social, ethnic, cultural, and/or historical?[3] How are these individual and collective identities related to each other?

My aim here is to show how closely intertwined global and local, or homogeneous and heterogeneous, aspects of identity are when it comes to representing an individual. I focus on replicated body types of female portrait statues of the Roman Empire, particularly regions like Italy, Greece, and Asia Minor, which offer the best evidence of such statues. Until recently these statues have not been considered in their own right because of their uniformity. However, it is their homogeneity that provides the key to the statue types' heterogeneity over time and space.

Since the 1990s, studies on globalization have criticized a false dichotomy set up between the global (general, homogeneous, or 'universal time') and the local (individual, heterogeneous, or 'particularistic space') and instead stressed the interdependence of both levels, that is, they understand globalization as 'glocalization' or hybridization.[4] In the context of studies on the Roman Empire, this approach allows us to explain cultural diversity, not in addition to or against, but precisely as a result of homogenizing forces of the colonizing power. Drawing on this assumption, I shall first explore the hybrid qualities of the statue types themselves, in space – as an effect of the practice of copying – and in time – as an effect of their performativity.

Sameness as Hybridity: Copying as a Glocal Practice

From the fourth century BCE onwards, women in the Greek world who rendered outstanding services to the community were honoured by the erection of a portrait statue. The statue types developed for this purpose, such as the so-called Herculaneum women (see Figures 10.3 and 10.4), and especially the Pudicitia types (see Figures 10.1 and 10.2), were very popular in Hellenistic times.[5] In Rome, however, the representation of women in a public display became a matter of course only in the late first century BCE. It seems that together with the practice of commemorating women in public, the Romans adopted the statue types created for this purpose in the Greek East and used them until at least the third century CE. Whether in an honorific or funerary context, the types were distributed in several areas around the Mediterranean, especially Italy, North Africa, Greece, and Asia Minor (see Figures 10.8 and 10.9). The broad distribution of some of the statues' body types was due to the globalizing

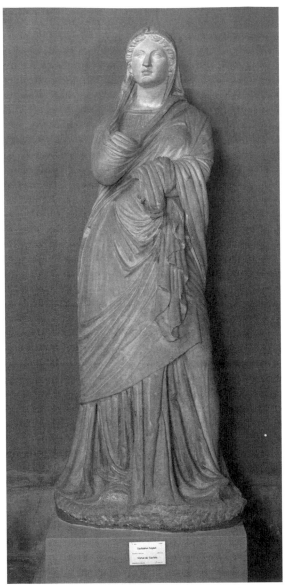

10.1. Statue of Saufeia from Magnesia, Pudicitia type, late second century BCE (Istanbul, Mus. Inv. no. 606, copyright DAI Istanbul, neg. no. 68/133)

effect of the Roman Empire: an increasing infrastructure guaranteed the exchange and copying of standard models for statue types to a degree never reached before.[6] At the same time, the tendency to honour women publicly by the erection of a portrait statue increased significantly in comparison with Hellenistic times.[7]

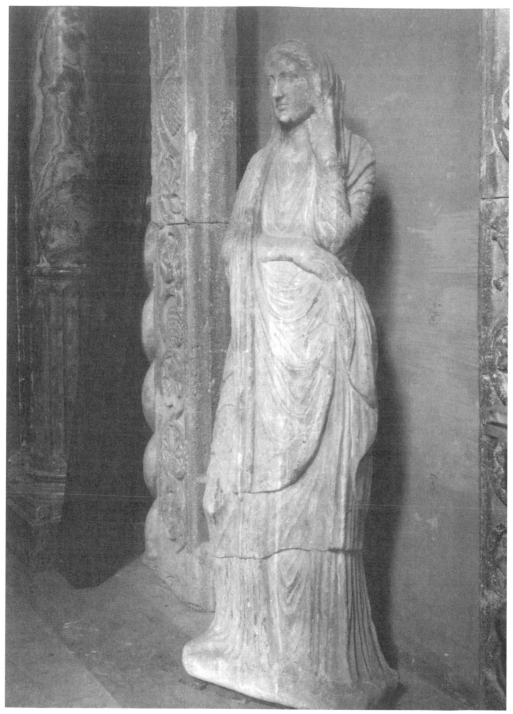

10.2. Statue of an unidentified woman from Rome, Pudicitia type, Augustan period (Photo: Felbermeyer, Rome, Via Barberini 97, property of KLM, copyright DAI Rom Inst., neg. no. 1932/1362)

Technology and infrastructure for the production and distribution of copies thus provided the global conditions for an increasing number of portrait statues on a local level. Whereas in some areas this seems to have been an innovation, as for instance in southern France and the Iberian Peninsula,[8] in others, such as the regions of Italy and the Greek East, older traditions were reinforced.[9] On a local level, therefore, the reliance upon 'global' models in the Roman Empire could have different effects: either they provided a form of modernity, and thus clear and unique distinction, or they stressed tradition. In some cases, the statues' meaning was specified, for example by the addition of a particularly Roman dress, such as the *stola*, and fine leather shoes (*calcei muliebres*). Furthermore, the statues erected in the Greek East under the Roman Empire showed different degrees of how both representational traditions could intermingle. They combined a body type that was of Greek origin but was replicated following the Roman practice, with either an idealized (as in Figure 10.3) or a more individualized face (see Figure 10.4), that is to say with a portrait either in a Greek or Roman tradition. The last case is especially striking because it points to a different body concept: whereas in Greek tradition the head and rest of the body are seen as a unity, in the Roman tradition they are conceived as separate entities.[10]

The interplay between global structure and local choices, or homogeneity and difference, thus is also effective within the likenesses themselves. Whereas in Roman (Republican) tradition, the portrait heads visualized difference by a more or less individualized physiognomy, hairstyle, or indication of age, the rest of the statues' bodies visualized sameness by replicating a limited selection of poses and garments.[11] At the same time, the portrait heads corresponded to general developments in representational modes or style,[12] whereas the bodies could differ in detail by attributes, drapery, or style. The statue types themselves were in most cases of Greek origin or relied heavily on Greek models.

Although Antonaccio (Chapter Two) and Hingley (Chapter Three) are right in reminding us of the simplification or the problematic ideological assumptions that lie in such terms as 'Greek' or 'Roman' and 'Hellenization' or 'Romanization' respectively,[13] we probably cannot manage without these labels. It is exactly because it is almost impossible to disentangle the different global, local, and individual aspects working together in every single object that I find these terms still

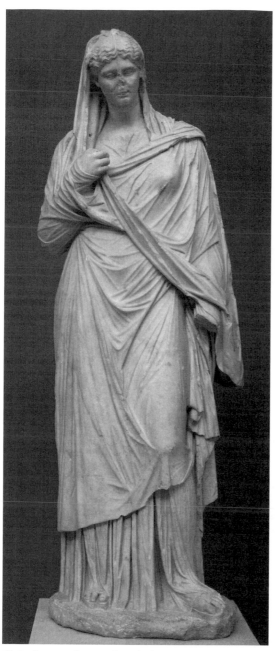

10.3. Statue of an unidentified woman from Athens, Large Herculaneum woman type, Hadrianic period (Athens, National Archaeological Museum Inv. no. 3622, copyright Judith Barringer)

10.4. Statue of Athenais from the Nymphaeum of Herodes Atticus in Olympia, Small Herculaneum woman type, Antonine period (Photo: Gösta Hellner, Olympia, Mus. Inv. no. 141, copyright DAI Athen Inst., neg. no. 79/400)

useful and necessary for heuristic reasons, if we want to describe either the homogenizing effects or some of the very striking elements of a cultural encounter. It goes without saying that this 'labelling' is done from an external perspective, but otherwise we would 'suffocate' in 'thick descriptions' without being able to discern change. In other words, we need these more static terms to describe hybridity as a form of cultural dynamics.[14]

In the case of the statue types here discussed, the terms 'Greek' and 'Roman' can help to highlight the interaction of different cultural traditions. The use of Greek models had a 'Hellenizing' effect in the sense of an externally unifying one. This does not mean that the statue types were copied because of their specific 'Greekness' – perhaps they would not even have been recognized as 'Greek,' but were only perceived as a sign of belonging to a broader elite culture. Most probably they just provided an example of how to represent an honourable woman in public.[15] They may have comprised the notion of 'Greek' only in certain regions and/or at certain periods. However, independent from the meaning of the Greek form, external homogeneity was also reached in both quantitative terms, by the number of statues produced, and qualitative terms, the copies being quite exact replicas of one original. Part of the statue types' 'success' thus was not due to the Greek models, but to the mechanisms of distribution and copying, which appear to be more specifically Roman. In this sense, the exact copy of a Greek original is already a hybrid in itself, homogeneity an effect of heterogeneity.

The general picture differs significantly from the situation in the Greek East world in Hellenistic times. Although the statues that were erected for female citizens at that time adopted a common formal scheme, for example, the so-called Pudicitia, they did not replicate one model exactly, but instead offered a broad, although subtle, variety as to drapery and pose. The portrait heads, however, had much more idealized facial features and showed only minor, if any, differences in hairstyle (usually in the so-called melon style) and physiognomy (see Figure 10.1).[16]

Sameness as Hybridity: Replication and Performativity

The female likenesses I analyse are firmly tied to social identity, as the women whom they were meant to represent belonged to a certain kind

of elite – of status, descent, or wealth.[17] This much is evident from the fact that their families could afford the erection of a portrait statue or that the represented women themselves were prominent enough to be commemorated. In most cases, the statues will have been erected by male relatives or male officials. But the continuous copying of the statue types as well as their omnipresence, be it in public or in a more private sphere either as honorary or as funerary statues, meant that they were seen also by women and other people who did not belong to the elite. It is then not so much as objects but as images that they had their broadest effect. And I assume that the statues thus not only reproduced, but also engendered in the imagination of both sexes and of different social strata a certain idea or image of the exemplary way in which a female of the higher and/or wealthy society should appear. This is especially striking on Attic grave reliefs of the imperial period, where females are often represented in a Pudicitia or one of the Herculaneum women types. The dedicants as well as the grave owners seem to have been freedmen for the most part.[18]

Thus, in the case of the elite women themselves, external and internal identities could converge. For others the statues provided images of different aspects of cultural, social, and gender identities, by visualizing either sameness or difference, even if these persons were neither represented nor involved themselves in the statues' production and erection. So, even if these likenesses as objects belonged to an elite culture, the visual and mental images they provided or caused were nevertheless shared by a broader part of the society. Following Gell's concept of the agency of objects, one could speak here of the agency of images, an agency that was effective on a global as well as a local level and that either generated or changed the meaning of an object.[19]

How can we interpret these statues or 'materialized images' that were used to represent the individual, female, social, and cultural identity of a specific person at a given time and place? If we assume that an intermingling of the general and the individual, of homogeneity and diversity – or of global and local culture, in Hingley's case – is at the core of the idea of 'identity,' how can we discern the specific elements working together to represent identity in a particular case as they seem to be inseparably entwined? In the context of Roman portraiture, research for a long time mainly focused either on the

'Roman' portrait heads or on typology, as well as questions of dat-
ing, workshops, and regional style of the statues' bodies. The statue
body types' meaning, however, seems to have been relevant only when
it came to reconstructing the (presupposed) Greek original. The fact
that these body types formed the major and visually predominant
part of a female portrait statue in Hellenistic and especially Roman
imperial times has been in most cases neglected. Many scholars sup-
posed that Roman copies reproduced not only the external form of
Greek statue types, but also their original meaning (whatever that
was); others suggested that using a Greek statue type was a deliber-
ate sign of Greek education or affinity to Greek culture. The broad
chronological and geographical distribution of the most common of
these types was taken by others as a proof that they were 'neutral
bodies,' especially in cases when no attributes had been added.[20] Two
major traditions in the study of ancient art are still effective within
all of these approaches, although they have been challenged in the
last decades: first, the idea of the artistically valuable and therefore
meaningful Greek original as opposed to the artistically worthless
Roman copies; second, the focus on portrait heads as an artistic
genre conceived to be 'genuinely' Roman, which is closely linked to
the modern assumption that only the face holds the 'message' of a
portrait, whereas the statue's replicated bodies seem to be excluded
from this concept of a likeness.

 Therefore, I want to focus on the replicated body types of the stat-
ues as material evidence in their own right to explore their content.
Male figures in the so-called ideal nude or wearing the toga, a Greek
himation or armour, or female portrait statues in the guise of Venus or
Artemis give very explicit hints as to their meaning.[21] But faced with
female body types completely covered by cloth and only differing in
the way the drapery is displayed, one seems to be helpless. Gestures,
poses, and even clothing itself are often difficult to explain of their
own accord.[22]

 There are two ways to face the problem of how to interpret the copies
of the statue types. The first one contextualizes by reconstructing their
original setting. In an important article, Jennifer Trimble demonstrates
how the reduced focus on two statues out of the whole set that was on
display in the theatre of Herculaneum caused a misreading of the famous

statue types of the so-called Large and Small Herculaneum women.[23] Contrary to the traditional interpretation, she shows that both statue types were never meant to represent the goddesses Demeter and Kore, but had originally been created as honorary statue types in the late fourth century BCE.

Unfortunately, in the majority of cases, the female statues are headless, and their original context and display are known only vaguely, if not completely unknown. Therefore, I propose a second approach, one that follows the statue types over time and focuses on the meaning they adopted through use. I want to point out that this more 'globalizing' approach does not conflict with the first, more 'localizing' one I have just mentioned, but that both approaches complement one another.

Following Judith Butler's concept of performativity, one can argue that the process of copying statue types offers a special dynamic in reaffirming and at the same time transforming the meaning of certain representational modes.[24] Repetition is not only involved in producing the copy as static object or fixed form, but also in the dynamic and fluid process of selecting, erecting, and beholding it or in simply imagining it. The imagining of identities thus becomes a performative act, and the statues both reflect and condition it.[25] It is due to their performative quality that the statue types were used to represent certain gender, social, or cultural identities, or rather a combination of all these. The repetition of one statue type in different chronological, geographical, and functional contexts had a reaffirming effect, and it indicates that the particular type must have possessed something like an overall meaning. It seems to have embodied a female ideal valid in the whole Greek world and most parts of the Roman Empire for many centuries. The meaning of the statue type as well as the ideal appearance it embodied were, on the one hand, reaffirmed with every new copy.[26] On the other hand, however, it is exactly the repetition of a statue type in different contexts that could at the same time create new meanings, or a widening or shift of meaning. So, for example, when a certain statue type was chosen very frequently for portrait statues, it could become less attractive for people who were looking for a more exclusive way to be represented. In contrast, the 'usurpation' of more exclusive ways of representation by 'outsiders' (people who usually would not use this specific form of representation) could have a subversive effect, even if

it was meant to be an act of appropriation in the positive sense, as in the case of theomorphic likenesses or a *stola* worn by a freedwoman.[27] Or, depending on the beholder and against the intention of the commissioner, it could simply seem inappropriate or even ridiculous.[28] If pursued over a longer period of time, the process of copying would finally break down the exclusivity of a specific way of representation, but it would also break down the disturbing effect of images that had adopted it inappropriately.[29]

That is exactly what happened to portrait statues in the guise of goddesses in Italy. In earlier Julio-Claudian times they seem to have been a privilege of members of the imperial family, be it in public or in private contexts. Under Claudius, theomorphic likenesses were adopted probably firstly by imperial freedmen. This had a certainly unintended subversive effect in that these images lost their exclusivity. And what might have been inappropriate in the eyes of some traditionalists became less scandalizing by the effects of repetition. Subsequently, theomorphic images are to be found more and more often in private/non-imperial funerary portraiture. Finally, they again make their way up the social scale: the assimilation to Greek gods and heroic figures is very popular on Roman sarcophagi in the second and third centuries CE that were commissioned by wealthy and or noble Romans.[30]

Portrait Statue Types and Identities

In the following, I focus upon some of the most common statue types, the so-called Pudicitia types (as Figures 10.1 and 10.2 exemplify), the Herculaneum women (of Figures 10.3 and 10.4), and the so-called Ceres type (of Figure 10.5), by comparing them with some rarely used types (shown in Figure 10.6).[31] The statues mainly come from Italy (especially Latium and Campania) and date from the period of the first century BCE to the second century CE. For analytical reasons, I will pick out different aspects of identity (gender, social, cultural), putting them together step by step, although all of them are closely linked to each other. We will only be able to discern more or less vague 'fields' of meaning that once could have been decisive for choosing a statue type for a given place or time or person. But this nevertheless proves that the statue types were not 'neutral bodies' at all.

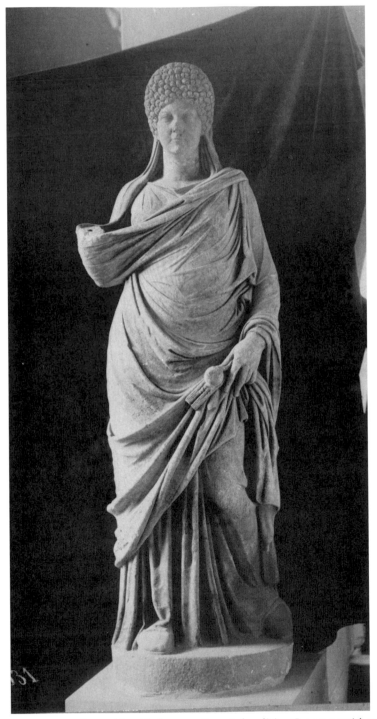

10.5. Statue of an unidentified woman from Aphrodisias, Ceres type with ears of wheat and poppies, Trajanic period (Istanbul, Mus. Inv. no. 2269 T, copyright DAI Istanbul R35.462 Repro)

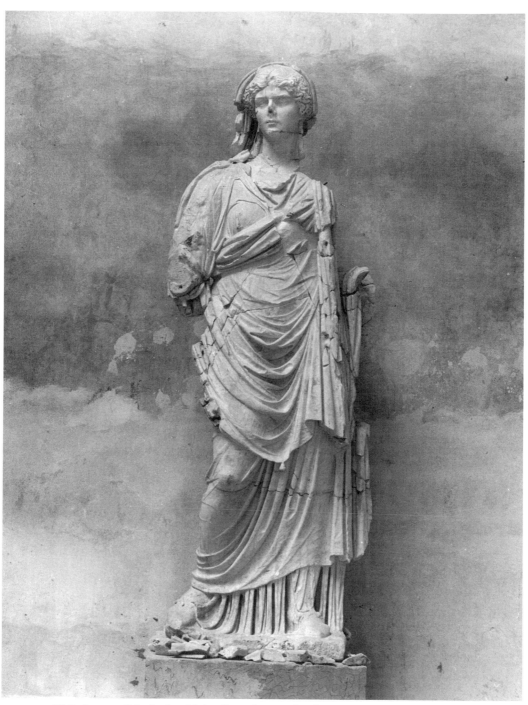

10.6. Statue of Agrippina Maior from the temple of Augustus and Roma at Leptis Magna, Leptis-Grosseto type, Tiberian period (Photo: Sichtermann, Tripoli, Museum, copyright DAI Rom Inst., neg. no. 58.152)

Female Identities

Pudicitia types and the Herculaneum women are among the most popular statue types from the Late Republic to the second century CE. The Pudicitia types are more appropriately considered as a scheme, because we know of several different types, although there are some characteristic features: the woman is completely wrapped in cloth; one arm lies across the body; the other arm is bent, with the elbow resting on the first arm; and with her hand, the woman supports her chin or cheek or grasps the edge of her veil (as shown in Figures 10.1 and 10.2).[32]

The Herculaneum women, both the Large and the Small, are clad in a *chiton* or undergarment and a *himation*, which wraps their left arm and hand more or less completely (as shown in Figures 10.3 and 10.4). Both differ particularly in the way the drapery is displayed. The Large Herculaneum woman pulls the cloak over her breast, thus creating a characteristic diagonal motif of folds. Her head is shown veiled in most copies. The Small Herculaneum woman appears mainly unveiled. She seems to put the mantle, which has come down from her left shoulder, back in its place.[33]

From Hellenistic times up to the Early Empire, Pudicitia types and Herculaneum women were used as 'bodies' for portrait statues in the Greek East as well as in Italy. This tradition ceased during the Julio-Claudian period. It is only at the end of the first century CE that these statue types regained their popularity. In the second century CE, they can be considered to be the most favoured statue types ever (see Figure 10.7).[34]

The fact that, in both periods of use, in some very few but significant cases they were provided with two different kinds of attributes indicates that they could be adapted to the actual ideal image of a (Roman) woman. In the Late Republic and beginning of the Empire, Pudicitia types in Italy, especially, are given elements of Roman costume, such as *calcei muliebres*, particularly fine leather shoes, and the *stola*, a garment to be worn by the Roman *matrona*, a married Roman female citizen.[35] These elements of dress not only indicated the social and juridical status of the woman represented, but also alluded to her ideal female qualities, as we can discern from funerary inscriptions and *laudationes funebrae* (funeral eulogies). According to these texts, the canon of Roman female virtues consisted of *fecunditas, castitas, gravitas, pulchritudo,* and *pietas*.[36] Although

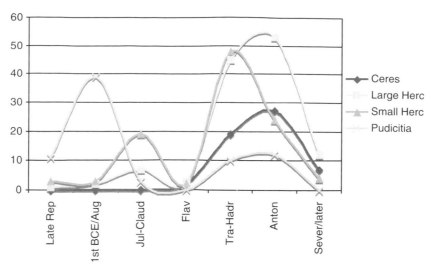

10.7. Chronological distribution of statue types

Greek by origin, the Pudicitia type seems to have been compatible to this specific image of a Roman *matrona*. Apparently, there existed something like a general idea in Italy and the Greek East as to a woman's ideal physical appearance and moral qualities. All the more so, as some of the virtues mentioned above correspond to the Greek *sophrosyne*, *eukosmia*, or *eusebeia*, attested also in the epigraphic evidence.[37]

When the Pudicitia types and Herculaneum women were reestablished at the end of the first century CE, instead of Roman costume, a bunch of ears of wheat and of poppies was sometimes added to the copies. This occurred especially with the Large Herculaneum woman type. Ears of wheat and poppies are attributes of Ceres and other goddesses of fertility. In a metaphorical way, they hint at *fecunditas*, already one of the most important female virtues in earlier times.[38] Female virtues now were no longer visualized by means of a socio-juridical status symbol, such as the *stola*, but by a metaphorical attribute.

In addition to this kind of new imagery we can observe a shift towards a more 'body-related' representation. For instance, the Pudicitia type copied since the late first century CE differs in a significant manner from the ones used earlier. The body is not as flat as that of the earlier examples and is much more emphasized by drapery and posture. The cloth is finer and displayed in a more elaborated way.[39] The best evidence for this shift in representational habit is offered by the fact

that, in the same period, the first century CE, a new statue type was introduced, one that matched the new requirements to emphasize the female body better than did the traditional ones. The so-called Ceres type (see Figure 10.5) adopts the Hellenistic style and pose, but seems to have been a new creation. The mantle covers the body almost completely. Only on the right shoulder is the undergarment visible. This could have allowed a more or less prominent display of the *stola*'s strap, but no copies with *stola* are known. Instead, many of the copies show a bunch of wheat and poppies. The pose of the left hand lifting the mantle makes it easier to add such an attribute without interfering with the whole posture. The attribute is again a metaphorical means to visualize the female virtue of *fecunditas*.[40] Although the figure is completely covered by garments – undergarment and mantle, while the head is often veiled – one gets the impression that the left leg is bare, uncovered by the left hand lifting the mantle. Both arms frame the body, rather than covering it, as occurs in the Pudicitia or Herculaneum women types.[41] While reproducing the image of a decently dressed woman, the Ceres type emphasizes the body underneath the garment much more than is the case with the traditional statue types. It thus bears the traces of a new ideal of representation that did not so much link female virtues to a certain socio-juridical status, as conceive them as the personal, if not body-related, qualities of the commemorated person.

A very specific form of this new, more body-related ideal is illustrated by the theomorphic likenesses, the so-called *consecratio in formam deorum*, that gain a certain popularity in non-imperial portraiture in Italy at about the same time. They combine a portrait head with contemporary hairstyle and even facial signs of older age with a Greek statue type, originally created to represent a goddess. The contrast between both elements powerfully implies that the statue's body is to be understood as a symbol or code, but it also makes clear the shift that the representation of female virtues had undergone.[42] In particular, it is not so much female virtues as such that have changed over the first century CE, but the way they were visualized. All statue types I have mentioned could be adapted to the actual female ideal, especially by the means of attributes. But, in fact, the majority of the copies were never given any attributes. So we may conclude that the statue types, especially the traditional ones, must have embodied, even in their 'pure' form, shifting

female identities. The statue types were more than neutral 'containers' to be filled with meaning: they offered a fixed external form that had performative qualities. Even if that form did not change, the intended image of an ideal female appearance to which it referred could differ.

Female and Social Identity

The slight shift in female portrait representation I have just outlined concerned not only gender, but also social identity. In any case, the visualization of a *matrona*'s status by means of costume implies a statement on social identity, as it underlines the social and juridical status of the person represented, no matter whether it was aspirative or achieved.[43] What about the statue types themselves? Could they convey a certain social identity?

As we have already seen, from the early first century CE onwards Herculaneum women and especially Pudicitiae were only rarely used for portrait representation. A vast number of newly created Roman statue types in Greek style (such as the one seen in Figure 10.6) took their place instead (and disappeared when the conventional types were reestablished).[44] What was it, therefore, that made these new types more appealing during the Julio-Claudian period? Obviously, they were more compatible with the status-related representation of the time: most of the new statue types were more suitable to display the V-neck and strap of the *stola*, as the figures' breasts were not totally covered by a mantle.

But, as one could argue, the *stola*'s purple border as well as the shoes could have been made visible just as easily by using the conventional types. There must have been another reason for the declining popularity of the Pudicitia and the Herculaneum statues. It is possible that these types – and the image they embodied – were simply too conventional at the time. They seem to have been 'contaminated,' as it were, by the fact that they could be used by nearly every woman, if she herself or her relatives could afford to erect a statue or a grave relief at all.[45] Strikingly, with the exception of one statue of Vipsania Agrippina, Tiberius' first wife before he became emperor, in Julio-Claudian times, and up to the Antonine period, the traditional statue types were never chosen for the rendering of an emperor's female relative.[46]

The newly created Julio-Claudian statue types still have a rather homogeneous appearance. Their bodies are completely covered by at

least two garments with a large quantity of folds, draped in an elaborate manner. But they exhibit a much broader, although subtle variety in posture and drapery than did the traditional ones.[47] They reproduce a general *habitus* without copying one another and thus convey a greater possibility of differentiation – and distinction.[48] Types like the Eumachia-Fundilia type[49] reached a certain popularity, whereas others, according to the number of extant replicas, were only used by a restricted group of persons.[50]

Some of the types even seem to have been conceived explicitly only for imperial portraits, like the so-called Leptis or the Leptis Grosseto statue types. Two of the eponymous copies come from Leptis Magna. They display the portraits of Antonia Minor and Agrippina Maior (see Figure 10.6) and belong to an imperial commemorative group erected probably under Tiberius or Caligula on the podium of the Temple of Augustus and Roma in the so-called ancient forum of the city.[51] The likenesses mirror the exceptional – and at that time ideologically ambivalent – position these imperial women held. Both women wear the costume of a Roman *matrona*: fine leather shoes (*calcei muliebres*), and *stola*. These attributes not only refer to the socio-juridical status of a *matrona*, but they also allude to the traditional Roman – and one might say ideologically republican – values connected with it. In an imperial portrait this element can additionally be understood as a political statement. These most prominent women are shown in the dress of an average, married, free Roman female citizen.

But the whole habit of the statues is different from what we have seen so far. The mantle is draped in both cases in a complicated manner. It does not cover the whole body. Parts of the undergarment on the right shoulder or the breasts remain visible. In the case of Antonia Minor, the left breast stands out by the way the mantle outlines its form. The *stola* as a typical garment of a married woman was supposed to cover the outlines of a female body as if to preserve its chastity. The portrait statues shown here, however, display a rather transparent or very thin cloth adhering to the women's breasts and legs. The 'wet' or transparent cloth is a characteristic feature of Greek female statues of the Late Classical period. This merging of Classical Greek style and traditional Roman Republican costume is a very characteristic distinctive feature of the new Julio-Claudian imperial statue types.[52] The fact that these new statue types were copied only in a very restricted number increased their distinctiveness.

The overlap of traditional attributes, an overtly Classical Greek style and a high degree of exclusiveness, had a specific meaning or function. In accordance with the ambivalent structure of the principate itself, which put the emperor's family in a position between a Hellenistic royal dynasty and a Roman Republican aristocratic *gens*, the portraits of imperial women had to articulate the exceptional position that the emperor's female relatives held, while at the same time adhering closely to Republican habit. The distinctive manner of the various new statue types fitted this intention perfectly, whereas Pudicitia and Herculaneum women types obviously were not exclusive enough to do so.

Female Identity in Italy, Greece, and Asia Minor, or Female and Cultural Identity

If we examine the geographical distribution of the most common statue types – Pudicitia, Herculaneum women, Ceres type – there is evidence for all of them in Italy, North Africa, Greece, and Asia Minor. Only the western and northern provinces provide scarce evidence, if any (see Figure 10.8). This, again, suggests that the types corresponded to a more or less general ideal of female elite appearance around the Mediterranean.

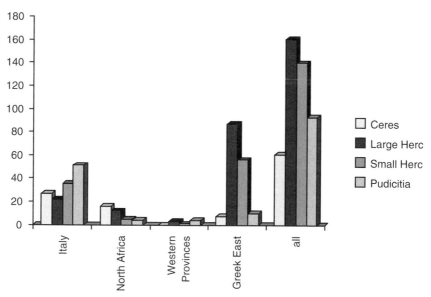

10.8. Geographical distribution of statue types

There are, however, very clear regional differences. The Herculaneum women were used especially in the Greek East, whereas in Italy we find more replicas of Pudicitia and Ceres types. The Ceres type was also very common in North Africa. This situation does not change significantly over the centuries.[53] Even though we cannot discern the precise reasons for certain regional preferences, it is at least possible to point out some differences in Greek and Roman tradition or intentions regarding portrait representation. These concern the external aspect of the replicas themselves as well as their setting.

Style, for example, can contain some information about different representational ideals. Hellenistic Pudicitiae in the Greek East were never exactly alike in posture and drapery. The drapery lavishly displayed in several more or less thin layers of cloth conveyed an image of richness and luxury (see Figure 10.1).[54] In contrast to this, the late Republican and early Imperial Roman Pudicitiae erected in Italy appear less elaborated, and sometimes rather stiff (see Figure 10.2). The folds of the drapery are arranged in a paratactic manner.[55] It is a 'Republican' simplicity that fits well a Roman *matrona* in traditional costume, denying the denounced luxury of the Greek East.

The statue types' setting also allows insight into regionally different habits of representation. When Pudicitia and Herculaneum women statue types were taken up again by the end of the first century CE, they seem to have had slightly different functions (see Figure 10.9). The Pudicitia and the Ceres type, which were more popular in the West, were only rarely used for funerary statues, whereas the Herculaneum women appear both in an honorary as well as in a funerary context.[56] This becomes clearer if we add the evidence of the grave reliefs and sarcophagi, that is, if we focus less on the statues as objects and more on the types as ideal images of women.[57]

Pudicitia and Ceres types were more often used for honorific statues. In contrast to the late Republican and early Imperial period, the Pudicitia types especially were not very common in a funerary context from the late first century CE onwards. At the same time, portraits in clear divine or mythical shape that illustrated personal virtues of the deceased in a metaphorical way became highly favoured on grave reliefs or sarcophagi, especially in Italy, but did not suit a public display (unless for imperial statues).

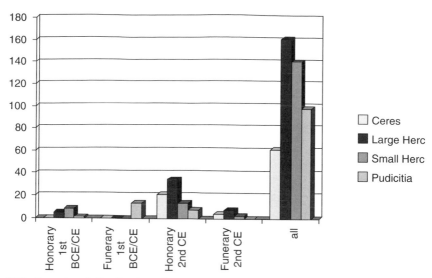

10.9. Functional distribution of statue types

It thus seems that in Italy there existed a distinction in representing women either in an honorific or a funerary context. Epigraphic evidence supports this impression. As Elizabeth Forbis has shown, honorary inscriptions in Italy from the first to the third centuries CE explicitly point out a woman's merits for the public, such as *munificentia, liberalitas, beneficia*, or *merita*. In contrast, typical female virtues such as *pudicitia* or *castitas* occur only rarely in this context, though they occur much more in funerary inscriptions.[58]

We are not able to relate statues and inscriptions directly, but the general differentiation both in the images and more prominently in the texts is striking. Although the concept of female virtues did not change over time, it seems that in non-imperial portraiture, the idea of a woman who was well regarded by the community could be visualized in a public honorary context only by one of the garmented statue types, but not by a theomorphic image. Rather than explicitly alluding to female qualities, the garmented statue types more likely just embodied the ideal appearance of a woman in public.

In the Greek East, the situation is different. Portraits in the guise of goddesses or heroines are not common at all. The epigraphic evidence indicates that representation in a public honorary context did not differ very much from a funerary one. As Ramsay MacMullen

and Riet van Bremen have pointed out, Greek honorary inscriptions of Roman times praise a woman's public merits along with her female virtues. The same occurs in inscriptions that are about a female patron's funeral. In contrast to Italy, public honorary and funeral contexts did not require a completely different epigraphic formula.[59]

Again, only in very few cases has the inscription that belonged to a portrait in one of the statue types I have analysed been preserved. But the functional distribution of the Herculaneum women, which were predominantly used in the Greek East, confirms the impression we get from the inscriptions: there is no specific distinction as to whether a likeness was to be erected in an honorific or a funerary context. The Herculaneum women are to be found equally in both settings. On grave reliefs, they are sometimes even depicted on a base like honorary statues. What does this mean for the cultural identity of the women represented? The statue types as such do not give any clue as to a specific cultural identity of their commissioners or the women they were designed to represent. As I have already shown, the apparent homogeneity of the statues is a result of a strong intermingling of Greek and Roman representational habits and mechanisms of replication. Nevertheless, their geographical and functional distribution points to certain differences in the way women were commemorated in Italy as opposed to Greece or Asia Minor. By being replicated in these specific contexts, the statues reaffirmed the cultural practices that caused their specific use. This probably also affected their meaning.

Conclusion

In Richard Hingley's Chapter Three, as well as in his recent study, *Globalizing Roman Culture*, which deals with the highly contested concept or concepts of 'Romanization,' Hingley stresses how important it is to consider the global and a local level, as well as the fact that both are often inextricably intertwined, if we want to understand what it meant to be a citizen or simply an inhabitant of the Roman Empire. Instancing the Sicilian Greeks, Carla Antonaccio (Chapter Two) emphasizes how identities performed on a local level contribute at the same time to the formation of a more global identity.

The statue types I have analysed offer very particular evidence for this intertwining of both levels, global and local, as they are in most cases not of Roman, but of Greek origin. Whereas their adoption and adaptation in Italy has often been interpreted in the context of the Hellenization of Italy, their distribution in large quantity around the Mediterranean occurred under Roman rule. If the statues' *habitus* as conveyed by posture and drapery was originally Greek, the practice of extensively and exactly copying them was not.

The wide distribution of the statues I have taken into consideration in geographical, chronological, and functional terms is not to be understood as an indication of meaninglessness or accident. In contrast, if we consider the process of copying as having caused a performative dynamic, the statue types are revealed to have had both a broad and flexible as well as more specific meaning, according to context. But their basic homogeneity was the precondition for change. Unity and diversity required each other.

On a global level, the statue types seem to have embodied a rather homogeneous idea of an exemplary female appearance, as their geographical distribution proves. On a local level, they reflected and perpetuated different cultural habits, as their functional context shows. According to chronological context and depending on the persons they were used to represent, they visualized shifting female and social identities. In any case, these were no neutral bodies at all.

Acknowledgements

I am very much indebted to Shelley Hales and Tamar Hodos, who transformed my text into real English and made invaluable comments that helped to sharpen its argument. I also would like to thank the anonymous reviewers of this paper for their thorough critique, as well as Charles Pazdernik and Alex Purves for discussing earlier versions of it with me.

Notes

1. See Gell 1998, 21–64, on agents and recipients in these interactions.
2. See Hingley, Chapter Three, who talks about a 'core of cultural identity,' and Antonaccio, Chapter Two, on the discrepancy between exterior and interior identity. Even in this approach we assume 'entities' of identity. Yet the problem

seems to be more complicated on a psychological level: how do we know that people's – hybrid or multiple – identities are coherent?

3. My chapter deals with statues erected by and for persons belonging to the elite and sharing a more or less common visual language, although they lived in different regions of the Roman world. While the statues bear evidence of a larger cultural *koine* as well as of regional or local differences, it is in both cases difficult to relate them to any form of ethnic identity in the sense that it is used by Antonaccio, that is, of a conscious distinction of communities based on the idea of a common descent or territory. For a broader discussion, see also Hodos (Chapter One) and Isayev (Chapter Eight), and, for a specifically Roman context, Terrenato 2005; Woolf 1994a. Furthermore, there is no explicit evidence that would allow us to make a distinction between internal and external evidence, as proposed by Antonaccio. I therefore shall prefer the terms 'cultural' on the one hand and 'local' or 'regional' on the other to the term 'ethnic,' although they overlap when it comes to evaluating the part of material culture in the formation of identities.

4. See especially Robertson 1995; but also Pieterse 1995; Hardt and Negri 2000, 42–9; Hingley 2005, 47–71, and 117–20.

5. Trimble 1999; Trimble 2000; Eule 2001; Alexandridis 2004; Alexandridis 2005a; Alexandridis 2005b. On the phenomenon of the Roman Greek East in general, see Woolf 1994a, 125–30.

6. Pfanner 1989, 157–61, and 176–236; Trimble 1999. Minor deviances among the replicas are, of course, possible, due, for example, to workshop traditions or skills, but I still prefer the term 'copy' or 'replica' to underline the repetitive quality of these figures. This is a specific characteristic of the culture of the Roman Empire, regardless of whether a particular type was of Greek or Roman origin: see Hallett 2005, 427–33.

7. Eule 2001, 119–61; Nollé 1994; van Bremen 1996, 41–81, and 170–90.

8. For the epigraphic evidence in the Tarraconensis, see Alföldy 1979, 209–27. For Tarraco itself, see Koppel 1985, 138–40, and Cat. nos. 45, 56, 57, 99–101, 104, 114, 128, 134; for Emerita, see Nogales Basarrate 1997, 133–8, and Cat. nos. 29–43 (Julio-Claudian period; statues: nos. 31–3, 36, 39, 40, 43); 44–5 (end of first century CE); 46–8 (Hadrianic period; statue: no. 48); 49–52 (Antonine period; statues: nos. 50–1).

9. See, e.g., Trimble 1999, 129–35.

10. Fabricius 2007, who deals also with the lingustic evidence.

11. For the particular implications of this phenomenon in a psychoanalytic and a gender perspective see, for example, Alexandridis 2005a.

12. See also Kockel 1993, 62–7; Zanker 1995. For gender-specific differences, see Alexandridis 2004, 65–6.

13. See Hölscher 1987, 11–14; Hölscher 1990, 73–4. Nevertheless, there is epigraphic evidence that people discerned clearly between a Greek or Roman habitus in portrait representation: Smith 1988, 70–5.

14. See also Isayev, Chapter Eight, on the 'Derridean dilemma.'

15. Trimble 2000, 42.

16. For the bodies, see, e.g., Eule 2001, KS 59, 60, 79, figs. 1–3, or KS 19, 21, 24, figs. 13–15; for the facial features, see, e.g., Eule 2001, KS 10, 12, 18, 19, 21, 74, figs. 26, 20, 4, 13, 15, 21.

17. The somewhat vague term 'elite' mirrors in itself the different and unequal levels of identity in the Roman Empire. Due to the high social mobility

members of 'elite' or 'elites' could be, e.g., wealthy freedmen – in contrast to poor free inhabitants of the Roman Empire. On complex identities, see Hingley, Chapter Three.

18. Von Moock 1998, 65–6, and 84–5.

19. Gell 1998, 16–64, and 104–6 (on images as part of an object). I support Gell's concern that images cannot be read like texts, but I do not see why the concept of agency and of meaning in a semiotic sense should be incompatible, as Gell seems to suggest (3–8). See Hölscher 1987; Hölscher 2000; and Gell himself (14). Gell's provokingly narrow idea of 'art' and 'aesthetics' cannot be applied to ancient culture, anyway. On different possible perceptions of visual culture depending on the beholder, see Wallace-Hadrill 1989, 162–4; Zanker 1988; Zanker 1994; Zanker 2000; Elsner 1995; Mayer 2002, 11–18, to name but a few.

20. See Trimble 1999, 2–12; Trimble 2000, 44–6; Alexandridis 2004, 219, with further bibliography.

21. Niemeyer 1968; Stemmer 1978; Wrede 1981; Matheson 1996; D'Ambra 1996; D'Ambra 2000; Bergmann 1998; Alexandridis 2004, 2–3, 82–92.

22. Trimble 1999, 43–5; Eule 2001, esp. 141–52; Davies 2002; de Grazia Vanderpool 2005, 13–14. Only in some exceptional cases is there explicit evidence they could refer to, such as the personification of Pudicitia (Shame) on Roman coins, where the legend tells us how to understand the body language of the figure. The Hellenistic and Late Republican statue types that show a similar scheme took their modern denomination (Pudicitia Types) in accordance to the personification on Hadrianic coins: see *LIMC* 7.1, 589–92.

23. Trimble 2000, 42–54.

24. Butler 1993, esp. 121–41.

25. See Hales (Chapter Nine) more specifically on the fashioning of the self as performative act.

26. I therefore do not follow de Grazia Vanderpool 2005, 15–24, according to whom pose and garment of the Herculaneum women stems from an Attic fourth century BCE tradition. Even if female values of Classical Athenian society and Hadrianic Asia Minor testify great continuity, the distribution of the Herculaneum women does not support Vanderpool's programmatically 'Atticizing' interpretation. It is not so much the type's origin as its continuous replicating that constitutes its meaning.

27. Kockel 1993, 51–2; Alexandridis 2004, 51–4.

28. A typical example would be the figure of the freedman Trimalchio in Petronius *Sat.* 27–78 (the banquet), and esp. 71 (description of Trimalchio's funerary monument).

29. Bhabha 1984; Butler 1993, 121–40.

30. Wrede 1981, 94–5, 158–9, and *supra* n. 22; Zanker and Ewald 2004, esp. 45–51.

31. The study is based on the list of replicas I have compiled in Alexandridis 2004, 229–31 (Ceres type, 61 copies), 238–43 (Large Herculaneum woman type, 161 copies without variant Aa), 243–8 (Small Herculaneum woman type, 140 copies without variant Aa), 261–5 (Pudicitia types A–D, 93 copies altogether without variants) with tab. 9–11, 13. On the difficulties of dating, see Trimble 1999, 69–76.

32. Kockel 1993, 25–6; Alexandridis 2004, 261–5. For the Hellenistic period, see Eule 2001.

33. Trimble 1999; Trimble 2000; Alexandridis 2004, 238–45.
34. For the following, see Alexandridis 2004, 51–61. The diagram takes into consideration statues and reliefs as long as they show the figures in life size, that is, as long as they give the visual impression of a life-size statue. My list of replicas of the Herculaneum women includes 161 examples of the Large Herculaneum and 140 of the Small Herculaneum woman. Trimble 1999 has assembled 155 and 129 replicas respectively, but her database was not accessible to me. The Herculaneum women were not as popular as the Pudicitia types in Hellenistic times: see Trimble 1999, 21–6, and Trimble 2000, 48–51. Daehner has revised the lists of replicas for the Large and Small Herculaneum women given in Trimble 1999 and Alexandridis 2004 (Daehner 2008, 156–7, 166, n.6). His corrections could not be taken into consideration here, but they do not change the overall image.
35. Zanker 1988, 162–6; Scholz 1992; Kockel 1993, 51–3.
36. These virtues are described by different adjectives: see von Hesberg-Tonn 1983, 106–217.
37. Van Bremen 1984, 234–5; van Bremen 1996, 156–70.
38. Alexandridis 2004, 55–7 with n. 517. On the iconography of Ceres, see Spaeth 1996.
39. Alexandridis 2004, 264–5 C (so-called Roman type).
40. The type derives its modern denomination from this attribute, but it nevertheless does not represent the goddess Ceres. Bunches of wheat and poppies are attributes of several goddesses or personifications that are related to abundance and fertility. See Alexandridis 2004, 55–61, with n. 517.
41. Trimble 1999, 43–5, and de Grazia Vanderpool 2005, 17–23, point out that the Herculaneum women's posture bears the possibility to exposure and that the drapery enhances single parts of the female body that allude to fertility, like breast and belly. Yet the Ceres type displays the female body much more overtly.
42. Wrede 1981; Alexandridis 2005a, 112–16.
43. Scholz 1992; Kockel 1993, 51–3.
44. For the following see Kockel 1993, 25–31; Alexandridis 2004, 51–7, 228–9 (Typus Berlin and Typus Conservatori), 257 (Typus Leptis and Leptis Grosseto), 258 (Octavia type), 258–9 (Orans type), 270 (Velleia types).
45. The *palliata*, which sometimes is identical with a *togata*, also counts among these conventional types: Alexandridis 2004, 259–61, and 270.
46. Alexandridis 2004, 59, 138 Cat. no. 53 pl. 11.2. Apart from the likeness of Vipsania Agrippina, only three statues of Faustina Maior are firmly identified (188–9 Cat. nos. 191–3 pl. 40). The identification of the so-called Sabina and Faustina Minor from Perge is problematic because of the highly idealized facial features: see Fittschen 1982, 64 n.58; 2000, 508 n.10. I therefore cannot follow Trimble 1999 and 2000, where she considers the Herculaneum women types as an especially imperial model of representation. She implies a "top-down" perspective for the transmission of visual and representational models, which is, in my opinion, precisely denied by the use of the Herculaneum women as well as the Pudicitia types.
47. See, e.g., the group from Lucus Feroniae, Boschung 2002, 35–9, pl. 24–5; Kockel 1993, 28 n.234, n.236, describes the subtle variations in pose between different types as a kind of continuous movement.
48. Bourdieu 1984.

49. Kockel 1993, 26–7 n. 229–30, with 29 replicas in the round.
50. See Kockel 1993, 25–31; Alexandridis 2004, 51–7, 228–9 (Typus Berlin and Typus Conservatori), 257 (Typus Leptis and Leptis Grosseto), 258 (Octavia type), 258–9 (Orans type), 270 (Velleia types).
51. Alexandridis 2004, 141–2, 145 Cat. nos. 61 and 68, pl. 12.4, 15, 2.3; p. 257, both types with only 2 replicas so far. On the whole complex, see Boschung 2002, 8–24.
52. Alexandridis 2004, 41–3. On the merging of Greek Classical and Roman Republican visual language, see Hölscher 1987; Zanker 1988, 239–43, 245–63.
53. Kruse 1975; Trimble 1999, 77–86, with a regionally more differentiated analysis.
54. Eule 2001, 146.
55. E.g. Alexandridis 2004, 263 B.
56. I admit that this is a somewhat schematic division, as funerary statues always have an honorific aspect; for more differentiated analyses of the practice of dedicating portrait statues, see Eule 2001, 10–11, 119–61; Trimble 1999, 86–96.
57. There is no systematic database that would enable me to take this into consideration in the diagram. Trimble 1999, 86–96, is right in stressing the honorific context, but from a more iconographic perspective the funerary context is very prominent, too. The fact that some of the representations on grave reliefs evoke honorary statues by indicating a statue base underlines the impression that both domains are not as easily separable as in the West. For Attica, see von Moock 1998: *Julio-Claudian*: Cat. nos. 165, 199, 449 (Small Herculaneum woman), 185, 389 (Pudicitia); *late first century – Severan period*: Cat. nos. 3, 12, 79, 134, 179, 193, 195, 196, 200, 204, 207, 214, 230, 233, 236, 242, 252, 259, 262, 288, 294, 307, 311, 330, 333, 351, 357, 382, 386, 387, 388, 394, 327, 439, 444, 538 (Small Herculaneum woman); 119, 217, 223, 229, 231, 237, 256, 262, 286, 290, 308, 311, 336, 339, 358, 385, 394, 397, 455, 457, 483, 492, 508, 540, 559 (Large Herculaneum woman); 1, 147, 300, 346, 389 (Pudicitia); *Undated*: Cat. nos. 252, 369, 440, 510, 533 (Small Herculaneum woman); 164, 167 (Large Herculaneum woman); 95, 554 (Pudicitia). See also Kruse 1975: *Large Herculaneum Woman* 264–5, nos. 18, 19, 26–111 (grave reliefs), 266, nos. 1–32 (sarcophagi); *Small Herculaneum Woman* 297–8, nos. 33–5, 52(?), 43–6, 48–57, 59–75 (grave reliefs), 298 nos. 1–4 (sarcophagi). Most of these examples come from the Greek East. Pudicitia and Ceres types appear on grave reliefs and sarcophagi from the late first century CE onwards only in a very restricted number: see, e.g., Kruse 1975, 230, nos. 1–6 (Ceres type, mostly from the Greek East).
58. Forbis 1990, 493–512, and Forbis 1996, compared to von Hesberg-Tonn 1983.
59. MacMullen 1980, 216; van Bremen 1996, 156–70; see also Alexandridis 2005b.

AFTERWORD

CHAPTER ELEVEN

CULTURAL CROSSOVERS: GLOBAL AND LOCAL IDENTITIES IN THE CLASSICAL WORLD

David Mattingly

Identity has become a key concept in archaeology and classical studies, its influence spreading like wild fire in drought-afflicted land.[1] Whether one sees oneself as the wind fanning the flames, the combustible material in its path, or the wildlife fleeing ahead of it, the importance of 'identity' in current debate cannot be ignored. Equally significant is the fact that its meanings are being actively (re)defined and contested in the ongoing discussion. This volume is very much at the cutting edge of this scholarly debate. In the best tradition of edited volumes, this book has evolved through the iterative process of the circulation of draft papers among the participants, encouraging all of them to engage with each other as well as presenting their own particular case studies and propositions.

The volume as a whole stands as a landmark discussion of a series of issues relating to identity, cultural change (especially in colonial situations), globalization in antiquity, cultural diversity and hybridity, ethnicity, material culture and the agency of objects, and the 'performative' aspects of identity. The theoretical underpinnings of the contributions are distinctive and striking, as are the chronological scope and geographical range of coverage. It is not feasible in these short final remarks to review all the aspects covered in exemplary detail and with great clarity by other contributors. Rather, I offer a few reflections on issues that seem to me to be of particular relevance to the developing agenda of identity studies in the ancient world, albeit reflecting my Roman bias.

One of the key questions that the collection unconsciously poses is how best to operationalize the concept of identity in relation to the study of the classical world. While the theoretical vigour of the debate conducted in these chapters is to be welcomed and admired, there is an issue about how best to integrate the new thinking into the conservative (and generally rather under-theorized) mainstream of classical studies.[2]

What struck me reading the final draft chapters of this book is the inherent flexibility of identity as a concept and the multiple directions from which it is possible to approach it. Some of the contributions (notably Hodos, Hingley, Antonaccio, Hales, and Sommer) come close to grand syntheses, while others use an artefact-based approach to particular case studies (Alexandridis, Ilieva, Isayev, Llewellyn-Jones, Riva). Rather in the manner of Deutz's *In Small Things Forgotten*,[3] the impact of this latter group of studies lies partly in the accumulation of close readings of material culture, employing to excellent effect new language and concepts. Both approaches are equally important to the developing debate about identity – we need more detailed and theoretically informed discussion of specific aspects of material culture (including non-elite culture) so that more refined syntheses can in turn be constructed, from which to develop revised conceptual approaches to artefacts and so on.

My interests in identity have evolved over the last decade or so, significantly influenced by an increasing engagement with postcolonial studies.[4] While much archaeological theory is heavily influenced by postmodernist thinking (as is particularly well discussed in the chapters by Hodos and Hales), there is a strong crossover in postcolonial studies with Marxist theory.[5] This has led to a much-needed shift in focus in the study of societies under colonial rule away from the ruling elite and towards the subject population at large. There is a danger here, though, of presenting a vision of the past that is simply the antithesis of a traditional colonial discourse. It is tempting and convenient to think of sets of binary oppositions juxtaposing, for instance, colonial/postcolonial perspectives with Western/non-Western traditions, modern/postmodern thinking and global/local scales of analysis. However, my first substantive point here is to argue that our analysis needs to be more flexible and to consider the issue of identity on a broad spectrum

of factors (profession, social group, language, religion, ethnicity, gender, etc.), both from the perspective of individuals/communities in the act of self-defining and from the perspective of the state seeking to control and dominate.[6] In other words, to understand the processes, impacts and implications of 'crossing cultures' we need to engage with both the local and the global aspects of identity. If theoretical positions are too dogmatically defined or the approach is limited to a narrow range of factors, the level of sophistication of our analyses will fall short of what is potentially achievable.

The -ization Problem

A second issue concerns the common tendency to simplify explanation by labelling complex realities with terms that exaggerate the degree of homogeneity. This may be in terms that invent or assume ethnic coherence – as in the case of 'the Celts,' who cast a long shadow over Iron Age archaeology across Europe.[7] The field of classical studies has long been plagued by such terms, most notably the two great '-izations,' Hellenization and Romanization.[8] While some of the contributors to this volume are understandably struggling to climb free from beneath the weight of these scholarly traditions, I think that one of the most obvious impacts of the current focus on identity as a concept is that these older paradigms are becoming increasingly difficult to sustain. The chapter by Llewellyn-Jones in this volume reviews some of the cultural complexity between Greek and Persian in Anatolia (a strength of that chapter is, of course, its avoidance of the term Hellenization in relation to Achaemenid Asia Minor). Similarly, Sommer explores the cultural identity of another group, the Phoenicians, whose influence on Mediterranean societies is often marginalized by the dominant paradigms of Hellenization and Romanization.

In my own writing I have now wholly discarded Romanization in favour of an approach framed around identity.[9] It could be argued that lesser '-izations' – colonization and globalization to name just two that figure prominently in this book[10] – pose similar dangers of channelling argument. However, I think that what makes Romanization and Hellenization particularly unhelpful constructs is that the terms are used to describe both *process* and *outcome*, so that the terms have become their

own explanation.[11] Self-fulfilling paradigms (that in any case were given much of their intellectual shape in the modern colonial age) provide a seriously flawed foundation for our subject in the twenty-first century.

While some classicists still remain committed to the Romanization concept,[12] many others appear to be voting with their feet. Within Roman archaeology identity has been particularly embraced by TRAC (the Theoretical Roman Archaeology Conference) and what may be referred to as the 'TRAC generation,'[13] but is also increasingly being adopted as a key concept across the mainstream.[14] The speed and scale of the uptake and the consequent decline in 'Romanization studies' can be measured by comparing the programme at the first Roman Archaeology Conference (Reading 1995) with that of the seventh (London 1997). Figure 11.1 charts the occurrences of the words

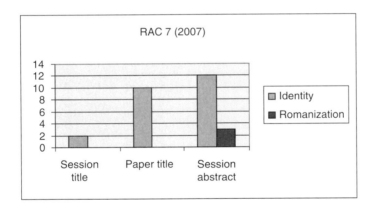

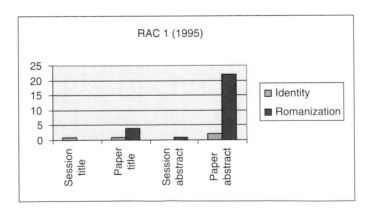

11.1. The relative predominance of the themes 'Romanization' and 'Identity' as reflected in occurrences of the terms in titles and abstracts at RAC 1 (1995) and RAC 7 (2007)

'identity' and 'Romanization' in session titles, session abstracts, paper titles, and paper abstracts. The difference in emphasis between RAC 1 and RAC 7 is striking.

What this heralds for the future development of the study of identity in classical antiquity needs careful thought (not least because there is undoubtedly an element of 'band-wagon jumping' going on and already there are complaints being voiced that identity is no better defined a concept than Romanization).[15] My sense is that we need to define how we are using 'identity' in a rigorous way and to avoid over-generalizing the global aspects at the expense of the local variability of identities. The worst of all worlds, it seems to me, is where a vague notion of identity is simply set alongside a continued use of the undeconstructed Romanization or Hellenization paradigms.[16] If it can be liberated from the strait-jacket of these older paradigms, 'identity' will work better as an analytical construct simply because it fundamentally concerns heterogeneity and diversity, whereas Romanization and Hellenization were primarily designed to examine degrees of homogeneity and similarity. As Hodos emphasizes in her chapter, the paradox of the globalization concept is that 'instead of culture homogeneity, it has highlighted and reinforced cultural heterogeneities.' In similar vein, Hingley concludes that heterogeneity became the 'binding force of imperial stability.'

Material Culture and Identity

The linkage between material culture and social identity is increasingly recognized as one of the most critical methodological issues to be negotiated. From an archaeological perspective artefacts are our 'primary sources' for exploring identity. However, it is important to remember that identity is not a simple equivalent of material culture. What most clearly defined identity was what was done with artefacts, not what artefacts an individual possessed. To put it succinctly (and pseudomathematically):

$I = mc \times p$ (where I = identity, mc = material culture and p = practice).

Practice, in part at least, equates with the performative aspect of identity, which is mentioned in several of the chapters (for example, those by Alexandridis, Antonaccio, Hales, Hodos, Llewellyn-Jones).

288 回凹回 David Mattingly

Some scholars have gone further, and ascribed agency to artefacts themselves, as active communicators and definers of social position.[17] The idea of reading cultural biographies of artefacts is certainly important, but so too is the realization that the same artefact can be imbued with very different meanings that are contingent on the social context and manner of use. There has been a concurrent revival of interest in artefact studies in classical archaeology, accompanied to some extent by a move from typological and aesthetic aspects to sociological issues.[18] This is a promising development and should be a research priority. The accumulation of detailed case studies focused either on particular artefact types or on the detailed composition of major assemblages from specific sites[19] will in time allow much greater sophistication of argument.

Singular and Multiple Identities

Western notions of ethnicity and social identity are to a large extent the product of modern nationalism and tend towards a model of singular identity affiliation, whether related to ethnicity or religion. Amartya Sen's recent critique of singular identity struck a chord with my own developing work on multiple identities in the Roman world. A central argument of Sen's *Identity and Violence: The Illusion of Destiny* is that much violence has been generated in human society on the basis of an illusory belief in unique ethnic or religious identities. For Sen:

> singular affiliation...takes the form of assuming that any person preeminently belongs, for all practical purposes, to one collectivity only – and no more and no less...The intricacies of plural groups and multiple loyalties are obliterated by seeing each person as firmly embedded in exactly one affiliation.[20]

My point here is that the construction of ethnicities (whether in the past or by archaeologists trying to make sense of material cultures) all too often represent a compression of multiple possibilities for defining identities into a singular and potentially misleading focus.[21]

An alternative approach is to recognize at the outset that the multiple life experiences of people will inevitably create cultural diversity and that expressing difference may be just as significant as registering similarity in the construction of identities. In the context of the Roman Empire,

there are obvious implications of this view for what it meant 'to become Roman' or 'to be Roman.'[22] In a similar way, Sommer's chapter in this volume draws attention to differences between Phoenician civic, social, and diasporic identities.

Discrepant Identity

Building on Said's postcolonial analysis of imperial discourse as discrepant experience, I have attempted to apply the same sort of approach to the Roman world. The search for discrepant experience directs us to look across the social spectrum, not simply at the imperial elite, and to try to assess the impact of empire from different perspectives, including those of the colonizing power and of different elements of subject peoples. I have developed this idea further into the study of discrepant identities.[23] What I am talking about here is the heterogeneity of response to Rome (not simply an opposition between Romanization and resistance), with varied decisions taken by different groups concerning culture change and identity reconfiguration. There is a strong echo of these views in Hingley's chapter in this volume (with which I am naturally very much in sympathy).

My main contention is that individual and group identities in the Roman period were multifaceted and dynamic. What has previously been described as Romanization in effect represents the interactions of multiple attempts at defining and redefining identity. A further intellectual step here is to recognize that identity must be studied in terms of both culture and power. I believe that it is possible to discern significant variability between certain important groups of people within Roman society and that the interplay between these different identities can reveal much about the operation of power and reactions to it within these societies. For instance, in my recent study of Britain in the Roman Empire I have identified radically different cultural histories for three broad 'communities' – the military, the urban populace, and rural dwellers – with each of these broad groupings on further examination revealing internal levels of difference. The diversity of material culture and behaviour patterns alike were the product of strategies for defining identity – not simply in emulation of a Roman 'standard.' A key observation is that these identities were often constructed so as to *create* rather than to *reduce* social distance

between groups. For example, the military community was actively differentiated from civilians by a whole raft of social norms, many based on literate behaviours (in terms of religion, commemoration, and self-representation).[24]

I want to stress that 'discrepancy' is to be understood here not simply as a postcolonial oppositional to participation and collaboration, but as representing the full spectrum of different experiences of and reactions to the empire. Thus, I seek to incorporate traditional elite-focused approaches into my broad scheme of social analysis, not to abandon these studies in favour of an agenda that prioritizes resistance as a theme.

Although I have highlighted the importance of native agency in cultural change, I also emphasize the colonial power networks that foreshadowed such transformations. Here again I see common ground with Sen, who observed that there is not an equal and infinite degree of freedom for individual agency to operate in the construction of identity. Indeed, there are sometimes severe limits on our ability 'to choose our identity in the eyes of others,' for example, in the eyes of aggressors. 'The constraints may be especially strict in defining the extent to which we can persuade others, in particular, to take us to be different from (or more than) what they insist on taking us to be.'[25] There is a need, then, to contextualize our studies of identity in terms of the power networks that operated in past societies (a point that is strongly endorsed here by Hingley and Hodos).

Ethnicity and Race

Ethnicity is a strong focus of several papers in this collection, but I am personally cautious about giving this too much prominence in our debates about past identities. It is just one of a number of factors on which identity could be built up in ancient societies and, as Antonaccio emphasizes, ethnic identity was often framed in terms of narratives of ancestry and homeland, as well as in relation to material culture. Both in the Greek and Roman worlds discourses of ethnicity played a significant role in defining insiders/outsiders, whether in the heartland territory or in relation to overseas colonies. This was a multilateral process that created not just oppositional understandings of Greek/barbarian or Roman/other, but also entirely new opportunities

for cultural crossover in the Middle Ground.[26] It is clear, for instance, that the contact situations generated by Roman imperialism produced profound and highly varied changes in behaviour, material culture, and social organization at the core, in the provinces and beyond the frontiers. The fundamental issue concerns whether we are witnesses to genuine ethnogenesis, or to enhanced ethnic identification, or whether the observed changes are better explained as a manifestation of other sorts of identity transformation. Moreover, if ethnicity was at some points a significant marker of identity, the archaeological evidence suggests that it was not a constant in time and space.

What are the reasons for relating ethnogenesis to colonial expansion? Writing of contacts between the Spanish and indigenous communities in South America, Neil Whitehead coined a memorable phrase summarizing the consequential relationship between expanding states and neighbouring 'tribal' societies: 'it is in the communality of that colonial history...that a basic anthropological rule of human grouping is demonstrated: *Tribes make states and states make tribes*.'[27]

What he meant by this is that the colonial contact situation works in two directions in terms of giving definition to ethnic difference. The 'interdependence of enemies' tends to lead to more defined ethnic identity in the communities under attack – in part due to categories and attitudes imposed by the imperial power, in part by indigenous societies coalescing in new ways. Meanwhile, the colonial power's own sense of self-identity is reshaped through the process, reinforcing perceived core values (often of innate superiority). The idea finds a strong echo in Peter Wells, in his *Barbarians Speak*:

> Tribes form in response to interaction between indigenous peoples and larger societies....When states expand through imperial conquest or colonization, they foster the formation of discrete political and territorial units among complex, multi-lingual, culturally diverse indigenous peoples. Such 'tribal' units are easier for empires to administer than are the typical pre-imperial diverse societies...[28]

Wars of colonial expansion thus often give definition and new shape to both sides of the imperial equation, with the state building its sense of purpose and identity on its perceived distance and difference from the barbarian 'other,' while indigenous societies are equally reordered in opposition to the colonial aggressor. Another of the main conclusions

of Whitehead's paper is that the early phases of colonial contact offer a small window on pre-colonial autochtonous practices – if we have a mind to look for the evidence rather than just accept the written records of the colonial power at face value. In any event we must be extremely cautious about back-projecting the ethnic structures recorded in those sources into the period before violent contact was established.

Race and racism are not really considered in this volume, perhaps because of a prevailing belief that these are essentially modern constructs and that the experience of empire in the ancient world was very different to what occurred in the nineteenth and twentieth centuries. The general approach to ethnicity in the papers of Ilieva, Isayev, and Riva stresses the positive construction of identities. However, there is also a need to engage with the negative construction of identity in intersocietal relations, particularly now that Isaac has advanced a strong case for identifying the origins of racism in the classical world (what he describes as 'proto-racism').[29]

There is something inherently dangerous about racist attitudes when applied to perceived ethnic identities (whether the latter were real or imagined, self-adopted or imposed from outside). In the Roman world, as in more recent colonial societies, proto-racist views about the inferiority of 'barbarian' peoples helped to justify war, subjugation, mass murder, enslavement, and exploitation on an unprecedented scale across vast territories. For this very reason, ethnic identities in the ancient world may have been historically contingent and of short duration. It can be suggested that they were predominantly a feature of the phases of first contact and assimilation of population groups by expanding states. Native ethnic identities became much less in evidence once people had been incorporated into the Roman Empire. Was this perhaps because the long-term interest of the empire was stability and the proto-racist overtones of Rome's ethnic categories were a strong disincentive for subject peoples to persist in strongly defining their own identity on ethnic lines?[30] It was on the frontiers of the empire that ethnicity tended to endure longest as a meaningful marker of difference.[31]

The Present in the Past and the Past in the Present

My final point is to reiterate and support two of Hingley's conclusions about why it is important for us to study identity in the ancient world

and why part of that process must involve us in deconstruction of modern historical discourses. The interrelationship between the modern colonial age and the rediscovery of the classical world had been of great significance in giving shape to classical studies in the twentieth century.[32] The investigations into the hybrid and discrepant identities of antiquity presented in this volume present something of a challenge to orthodox approaches to and understandings of the classical world. The process of crossing cultures is revealed as something much more complex than the traditional paradigms have allowed. However, it is also clear that we need to analyse and trace in detail the evolution of those traditional frameworks if we are to revise them so as to deploy fully these new ideas and concepts.

Finally, as we develop new models in the early twenty-first century, we do so not simply to gain a better understanding of the ancient world, but also to enable us to make better use of that knowledge of past societies in relation to the challenges and political paradoxes of our own times.

Notes

1. On the archaeology of identity in general see Díaz-Andreu et al. 2005; Insoll 2007; Jones 1997; Meskell 2001. On its application in classical archaeology, see, inter alia, Laurence and Berry 1998; Hall 2007a; Huskinson 2000; van Dommelen and Terrenato 2007a; Wallace-Hadrill 2007.
2. For some recent general discussions of the role of theory (or otherwise) in Roman archaeology, see Dyson 1993; Gardner 2003; Gardner 2006; Gardner 2007; James 2003; Laurence 1999; Laurence 2006; Scott 1993a; Scott 2006; Woolf 2004.
3. Deetz 1977.
4. Said 2003 [1978] is widely recognized as the foundational work of postcolonial studies. For general overviews of postcolonial studies, see Ashcroft, Griffiths, and Tiffin 1995; Ashcroft, Griffiths, and Tiffin 1998; Schwarz and Ray 2000. My chief publications in the field are: Mattingly 1996; Mattingly 1997a; Mattingly 1997b; Mattingly 1997c; Mattingly 1999; Mattingly 2002; Mattingly 2003b; Mattingly 2004; Mattingly 2006a; Mattingly (forthcoming). For other applications of postcolonial theory in Roman archaeology, see Hingley 2000; Hingley 2001; Hingley 2005; Scott and Webster 2003; van Dommelen 1997; van Dommelen 1998; van Dommelen 2002; van Dommelen 2005; Webster 1996a; Webster 1996b; Webster 1997a; Webster 1999; Webster 2001; Webster 2005; Webster 2007; Webster and Cooper 1996.
5. As a number of papers make clear, the influence of Bourdieu 1977 (*habitus*) and Giddens 1984 (structuration) on the postmodernist theoretical thrust has been significant. See also, Gardner 2002. For another critique of some of

the failings of the postmodernist approaches to classical antiquity, see Dench 2005, 4–35. For the crossover with Marxist theory, see, for example, Gramsci 1971; Fanon 1968 [1952]; Said 2003 [1978]; Said 1992.

6. The point is illustrated graphically by Gardner 2002, 345, envisaging macro, meso, and micro levels of social interaction going from the global to the local (with the state at the top and the individual at the bottom).

7. James 1999a.

8. Wallace-Hadrill 2007, to cite a particularly recent account, happily deploys Hellenization and Romanization in exploring identity, albeit in inverted commas – though I am not convinced by the analysis. On Hellenization more generally: Hall 2002; Hall 2007a; Antonaccio, Chapter Two. On Romanization: James 2001a; Hingley 2005, 14–48, and Chapter Three; Mattingly 2002; Terrenato 1998; Webster 2001.

9. Mattingly 2002, 536–40; Mattingly 2006a, 13–20.

10. See, inter alia, Given 2004; Gosden 2004; Hodos 2006; Hurst and Owen 2005; Lyons and Papadopoulos 2002; Stein 2005; Hingley 2005; Witcher 2000.

11. The following quote illustrates the differential use of the term as both process and cultural outcome: 'Virgil's exhortations regarding the use of Rome's military might were set in a broader context – that of a "civilising mission." Indeed, military conquest was not, except perhaps in the minds of a few traditionalists, an end in itself; its purpose was to establish the conditions in which a culture of Romanisation could flourish…Only thus could prosperity be realized in the provinces and (eventually) the empire at large. Romanisation was, therefore, a crucial part of the process of empire building' (Shotter 2003, 230–2).

12. See, for example, De la Bédoyère 2007, reacting to Mattingly 2006b, 55, with further exchanges of views likely to be occasioned by Hingley 2007, joining the debate in my support.

13. See for example, Bruhn, Croxford, and Grigoropoulos 2005; Croxford et al. 2004; Croxford et al. 2006; Croxford et al. 2007 for recent TRAC volumes. See Gardner 2002; Gardner 2004; Eckardt 2005; Pitts 2005a; Pitts 2005b; Pitts 2007a; Pitts 2007b for some salient publications by prominent members of the TRAC generation.

14. Dench 2005; Huskinson 2000; van Dommelen and Terrenato 2007a. The monumental study of bilingualism in the Roman world by Adams makes identity a central feature: 'It is often argued in linguistic literature that language is the most important marker of identity that there is…This book is overwhelmingly about identity' (Adams 2003b, 351).

15. Pitts 2007b, 693–713.

16. A useful discussion of recent critiques of Romanization in van Dommelen and Terrenato 2007b, 8–9, notes that discrepant identity and creolization/hybridity offer 'a way out of the Romanization controversy' but (disappointingly) then concludes that most of the papers take their 'lead from the Romanization debates, and that term will appear frequently in the chapters below.' Oltean 2007, an interesting new study of Dacia under Roman rule, is somewhat held back, in my view, by a continued reliance on the Romanization paradigm.

17. Appadurai 1986; Gell 1998; Gosden and Marshall 1999.

18. See, inter alia, Cool 2007; Cool and Baxter 2002; Eckardt 2005; Hingley and Willis 2007.

19. Cool and Philo 1998; Wilson 2002.
20. Sen 2006, 20. It is somehow no surprise to find Roma in the thick of the bloody action on the dust jacket of my edition! See also Anderson 1991 [1983].
21. This is also the fundamental conclusion of Jones 1997.
22. Hingley 2005, 91–116; Woolf 1998.
23. Mattingly 1997b, with further development in Mattingly 2004 and a full-scale provincial case study in Mattingly 2006a.
24. Mattingly 2006a, 166–224; see also Goldsworthy and Haynes 1999; James 1999b; James 2001b.
25. Sen 2006, 31.
26. Gosden 2004, 82–113; Webster 2007; see also Llewellyn-Jones, Chapter Seven.
27. Whitehead 1992, 149 (my emphasis).
28. Wells 1999, 116.
29. Isaac 2004.
30. I explored these issues in a paper at the seventh Roman Archaeology Conference (London, 2007) and will publish some of the ideas in more detail in Mattingly, forthcoming.
31. A point well illustrated by my study of the Garamantes of the Libyan Sahara, in Mattingly 2003a, 76–90, and 346–62. See also Webster 2007.
32. See, for example, Dyson 2006, 86–213; Hingley 2000; Hingley 2001; Vasunia 2005, 38–64.

BIBLIOGRAPHY

Abbreviations

CIL: *Corpus Inscriptionum Latinarum*

FGrHist: Jacoby, F. 1923– . *Die Fragmente der griechischen Historiker.* Leiden.

IG: *Inscriptiones Graecae*

ILS: *Inscriptiones Latinae Selectae*

LIMC: *Lexicon Iconographicum Mythologiae Classicae.* 1981– . Zürich.

RV: Rossano di Vaglio inscriptions

ST: Rix, H. 2002. *Sabellische Texte: die Texte des Oskischen, Umbrischen und Südpikenischen.* Heidelberg.

Ve: Vetter, E. 1953. *Handbuch der italischen Dialekte.* Heidelberg.

Acconcia, V. 2004. 'Note sulla Produzione e Tecnologia del Bucchero Etrusco.' In Naso 2004: 281–91.

Acheilara, L. [Αχειλαρά, Λ.] 1987 (1992). 'Museum Explorations in Lesbos: Methymna.' ['Μουσιακές εργασίες. Νομός Λέσβου. Μήθυμνα.'] *Archaiologikon Deltion* [*Αρχαιολογικόν Δελτίον*] 42: 481–2, pl. 289γ.

Acquaro, E. 1988. 'Le monete.' In Mosacti 1988a: 464–73.

Adamesteanu, D. 1990. 'Rossano di Vaglio.' In M. Salvatore, ed., *Basilicata: l'espansionismo romano nel sud-est d'Italia: il quadro archeologico: atti del convegno, Venosa, 23–25 aprile 1987.* Venosa: 79–82.

——. 1992. 'Macchia di Rossano – Santuario della dea Mefitis.' In de Lachenal 1992: 62–5.

Adamesteanu, D., and H. Dilthey. 1992. *Macchia di Rossano: il Santuario della Mefitis: rapporto preliminare.* Galatina.

Adamesteanu, D., and M. Lejeune. 1971. 'Il santuario lucano di Macchia di Rossano di Vaglio.' *Memorie della classe di Scienze Morali e Storiche dell'Accademia dei Lincei* 16: 39–83, pl. 1–20.

Adams, J. N. 2003a. '"Romanitas" and the Latin Language.' *Classics Quarterly* 53: 184–205.

———. 2003b. *Bilingualism and the Latin Language*. Cambridge.

Alcock, S. 2001. 'Vulgar Romanization and the Dominance of the Elites.' In Keay and Terrenato 2001: 227–30.

Alcock, S., and R. Osborne, eds. 2007. *Classical Archaeology*. Oxford.

Alexandridis, A. 2004. *Die Frauen des römischen Kaiserhauses. Eine Untersuchung ihrer bildlichen Darstellung von Livia bis Iulia Domna*. Mainz.

———. 2005a. 'Individualisierung, Homogenisierung, Angst vor Vergänglichkeit. Weibliche Grab- und Ehrenstatuen der römischen Republik und der Kaiserzeit.' In N. Sojc, ed., *Neue Fragen, neue Antworten. Antike Kunst als Thema der Gender Studies*. Geschlecht – Symbol – Religion 3. Berlin: 111–24.

———. 2005b. 'Überall (götter)gleich? Theomorphe Bildnisse der Frauen des römischen Kaiserhauses.' In M. Sanader and A. Rendic Miocevic, eds., *Religion and Myth as an Impetus for the Roman Provincial Sculpture. The Proceedings of the 8th International Colloquium on Problems of Roman Provincial Art, Zagreb 5–8 May 2003*. Zagreb: 415–22.

Alföldy, G., 1974. *Noricum*. Trans. A. Birley. London.

———. 1979. 'Bildprogramme in den römischen Städten des Conventus Tarraconensis. Das Zeugnis der Statuenportamente.' *Revista de la Universidad Complutense* 1 (18) (= Homenaje a Garcia Bellido vol. 4): 177–275.

Amadasi Guzzo, M. G. 1987. Iscrizioni semitiche di nord-ovest in contesti greci e italici. *Dialoghi di Archeologia* 5 (2): 13–28.

Ameling, W. 1993. *Karthago. Studien zu Militär, Staat und Gesellschaft*. Munich.

Amiet, P. 1977. *L'art du Proche-Orient: L'art et les grandes civilisations*. Paris.

Anderson, B. 1991 [1983]. *Imagined Communities: Reflections on the Origin and Spread of Nationalism*. London.

Antonaccio, C. 2001. 'Ethnicity and Colonization.' In Malkin 2001a: 113–57.

———. 2003. 'Hybridity and the Cultures within Greek Culture.' In Dougherty and Kurke 2003: 57–74.

———. 2004. 'Siculo-geometric and the Sikels: Identity and Material Culture in Eastern Sicily.' In Lomas 2004: 55–81.

———. 2005. 'Excavating Colonization.' In Hurst and Owen 2005: 97–113.

Appadurai, A., ed. 1986. *The Social Life of Things: Commodities in Cultural Perspective*. Cambridge.

Arena, R. 1972. 'Sull'iscrizione arcaica di Nerulum.' *La Parola del Passato* 27: 322–30.

Arias, P., B. Shefton, and M. Hirmer. 1962. *A History of Greek Vase Painting*. London.

Armstrong, C. 1989. 'The Reflexive and the Possessive View: Thoughts on Kertesz, Brandt and the Photographic Nude.' *Representations* 25: 57–70.

Arnold Biucchi, C. 1993. 'A New Coin of the Serdaioi (?) at the ANS.' In M. Price, A. Burnett, and R. Bland, eds., *Essays in Honour of Robert Carson and Kenneth Jenkins*. London: 1–3.

Arslan, N., and N. Sevinç. 2003. 'Die eisenzeitlichen Gräber von Tenedos.' *Istanbuler Mitteilungen* 53: 223–49.

Ashcroft, B., G. Griffiths, and H. Tiffin. 1995. *The Post-Colonial Studies Reader*. London.

———. 1998. *Key Concepts in Post-Colonial Studies*. London.

Asheri, D. 1999. 'Processi de "decolonizzazione."' In *La colonisation grecque en Méditerranée occidentale. Actes de la rencontre scientifique en hommage à Georges Vallet G. (Rome-Naples, 15–18 novembre 1995).* Collection de l'École française de Rome 251. Rome: 361-70.

Assante, J. 2002. 'Sex, Magic and the Liminal Body in the Erotic Art and Texts of the Old Babylonian Period.' In Parpola and Whiting 2002, Part 1: 27-52.

Assmann, J. 2002. *Herrschaft und Heil. Politische Theologie in Altägypten, Israel und Europa.* Frankfurt am Main.

——. 2006 [1992]. *Politische Theologie zwischen Ägypten und Israel.* Munich.

Aubet, M. E. 2001 [1993]. *The Phoenicians and the West. Politics, Colonies and Trade.* Cambridge.

——. 2006. 'On the Organization of the Phoenician Colonial System in Iberia.' In Riva and Vella 2006: 94-109.

——. 2007. *Comercio y colonialism en el Próximo Oriente antiguo. Los antecedentes coloniales del III y II milenios a.C.* Barcelona.

Bagnasco Gianni, G. 1996. *Oggetti Iscritti di Epoca Orientalizzante in Etruria.* Florence.

Bakir, T., H. Sancisi-Weerdenburg, G. Gürtekin, P. Briant, and W. Henkelman, eds. 2001. *Achaemenid Anatolia.* Leiden.

Balakrishnan, G. 2000. 'Gopal Balakrishnan on Michael Hardt and Antonio Negri, Empire. Globalization as a New Roman Order, Awaiting its Early Christians.' *New Left Review* 5, September-October, http://www.newleftreview.net/NLR23909.shtml.

——. 2003a. 'Introduction.' In Balakrishnan 2003b: vii-xix.

——, ed. 2003b. *Debating Empire.* London.

Balensi, J., and M.D. Herrera. 1985. 'Hawam 1983-84. Rapport préliminaire.' *Revue Biblique* 92: 82-128.

Balensiefen, L. 1990. *Die Bedeutung des Spiegelbildes als ikonographisches Motiv in der antiken Kunst.* Tübingen.

Barker, A. 1996. 'Doderer's Habsburg Myth.' In Bushell 1996b: 37-54.

Barker, T.M. 1984. *The Slovene Minority of Carinthia.* New York.

Bartoloni, G. 2000. 'La Prima età del Ferro a Populonia: le Strutture Tombali.' In Zifferero 2000: 19-36.

——. 2003. *Le Società dell'Italia Primitiva. Lo Studio delle Necropoli e la Nascita delle Aristocrazie.* Rome.

Barton, T. 1994. *Power and Knowledge: Astrology, Physiognomics, and Medicine under the Roman Empire.* Ann Arbor.

Bartsch, S. 1994. *Actors in the Audience: Theatricality and Double Speak from Nero to Hadrian.* Cambridge, MA.

——. 2006. *The Mirror of the Self: Sexuality, Self-Knowledge and the Gaze in the Early Roman Empire.* Chicago.

Bassi, K., and P. Euben. 2003. 'De-Classifying Hellenism: Untimely Meditations.' *parallax* 9: 1-7.

Bauman, Z. 1999. *Culture as Praxis.* London.

Bayne, N. 2000. *The Gray Wares of North-West Anatolia in the Middle and Late Bronze Age and the Early Iron Age and Their Relation to the Early Greek Settlements.* Asia Minor Studies 37. Bonn.

Beazley, J.D. 1925 *Attische Vasenmaler des rotfigurigen Stils.* Tübingen.

Bellelli, V. 2000–2003. 'Gli Argonauti all'Imbarco.' *Annali, Istituto Universitario Orientale, Napoli: Sezione di Archeologia e Storia Antica* new series 9-10: 79–94.

Beltrán Lloris, F. 1999. 'Writing, Language and Society: Iberians, Celts and Romans in Northeastern Spain in the 2nd and 1st Centuries BC.' *Bulletin of the Institute of Classical Studies* 43: 131–51.

Bénabou, M. 1976. *La résistance africaine à la romanisation.* Paris.

Benton, C., and T. Fear. 2003. 'Introduction: From Rome to Buffalo.' *Arethusa* 36: 267–70.

Berg, W. B., and C. Mair. 1999. 'Kreol! Sprachliche und kulturelle Grenzgänge in Argentinien und der Karibik.' In Fludernik and Gehrke 1999: 447–60.

Bergmann, M. 1998. *Die Strahlen der Herrscher. Theomorphes Herrscherbild und politische Symbolik im Hellenismus und in der römischen Kaiserzeit.* Mainz.

Berkin, J. 2002. *The Orientalizing Bucchero from the Lower Building at Poggio Civitate (Murlo).* Philadelphia.

Berlinerblau, J. 1999. *Heresy in the University: The Black Athena Controversy and the Responsibilities of American Intellectuals.* New Brunswick.

Bernal, M. 1987. *Black Athena: The Afroasiatic Roots of Classical Civilization I: The Fabrication of Ancient Greece 1785–1985.* London.

——. 1991. *Black Athena: The Afroasiatic Roots of Classical Civilization II: The Archaeological and Documentary Evidence.* London.

——. 2006. *Black Athena: The Afroasiatic Roots of Classical Civilization III: The Linguistic Evidence.* New Brunswick.

Bernard, P. 1964. 'Céramiques de la première moitie du VIIe siècle à Thasos.' *Bulletin de Correspondance Hellénique* 88 (1): 77–146.

Bernardini, P., and R. Zucca, eds. 2005. *Il Mediterraneo di Herakles. Studi e ricerche.* Sassari.

Berrendoner, C. 2003. 'La romanisation de Volterra: "A Case of Mostly Negotiated Incorporation, that Leaves the Basic Social and Cultural Structure Intact" (N. Terrenato, in Italy and the West, Oxford 2001).' *Digressus: The Internet Journal for the Classical World* 3: 46–59.

Beschi, L. 1994. 'The Temple of the Kabeiroi on Lemnos' ['Το Ιερό των Καβείρων στη Λήμνο.'] *Archaeology (Αρχαιολογία)* 50: 31–7.

——. 1996. 'I Tirreni di Lemno alla luce dei recenti dati di scavo.' In *Magna Grecia Etruschi Fenici.* Naples: 23–50.

——. 1998. 'Arte e cultura di Lemno arcaica.' *La Parola del Passato* 53: 48–76.

——. 2003. 'Ceramiche arcaiche di Lemno: alcuni problemi.' *Annuario della Scuola Archeologica di Atene* LXXXI, series III. 3, vol. I: 303–49.

——. 2005. 'Il primitivo Telesterio del Cabirio di Lemno (campagne di scavo 1990–1991).' *Annuario della Scuola Archeologica di Atene* LXXXI, series III. 3, vol. II: 963–1023.

Bhabha, H. K. 1983. 'Difference, Discrimination, and the Discourse of Colonialism.' In F. Barker, P. Hulme, M. Iversen, and D. Loxley, eds, *The Politics of Theory.* Colchester: 194–211.

——. 1984. 'Of Mimicry and Man: The Ambivalence of Colonial Discourse.' *October* 28, Spring: 125–33.

——, ed. 1990. *Nation and Narration.* London.

——. 1994. *The Location of Culture.* New York.

Bianco, S., A. Bottini, A. Pontrandolfo, A. Russo Tagliente, and E. Setari, eds. 1996. *I Greci in Occidente. Greci, Enotri e Lucani nella Basilicata meridionale.* Naples.

Bieber, M. 1977. *Ancient Copies. Contributions to the History of Greek and Roman Art.* New York.

Bietti-Sestieri, A.M., A. De Santis, and A. La Regina. 1989–1990. 'Elementi di Tipo Culturale e Doni Personali nella Necropoli Laziale di Osteria dell'Osa.' *Scienze dell'Antichità Storia Archeologia Antropologia* 3–4: 65–88.

Binford, L. 1965. 'Archaeological Systematics and the Study of Culture Process.' *American Antiquity* 31: 201–10.

Bintliff, J. 1993. 'Why Indiana Jones Is Smarter than the Postprocessualists.' *Norwegian Archaeological Review* 26: 91–100.

Blackman, D. 1996–1997. 'Archaeology in Greece 1996–97.' *Archaeological Reports* 43: 1–125.

Blegen, C., C. Boulter, J. Caskey, and M. Rawson. 1958. *Troy, Settlement VIIa, VIIb and VIII.* Vol. IV. Princeton.

Blegen, C., H. Palmer, and R. Young. 1964. *Corinth: Results of the Excavations Conducted by the American School of Classical Studies at Athens. Vol. XIII. The North Cemetery.* Princeton.

Bloom, A. 1987. *The Closing of the American Mind.* New York.

Blundell, S. 2002. 'Clutching at Clothes.' In Llewellyn-Jones 2002b: 143–69.

Boardman, J. 1969. 'Three Greek Gem Masters.' *Burlington Magazine* 111 (799): 587–96.

——. 1970. 'Pyramidal Stamp Seals in the Persian Empire.' *Iran* 8: 19–45.

——. 1980. 'Greek Gem Engravers.' In E. Porada ed., *Ancient Art in Seals.* Princeton: 101–25.

——. 1994. *The Diffusion of Art in Classical Antiquity.* London.

——. 1999 [1964]. *The Greeks Overseas: Their Early Colonies and Trade.* London.

——. 2000. *Persia and the West: An Archaeological Investigation of the Genesis of Achaemenid Art.* London.

——. 2001 [1970]. *Greek Gems and Finger Rings: Early Bronze Age to Late Classical.* London.

Boatwright, M.T. 1991. 'Plancia Magna of Perge: Women's Roles and Status in Roman Asia Minor.' In S.B. Pomeroy, ed., *Women's History and Ancient History.* Chapel Hill/London: 249–72.

Bol, R. 1984. *Das Statuenprogramm des Herodes-Atticus-Nymphäums.* Olympische Forschungen 15. Berlin.

Bondì, S.F. 1995a. 'La société.' In Krings 1995: 345–53.

——. 1995b. 'Les institutions, l'organisation politique et administrative.' In Krings 1995: 290–302.

——. 2005. 'Il Mediterraneo di Herakles-Melqart. Conclusioni e prospettive.' In Bernardini and Zucca 2005: 259–63.

Bonfante, G. 1955. 'A Note on the Samothracian Language.' *Hesperia* 24: 101–9.

Bonghi-Jovino, M., ed. 1986. *Gli Etruschi di Tarquinia. Catalogo della Mostra Milano 1986.* Modena.

——, ed. 1993. *Produzione artigianale ed esportazione nel mondo antico. Il bucchero etrusco. Atti del Colloquio Internazionale, Milano, 10–11 maggio 1990.* Milan.

Bonghi-Jovino, M., and C. Chiaramonte-Treré, eds. 1997. *Tarquinia. Testimonianze Archeologiche e Ricostruzione Storica. Scavi Sistematici nell'Abitato. Campagne 1982–1988.* Rome.

Bonnet, C. 1995. 'Monde égéen.' In Krings 1995: 646–62.

Bonnet, C., and P. Xella. 1995. 'La religion.' In Krings 1995: 316–33.

Borbein, A.H., T. Hölscher, and P. Zanker, eds. 2000. *Klassische Archäologie. Eine Einführung.* Berlin.

Boron, A.A. 2005. *Empire & Imperialism: A Critical Reading of Michael Hardt and Antonio Negri.* London.

Boschung, D. 2002. *Gens Augusta. Untersuchungen zur Aufstellung, Wirkung und Bedeutung der Statuengruppen des julisch-claudischen Kaiserhauses.* Mainz.

Botting, K., and D. Botting. 1995. *Sex Appeal: the Art and Science of Sexual Attraction.* London.

Bottini, A., I. Rainini, and S. Isenghi Colazzo. 1976. 'Valle d'Ansanto. Rocca San Felice (Avellino): Il deposito votivo del santuario di Mefite.' *Notizie degli Scavi di Antichità* 30: 359–524.

Botto, M. 1995. 'I commerci fenici nel Tirreno centrale. Conoscenze, problemi e prospettive.' In *I fenici. Ieri, oggi, domani. Ricerche, scoperte, progetti.* Rome: 43–53.

Bourdieu, P. 1977. *Outline of a Theory of Practice.* Cambridge.

——. 1984. *Distinction. A Social Critique of the Judgement of Taste.* Cambridge, MA.

——. 1990. *The Logic of Practice.* Cambridge.

Bowman, A.K. 1994a. *Life and Letters on the Roman Frontier.* London.

——. 1994b. 'The Roman Imperial Army: Letters and Literacy on the Northern Frontier.' In Bowman and Woolf 1994: 109–26.

Bowman, A.K., and G. Woolf, eds. 1994. *Literacy and Power in the Ancient World.* Cambridge.

Bradley, G. 2000. *Ancient Umbria: State, Culture, and Identity in Central Italy from the Iron Age to the Augustan Era.* Oxford.

Branham, R.B. 1989. *Unruly Eloquence: Lucian and the Comedy of Traditions.* Cambridge, MA.

Braund, D. 1994. *Georgia in Antiquity: A History of Colchis and Transcaucasian Iberia, 550 BC–AD 562.* Oxford.

Braziel, J.E., and K. LeBrosco, eds. 2001. *Bodies Out of Bounds: Fatness and Transgression.* Berkeley.

Brennan, T. 2003. 'The Italian Ideology.' In Balakrishnan 2003b: 97–120.

Briant, P. 2002. *From Cyrus to Alexander: A History of the Persian Empire.* Winona Lake.

Briend, J. 1980. *Tell Keisan 1971–1976. Une cité phénicienne en Galilée.* Fribourg.

Brizzi, G. 1995. 'L'armée et la guerre.' In Krings 1995: 303–15.

Brosius, M. 1996. *Women in Ancient Persia (559–331 BC).* Oxford.

Bruhn, J., B. Croxford, and D. Grigoropoulos, eds. 2005. *TRAC 2004: Proceedings of the Fourteenth Annual Theoretical Roman Archaeology Conference, Durham 2004.* Oxford.

Buckler, W.H., and W.M. Calder. 1939. *Monuments from Phrygia and Caria: Monumenta Asiae Minoris Antiqua.* Vol. 6. Manchester.

Bulwer, J. 2006. *Classics Teaching in Europe.* London.

Bunnens, G. 1979. *L'expansion phénicienne en Méditerranée. Essai d'interprétation fondé sur une analyse des traditions littéraires.* Brussels.

Burkert, W. 1970. 'Jason, Hypsipyle, and New Fire at Lemnos: A Study in Myth and Ritual.' *Classical Quarterly* 20 (1): 1–16.

——. 1993. 'Concordia Discors: The Literary and the Archaeological Evidence on the Sanctuary of Samothrace.' In Marinatos and Hägg 1993: 178–91.

——. 2002. 'Greek Margins: Mysteries of Samothrace.' In *Religions on the Periphery of the Ancient Greek World* [Λατρείες στην «περιφέρεια» του αρχαίου ελληνικού κόσμου]. Athens: 31–63.

Burr Carter, J. 1989. 'The Chests of Periander.' *American Journal of Archaeology* 93 (3): 355–78.

Bushell, A. 1996a. 'Austria's Political and Cultural Re-emergence: The First Decade.' In Bushell 1996b: 1–10.

——, ed. 1996b. *Austria 1945–55: Studies in Political and Cultural Re-Emergence.* Cardiff.

Butcher, K. 2005. 'Information, Legitimation, or Self-Legitimation? Popular and Elite Designs on the Coin Types of Syria.' In Howgego, Heuchart, and Burnett 2005: 143–56.

Butler, J. 1993. *Bodies that Matter: On the Discursive Limits of 'Sex.'* London.

——. 1999 [1990]. *Gender Trouble: Feminism and the Subversion of Identity.* New York.

Caiuby-Novaes, S. 1997. *The Play of Mirrors: The Representation of Self as Mirrored in the Other.* Austin.

Campbell, B. 2002. *War and Society in Imperial Rome, 31 BC–AD 284.* London.

Caner, E. 1982. *Fibeln in Anatolien I.* Prähistorische Bronzefunde, Abteilung XIV, 8. Munich.

Carpenter, T. H. 1991. *Art and Myth in Ancient Greece.* London.

Carroll, M. 2001. *Romans, Celts and Germans: The German Provinces of Rome.* Stroud.

——. 2003. 'The Genesis of Roman Towns on the Lower Rhine.' In Wilson 2003: 22–30.

Cartledge, P. 1998a. 'Classics: From Discipline in Crisis to (Multi-) Cultural Capital.' In Y. L. Too and N. Livingstone, eds., *Pedagogy and Power: Rhetorics of Classical Learning.* Cambridge: 16–28.

——. 1998b. 'The *Machismo* of the Athenian Empire – or the Reign of the Phallus?' In L. Foxhall and J. Salmon, eds., *When Men Were Men: Masculinity, Power and Identity in Classical Antiquity.* London: 54–67.

——. 2002 [1993]. *The Greeks: A Portrait of Self and Others.* Oxford.

Casabonne, O. 2004. *La Cilicie à l'Époque Achéménide.* Paris.

Casella, E. D., and C. Fowler. 2004. 'Beyond Identification.' In E. D. Casella and C. Fowler, eds., *The Archaeology of Plural and Changing Identities: Beyond Identification.* New York: 1–8.

Caubet, A., and D. Gaborit-Chopin. 2004. *Ivories de l'Orient ancient aux temps Modernes.* Paris.

Cerchiai, L., L. Jannelli, F. Longo, and M. E. Smith. 2004. *Die Griechen in Süditalien. Auf Spurensuche zwischen Neapel und Syrakus.* Stuttgart.

Cevizoğlu, H. 2004. 'Archaic Relief Ware from Klazomenai.' In Moustaka et al. 2004: 185–98.

Childe, V. G. 1925. *The Dawn of European Civilization.* London.

——. 1929. *The Danube in Prehistory.* Oxford.

——. 1930. *The Bronze Age.* Cambridge.

Clark, K. 1956. *The Nude: A Study in Ideal Form.* Princeton.

Clarke, J. R. 2003. *Art in the Lives of Ordinary Romans: Visual Representation and Non-Elite Viewers in Italy, 100 B –AD 315.* Berkeley.

Coarelli, F. 1998. 'Il culto di Mefitis in Campania e a Roma.' In S. Adamo Muscettola, G. Greco, and L. Cicala, eds., *I culti della Campania antica: atti del convegno internazionale di studi in ricordo di Nazarena Valenza Mele, Napoli, 15–17 maggio 1995.* Rome: 185–90.

Cochran, M., and M. Beaudry. 2006. 'Material Culture Studies and Historical Archaeology.' In D. Hicks and M. Beaudry, eds., *The Cambridge Companion to Historical Archaeology.* Cambridge: 191–204.

Cohen, A. 1985. *The Symbolic Construction of Community*. London.

Cohen, B. 2000. *Not the Classical Ideal: Athens and the Construction of the Other in Greek Art*. Leiden.

Coldstream, J. N. 1982. 'Greeks and Phoenicians in the Aegean.' In Niemeyer 1982: 261–72.

Colonna, G., and F. W. von Hase. 1984. 'Alle Origini della Statuaria Etrusca: la Tomba delle Statue presso Ceri.' *Studi Etruschi* 52: 13–59.

Connerton, P. 1989. *How Societies Remember*. Cambridge.

Cook, R. M. 1997. *Greek Painted Pottery*. London.

Cook, R. M., and P. Dupont. 1998. *East Greek Pottery*. London/New York.

Cool, H. E. M. 2007. *Eating and Drinking in Roman Britain*. Cambridge.

Cool, H. E. M., and M. J. Baxter. 2002. 'Exploring Romano-British Finds Assemblages.' *Oxford Journal of Archaeology* 21: 363–80.

Cool, H. E. M., and C. Philo, eds. 1998. *Roman Castleford. Excavations 1974–85. Volume 1: The Small Finds*. 1998.

Cool Root, M. 1979. *The King and Kingship in Achaemenid Art*. Leiden.

——. 2003. 'The Lioness of Elam: Politics and Fecundity at Persepolis.' In Henkelman and Kuhrt 2003: 9–32.

Cooley, A., ed. 2002a. *Becoming Roman, Writing Latin? Literacy and Epigraphy in the Roman West*. Journal of Roman Archaeology, Supplementary Series 48. Portsmouth, RI.

——. 2002b. 'Introduction.' In Cooley 2002a: 9–14.

Corbeill, A. 2001. 'Education in the Roman Republic: Creating Traditions.' In Y. L. Too, ed., *Education in Greek and Roman Antiquity*. Leiden: 261–87.

——. 2002. 'Political Movement: Walking and Ideology in Republican Rome.' In D. Frederick, ed., *The Roman Gaze: Vision, Power and the Body*. Baltimore: 182–215.

Cornell, T. J. 1995. *The Beginnings of Rome: Italy and Rome from the Bronze Age to the Punic Wars (c. 1000–264 BC)*. London/New York.

Coulié, A. 2002. *La céramique Thasienne à Figures Noires*. Études Thassiennes 19. Athens.

Courtney, E. 1995. *Musa Lapidaria: A Selection of Latin Verse Inscriptions*. Atlanta, GA.

Croxford, B., H. Eckardt, J. Meade, and J. Weekes, eds. 2004. *TRAC 2003: Proceedings of the Thirteenth Annual Theoretical Roman Archaeology Conference, Leicester 2003*. Oxford.

Croxford, B., H. Goodchild, J. Lucas, and N. Ray, eds. 2006. *TRAC 2005: Proceedings of the Fifteenth Annual Theoretical Roman Archaeology Conference, Birmingham 2005*. Oxford.

Croxford, B., N. Ray, R. Roth, and N. White, eds. 2007. *TRAC 2006: Proceedings of the Sixteenth Annual Theoretical Roman Archaeology Conference, Durham 2004*. Oxford.

Curchin, L. A. 2004. *The Romanization of Central Spain: Complexity, Diversity and Change in a Provincial Hinterland*. London.

Curti, E. 2001. 'Toynbee's Legacy: Discussing Aspects of the Romanization of Italy.' In Keay and Terrenato 2001: 17–26.

Curti, E., E. Dench, and J. Patterson. 1996. 'The Archaeology of Central and Southern Italy: Some Recent Trends and Approaches.' *Journal of Roman Studies* 86: 170–89.

Curtis, J. 2005. 'Greek Influence on Achaemenid Art and Architecture.' In Villing 2005: 115–23, plates 1–7.

Daehner, J., ed. 2008. *The Herculaneum Women, History: Context, Identities*. Los Angeles.

Daems, A. 2001. 'The Iconography of Pre-Islamic Women in Iran.' *Iranica Antiqua* 36: 1–150.

D'Ambra, E. 1996. 'The Calculus of Venus: Nude Portraits of Roman Matrons.' In Kampen 1996: 219–32.

——. 2000. 'Nudity and Adornment in Female Portrait Sculpture of the 2nd Century AD.' In D. E. E. Kleiner and S. B. Matheson, eds., *I, Claudia: Women in Roman Art and Society* II. Austin: 101–14.

D'Amore, P. 1992. 'Glittica a cilindro achemenide: linee di uno sviluppo tematico-cronologico.' *Contributi e Materiali di Archeologia Orientale* 4: 187–267.

D'Arms, J. 1999. 'Performing Culture: Roman Spectacle and the Banquets of the Powerful.' In B. Bergmann and C. Kondoleon, ed., *The Art of Ancient Spectacle*, Washington: 301–19.

Daux, G. 1967. 'Chronique des Fouilles 1966.' *Bulletin de Correspondance Hellénique* 91 (2): 722–34.

Davies, G. 2002. 'Clothes as Sign: The Case of the Large and the Small Herculaneum Women.' In Llewellyn-Jones 2002b: 227–41.

Davis, T. C., and T. Postlewait, eds. 2003. *Theatricality*. Cambridge.

De Grazia Vanderpool, C. 2005. 'Fashioning Plancia Magna: Memory and Revival in the Greek East during the Second Century AD.' In J. Pollini, ed., *Terra Marique: Studies in Art History and Marine Archaeology in Honour of Anna Marguerite McCann*. Oxford: 12–29.

De la Bédoyère, G. 2007. Letter. *British Archaeology* January/February: http://www.britarch.ac.uk/BA/ba92/letters.shtml.

De la Genière, J. 1999. 'Quelques reflexions sur les clients de la céramique attique.' In M.-C. Villanueva Puig, F. Lissarrague, P. Rouillard, and A. Rouveret, eds, *Céramique et peinture grecques: modes d'emploi. Actes du colloque international, Ecole du Louvre, 26–27–28 avril 1995*. Paris: 411–23.

De Lachenal, L., ed. 1992. *Da Leukania a Lucania: la Lucania centro-orientale fra Pirro e i Giulio-Claudii*. Rome.

De Simone, C. 1996. *I Tirreni a Lemnos. Evidenza linguistica e tradizioni storiche*. Florence.

De Vaumas, E. 1954. *Le Liban. Montagne libanaise, Bekaa, Anti-Liban, Hermon, Haute Galilâee libanaise. Étude de géographie physique*. Paris.

De Vries, K. 1977. 'Attic Pottery in the Achaemenid Empire.' *American Journal of Archaeology* 81: 544–8.

Deetz, J. F. 1977. *In Small Things Forgotten*. New York.

Dench, E. 1995. *From Barbarians to New Men: Greek, Roman, and Modern Perceptions of Peoples of the Central Apennines*. Oxford.

——. 2005. *Romulus' Asylum: Roman Identities from the Age of Alexander to the Age of Hadrian*. Oxford.

Denti, M. 1992a. *La statuaria in marmo del santuario di Rossano di Vaglio*. Galatina.

——. 1992b. 'Macchia di Rossano – Sculture Lapidee.' In de Lachenal 1992: 70–9.

Derks, T. 1998. *Gods, Temples and Ritual Practices: the Transformation of Religious Ideas and Values in Roman Gaul*. Amsterdam.

Derks, T., and N. Roymans. 2002. 'Seal-Boxes and the Spread of Latin Literacy in the Rhine Delta.' In Cooley 2002a: 87–134.

Desideri, P. 1991. 'La Romanizzazione dell'Impero.' *Storia di Roma* 2 (2): 577–626.

Destrooper-Georgiades, A. 1995. 'La numismatique partim Orient.' In Krings 1995: 148–65.

Diawara, M. 1995. 'Cultural Studies/Black Studies.' In Henderson 1995: 202–11.

Díaz-Andreu, M., and S. Lucy. 2005. 'Introduction.' In Díaz-Andreu et al. 2005: 1–12.

Díaz-Andreu, M., S. Lucy, S. Babić, and D.N. Edwards. 2005. *The Archaeology of Identity: Approaches to Gender, Age, Status, Ethnicity and Religion.* London.

Dietler, M. 1997. 'The Iron Age in Mediterranean France: Colonial Entanglements, Encounters and Transformations.' *Journal of World Prehistory* 11 (3): 269–358.

——. 2006. 'Culinary Encounters: Food, Identity and Colonialism.' In K.C. Twiss, ed. *The Archaeology of Food and Identity.* Carbondale: 218–42.

Diez, E. 1953. 'Norisches Mädchen in besonderer Tracht'. *Jahreshefte des Österreichischen Archäologischen Institutes in Wien* 40: 107–28.

Dimitrova, N., and K. Clinton. 2003. 'An Archaic Inscription from Samothrace.' *Hesperia* 72: 235–9.

Docter, R.F., H.G. Niemeyer, A.J. Nijboer, and H. van der Plicht. 2004. 'Radiocarbon Dates of Animal Bones in the Earliest Levels of Carthage.' *Mediterranea* 1: 557–77.

Dollinger, P. 1998 [1964]. *Die Hanse.* Stuttgart.

Donati, L. 2000. 'Civil, Religious and Domestic Architecture.' In Torelli 2000: 313–33.

Dondin-Payre, M. 1991. 'L'exercitus Africae inspiratrice de l'armée française d'Afrique: *Ense et aratro.*' *Antiquités Africaines* 27: 141–9.

Donner, H., and W. Röllig. 1962. *Kanaanäische und aramäische Inschriften.* 3 vols. Wiesbaden.

Donohue, A.A. 2003. 'Introduction.' In Donohue and Fullerton 2003: 1–12.

Donohue, A.A., and M.D. Fullerton, eds. 2003. *Ancient Art and Its Historiography.* Cambridge.

Dore A., M. Marchesi, and L. Minarini. 2000. *Principi Etruschi. Tra Mediterraneo ed Europa.* Venice.

Dougherty, C. 2003. 'The Aristonothos Krater: Competing Stories of Conflict and Collaboration.' In Dougherty and Kurke 2003: 35–56.

Dougherty, C., and L. Kurke, eds. 1993. *Cultural Poetics in Archaic Greece.* Cambridge.

——. 2003. *The Cultures within Ancient Greek Culture: Contact, Conflict, Collaboration.* Cambridge.

Douglas, M., and B. Isherwood. 1996 [1979]. *The World of Goods: Towards an Anthropology of Consumption.* London.

Droysen, J.G. 1998. *Geschichte Alexanders Des Grossen. Vol. 1, Geschichte Des Hellenismus.* Darmstadt.

DuBois, P. 2001. *Trojan Horses: Saving the Classics from Conservatives.* New York.

Duhard, J.-P. 1990. 'Le corps feminin et son langage dans l'art paleolithique.' *Oxford Journal of Archaeology* 9: 241–55.

——. 1991. 'The Shape of Pleistocene Women.' *Antiquity* 65: 552–61.

Dusenbery, E. 1998. *Samothrace. Vol. 11. The Necropoleis.* Princeton.

Dusinberre, E.R.M. 1997. 'Imperial Style and Constructed Identity: A "Graeco-Persian" Cylinder Seal from Sardis.' *Ars Orientalis* 27: 99–129.

——. 2003. *Aspects of Empire in Achaemenid Sardis.* Cambridge.

Dyson, S. L. 1993. 'From New to New Age Archaeology, Archaeological Theory and Classical Archaeology: A 1990s Perspective.' *American Journal of Archaeology* 97 (2): 195–206.

———. 2003. *The Roman Countryside.* London.

———. 2006. *In Pursuit of Ancient Pasts: A History of Classical Archaeology in the Nineteenth and Twentieth Centuries.* New Haven.

Eckardt, H. 2005. 'The Social Distribution of Roman Artefacts: the Case of Nail-cleaners and Brooches in Britain.' *Journal of Roman Archaeology* 18: 139–60.

Eco, U., ed. 2004. *On Beauty: A History of a Western Idea.* London.

Edwards, C., ed. 1999. *Roman Presences: Receptions of Rome in European Culture, 1789–1945.* Cambridge.

Efstratiou, N. 1993. 'The Archaeology of Greek Uplands: The Early Iron Age Site of Tsouka in the Rhodope Mountains.' *Annual of the British School at Athens* 88: 135–71.

Egger, R. 1921. *Führer durch die Antiken-Sammlung des Landesmuseums in Klagenfurt.* Vienna.

Elsner, J. 1995. *Art and the Roman Viewer: The Transformation of Art from the Pagan World to Christianity.* Cambridge.

———. 2000. 'Caught in the Ocular: Visualising Narcissus in the Roman World.' In L. Spaas, ed., *Echoes of Narcissus.* New York: 89–110.

Emberling, G. 1997. 'Ethnicity in Complex Societies: Archaeological Perspectives.' *Journal of Archaeological Research* 5 (4): 295–344.

Emiliozzi, A., ed. 1999. *Carri da Guerra e Principi Etruschi. Catalogo della mostra, Viterbo, Palazzo dei Papi, 24 maggio 1997–31 gennaio 1998.* Rome.

Ersoy, Y. 2004. 'Klazomenai: 900–500 BC History and Settlement Evidence.' In Moustaka et al. 2004: 43–76.

Esposito, A. M. 1999. *Principi Guerrieri. La Necropoli Etrusca di Casale Marittimo.* Milan.

Essbach, W. 2000. *wir – ihr – sie, Identitäten und Alteritäten.* Vol. 2. Würzburg.

Eule, J. C. 2001. *Hellenistische Bürgerinnen aus Kleinasien. Weibliche Gewandstatuen in ihrem antiken Kontext.* Istanbul.

Evans, A. 1921–1936. *The Palace of Minos: A Comparative Account of the Successive Stages of the Early Cretan Civilization as Illustrated by the Discoveries at Knossos.* London.

Ewald, B. C. 2004. 'Men, Muscle and Myth: Attic Sarcophagi in the Cultural Context of the Second Sophistic.' In B. Borg, ed., *Paideia: The World of the Second Sophistic.* Berlin/New York: 229–75.

Fabricius, J. 2007. 'Grenzziehungen. Zu Strategien somatischer Geschlechter-diskurse in der griechischen und römischen Kultur.' In E. Hartmann, U. Hartmann, and K. Pietzner, eds., *Geschlechterdefinitionen und Geschlechtergrenzen in der Antike. Tagung Humboldt-Universität Berlin, 17–20 Feb. 2005.* Stuttgart: 65–86.

Fanon, F. 1968 [1952] *Black Skin, White Masks.* Trans. C. L. Markmann. London.

Farrell, J. 2001. *Latin Language and Latin Culture: From Ancient to Modern Times.* Cambridge.

Featherstone, M. 1988. 'In Pursuit of the Postmodern: An Introduction.' *Theory, Culture and Society* 5: 195–215.

———. 1990. 'Global Culture: An Introduction.' *Theory, Culture and Society* 7: 1–14.

———. 1991. *Consumer Culture and Postmodernism.* London.

———. 1995. *Undoing Culture: Globalization, Postmodernism and Identity.* London.

Featherstone, M., S. Lash, and R. Robertson, eds. 1995. *Global Modernities*. London.

Fenton, S. 2003. *Ethnicity*. Cambridge.

Ferguson, R. B., and N. L. Whitehead. 1992. *War in the Tribal Zone: Expanding States and Indigenous Warfare*. Santa Fe.

Ferrary, J.-L. 1994. 'L'Empire Romain, l'oikoumène et l'Europe.' In M. Perrin, ed., *L'idée de l'Europe au fil de deux millénaires*. Le Centre d'Histoire des Idées Université de Picardie Jules-Verne. Paris: 39–54.

Ferri, S. 1933. *Arte romana sul Danubio: considerazioni sullo sviluppo, sulle derivazioni e sui caratteri dell' arte provinciale romana*. Milan.

Filow, B. [Филов, Б.] 1934. *The Burial Tumuli at Duvanlii, Plovdiv District (with the cooperation of I. Velkov and V. Mikov)*. [Надгробните могили при Дуванлий в Пловдивско (при сътрудничеството на Ив. Велков и В. Миков).] Sophia.

Fisher, N., and H. van Wees, eds. 1998. *Archaic Greece: New Approaches and New Evidence*. London/Swansea.

Fisher, W. B. 1978 [1950]. *The Middle East: A Physical, Social, and Regional Geography*. London.

Fittschen, K. 1982. *Die Bildnistypen der Faustina minor und die Fecunditas Augustae*. Abhandlungen der Akademie der Wissenscahften in Göttingen. Philologisch-Historische Klasse. 3.126. Göttingen.

———. 2000. 'Nicht Sabina.' *Archäologischer Anzeiger*: 507–14.

Flower, H. 1996. *Ancestor Masks and Aristocratic Power in Roman Culture*. Oxford.

Fludernik, M., and H.-J. Gehrke, eds. 1999. *Grenzgänger zwischen Kulturen*. Würzburg.

Fol, A. [Фол, А.] ed. 1982. 'The Megaliths.' In *Thrace. Part 2. Thracia Pontica. Thracian Monuments*, vol. 3. [Мегалитите в Тракия, ч. 2. Тракия Понтика. Тракийски паметници, т. 3.] Sophia.

Forbis, E. 1990. 'Women's Public Image in Italian Honorary Inscriptions.' *American Journal of Philology* 111: 493–512.

———. 1996. *Municipal Virtues in the Roman Empire: The Evidence of Italian Honorary Inscriptions*. Beiträge zur Altertumskunde 79. Stuttgart/Leipzig.

Forcey, C., J. Hawthorn, and R. Witcher, eds. 1998. *TRAC 97: Proceedings of the Seventh Annual Theoretical Roman Archaeology Conference, Nottingham 1997*. Oxford.

Fracchia, H., and M. Gualtieri. 1989. 'The Social Context of Cult Practices in Pre-Roman Lucania.' *American Journal of Archaeology* 93: 217–32.

Fraser, P. M. 1960. *Samothrace. Vol. 2. Part. I. The Inscriptions on Stone*. New York.

Fredrich, C. 1909. 'Aus Samothrake.' *Mitteilungen des Deutschen Archäologischen Instituts. Athenische Abteilung* 34: 23–8.

Freeman, P. 1993. '"Romanisation" and Roman Material Culture.' *Journal of Roman Archaeology* 6: 438–45.

———. 1996. 'British Imperialism and the Roman Empire.' In Webster and Cooper 1996: 19–34.

Friedland, K. 1991. *Die Hanse*. Stuttgart.

Friedman, J. 1994. *Cultural Identity and Global Process*. London.

Frontisi-Ducroux, F. 1975. *Dédale. Mythologie de l'Artisan en Grèce Ancienne*. Paris.

Furtwängler, A. 1900. *Die antiken Gemmen: Geschichte der Steinschneidekunst im klassischen Altertum*. Leipzig.

Fuss, D. 1994. 'Interior Colonies: Frantz Fanon and the Politics of Identification.' *Diacritics* Summer/Fall: 20–42.

Gabelmann, H. 1987. 'Römische Grabbauten der Nordprovinzen im 2. und 3.Jh. N. Chr.' In H. von Hesberg and P. Zanker, ed., *Römische Gr berstrassen: Selbstdarstellung-Status-Standard*. Munich: 291–308.

Garbini, G. 1980. *I Fenici. Storia e religione*. Naples.

Garbsch, J. 1965. *Die Norisch-Pannonische Frauentracht im I. und 2. Jahrhundert*. Munich.

Gardner, A. 2002. 'Social Identity and the Duality of Structure in Late Roman-period Britain.' *Journal of Social Archaeology* 2 (3): 323–51.

——. 2003. 'Debating the Health of Roman Archaeology.' *Journal of Roman Archaeology* 16: 435–41.

——, ed. 2004. *Agency Uncovered: Archaeological Perspectives on Social Agency, Power, and Being Human*. London.

——. 2006. 'The Future of TRAC.' In Croxford et al., 2006, 128–37.

——. 2007. *An Archaeology of Identity*. Walnut Creek.

Gardner, K., and D. Lewis. 1996. *Anthropology, Development and the Post-modern Challenge*. London.

Garland, R. 1990. *The Greek Way of Life*. London.

——. 1995. *The Eye of the Beholder: Deformity and Disability in the Graeco-Roman World*. London.

Garrison, M.B. 2000. 'Achaemenid Iconography as Evidenced by Glyptic Art: Subject Matter, Social Function, Audience and Diffusion.' In C. Uehlinger, ed., *Images as Media: Sources for the Cultural History of the Near East and the Eastern Mediterranean (1st Millennium BCE)*. Winona Lake: 115–63.

Gehrig, U., and H.G. Niemeyer, eds. 1990. *Die Phönizier im Zeitalter Homers*. Mainz.

Gehrke, H.-J. 2004. 'Identität in der Alterität: Heroen als Grenzgänger zwischen Hellenen und Barbaren.' In M. Fludernik and H.-J. Gehrke, eds., *Normen, Ausgrenzungen, Hybridierungen und 'Acts of Identity.'* Würzburg: 117–34.

Gell, A. 1998. *Art and Agency: An Anthropological Theory*. Oxford.

Georgiev, V. [Георгиев, В.] 1979. 'The Thracian Language.' ['Тракийският език.'] In V. Velkov, G. Georgiev, C. Danov, T. Ivanov and A. Fol [В. Велков, Г. Георгиев, Х. Данов, Т. Иванов, А. Фол], eds., *The History of Bulgaria* vol. 1 [История на България т.1.],. Sophia.

Georgieva, R. 2003. 'Sepultures insolites de Thrace (fin du IIe – Ier mill. Av. J.-C.).' *Thracia* XV: 313–23.

Gercke, P., and W. Löwe. 1996. *Samos – die Kasseler Grabung 1894*. Kassel.

Gergova, D. 1987. *Früh- und ältereisenzeitliche Fibeln in Bulgarien*. Prähistorische Bronzefunde, Abteilung XIV, Band 7. Munich.

Gessner, V., and A. Schade. 1990. 'Conflicts of Culture in Cross-border Legal Relations: The Conception of a Research Topic in the Sociology of Law.' *Theory, Culture and Society* 7: 253–77.

Getov, L. [Гетов, Л.] 1965. 'Tumular Burial in the Region of Dolno Sahrane Village, Municipality of Stara Zagora.' ['Могилно погребение при с. Долно Сахране, Старозагорско.']. *Bulletin de l'Institut Archéologique Bulgare* [Известия на Археологическия Институт] 28: 203–29.

Giddens, A. 1984. *The Constitution of Society: Outline of a Theory of Structuration*. Cambridge.

Gilman, S.L. 1986. 'Black Bodies, White Bodies: Toward an Iconography of Female Sexuality in Late Nineteenth-Century Art, Medicine, and Literature.' In H.L. Gates Jr, ed., *Race, Writing and Difference*. Chicago: 223–61.

Gimatzidis, S. [Γιματζίδης, Σ.] 2002. 'The Colonization of Thasos: A Re-examination of the Pottery of the Early Phases of the Ancient City.' ['Ο αποκισμός της Θάσου: η επανεξέταση της κεραμικής πρώιμων φάσεων της αρχαίας πόλης.'] *Archaeological Work in Macedonia and Thrace* [*Το Αρχαιολογικό Έργο στη Μακεδονία και στη Θράκη*] 16: 73–81.

Given, M. 2004. *The Archaeology of the Colonized*. London.

Gleason, M. 1995. *Making Men: Sophists and Self-Presentation in Ancient Greece*. Princeton.

Glinister, F. 2003. 'Gifts of the Gods: Sanctuary and Society in Archaic Tyrrhenian Italy.' In J. B. Wilkins and E. Herring, eds., *Inhabiting Symbols: Symbol and Image in the Ancient Mediterranean*. London: 137–47.

Goette, H. R. 1990. *Studien zu römischen Togadarstellungen*. Mainz.

Goff, B., ed. 2005a. *Classics and Colonialism*. London.

———. 2005b. 'Introduction.' In Goff 2005a: 1–24.

Golden, M., and P. Toohey, eds. 1997. *Inventing Ancient Culture: Historicism, Periodization, and the Ancient World*. London.

Goldhill, S., ed. 2001. *Being Greek under Rome: Cultural Identity, the Second Sophistic and the Development of Empire*. Cambridge.

Goldman, A. H. 1995. 'Comparative Identities: Exile in the Writing of Franz Fanon and W. E. B. Du Bois.' In Henderson 1995: 107–32.

Goldman, B. 1991. 'Women's Robes: The Achaemenid Era.' *Bulletin of the Asia Institute* 5: 83–103.

Goldsworthy, A., and I. Haynes, eds. 1999. *The Roman Army as a Community*. Journal of Roman Archaeology, Supplementary Series 34. Portsmouth, RI.

Gori, S., and M. Chiara Bettini, eds. 2006. *Gli Etruschi Da Genova Ad Ampurias. Atti del XXIV Convegno di Studi Etruschi ed Italici, Marseilles-Lattes, 26 settembre-1 ottobre 2002*. Pisa/Rome.

Gosden, C. 2004. *Archaeology and Colonialism: Cultural Contact from 5000 BC to the Present*. Cambridge.

———. 2006. 'Race and Racism in Archaeology: Introduction.' *World Archaeology* 38 (1): 1–7.

Gosden, C., and Y. Marshall. 1999. 'The Cultural Biography of Objects.' *World Archaeology* 31: 169–78.

Graham, A. J. 1978. 'The Foundation of Thasos.' *Annual of the British School at Athens* 73: 62–98.

———. 1982. 'The Colonial Expansion of Greece.' In *Cambridge Ancient History III. The Expansion of the Greek World, Eighth to Sixth Centuries B.C.* London: 83–162.

———. 2002. 'The Colonization of Samothrace.' *Hesperia* 71 (3): 221–60.

Gramsch, A. 2000. '"Reflexiveness" in Archaeology, Nationalism, and Europeanism.' *Archaeological Dialogues* 7 (1): 4–19.

Gramsci, A. 1971. *Selections from the Prison Notebooks*. London.

Gran, A., and M. J. Jean. 1993. 'Observation Generales sur l'Evolution et la Diffusion du Bucchero.' In Bonghi-Jovino 1993: 19–41.

———. 1999. 'Images et Mythes sur les Vases Noirs d'Étrurie (VIII-VI siècle a.v. J.-C.).' In Massa-Pairault 1999: 383–404.

Gras, M. 1985. *Trafics Tyrrhéniens Archaïques*. Rome.

Graves-Brown, P., S. Jones, and C. Gamble, eds. 1996. *Cultural Identity and Archaeology: The Construction of European Communities*. London.

Greco, E. 1990. 'Serdaioi.' *Annali dell'Istituto universitario orientale di Napoli Dipartimento di studi del mondo classico e mediterraneo antico, Sezione di archeologia e storia antica* 12: 39–57.

Gregory, D. 2004. *The Colonial Present*. Oxford.

Gschnitzer, F. 1993. 'Phoinikisch-punisches Verfassungsdenken.' In K. A. Raaflaub, ed., *Anfänge politischen Denkens in der Antike. Die nahöstlichen Kulturen und die Griechen*. Munich: 187–98.

Gualtieri, M. 1993. 'The Community at Roccagloriosa: Interpretations and Hypotheses.' In M. Gualtieri, ed., *Fourth Century BC Magna Graecia: A Case Study*. Jonsered: 325–45.

Gualtieri, M., and P. Poccetti. 2001. 'Frammento di tabula bronzea con iscrizione osca dal pianoro centrale.' In M. Gualtieri and H. Fracchia, eds., *Roccagloriosa II: L'oppidum lucano e il territorio*. Naples: 187–275.

Gubel, E. 2006. 'Notes on the Phoenician Component of the Orientalizing Horizon.' In Riva and Vella 2006: 85–93.

Gupta, A., and J. Ferguson. 2002. 'Beyond "Culture": Space, Identity, and Politics of Difference.' In J. X. Inda and R. Rosaldo, eds., *The Anthropology of Globalization: A Reader*. Oxford: 65–79.

Habinek, T. N. 1998. *The Politics of Latin Literature: Writing, Identity and Empire in Ancient Rome*. Princeton.

Hales, S. 2003. *The Roman House and Social Identity*. Cambridge.

Haley, E. W. 2003. *Baetica Felix: People and Prosperity in Southern Spain from Caesar to Septimius Severus*. Austin.

Hall, E. 1989. *Inventing the Barbarian: Greek Self-Definition through Tragedy*. Oxford.

———. 2006. *The Theatrical Cast of Athens: Interactions between Greek Drama and Society*. Oxford.

Hall, J. 1997. *Ethnic Identity in Greek Antiquity*. Cambridge.

———. 2002. *Hellenicity: Between Ethnicity and Culture*. Chicago.

———. 2007a. 'The Creation and Expression of Identity: The Greek World.' In Alcock and Osborne 2007: 337–54.

———. 2007b. *A History of the Archaic Greek World: Ca. 1200–479 BCE*. Oxford.

———. Forthcoming. 'Ethnicity and Cultural Exchange.' In K. Raaflaub and H. van Wees, eds., *The Blackwell Companion to the Archaic Greek World*. Oxford.

Hall, S. 1990. 'Cultural Identity and Diaspora.' In Rutherford 1990a: 222–37.

———. 1992. 'The Question of Cultural Identity.' In S. Hall, D. Held, and T. McGrew, eds, *Modernity and Its Futures*. Cambridge: 273–325.

———. 2003a. 'Créolité and the Process of Creolization.' In O. Enwezor, ed., *Créolité and creolization. Dokumenta 11-Platform 3*. Ostfildern: 27–41.

———. 2003b. 'Cultural Identity and Diaspora.' In J. E. Braziel and A. Mannur, eds., *Theorizing Diaspora*. Oxford: 233–46.

Hallesten, K. 1995. 'In Exile in the Mother Tongue: Yiddish and the Woman Poet.' In Henderson 1995: 64–106.

Hallett, C. H. 2005. 'Emulation Versus Replication: Redefining Roman Copying.' *Journal of Roman Archaeology* 18: 419–35.

Hansen, M. H. 1993. 'The Polis as a Citizen-state.' In M. H. Hansen, ed., *The Ancient Greek City-State*. Copenhagen: 7–29.

Hanson, V. D., and J. Heath. 1998. *Who Killed Homer? The Demise of Classical Education and the Recovery of Greek Wisdom*. New York.

Hanson, W. S. 1994. 'Dealing with Barbarians: The Romanization of Britain.' In B. Vyner, ed., *Building on the Past: Papers Celebrating 150 Years of the Royal Archaeological Institute*. London: 149–63.

Harden, D. B. 1971 [1962]. *The Phoenicians*. Middlesex.

Hardt, M., and A. Negri. 2000. *Empire*. London.

Harrison, S.J. 2001. 'General Introduction: Working Together.' In S.J. Harrison, ed., *Texts, Ideas and the Classics: Scholarship, Theory and Classical Literature*. Oxford: 1–17.

Harvey, D. 1989. *The Condition of Postmodernity*. Oxford.

Haynes, I.P. 2001. 'The Impact of Auxiliary Recruitment on Provincial Societies from Augustus to Caracalla.' In L. de Blois, ed., *Administration, Prosopography and Appointment Policy in the Roman Empire: Proceedings of the First Workshop of the International Network Impact of Empire (Roman Empire, 27 BC–AD 406) Leiden, June 28-July 1, 2000*. Amsterdam: 62–83.

Hemelrijk, J.M. 1984. *Caeretan Hydriae*. Mainz.

Henderson, J. 2002. *Pliny's Statue: The Letters, Self-Portraiture, and Classical Art*. Exeter.

Henderson, M., ed. 1995. *Borders, Boundaries and Frames*. New York/London.

Henkelman, H., and A. Kuhrt, eds. 2003. *A Persian Perspective: Essays in Memory of Heleen Sancisi-Weerdenburg*. Leiden.

Herring, E., and K. Lomas, ed. 2000. *The Emergence of State Identities in Italy in the First Millennium BC*. London.

Hersey, G.L. 1996. *The Evolution of Allure*. Cambridge, MA.

Hessing, W. 2001. 'Foreign Oppressor Versus Civiliser: The Batavian Myth as the Source for Contrasting Associations of Rome in Dutch Historiography and Archaeology.' In Hingley 2001: 126–44.

Hingley, R. 1996. 'The "Legacy" of Rome: The Rise, Decline and Fall of the Theory of Romanization.' In Webster and Cooper 1996: 35–48.

——. 1997. 'Resistance and Domination: Social Change in Roman Britain.' In Mattingly 1997b: 81–102.

——. 2000. *Roman Officers and English Gentlemen*. London.

——, ed. 2001. *Images of Rome: Perceptions of Ancient Rome in Europe and the United States of America in the Modern Age*. Journal of Roman Archaeology, Supplementary Series 44. Portsmouth, RI.

——. 2003. 'Recreating Coherence without Reinventing Romanization.' *Digressus: The Internet Journal for the Classical World* 3: 112–19.

——. 2005. *Globalizing Roman Culture: Unity, Diversity and Empire*. London.

——. 2007. 'R****ization.' Letter. *British Archaeology* July/August: 20.

Hingley, R., and S. Willis. 2007. *Promoting Roman Finds: Context and Theory*. Oxford.

Hodder, I. 1982. *Symbols in Action: Ethnoarchaeological Studies of Material Culture*. Cambridge.

——, ed. 2001. *Archaeological Theory Today*. Cambridge.

Hodos, T. 2006. *Local Responses to Colonization in the Iron Age Mediterranean*. London.

Hölscher, T. 1987. *Römische Bildsprache als semantisches System*. Abhandlungen Heidelberger Akademie der Wissenschaften, Philosophisch-Historische Klasse. 2. Heidelberg. (English edn, 2006. *The Language of Images in Roman Art*. Trans. A. Snodgrass and A-M. Künzl-Snodgrass. Cambridge.)

——. 1990. 'Römische Nobiles und hellenistische Herrscher.' In *Akten des 13. Internationalen Kongresses für Klassische Archäologie. Berlin 1988*. Mainz: 73–84.

——. 2000. 'Bildwerke: Darstellungen, Funktionen, Botschaften.' In Borbein, Hölscher, and Zanker 2000: 147–65.

Holton, R.J. 1998. *Globalization and the Nation-State*. London.

Hoogvelt, A. 2001 [1997]. *Globalization and the Postcolonial World*. Basingstoke.

Horden, P., and N. Purcell. 2000. *The Corrupting Sea: A Study of Mediterranean History*. Oxford.

Horsnaes, H. W. 2002. *The Cultural Development in North Western Lucania c. 600–273 BC*. Rome.

Howgego, C. 2005. 'Coinage and Identity in the Roman Provinces.' In Howgego, Heuchert, and Burnett 2005: 1–18.

Howgego, C., V. Heuchert, and A. Burnett, eds. 2005. *Coinage and Identity in the Roman Provinces*. Oxford/New York.

Hunt, D. W. S. 1945. 'An Archaeological Survey of the Classical Antiquities of the Island of Chios Carried Out between the Months March and July 1938.' *Annual of the British School at Athens* 41: 31–2.

Hürmüzlü, B. 2004. 'Burial Grounds at Klazomenai: Geometric through Hellenistic Periods.' In Moustaka et al. 2004: 77–95.

Hurst, H. 2005. 'Introduction' In Hurst and Owen 2005: 1–3.

Hurst, H., and S. Owen, eds. 2005. *Ancient Colonizations. Analogy, Similarity and Difference*. London.

Huskinson, J., ed. 2000. *Experiencing Rome: Culture, Identity and Power in the Roman Empire*. London.

Huss, W. 1994 [1990]. *Die Karthager*. Munich.

Iggers, G. G. 1997. *Historiography in the Twentieth Century: From Scientific Objectivity to the Postmodern Challenge*. London.

Ilieva, P. [Илиева, П.] 2006a. 'Aegean Thrace between Bistonis Lake and Propontis (8th–6th c. BC).' [Егейска Тракия между Бистонида и Пропонтида (8–6 в. пр. Хр.)] Unpublished PhD dissertation, Sophia University.

——. 2006b. 'Long-necked Jugs of Samothrace and the Subgeometric Pottery of the Northeastern Aegean.' ['Οινοχόες με μακρύ λαιμό από την Σαμοθράκη και η υπογεωμετρική κεραμική παράδωση του βορειοανατολικού Αιγαίου.']. Paper presented at Samothrace: History, Archaeology, Culture Conference, Samothrace, Greece, 1–2 September 2006.

——. 2007. 'Thracian-Greek "συμβίωσις" on the Shore of Aegean.' In *Thrace in the Graeco-Roman World: Proceedings of the 10th International Congress of Thracology, Komotini-Alexandroupolis 18–23 October 2005*. Athens: 212–27.

Inan, J., and E. Alföldi-Rosenbaum. 1979. *Römische und frühbyzantinische Porträtplastik aus der Türkei. Neue Funde*. 2 vols. Mainz.

Inan, J., and E. Rosenbaum. 1966. *Roman and Early Byzantine Portrait Sculpture in Asia Minor*. London.

Insoll, T., ed. 2007. *The Archaeology of Identities: A Reader*. Abingdon.

Iren, K. 2003. *Aiolische orientalisierende Keramik*. Istanbul.

Isaac, B. 1986. *The Greek Settlements in Thrace until the Macedonian Conquest*. Studies of the Dutch Archaeological and Historical Society 10. Leiden.

Isaac, B. H. 2004. *The Invention of Racism in Classical Antiquity*. Princeton.

——. 2006. 'Proto-racism in Graeco-Roman Antiquity.' *World Archaeology* 38 (1): 32–47.

Isayev, E. 2007. *Inside Ancient Lucania: Dialogues in History and Archaeology*. London.

Izzet, V. 2004. 'Purloined Letters: The Aristonothos Inscription and Crater.' In K. Lomas, ed., *The Greeks in the West: Papers in Honour of Brian Shefton*. Leiden: 191–210.

Jacobsen, T. 1943. 'Primitive Democracy in Ancient Mesopotamia.' *Journal of Near Eastern Studies* 2: 159–72.

James, P., and T. Nairn. 2006. 'A Critical Introduction to *Globalization and Culture*.' http://www.sagepub.com/upm-data/9930_45373intro.pdf.

James, S. 1999a. *The Atlantic Celts: Ancient People or Modern Invention*. London.

——. 1999b. 'The Community of Soldiers: A Major Identity and Centre of Power in the Roman Empire.' In P. Baker, C. Forcey, S. Jundy, and R. Witcher, eds., *TRAC 98: Proceedings of the Eighth Annual Theoretical Roman Archaeology Conference, Leicester 1998*. Oxford: 14–25.

——. 2001a. "Romanization' and the Peoples of Britain.' In Keay and Terrenato 2001: 187–209.

——. 2001b. 'Soldiers and Civilians: Identity and Interaction in Roman Britain.' In S. James and M. Millett, eds., *Britons and Romans: Advancing an Archaeological Agenda*. York: 77–89.

——. 2003. 'Roman Archaeology: Crisis and Revolution.' *Antiquity* 77: 178–84.

Jeffery, L. 1990. *The Local Scripts of Archaic Greece*. Rev. edn. Oxford.

Jenkins, R. 1997. *Rethinking Ethnicity: Arguments and Explorations*. London.

Johnson, C.A. 2004. *The Sorrows of Empire: Militarism, Secrecy, and the End of the Republic*. London.

Jones, S. 1996. 'Discourses of Identity in the Interpretation of the Past.' In Graves-Brown, Jones, and Gamble 1996: 62–80.

——. 1997. *The Archaeology of Ethnicity*. London.

Joshel, S.R. 1992. *Work, Identity and Legal Status at Rome: A Study of the Occupational Inscriptions*. London.

Kaeser, M.-A. 2000. 'Talking about Readings of the Past: A Delusive Debate.' *Archaeological Dialogues* 7 (1): 34–6.

Kampen, N.B. 1996. *Sexuality in Ancient Art*. Cambridge.

Kant, I. 2000 [1790]. *Critique of the Power of Judgement*. Trans. P. Guyer and E. Matthews. Ed. P. Guyer. Cambridge.

Kaptan, D. 2002. *The Daskyleion Bullae: Seal Images from the Western Achaemenid Empire*. 2 vols. Leiden.

——. 2003. 'A Glance at Northwestern Asia Minor during the Achaemenid Period.' In Henkelman and Kuhrt 2003: 189–202.

Karadima, C. [Καράδημα, Χ.] 1995. 'Archaeological Excavations in Maroneia and Samothrace in 1995.' ['Αρχαιολογικές εργασίες στη Μαρώνεια και στη Σαμοθράκη το 1995.'] *Archaeological Work in Macedonia and Thrace* [*Το Αρχαιολογικό Έργο στη Μακεδονία και στη Θράκη*] 9: 487–97.

Karadima, C., and M. Koutsoumanis. [Καράδημα, Χ., and Μ. Κουτσουμανής.] 1992. 'Archaeological Investigations at Samothrace 1992.' ['Αρχαιολογικές εργασίες Σαμοθράκης 1992.'] *Archaeological Work in Macedonia and Thrace* [*Το Αρχαιολογικό Έργο στη Μακεδονία και στη Θράκη*] 6: 677–83.

Karadima, C., D. Matsas, F. Blondé, and M. Picon. 2002. 'Workshop References and Clay Surveying in Samothrace: An Application to the Study of the Origin of Some Ceramic Groups.' In V. Kilikoglou, A. Hein, and Y. Maniatis, eds., *Modern Trends in Scientific Studies on Ancient Ceramics*. BAR International Series 1011: 157–62.

Katzenstein, H.J. 1973. *The History of Tyre: From the Beginning of the Second Millenium B.C.E. until the Fall of the Neo-Babylonian Empire in 538 B.C.E.* Jerusalem.

Keay, S., and N. Terranato, eds. 2001. *Italy and the West: Comparative Issues in Romanization*. Oxford.

Keesling, C.M. 2003. *The Votive Statues of the Athenian Acropolis*. Cambridge.

Kennedy, D.F. 1992. '"Augustan" and "Anti-Augustan": Reflections on Terms of Reference.' In A. Powell, ed., *Roman Poetry & Propaganda in the Age of Augustus*. Bristol: 26–58.

Kenner, H. 1951. 'Zur Kultur und Kunst der Kelten (Mit besonderer Berücksichtigung der Kärntner Funde).' *Carinthia I* 141: 566–93.

Kern, O. 1893. 'Aus Samothrake.' *Mitteilungen des Deutschen Archäologischen Instituts. Athenische Abteilung* 18: 337–84.

Khatchadourian, L. 2008. 'Making Nations from the Ground Up: Traditions of Classical Archaeology in the South Caucasus.' *American Journal of Archaeology* 112 (2): 247–78.

Kilian-Dirlmeier, I. 1985. 'Fremde Weihungen in Griechischen Heiligtümern vom 8. bis zum Beginn des 7. Jahrhunderts v. Chr.' *Jahrbuch des Römisch-Germanischen Zentralmuseums Mainz*: 215–53.

Kilmer, M. 1993. *Greek Erotica*. London.

Klein, R. 1996. *Eat Fat*. New York.

Knapp, A. B. 2008. *Prehistoric and Protohistoric Cyprus: Identity, Insularity and Connectivity*. Oxford.

Knapp, A. B., and P. van Dommelen. 2008. 'Past Practices: Rethinking Individuals and Agents in Archaeology.' *Cambridge Archaeological Journal* 18 (1): 15–34.

Knappett, C. 2005. *Thinking through Material Culture: An Interdisciplinary Perspective*. Philadelphia.

Knauft, B. M., ed. 2002a. *Critically Modern: Alternatives, Alterities, Anthropologies*. Bloomington.

———. 2002b. 'Critically Modern: An Introduction.' In Knauft 2002a: 1–55.

Knox, B. 1993. *The Oldest Dead White European Males*. New York.

Kockel, V. 1993. *Porträtreliefs stadtrömischer Grabbauten. Ein Beitrag zur Geschichte und zum Verständnis des spätrepublikanisch-frühkaiserzeitlichen Privatporträts*. Beiträge zur Erschliessung hellenistischer und kaiserzeitlicher Skulptur und Architektur 12. Mainz.

Koloski-Ostrow, A. O., and C. L. Lyons, eds. 1997. *Naked Truths: Women, Sexuality and Gender in Classical Art and Archaeology*. London.

Köpenhofer, D. 1997. 'Troia VII – versuch einer zusammenschau einschliesslich der Ergebnisse des Jahres 1995.' *Studia Troica* 7: 295–353.

Koppel, E. M. 1985. *Die römischen Skulpturen von Tarraco*. Madrider Forschungen 15. Berlin.

Kopytoff, I. 1986. 'The Cultural Biography of Things: Commoditization as Process.' In Appadurai 1986: 64–94.

Koukouli-Chrysanthaki, C. [Κουκούλη-Χρυσανθάκη, Χ.] 1992. *Prehistoric Thasos. The Cemeteries at Kastri*. [*Προϊστορική Θάσος. Τα νεκροταφεία του οικισμού Καστρί.*] Athens.

———. 1993. 'The Early Iron Age in Eastern Macedonia.' ['Η πρώιμη εποχή του σιδήρου στην Ανατολική Μακεδονία.'] *Ancient Macedonia* [*Αρχαία Μακεδονία*] 1: 679–733.

———. 1994. 'The Cemeteries of Abdera.' In *Necropoles et societés antiques (Grèce, Italie, Lavenedoc)*. Actes du Colloque International du Centre de Recherches Archéologiques de l'Université de Lille III, Lille, 2–3 Decembre 1991, Cahiers du Centre Jean Bérard XVIII. Naples: 33–77.

Kremer, G. 2004. 'Die norisch-pannonischen Grabbauten als Ausdruck kulturel-ler Identität?' In Schmidt-Colinet 2004: 147–59.

Krings, V., ed. 1995. *La civilisation phénicienne et punique. Manuel de recherche*. Leiden.

Kristiansen, K. 1998. 'The Emergence of the European World System in the Bronze Age: Divergence, Convergence and Social Evolution during the First and Second Millennia BC in Europe.' In K. Kristiansen and M. Rowlands,

eds., *Social Transformations in Archaeology: Global and Local Perspectives*. London: 287–323.

Kruse, H.-J. 1975. *Römische weibliche Gewandstatuen des 2. Jahrhunderts n. Chr.* Göttingen.

Kullmann, W. 1960. *Die Quellen der Ilias (Troischer Sagenkreis)*. Wiesbaden.

Kulov, G. [Кулов, Г.] 1991. 'Thracian Culture during the Bronze and Early Iron Age in the Middle Arda Valley and Its Tributaries.' ['Тракийската култура през бронзовата и ранножелязната епоха по средното течение на р. Арда и нейните притоци.'] *Bulletin of the Museums of South Bulgaria* [Известия на Музеите от Южна България] XVII: 73–86.

Kyrieleis, H. 1993. 'The Heraion at Samos.' In Marinatos and Hägg 1993: 125–53.

Lamb, W. 1932. 'Antissa.' *Annual of the British School at Athens* 32: 41–67, plates 17–25.

Lane Fox, R., ed. 2004a. *The Long March: Xenophon and the Ten Thousand*. New Haven.

——. 2004b. 'Sex, Gender, and the Other in Xenophon's Anabasis.' In Lane Fox 2004a: 184–214.

Latacz, J. 1985. *Homer. Eine Einführung*. Munich.

——. 2003 [1985]. *Homer. Der erste Dichter des Abendlands*. Düsseldorf.

Laurence, R. 1998. 'Introduction.' In Laurence and Berry 1998: 1–9.

——. 1999. 'Theoretical Roman Archaeology.' Review. *Britannia* 30: 387–90.

——. 2001a. 'The Creation of Geography: An Interpretation of Roman Britain.' In C. Adams and R. Laurence, eds., *Travel and Geography in the Roman Empire*. London: 67–94.

——. 2001b. 'Roman Narratives: the Writing of Archaeological Discourse – a View from Britain?' *Archaeological Dialogues* 8: 90–101.

——. 2004. 'The Uneasy Dialogue between Ancient History and Archaeology.' In Sauer 2004a: 99–113.

——. 2006. '21st Century TRAC: Is the Battery Flat?' In Croxford et al. 2006: 116–27.

Laurence, R., and J. Berry, eds. 1998. *Cultural Identity in the Roman Empire*. London.

Lefkowitz, M. R., and G. M. Rogers, eds. 1996. *Black Athena Revisited*. Chapel Hill.

Lehmann, G. 2005. 'Al Mina and the East. A Report on Research in Progress.' In Villing 2005: 61–92.

Lehmann, K. 1952. 'Samothrace: Fifth Preliminary Report.' *Hesperia* 21: 19–44, plates 3–11.

——. 1960. *Samothrace. Vol. 2. Part 2. The Inscriptions on Ceramics and Minor Objects*. New York.

——. 1962. *Samothrace. Vol. 4. Part 1. The Hall of Votive Gifts*. New York.

——. 1998. *Samothrace. A Guide to the Excavations and the Museum*, 6th edn. Thessaloniki.

Lehmann, K., and D. Spittle. 1964. *Samothrace. Vol. 4. Part 2. The Altar Court*. New York.

Lehmann, P., and D. Spittle. 1982. *Samothrace. Vol. 5. The Temenos*. New York.

Leick, G. 1994. *Sex and Eroticism in Mesopotamian Literature*. London.

Lejeune, M. 1972. 'Inscriptions de Rossano di Vaglio 1972.' *Rendiconti della classe di scienze morali, storiche e filologiche dell'Accademia dei Lincei* 27: 399–414.

——. 1975. 'Inscriptions de Rossano di Vaglio 1973-1974.' *Rendiconti della classe di scienze morali, storiche e filologiche dell'Accademia dei Lincei* 30: 319–39.

——. 1990. *Méfitis d'après les dédicaces lucaniennes de Rossano di Vaglio*. Louvain-la-Neuve.

Lemos, A. 1997. 'Rizari. A Cemetery in Chios Town.' In O. Palagia, ed., *Greek Offerings: Essays on Greek Art in Honour of John Boardman*. Oxford: 73–85.

Lemos, I. S. 2005. 'The Changing Relationship of the Euboeans and the East.' In Villing 2005: 53–60.

Letta, C. 1994. 'Dall'oppidum al nomen: I diversi livelli dell'aggregazione politica nel mondo osco-umbro.' In L. Aigner Foresti, A. Barzanò, C. Bearzot, L. Prandi, and G. Zecchini, eds., *Federazioni e federalismo nell'Europa antica: Bergamo, 21–25 settembre 1992*. Milan: 387–406.

Lewis, N. 1958. *Samothrace. Vol. 1. The Literary Sources*. New York.

Lewis, S. 2002. *The Athenian Woman: An Iconographic Handbook*. London.

Lissarrague, F. 1987. *Un flot d'images. Une esthétique du banquet grec*. Paris.

———. 2000. *Greek Vases: The Athenians and Their Images*. New York.

Liverani, M. 1976. 'La struttura politica.' In S. Mosacti, ed., *L'alba della civiltà. Società, economia e pensiero nel Vicino Oriente antico*. Turin: 275–414.

———. 1988. *Antico Oriente. Storia, società, economia*. Bari.

———. 1991. 'The Trade Network of Tyre According to Ezek. 27.' In M. Cogan and I. Eph'al, eds., *Ah. Assyria (Festschrift HayyîmTadmor)*. Jerusalem: 65–79.

Llewellyn-Jones. L. 2002a. 'A Woman's View? Dress, Eroticism and the Ideal Female Body in Athenian Art.' In Llewellyn-Jones 2002b: 171–202.

———, ed. 2002b. *Women's Dress in the Ancient Greek World*. Swansea/London.

———. 2003. *Aphrodite's Tortoise: The Veiled Woman of Ancient Greece*. Swansea.

Lo Schiavo, F. 2000. 'L'ambiente Nuragico.' In Zifferero 2000: 101–22.

Lomas, K., ed. 2004. *Greek Identity in the Western Mediterranean*. Leiden.

Loomba, A. 1998. *Colonialism/Postcolonialism*. London.

Loukopoulou, L. 1989. *Contribution à l'Histoire de la Thrace Propontique*. Melethemata 9. Athènes.

Love, I. 1964. 'Kantharos or Karchesion? A Samothracian Contribution.' In L. Freedman Sadler, ed., *Essays in Memory of Karl Lehmann*. New York: 204–22.

Lubbock, J. 1865. *Pre-historic Times, as Illustrated by Ancient Remains, and the Manners and Customs of Modern Savages*. London.

———. 1870. *The Origins of Civilisation and the Primitive Condition of Man*. London.

Lucy, S. 2005. 'Ethnic and Cultural Identities.' In Díaz-Andreu et al. 2005: 86–109.

Lulof, P. S. 2000. 'Archaic Terracotta Acroteria Representing Athena and Heracles: Manifestations of Power in Central Italy.' *Journal of Roman Archaeology* 13: 207–19.

Lyons, C. L., and J. K. Papadopoulos, eds. 2002. *The Archaeology of Colonialism*. Los Angeles.

Lyotard, J.-F. 1984. *The Postmodern Condition*. Minneapolis.

Mace, R., C. J. Holden, and S. Shennan, eds. 2005. *The Evolution of Cultural Diversity: A Phylogenetic Approach*. London.

Mack, R. 2002. 'Facing Down Medusa (An Aetiology of the Gaze).' *Art History* 25: 571–604.

MacMullen, R. 1980. 'Women in Public in the Roman Empire.' *Historia* 29: 208–18.

Malkin, I. 1987. *Religion and Colonization in Ancient Greece*. Leiden.

———. 1998. *The Returns of Odysseus: Colonization and Ethnicity*. Berkeley.

———, ed. 2001a. *Ancient Perceptions of Greek Ethnicity*. Washington, DC/Cambridge, MA.

———. 2001b. 'Introduction.' In Malkin 2001a: 1–28.

——. 2002. 'A Colonial Middle Ground: Greek, Etruscan and Local Elites in the Bay of Naples.' In Lyons and Papadopoulos 2002: 151–81.

——. 2003. 'Networks and the Emergence of Greek Identity.' *Mediterranean Historical Review* 18: 56–74.

——. 2004. 'Postcolonial Concepts and Ancient Greek Colonization.' *Modern Language Quarterly* 65: 341–64.

Mano-Zisi, D., and L. Popović. 1971. *Der Fund von Novi Pazar (Serbien)*. Bericht der Römisch Germanisch Komission 50. Berlin.

Marchand, S. L. 1996. *Down from Olympus: Archaeology and Philehllenism in Germany, 1750–1970*. Princeton.

Marinatos, N., and R. Hägg, eds. 1993. *Greek Sanctuaries. New Approaches*. London.

Markoe, G. E. 1985. *Phoenician Bronze and Silver Bowls from Cyprus and the Mediterranean*. Berkeley/Los Angeles/London.

——. 2000. *Phoenicians*. London.

Martelli, M., ed. 1987. *La Ceramica degli Etruschi. La Pittura Vascolare*. Novara.

——. 2001. 'Nuove Proposte per i Pittori dell'Eptacordo e delle Gru.' *Prospettiva* 101: 2–18.

Massa-Pairault, F. H. 1994. 'Lemnos, Corinthe et l'Étrurie. Iconographie et Iconologie a propos d'une Olpè de Cerveteri (VII siecle av. n.è.).' *La Parola del Passato* 49: 437–68.

——, ed. 1999. *Le mythe Grec dans l'Italie antique. Actes du colloque international organisé par l'École française de Rome, l'Istituto italiano per gli studi filosofici (Naples) et l'UMR 126 du CNRS (archéologies d'Orient et d'Occident) Rome 14–16 nov. 1996*. Rome.

Matheson, S. B. 1996. 'The Divine Claudia: Women as Goddesses in Roman Art.' In D. E. E. Kleiner and S. B. Matheson, eds., *I, Claudia: Women in Roman Art and Society*. Austin: 182–93.

Matsas, D. [Μάτσας, Δ.] 2004. 'Samothrace in the Early Iron Age.' ['Η Σαμοτηράκη στη πρώιμη εποχή του Σιδήρου.'] In N. Stampolidis and A. Giannikouris, [Ν. Σταμπολίδης and A. Γιαννικουρή], eds., *The Aegean in the Early Iron Age*. [*Το Αιγαίο στην πρώιμη εποχή του Σιδήρου*.] Athens: 227–57.

Matsas, D., and A. Bakirtzis. 2001. *Samothrace: A Short Cultural Guide*. 2nd edn. Athens.

Matsas, D., C. Karadima, and M. Koutsoumanis. [Μάτσας, Δ., Χ. Καράδημα and M. Κουτσουμανής.] 1989. 'Archaeological Investigations in Samothrace 1989.' ['Αρχαιολογικές εργασίες Σαμοθράκης 1989.'] *Archaeological Work in Macedonia and Thrace* [*Το Αρχαιολογικό Έργο στη Μακεδονία και στη Θράκη*] 3: 607–17, figs.1–5.

——. 1993. 'Excavation at Panaya t'Mandal on Samothrace in 1993.' ['Η ανασκαφή στην Παναγιά τ᾽Μάνταλ της Σαμοθράκης το 1993.'] *Archaeological Work in Macedonia and Thrace* [*Το Αρχαιολογικό Έργο στη Μακεδονία και στη Θράκη*] 7: 647–55.

Mattingly, D. J. 1996. 'From One Colonialism to Another: Imperialism and the Maghreb.' In Webster and Cooper 1996: 49–70.

——. 1997a. 'Dialogues of Power and Experience in the Roman Empire.' In Mattingly 1997b: 1–16.

——, ed. 1997b. *Dialogues in Roman Imperialism: Power, Discourse and Discrepant Experience in the Roman Empire*. Journal of Roman Archaeology Supplementary Series 23. Portsmouth, RI.

——. 1997c. 'Imperialism and Territory: Africa, a Landscape of Opportunity?' In Mattingly 1997b: 115–38.

——. 1999. 'The Art of the Unexpected: Ghirza in the Libyan Pre-desert.' In S. Lancel, ed., *Numismatique, langues, écriture et arts du livre, spécificité des arts figures. Actes du VIIe colloque international sur l'histoire et l'archéologie de l'Afrique du nord.* Paris: 383–405.

——. 2002. 'Vulgar and Weak "Romanization" or Time for a Paradigm Shift.' *Journal of Roman Archaeology* 15: 536–40.

——, ed. 2003a. *The Archaeology of Fazzan, 1 Synthesis.* London.

——. 2003b. 'Family Values: Art and Power at Ghirza in the Libyan Pre-desert.' In Scott and Webster 2003: 153–70.

——. 2004. 'Being Roman: Expressing Identity in a Provincial Setting.' *Journal of Roman Archaeology* 17: 5–25.

——. 2006a. *An Imperial Possession: Britain in the Roman Empire.* London.

——. 2006b. 'Roman Britain was more than Romans in Britain.' *British Archaeology* November/December: 55.

——. Forthcoming. *Experiencing Empire: Identity and Power in the Roman World.* Journal of Roman Archaeology Supplementary Series. Portsmouth, RI.

Mau, A. 1882. *Geschichte der decorativen Wandmalerei in Pompeji.* Berlin.

Mayer, E. 2002. *Rom ist dort, wo der Kaiser ist. Untersuchungen zu den Staatsdenkmälern des dezentralisierten Reiches von Diocletian bis Theodosius II.* Mainz/Bonn.

Mazarakis Ainian, A. 1997. *From Rulers' Dwellings to Temples: Architecture, Religion and Society in Early Iron Age Greece (1100–700 BC).* Jonsered.

——. 1998. 'Oropos in the Early Iron Age.' In B. d'Agostino and M. Bats, eds., *Euboica. L'Eubea e la Presenza Euboica in Calcidica e in Occidente. Atti del Convegno Internazionale di Napoli, 13–16 novembre 1996.* Naples: 179–215.

McCarty, W. 1989. 'The Shape of the Mirror: Metaphorical Catoptrics in Classical Literature.' *Arethusa* 22: 161–95.

Meier, C. 1994 [1993]. *Athen. Ein Neubeginn der Weltgeschichte.* Berlin.

——. 2001 [1980]. *Die Entstehung des Politischen bei den Griechen.* Frankfurt am Main.

Meiggs, R., and D. Lewis, eds., 1988 [1969]. *A Selection of Greek Historical Inscriptions to the End of the Fifth Century BC.* Oxford/New York.

Mele, A. 1995. 'Leonida e le armi dei Lucani.' In S. Cerasuolo, ed., *Mathesis e philia: studi in onore di Marcello Gigante.* Naples: 111–29.

Menichetti, M. 1992. 'L' oinochóe di Tragliatella: Mito e Rito tra Grecia ed Etruria.' *Ostraka* 1 (1): 7–30.

——. 1994. *Archeologia del Potere. Re, Immagini e Miti a Roma e in Etruria in Età Arcaica.* Milan.

——. 1995. 'Giasone e il Fuoco di Lemno su un'Olpe Etrusca in Bucchero di Epoca Orientalizzante.' *Ostraka* 4: 273–83.

Mensching, H., and E. Wirth. 1977. *Nordafrika und Vorderasien.* Frankfurt am Main.

Mercer, K. 1990. 'Welcome to the Jungle: Identity and Diversity in Postmodern Politics.' In Rutherford 1990a: 43–71.

Merrillees, P. H. 2005. *Catalogue of the Western Asiatic Seals in the British Museum. Cylinder Seals VI. Pre-Achaemenid and Achaemenid Periods.* London.

Meskell, L. 2001. 'Archaeologies of Identity.' In Hodder 2001: 187–213.

Messineo, G. 2001. *Efestia. Scavi Adriani 1928–1930. Monografie della Scuola Archeologica di Atene e delle missioni Italiani in Oriente.* Padua.

Metzler, J., M. Millett, N. Roymans, and J. Slofstra, eds. 1995. *Integration in the Early Roman West: The Role of Culture and Ideology*. Dossiers d'Archéologie du Musée National d'Histoire et d'Art 4. Luxemburg.

Meyer, H. 1991. *Antinoos*. Munich.

Miles, Richard. 2004. 'Rivalling Rome: Carthage as Cosmopolis.' In Catherine Edwards and Greg Woolf, eds., *Rome the Cosmopolis*. Cambridge: 123–46.

Millar, F. 1993. *The Roman Near East. 31 BC–AD 337*. Cambridge, MA.

Miller, D., ed. 2005. *Materiality*. Durham, NC.

Miller, M. C. 1997. *Athens and Persia in the Fifth Century BC: A Study in Cultural Receptivity*. Cambridge.

Miller Ammerman, R. 2002. *The Sanctuary of Santa Venera at Paestum: II, The Votive Terracottas*. Ann Arbor.

Millett, M. 1990. *The Romanization of Britain: An Essay in Archaeological Interpretation*. Cambridge.

——. 2007. 'What Is Classical Archaeology? Roman.' In Alcock and Osborne 2007: 30–50.

Mócsy, A. 1974. *Pannonia and Upper Moesia*. London/Boston.

Momsen, H., D. Hertel, and P. Mountjoy. 2001. 'Neutron Activation Analysis of the Pottery from Troy in the Berlin Schliemann Collection.' *Archäologischer Anzeiger*: 169–211.

Moore, M., M. Philippides, and D. von Bothmer. 1986. *The Athenian Agora: Results of the Excavations Conducted by the American School of Classical Studies. Vol. XXIII. Attic Black-Figure Pottery*. Princeton.

Morgan, C. 1993. 'The Origins of Pan-Hellenism.' In Marinatos and Hägg 1993: 18–44.

Morley, N. 2007. *Trade in Classical Antiquity*. Cambridge.

Morris, D. 2004. *The Naked Woman: A Study of the Female Body*. London.

Morris, I. 1994. 'Archaeologies of Greece.' In I. Morris, ed., *Classical Greece: Ancient Histories and Modern Ideologies*. Cambridge: 8–47.

——. 1998. 'Archaeology and Archaic Greek History.' In Fisher and van Wees 1998: 1–93.

——. 2000. *Archaeology as Cultural History*. Oxford.

——. 2003. 'Mediterraneanization.' *Mediterranean Historical Review* 18: 30–55.

Morris, S. 1992. *Daidalos and the Origins of Greek Art*. Princeton.

Moscati, S. 1975. *Die Phöniker. Von 1200 vor Christus bis zum Untergang Karthagos*. Essen.

——, ed. 1988a. *I fenici*. Milan.

——. 1988b. 'Il territorio e gli insediamenti.' In Moscati 1998a: 26–7.

——. 1988c. 'L'impero di Cartagine.' In Moscati 1998a: 54–61.

——. 1992. *Chi furono i fenici*. Turin.

Mouritsen, H. 1998. *Italian Unification: A Study in Ancient and Modern Historiography*. London.

Moustaka, A., E. Skarlatidou, M.-C. Tzannes, and Y. Ersoy, eds. 2004. *Klazomenai, Teos and Abdera: Metropolis and Colony*. Thessaloniki.

Moutsopoulos, N. 1989. 'Tournée au Rhodope du Sud et à Samothrace.' In J. Best and N. de Vries, eds., *Thracians and Mycenaeans*. Leiden/Sophia: 246–79.

Münkler, H. 2007. *Empires: The Logic of World Domination from Ancient Rome to the United States*. Cambridge.

Murray, O. 1994. 'Nestor's Cup and the Origin of the Greek Symposion.' In B. d'Agostino and D. Ridgway, eds., *Apoikia: I piu' Antichi Insediamenti Greci in Occidente: Funzioni e Modi dell'Organizzazione Politica e Sociale Scritti in onore di Giorgio Buchner. Annali di Archeologia e Storia Antica. New series 1.* Naples: 47–54.

Murray, T. 2004. 'The Archaeology of Contact in Settler Societies.' In T. Murray, ed., *The Archaeology of Contact in Settler Societies.* Cambridge: 1–16.

Musti, D. 1988. *Strabone e la Magna Grecia: città e popoli dell'Italia antica.* Padua.

Myres, J. L. 1930. *Who Were the Greeks?* Berkeley.

Naso, A. 1996. 'Osservazioni sull'Origine dei Tumuli Monumentali nell'Italia Centrale.' *Opuscola Romana* XX: 69–85.

——. 1998. 'I Tumuli Monumentali in Etruria Meridionale: Caratteri Propri e Possibili Ascendenze Orientali.' In G. Bartolini, D. Briquel, and G. Camporeale, eds., *Archäologische Untersuchungen zu den Benziehungen zwischen Altitalien und der Zone Norwärts der Alpen während der frühen Eisenzeit Alteuropas. Ergbnisse eines Kolloquiums, Regensburg 1994.* Regensburg: 117–57.

——, ed. 2004. *Appunti sul Bucchero. Atti delle Giornate di Studio.* Florence.

——. 2006. 'Anathemata. Etruschi nel Mediterraneo Orientale.' *Gli Etruschi e il Mediterraneo. Commerci e Politica. Annali della Fondazione per il Museo Claudio Faina* XIII: 351–416.

Nava, L. M. 1999. 'L'attività archeologica in Basilicata nel 1998.' In *L'Italia meridionale in età tardo antica: atti del trentottesimo convegno di studi sulla Magna Grecia: Taranto 2–6 ottobre 1998.* Taranto: 689–732.

Nava, L. M., and P. Poccetti. 2001. 'Il santuario lucano di Rossano di Vaglio. Una nuova dedica osca ad Ercole.' *Mélanges d'archéologie et d'histoire de l'École Française de Rome: Antiquité* 113 (1): 95–122.

Neer, R. 1997. 'Beazley and the Language of Connoisseurship.' *Hephaistos* 15: 7–30.

Neils, J., and J. H. Oakley. 2003. *Coming of Age in Ancient Greece. Images of Childhood from the Classical Past.* New Haven.

Neumann, G. 1968. 'Epigraphische Mitteilungen. Kleinasien.' *Kadmos* 7: 180–9.

Niemeyer, H. G. 1968. *Studien zur statuarischen Darstellung der römischen Kaiser.* Monumenta Artis Romanae 7. Berlin.

——, ed. 1982. *Phönizier im Westen, Madrider Beiträge.* Mainz am Rhein.

——. 1990. 'Die phönizischen Niederlassungen im Mittelmeerraum.' In Gehrig and Niemeyer 1990: 45–64.

——. 1995. 'Expansion et colonisation.' In Krings 1995: 247–67.

——. 2002. 'Die Phönizier im Mittelmeer. Neue Forschungen zur frühen Expansion.' In E. A. Braun-Holzinger, ed., *Die nahöstlichen Kulturen und Griechenland an der Wende vom 2. zum 1. Jahrtausend v.Chr. Kontinuität und Wandel von Strukturen und Mechanismen kultureller Interaktion.* Möhnesee: 177–95.

——. 2003a. 'On Phoenician Art and Its Role in Trans-Mediterranean Interconnections ca. 1100 – 600 BC.' In N. C. Stampolidis and V. Karageorghis, eds., *Ploes: Sea Routes: Interconnections in the Mediterranean 16th–6th C. BC. Proceedings of the International Symposium held at Rethymnon, Crete, Sept. 29th – Oct. 2nd 2002.* Athens: 201–8.

——. 2003b. 'Zur Einführung. Frühformen der Globalisierung im Mittelmeerraum.' In K. J. Hopt, E. Kantzenbach and T. Straubhaar, eds., *Herausforderungen der Globalisierung.* Göttingen: 47–55.

——. 2004. 'Phoenician or Greek: Is There a Reasonable Way Out of the Al Mina Debate?' *Ancient West & East* 3 (1): 38–50.

——. 2007. 'Zu Problemen in archäologischen Kontaktzonen.' In F.M. Andraschko, B. Kraus and B. Meller, eds., *Archäologie zwischen Befund und Rekonstruktion. Ansprache und Anschaulichkeiten. Festschrift Renate Rolle.* Hamburg: 11–21.

Niemeyer, H.G., R.F. Docter, and K. Schmidt, eds. 2007. *Karthago. Die Ergebnisse der Hamburger Grabung unter dem Decumanus Maximus.* Mainz.

Nikolov, B. [Николов, Б.] 1965. 'Thracian Monuments in Vratsa District.' ['Тракийски паметници във Врачанско.'] *Bulletin de l'Institut Archéologique Bulgare* [Известия на Археологическия Институт] 28: 163–202.

Nikov, K. [Ников, К.] 1999. 'Cultural Contacts of South Thrace with the Aegean World in the Early Iron Age on the Basis of Pottery Evidence.' ['Културни контакти на Южна Тракия с Егейския свят през ранната желязна епоха по данни на керамиката.'] Unpublished PhD dissertation, Sophia University.

——. n.d. 'Grey Monochrome Ware from Apollonia – its Origin and Initial Appearance (End of 7th–6th c. BC).' ['Сивата монохромна керамика от Аполония. Към въпроса за нейния произход и първоначална поява (кр. на VII–VI в.пр. Хр.).'] Unpublished manuscript.

Nogales Basarrate, T. 1997. *El retrato privado en Augusta Emerita.* 2 vols. Badajoz.

Nollé, J. 1994. 'Frauen wie Omphale? Überlegungen zu politischen Ämtern von Frauen im kaiserzeitlichen Kleinasien.' In M.H. Dettenhofer, ed., *Reine Männersache? Frauen in Männerdomänen der antiken Welt.* Munich: 229–59.

Oakley, J.H., and R.H. Sinos, eds. 1993. *The Wedding in Ancient Athens.* Madison.

Ogden, D. 1999. *Polygamy, Prostitutes and Death. The Hellenistic Dynasties.* Swansea/London.

O'Gorman, E. 1993. 'No Place like Rome: Identity and Difference in the *Germania* of Tacitus.' *Ramus* 22: 135–54.

Oltean, I. 2007. *Dacia: Landscape, Colonisation, Romanisation.* Abingdon.

Ornan, T. 2002. 'The Queen in Public: Royal Women in Neo-Assyrian Art.' In Parpola and Whiting 2002. Part 2: 461–77.

Osborne, R. 1998. 'Early Greek Colonization? The Nature of Greek Settlements in the West'. In Fisher and van Wees 1998: 251–69.

——. 2007. 'What Travelled with Greek Pottery?' *Mediterranean Historical Review* 22 (1): 85–95.

Osborne, R., and S.E. Alcock. 2007. 'Introduction.' In Alcock and Osborne 2007: 1–12.

Östenberg, C.E. 1975. *Case Etrusche di Acquarossa.* Rome.

Owen, S. 2005. 'Analogy, Archaeology and Archaic Greek Colonization.' In Hurst and Owen 2005: 5–22.

Özer, B. 2004. 'Clazomenian and Related Black-Figured Pottery from Klazomenai: Preliminary Observations.' In Moustaka et al. 2004: 199–219.

Özgen, İ., and J. Öztürk. 1996. *Heritage Recovered. The Lydian Treasure.* Istanbul.

Pacciarelli, M. 2000. *Dal Villaggio alla città. La Svolta Protourbana del 1000 a.C. nell'Italia Tirrenica.* Florence.

——. 2005. '14C e Correlazioni con le Dendrodate Nordalpine: Elementi per una Cronologia Assoluta del Bronzo finale 3 e del Primo Ferro dell'Italia Peninsulare.' In G. Bartoloni and F. Delpino, eds., *Oriente e Occidente. Metodi*

 e Discipline a Confronto, Riflessioni sulla Cronologia dell'Età del ferro in Italia. Atti dell'Incontro di studi, Roma, 30–31 ottobre 2003. Pisa: 81–90.

Pajaczowski, C. 1997. 'The Ecstatic Solace of Culture.' In Steyn 1997: 101–12.

Pandolfini, M., and A. L. Prosdocimi. 1990. *Alfabetari e Insegnamento della Scrittura in Etruria e nell'Italia Antica.* Florence.

Pareti, L. 1947. *La Tomba Regolini-Galassi del Museo Gregoriano Etrusco e la Civiltà dell'Italia Centrale nel sec. VII A.C.* Vatican City.

Parker, A., and E. K. Sedgwick, eds. 1995. *Performativity and Performance.* New York/London.

Parpola, S., and R. M. Whiting, eds. 2002. *Sex and Gender in the Ancient Near East.* Parts 1 and 2. Helsinki.

Pavolini, C. 1981. 'Ficana. Edificio sulle Pendici di Monte Cugno.' *Archeologia Laziale* 4: 258–68.

Peradotto, J., and M. M. Levine, eds. 1989. *The Challenge of Black Athena.* Arethusa special issue.

Petras, J. F., and H. Veltmeyer. 2001. *Globalization Unmasked: Imperialism in the 21st Century.* London.

Pfanner, M. 1989. 'Über das Herstellen von Porträts. Ein Beitrag zu Rationalisierungsmaßnahmen und Produktionsmechanismen von Massenware im späten Hellenismus und in der römischen Kaiserzeit.' *Mitteilungen des Deutschen Archäologischen Instituts* 104: 157–257.

Philipp, H. 1981. 'Archaische Gräber in Ostionien.' *Istanbuler Mitteilungen* 31, 149–66.

Phillips, Jr, K. M. 1992. *In the Hills of Tuscany: Recent Excavations at the Etruscan Site of Poggio Civitate (Murlo, Siena).* Philadelphia.

Piccottini, G. 1996. *Die Römersteinsammlung des Landesmuseums für Kärnten.* Klagenfurt.

Pieterse, J. N. 1995. 'Globalization as Hybridization.' In Featherstone, Lash, and Robertson 1995: 45–68.

Pinault, J. R. 1993. 'Women, Fat and Fertility: Hippocratic Theorizing and Treatment.' In M. DeForrest, ed., *Woman's Power, Man's Game: Essays on Classical Antiquity in Honor of Joy K. King.* Wauconda: 78–90.

Pinney, C. 2005. 'Things Happen or, from Which Moment Does that Object Come?' In Miller 2005: 256–72.

Pitts, M. 2005a. 'Pots and Pits: Drinking and Deposition in Late Iron Age South-East Britain.' *Oxford Journal of Archaeology* 24 (2): 143–161.

——. 2005b. 'Regional Identities and the Social Use of Ceramics.' In Bruhn, Croxford, and Gligoropoulos 2005: 50–64.

——. 2007a. 'Consumption, Deposition and Social Practice: A Ceramic Approach to Intra-site Analysis in Late Iron Age to Roman Britain.' *Internet Archaeology* 21. http://intarch.ac.uk/journal/issue21/pitts_index.html.

——. 2007b. 'The Emperor's New Clothes? The Utility of Identity in Roman Archaeology.' *American Journal of Archaeology* 111 (4): 693–713.

Platt, V. 2002. 'Viewing, Desiring, Believing: Confronting the Divine in a Pompeian House.' *Art History* 25: 87–112.

Pobjoy, M. 2000. 'The First Italia.' In Herring and Lomas 2000: 187–211.

Pochmarski, E. 2004. 'Das sogenannte norische Maedchen. Ein Beispiel fuer den Ausdruck lokaler Identitaet in der provinzialroemischen Plastik.' In Schmidt-Colinet 2004: 161–74.

Polat, Y. 2004. 'A Grey Monochrome Karchesion from Daskyleion.' *Türkiye Bilimler Akademisi Arkeoloji Dergisi* VII: 215–23.

Pontrandolfo, A., and E. Mugione. 1999. 'La Saga degli Argonauti nella Ceramica Attica e Protoitaliota. Uso e Rifunzionalizzazione di un Mito.' In Massa-Pairault 1999: 329–52.

Porter, J. 2001. 'Ideals and Ruins.' In S. Alcock, J. Cherry, and J. Elsner, eds., *Pausanias: Travel and Memory in Roman Greece.* Oxford: 63–92.

———. 2003. 'The Materiality of Classical Studies.' *parallax* 9: 64–74.

Postgate, J. N. 1992. *Early Mesopotamia. Society and Economy at the Dawn of History.* London.

Potter, D. S. 1999. *Literary Texts and the Roman Historian.* London.

Poucet, J. 2000. *Les Rois de Rome. Tradition et Histoire.* Brussels.

Prag, J. 2006. 'Poenus Plane Est – but Who Were the "Punickes"?' *Papers of the British School at Rome* 74: 1–37.

Prausnitz, M. W. 1962. 'Achzib.' *Revue Biblique* 69: 404–5.

Pritchard, J. B. 1978. *Recovering Sarepta, a Phoenician City: Excavations at Sarafand, Lebanon, 1969–1974, by the University Museum of the University of Pennsylvania.* Princeton.

Pugliese Carratelli, G. 1994. 'KANNA o KAVNA nell'Epigrafe del Fregio di un'Olpe Ceretana?' *La Parola del Passato* 278: 363–4.

Purcell, N. 'Colonization and Mediterranean History.' In Hurst and Owen 2005: 115–39.

Raaflaub, K. A. 1997. 'Citizens, Soldiers, and the Evolution of the Early Greek Polis.' In L. G. Mitchell and P. J. Rhodes, eds., *The Development of the Polis in Archaic Greece.* London: 49–59.

———. 1999. 'Archaic Greece.' In K. A. Raaflaub and N. Rosenstein, eds., *War and Society in the Ancient and Medieval Worlds.* Cambridge, MA: 161–92.

———. 2005. 'Homerische Krieger, Protohopliten und die Polis. Schritte zur Lösung alter Probleme.' In B. Meissner, O. Schmitt and M. Sommer, eds., *Krieg – Gesellschaft – Institutionen. Beiträge zu einer vergleichenden Kriegsgeschichte.* Berlin: 229–66.

Radke, G. 1965. *Die Götter Altitaliens.* Münster.

Rainini, I. 1985. *Il santuario di Mefite in Valle d'Ansanto.* Rome.

Rasmussen, T. 1991. 'Corinth and the Orientalising Phenomenon.' In T. Rasmussen and N. Spivey, eds., *Looking at Greek Vases.* Cambridge: 57–78.

Rathje, A. 1983. 'A Banquet Service from the Latin City of Ficana.' *Analecta Romana Instituti Danici* 22: 7–29.

Reade, J. 1983. *Assyrian Sculpture.* London.

Reece, R. 1980. 'Town and Country: The End of Roman Britain.' *World Archaeology* 12: 77–91.

Reeder, E. D. 1995. *Pandora: Women in Classical Greece.* Baltimore.

Renard, M. 1979. *Le Bucchero Nero Étrusque et Sa Diffusion en Gaule Méridionale.* Wetteren.

Renfrew, C. 1989. 'Comments on "Archaeology into the 1990s."' *Norwegian Archaeological Review* 22: 33–41.

Revermann, M. 1998. 'The Text of *Iliad* 18.603–6 and the Presence of an Aoidos on the Shield of Achilles.' *Classical Quarterly* 48: 29–38.

Rich, J., and G. Shipley, eds. 1993. *War and Society in the Roman World.* London.

Richlin, A. 1995. 'Making Up a Woman: The Face of Roman Gender.' In H. Eilberg-Schwartz and W. Doniger, eds., *Off With Her Head! The Denial of Women's Identity in Myth, Religion and Culture.* Berkeley: 185–213.

Richter, G. M. A. 1956. *Catalogue of Engraved Gems: Greek, Etruscan and Roman*. New York.

Ridgway, D. 1992. *The First Western Greeks*. Cambridge.

———. 1996. 'Greek Letters at Osteria dell'Osa.' *Opuscola Romana* XX: 87–97.

———. 2006. 'Riflessioni su Tarquinia. Demarato e "l'ellenizzazione dei barbari.' In M. Bonghi-Jovino, ed., *Tarquinia e le Civiltà del Mediterraneo*. Milan: 27–47.

Ridgway, D., and F. Serra Ridgway. 1994. 'Demaratus and the Archaeologist.' In R. De Puma, ed., *Murlo and the Etruscans*. Madison: 6–15.

Ripollès, P. P. 2005. 'Coinage and Identity in the Roman Provinces: Spain.' In Howgego, Heuchert, and Burnett 2005: 79–94.

Rist, G. 1997. *The History of Development: From Western Origins to Global Faith*. London.

Riva, C. 2000. 'The Genesis of the Etruscan City-State.' Unpublished PhD dissertation. Cambridge University.

———. 2006. 'The Orientalizing Period in Etruria: Sophisticated Communities.' In Riva and Vella 2006: 110–34.

Riva, C., and N. Vella, eds. 2006. *Debating Orientalization: Multidisciplinary Approaches to Change in the Ancient Mediterranean*. Monographs in Mediterranean Archaeology 10. London.

Rix, H. 2002. *Sabellische Texte: die Texte des Oskischen, Umbrischen und Südpikenischen*. Heidelberg.

Rizzo, M. A. 2001. 'Tombe Orientalizzanti di San Paolo.' In A. M. Moretti Sgubini, ed., *Veio, Cerveteri, Vulci. Città d'Etruria a confronto*. Rome: 163–76.

Rizzo, M. A., and M. Martelli. 1993. 'Un Incunabolo del Mito Greco in Etruria.' *Annuario della Scuola Archeologica di Atene* new series LXVI–LXVII: 7–56.

Robertson, R. 1992. *Globalization, Social Theory and Global Culture*. London.

———. 1995. 'Glocalization: Time-Space and Homogeneity-Heterogeneity.' In Featherstone, Lash, and Robertson 1995: 25–44.

Robertson, R., and D. Inglis. 2006. 'The Global Animus.' In B. K. Gills and W. R. Thompson, eds., *Globalization and Global History*. London: 33–47.

Robertson, R., and F. Lechner. 1985. 'Modernization, Globalization and the Problem of Culture in World-Systems Theory.' *Theory, Culture and Society* 2 (3): 103–17.

Roebuck, C. 1959. *Ionian Trade and Colonization*. New York.

Rofel, L. 2002. 'Modernity's Masculine Fantasies.' In Knauft 2002a: 175–93.

Roymans, N. 1995. 'Romanization, Cultural Identity and the Ethnic Discussion: The Integration of the Lower Rhine Populations in the Roman Empire.' In Metzler et al. 1995: 47–64.

———. 1996. 'The Sword or the Plough: Regional Dynamics in the Romanisation of Belgic Gaul and the Rhineland Area.' In N. Roymans, ed., *From the Sword to the Plough*. Amsterdam Archaeological Studies 1. Amsterdam: 9–126.

———. 2004. *Ethnic Identity and Imperial Power: The Batavians in the Early Roman Empire*. Amsterdam.

Russo Tagliente, A. 1995. *Armento: archeologia di un centro indigeno*. Bollettino di Archeologia 35. Rome.

Rutherford, J. ed., 1990a. *Identity, Community, Culture, Difference*. London.

———. 1990b. 'The Third Space: Interview with Homi Bhabha.' In Rutherford 1990a: 207–21.

Rutter, N. K., ed. 2001. *Historia Numorum, Italy*. London.

Saggs, H. W. F. 1955. 'The Nimrud letters.' *Iraq* 17: 21–56; 126–60.

———. 2005. *The Middle East under Rome*. Cambridge, MA.

Sagona, C. 2004. 'The Phoenicians in Spain from a Central Mediterranean Perspective: A Review Essay.' *Ancient Near Eastern Studies* 41: 240–66.

Sahlins, M. 1976. *Culture and Practical Reason*. Chicago.

Said, E. W. 1992. *Culture and Imperialism*. London.

———. 2003 [1978]. *Orientalism*. London.

Sancisi-Weerdenberg, H. 1990. 'The Quest for an Elusive Empire.' In A. Kuhrt and H. Sancisi-Weerdenberg, eds., *Achaemenid History IV: Centre and Periphery*. Leiden: 263–74.

Sardar, Z. 1997. 'British, Muslim, Writer.' In Steyn 1997: 63–82.

Sauer, E., ed. 2004a. *Archaeology and Ancient History: Breaking Down the Boundaries*. London.

———. 2004b. 'The Disunited Subject: Human History's Split into "History" and "Archaeology."' In Sauer 2004a: 17–45.

Schachter, A. 1981. *Cults of Boiotia* 1. London.

Schefold, K. 1992. *Gods and Heroes in Late Archaic Greek Art*. Cambridge.

Schildhauer, J., K. Fritze, and W. Stark. 1982 [1974]. *Die Hanse*. East Berlin.

Schliemann, H. 1880. *Ilios: The City and Country of the Trojans: The Results of Researches and Discoveries on the Site of Troy and throughout the Troad in the Years 1871–72–73–78–79*. Leipzig.

Schmandt-Besserat, D. 1978. *Ancient Persia: The Art of an Empire*. Austin.

Schmidt, H. 1902. *Schliemann's Sammlung Trojanischer Altertümer*. Berlin.

Schmidt-Colinet, A., ed. 2004. *Lokale Identitäten in Randgebieten des römischen Reiches*. Vienna.

Schober, A. 1923. *Die römischen Grabsteine von Noricum und Pannonien*. Vienna.

Scholz, B. I. 1992. *Untersuchungen zur Tracht der römischen matrona*. Cologne; Weimar; Vienna.

Schwarz, H., and S. Ray, eds. 2000. *A Companion to Postcolonial Studies*. Oxford.

Sciacca, F. 2004. 'I Buccheri della Tomba Calabresi: una Produzione di Prestigio dell'Orientalizzante Medio Ceretano.' In Naso 2004: 29–42.

Scott, E. 1993a. 'Introduction.' In Scott 1993b: 1–4.

———, ed. 1993b. *Theoretical Roman Archaeology: First Conference Proceedings 1991*. Aldershot.

———. 1998. 'Tales from a Romanist: A Personal View of Archaeology and "Equal Opportunities."' In Forcey, Hawthorn, and Witcher 1998: 138–47.

———. 2006. '15 years of TRAC – Reflections on a Journey.' In Croxford et al. 2006: 111–15.

Scott, E., and J. Webster, eds. 2003. *Roman Imperialism and Provincial Art*. Cambridge.

Segal, C. 1986. *Pindar's Mythmaking: The Fourth Pythian*. Princeton.

Semantoni-Bournia, E. 1992. *La céramique à reliefs au musée de Chios*. Athens.

———. [Σημαντώνη-Μπουρνιά, Ε.] 1996. 'The Relief Ware from the Coast of the Northern Aegean.' ['Η ανάγλυφη κεραμική στα παράλια του Βόρειου Αιγαίου.'] Ancient Macedonia [Αρχαία Μακεδονία] 2: 1011–29.

Sen, A. 2006. *Identity and Violence: The Illusion of Destiny*. New York.

Settis, S. 2006. *The Future of the Classical*. London.

Shanin, T. 1997. 'The Idea of Progress.' In M. Rahnema and V. Bawtree, eds., *The Post-Development Reader*. London: 65–72.

Shanks, M. 2001. 'Culture/Archaeology: The Dispersion of a Discipline and Its Objects.' In Hodder 2001: 284–305.

Shennan, S. 1989. *Archaeological Approaches to Cultural Identity.* London.

Shepherd, G. 2005. 'Dead Men Tell No Tales: Ethnic Diversity in Sicilian Colonies and the Evidence from the Cemeteries.' *Oxford Journal of Archaeology* 24 (2): 115–36.

Sherratt, S. 2003. 'Visible Writing: Questions of Script and Identity in Early Iron Age Greece and Cyprus.' *Oxford Journal of Archaeology* 22 (3): 225–42.

Shotter, D. 2003. *Rome and Her Empire.* London.

Siciliano, A. 1996. 'La monetazione.' In Bianco et al. 1996: 235–7.

Sisani, S. 2001. *Tuta Ikuvina: sviluppo e ideologia della forma urbana a Gubbio.* Rome.

Skarlatidou, E. [Σκαρλατίδου, Ε.] 2001. 'Early Archaic Cremation Burials in Abdera.' ['Η καύση των νεκρών στα Άβδηρα κατά την πρώιμη αρχαική εποχή.'] In N. Stampolidis [Ν. Σταμπολίδης], ed., *Cremations in the Bronze and Early Iron Age.* [*Καύσεις στην εποχή του Χαλκού και την Πρώιμη εποχή του Σιδήρου.*] Athens: 331–43.

Small, J. P. 2003. *The Parallel Worlds of Classical Art and Text.* Cambridge.

Smith, A.D. 1990. 'Towards a Global Culture?' *Theory, Culture and Society* 7: 171–91.

Smith, C. 'Traders and Artisans in Archaic Central Italy.' In H. Parkins and C. Smith, eds., *Trade, Traders and the Ancient City.* London; New York: 31–51.

———. 1999. 'Medea in Italy: Barter and Exchange in the Archaic Mediterranean.' In G. Tsetskhladze, ed., *Ancient Greeks West and East.* Leiden/Boston: 179–206.

Smith, R.R.R. 1998. 'Cultural Choice and Political Identity in Honorific Portrait Statues in the Greek East in the Second Century A.D.' *Journal of Roman Studies* 88: 56–93.

Snodgrass, A.M. 1980. *Archaic Greece: The Age of Experiment.* London.

———. 1998. *Homer and the Artist: Text and Picture in Early Greek Art.* Cambridge.

———. 2007. 'What is Classical Archaeology? Greek.' In Alcock and Osborne 2007: 13–29.

Sommer, M. 2000. *Europas Ahnen. Ursprünge des Politischen bei den Phönikern.* Darmstadt.

———. 2001. 'Die Levante in der Eisenzeit. Ethnizität und Akkulturation zwischen Stadt und Land.' In M. Sommer, ed., *Die Levante. Beiträge zur Historisierung des Nahostkonflikts.* Freiburg: 71–82.

———. 2002. 'Kunst als Ware. Bildproduktion und Fernhandel zwischen Levante und Griechenland.' In M. Heinz and D. Bonatz, eds., *Bild – Macht – Geschichte. Visuelle Kommunikation im Alten Orient.* Berlin: 207–24.

———. 2004. 'Die Peripherie als Zentrum. Die Phöniker und der interkontinentale Fernhandel im Weltsystem der Eisenzeit.' In R. Rollinger and C. Ulf, eds., *Commerce and Monetary Systems in the Ancient World: Means of Transmission and Cultural Interaction.* Stuttgart: 233–44.

———. 2005a. *Die Phönizier. Handelsherren zwischen Orient und Okzident.* Stuttgart.

———. 2005b. *Roms orientalische Steppengrenze.* Stuttgart.

———. 2007. 'Networks of Commerce and Knowledge in the Iron Age: The Case of the Phoenicians.' *Mediterranean Historical Review* 21: 97–111.

Spaeth, B.S. 1996. *The Roman Goddess Ceres.* Austin.

Sparkes, B., and L. Talcott. 1970. *The Athenian Agora: Results of the Excavations Conducted by the American School of Classical Studies. Vol. XII. Black and Plain Pottery.* Princeton.

Spencer, N. 1995. 'Early Lesbos between East and West: A "Grey Area" of Aegean Archaeology.' *Annual of the British School at Athens* 90: 269–306, plate 33.

Spivak, G. C. 1987. *In Other Worlds: Essays in Cultural Politics*. London.

Stampolidis, N., and A. Giannikouri [Σταμπολίδης, Ν., and Α. Γιαννικουρή], eds. 2004. *The Aegean in the Early Iron Age*. [Το Αιγαίο στην πρώιμη εποχή του Σιδήρου.] Athens.

Stansbury-O'Donnell, M. 1999. *Pictorial Narrative in Ancient Greek Art*. Cambridge.

Stearns, J. M. 2003. 'Jargon, Authenticity, and the Nature of Cultural History-Writing: Not Out of Africa and the Black Athena Debate.' In Donohue and Fullerton 2003: 171–201.

Stein, G. J. 2002. 'Colonies without Colonialism: A Trade Diaspora Model of Fourth Millennium BC Mesopotamian Enclaves in Anatolia.' In Lyons and Papadopoulos. 2002: 27–64.

——, ed. 2005. *The Archaeology of Colonial Encounters: Comparative Perspectives*. Santa Fe.

Steingräber, S. 2000. 'Etruscan Urban Planning.' In Torelli 2000: 291–311.

Stemmer, K. 1978. *Untersuchungen zu Typologie, Chronologie und Ikonographie der Panzerstatuen*. Berlin.

Stewart, A. 1997. *Art, Desire and the Body in Ancient Greece*. Cambridge.

Steyn, J., ed. 1997. *Other than Identity – The Subject, Politics and Art*. Manchester.

Stieber, M. 2004. *The Poetics of Appearance in the Attic Korai*. Austin.

Stopponi, S., ed. 1985. *Case e palazzi d'Etruria*. Milan.

Strauss, A. L. 1969. *Mirrors and Masks: The Search for Identity*. Mill Valley, CA.

Stucky, R. A. 1985. 'Achämenidische hölzer und elfenbeine aus Ägypten und vorderasien im Louvre.' *Antike Kunst* 28: 7–32.

Suleri, S. 1995. 'Criticism and Its Alterity.' In Henderson 1995: 171–84.

Teixidor, J., M. Gras, and P. Rouillard. 1989. *L' univers Phénicien*. Paris.

Terrenato, N. 1998a. 'The Romanization of Italy: Global Acculturation or Cultural Bricolage?' In Forcey, Hawthorn, and Witcher 1998: 20–7.

——. 1998b. 'Tam Firmum Municipium. The Romanization of Volaterrae and Its Cultural Implications.' *Journal of Roman Studies* 88: 94–114.

——. 2001. 'Introduction.' In Keay and Terrenato 2001: 1–6.

——. 2005. 'The Deceptive Archetype: Roman Colonialism in Italy and Postcolonial Thought.' In Hurst and Owen 2005: 59–72.

Thomas, J. 2004. *Archaeology and Modernity*. London.

Thomas, N. 1991. *Entangled Objects: Exchange, Material Culture, and Colonialism in the Pacific*. Cambridge, MA.

Tiverios, M. [Τιβέριος, Μ.] 1989. 'Greek Island Pottery of the Archaic Period in the North Aegean.' ['Από τη νησιώτικη κεραμική παραγωγή των αρχαϊκών χρόνων στο Βορειοελλαδικό χώρο.'] *Archaeological Work in Macedonia and Thrace* [Το Αρχαιολογικό Έργο στη Μακεδονία και στη Θράκη] 3: 615–23.

——. 2004. 'The University Excavations at Karabournaki of Thessaloniki and the Phoenician Presence in the North Aegean.' ['Οι Πανεπιστημιακές Ανασκαφές στο Καραμπουρνάκη Θεσσαλονίκης και η Παρουσία των Φοινίκων στο Βόρειο Αιγαίο.'] In Stampolidis and Giannikouri 2004: 295–307.

Tomlinson, J. 1999. *Globalisation and Culture*. Oxford.

Toner, J. 2002. *Rethinking Roman History*. Cambridge.

Torbov, N. [Торбов, Н.] 1993. 'Thracian Finds from Vratsa District.' ['Тракийски находки от Врачанско.'] *Bulletin of the Museums of North-West Bulgaria* [Известия на Музеите от Северозападна България] 21: 27–43.

Torelli, M. 1999. 'I Principi Guerrieri di Cecina. Qualche Osservazione di un Visitatore Curioso.' *Ostraka* 8 (1): 247–59.

——, ed. 2000. *The Etruscans*. London.

Triantaphyllos, D. [Τριαντάφυλλος, Δ.] 1981. 'The Megalithic Monuments of Western Thrace.' ['Τα μεγαλιθικά μνημεία της Δυτικής Θράκης.'] *Thracian Chronicles* [Θρακηκά χρονικά] 36: 61–4.

——. 1984. 'Nécropole archaïque en Thrace occidentale' ['Αρχαικό νεκροταφείο στη Δυτική Θράκη.'] *Annuario della Scuola Archeologica di Atene* XLV: 179–207.

——. 1990. 'Aegean Thrace Prior to Greek Colonization.' ['Η Θράκη του Αιγαίου πριν από τον ελληνικό αποικισμό.'] *Thracian Annual* [Θρακική επετηρίδα] 7: 297–322.

Trigger, B. G. 1989. *A History of Archaeological Thought*. Cambridge.

Trimble, J. 1999. *The Aesthetics of Sameness: A Contextual Analysis of the Large and Small Herculaneum Woman Statue Types in the Roman Empire*. Microfiche. Michigan.

——. 2000. 'Replicating the Body Politic: The Herculaneum Women Statue Types in Early Imperial Italy.' *Journal of Roman Archaeology* 13: 41–68.

Tsakos, K. [Τσάκος, Κ.] 1968. 'Samos. Western Necropolis' ['Σάμος. Δυτική Νεκρόπολις.'] *Archaeological Bulletin* [Αρχαιολογικόν Δελτίον] 24: 388–90.

——. 1970. 'Samos. Western Necropolis' ['Σάμος. Δυτική Νεκρόπολις.'] *Archaeological Bulletin* [Αρχαιολογικόν Δελτίον] 25: 417–18.

Tsatsopoulou, P. [Τσατσοπούλου, Π.] 1989. 'Archaeological Investigation in Ancient Mesembria in Thrace in 1989.' ['Η ανασκαφική έρευνα στη αρχαία Μεσημβρία Θράκης κατά το 1989.'] *Archaeological Work in Macedonia and Thrace* [Το Αρχαιολογικό Έργο στη Μακεδονία και στη Θράκη] 3: 577–85, figs.1–9.

——. 1990. 'Archaeological Investigation in Ancient Mesembria in 1990.' ['Η ανασκαφική έρευνα στη αρχαία Μεσημβρία κατά το 1990.'] *Archaeological Work in Macedonia and Thrace* [Το Αρχαιολογικό Έργο στη Μακεδονία και στη Θράκη] 4: 587–94, figs.1–16.

——. 2001. *Mesembria-Zone* [Μεσημβρία-Ζώνη]. Athens.

Tsvetkova, J. 2000. 'Siedlungen und Siedlungssystem auf der Thrakischen Chersonesos in der Vorrömischer Zeit.' *Thracia* 13: 431–62.

——. 2000/1. 'Die Thrakische Chersones und die thrako-griechischen kontakte inter Zeit vor den Philiaden.' *BOREAS. Münstersche Beiträge zur Archäologie* 23/24: 23–34.

Tuplin, C. 2004. 'The Persian Empire.' In Lane Fox 2004a: 154–83.

Tuplin, C., S. Burstein, and A. Domínguez. 2007. 'Racism in Classical Antiquity? Three Opinions.' *Ancient West and East* 6: 327–45.

Useem, J., R. Hill Useem, and J. Donoghue. 1963. 'Men in the Middle of the Third Culture: The Roles of American and Non-Western Peoples in Cross-cultural Administration.' *Human Organization* 22: 169–79.

Utili, F. 1995. *Die Archaische Necropole von Assos*, Asia Minor Studien 31, Bonn.

Van Bremen, R. 1984. 'Women and Wealth.' In A. Cameron and A. Kuhrt, eds, *Images of Women in Antiquity*. London/Sydney: 223–42.

——. 1996. *The Limits of Participation: Women and Civic Life in the Greek East in the Hellenistic and Roman Periods*. Amsterdam.

Van Dommelen, P. 1993. 'Roman Peasants and Rural Organization in Central Italy: An Archaeological Perspective.' In Scott 1993b: 167–86.

——. 1997. 'Colonial Constructs: Colonialism and Archaeology in the Mediterranean.' *World Archaeology* 28: 305–23.

———. 1998. *On Colonial Grounds: A Comparative Study of Colonialism and Rural Settlement in 1st Millennium BC West Central Sardinia.* Leiden.

———. 2002. 'Ambiguous Matters: Colonialism and Local Identities in Punic Sardinia.' In Lyons and Papadopoulos 2002: 121–47.

———. 2005. 'Colonial Interactions and Hybrid Practices: Phoenician and Carthaginian Settlement in the Ancient Mediterranean.' In Stein 2005: 109–41.

———. 2006a. 'Colonial Matters: Material Culture and Postcolonial Theory in Colonial Situations.' In C. Tilley, W. Keane, S. Kuechler, M. Rowlands, and P. Spyer, eds., *Handbook of Material Culture.* London: 104–24.

———. 2006b. 'The Orientalizing Phenomenon: Hybridity and Material Culture in the Western Mediterranean.' In Riva and Vella 2006: 135–52.

Van Dommelen, P., and N. Terrenato, eds. 2007a. *Articulating Local Cultures: Power and Identity under the Expanding Roman Republic.* Journal of Roman Archaeology, Supplementary Series 63. Portsmouth, RI.

———. 2007b. 'Introduction: Local Cultures and the Expanding Roman Republic.' In van Dommelen and Terrenato 2007a: 7–12.

Van Driel-Murray, C. 2002. 'Ethnic Soldiers: The Experience of the Lower Rhine Tribes.' In T. Grünewald and S. Seibel, eds, *Kontinuität und Diskontinuität: Germania inferior am Beginn und am Ende der römischen Herrschaft.* Beiträge des deutsch-niederländischen Kolloquiums in der Katholieke Universiteit Nijmegen (27. bis 30.06.2001). Berlin: 200–17.

Van Effenterre, H., and F. Ruzé. 1994. *Nomima: recueil d'inscriptions politiques et juridiques de l'archaïsme grec. Vol. 1, Cités et institutions.* Rome.

Van Enckevort, H., and J. Thijssen. 2003. 'Nijmegen – A Roman Town in the Frontier Zone of Germania Inferior.' In Wilson 2003: 59–71.

Vasunia, P. 2003. 'Hellenism and Empire: Reading Edward Said.' *parallax* 9: 88–97.

———. 2005. 'Greater Rome and Greater Britain.' In Goff 2005a: 38–64.

Vavritsas, A. [Βαβρίτσας, A.] 1967. 'Excavation in Mesembria in Thrace.' ['Ανασκαφή Μεσέμβριας Θράκης.'] *Proceedings of the Archaeological Commission in Athens* [Πρακτικά της εν Αθήναις Αρχαιολογικής Εταιρείας]: 89–95, plates 67–73.

Veit, U. 1984. 'Gustaf Kossinna und V. Gordon Childe: Ansaetze zu einer theoretischen Grundlegung der Vorgeschichte.' *Saeculum* 35: 326–64.

Vernant, J.-P. 1991. *Mortals and Immortals: Collected Essays.* Princeton.

Vernant, J.-P., and F. Frontisi-Ducroux. 1997. *Dans l'oeil du miroir.* Paris.

Vetter, E. 1953. *Handbuch der italischen Dialekte.* Heidelberg.

Villing, A., ed. 2005. *The Greeks in the East.* London.

Vokotopoulou, I., [Βοκοτοπούλου, I.] ed. 1985. *Sindos: Catalogue of the Exhibition.* [Σίνδος: Κατάλογος της έκθεσης.] Thessaloniki.

Von der Osten, H. H. 1931. 'The Ancient Seals from the Near East in the Metropolitan Museum: Old and Middle Persian Seals.' *Art Bulletin* 13: 221–41.

Von Hesberg, H. 2008. 'The Image of the Family on Sepulchral Monuments in the North-West Provinces.' In S. Bell and I. Hansen, eds., *Role Models: Identity and Assimilation in the Roman World.* Memoirs of the American Academy in Rome, Supplementary Series. Michigan: 257–72.

Von Hesberg-Tonn, B. 1983. *Coniunx carissima. Untersuchungen zum Normcharakter im Erscheinungsbild der römischen Frau.* Stuttgart.

Von Moock, D. W. 1998. *Die figürlichen Grabstelen Attikas in der Kaiserzeit. Studien zur Verbreitung, Chronologie, Typologie und Ikonographie.* Mainz.

Vout, C. 2003. 'Embracing Egypt.' In C. Edwards and G. Woolf, eds, *Rome the Cosmopolis*. Cambridge: 177–202.

Wachter, R. 1987. *Altlateinische Inschriften: sprachliche und epigraphische Untersuchungen zu den Dokumenten bis etwa 150 v. Chr*. Bern; New York.

Waldbaum, J. 1997. 'Greeks in the East or Greeks and the East? Problems in the Definition and Recognition of Presence.' *Bulletin of the American Schools of Oriental Research* 305: 1–17.

Waldenfels, B. 1999. 'Schwellenerfahrung und Grenzziehung.' In Fludernik and Gehrke 1999: 137–54.

Wallace-Hadrill, A. 1989. 'Rome's Cultural Revolution.' *Journal of Roman Studies* 79: 157–64.

——. 1997. 'Mutatio morum: The Idea of a Cultural Revolution.' In T. N. Habinek and A. Schiesaro, eds, *The Roman Cultural Revolution*. Cambridge: 3–22.

——. 2000. 'The Roman Revolution and Material Culture.' In A. Giovannini, ed., *La Révolution Romaine après Ronald Syme: Bilans et perspectives. Entretiens sur l'antiquité classique*. Geneva: 283–314.

——. 2007. 'The Creation and Expression of Identity: The Roman World.' In Alcock and Osborne 2007: 355–80.

Walter, H. 1968. *Frühe Samische Gefässe. Chronologie und Landschaftssile ostgriechischer Gefässe. Samos V*. Bonn.

Walter-Karydi, E. 1973. *Samische Gefässe des 6. Jahrhunderts v. Chr. Samos VI.1*. Bonn.

Watanabe, K., J. E. Reade, and S. Parpola. 1988. *Neo-Assyrian Treaties and Loyalty Oaths. Vol. 2, State Archives of Assyria*. Helsinki.

Weber, M. 2005. *Wirtschaft und Gesellschaft. Grundriss der verstehenden Soziologie*. Frankfurt am Main.

Webster, J. 1995. 'The Just War: Graeco-Roman Text as Colonial Discourse.' In S. Cottam, D. Dungworth, S. Scott, and J. Taylor, eds., *TRAC 1994: Proceedings of the Fourth Theoretical Roman Archaeology Conference Durham 1994*. Oxford: 1–10.

——. 1996a. 'Ethnographic Barbarity: Colonial Discourse and "Celtic Warrior Societies."' In Webster and Cooper 1996: 111–23.

——. 1996b. 'Roman Imperialism and the "Post-imperial Age."' In Webster and Cooper 1996: 1–17.

——. 1997a. 'Necessary Comparisons: A Post-colonial Approach to Religious Syncretism in the Roman Provinces.' *World Archaeology* 28 (3): 324–38.

——. 1997b. 'A Negotiated Syncretism: Readings on the Development of Romano-Celtic Religion.' In Mattingly 1997b: 165–84.

——. 1999. 'At the End of the World: Druidic and other Revitalization Movements in Post-Conquest Gaul and Britain.' *Britannia* 30: 1–20.

——. 2001. 'Creolising Roman Britain.' *American Journal of Archaeology* 105 (2): 209–25.

——. 2005. 'Archaeologies of Slavery and Servitude: Bringing "New World" Perspectives to Roman Britain.' *Journal of Roman Archaeology* 18: 161–79.

——. 2007. 'Linking with a Wider World. Rome and "Barbarians."' In Alcock and Osborne 2007: 401–24.

Webster, J., and N. J. Cooper, eds. 1996. *Roman Imperialism: Post-colonial Perspectives*. Leicester Archaeological Monographs 3. Leicester.

Wells, P. S. 1999. *The Barbarians Speak: How the Conquered Peoples Shaped Roman Europe*. Princeton.

White, R. 1991. *The Middle Ground: Indians, Empires, and Republics in the Great Lakes Region, 1650–1815*. Cambridge.

Whitehead, N. L. 1992. 'Tribes Make States and States Make Tribes: Warfare and the Creation of Colonial Tribes and States in Northeastern South America.' In Ferguson and Whitehead 1992: 127–50.

Whitmarsh, T. 2001. 'Greece Is the World: Exile and Identity in the Second Sophistic.' In Goldhill 2001: 269–305.

Whittaker, C. R. 1995. 'Integration of the Early Roman West: The Example of Africa.' In Metzler et al. 1995: 143–64.

Wikander, Ö., and P. Roos. 1986. *Architettura etrusca nel viterbese. Ricerche svedesi a San Giovenale e Acquarossa, 1956–1986.* Rome.

Willems, W. J. H. 1984. 'Romans and Batavians: A Regional Study in the Dutch East Rivers Area II.' *Berichten van de Rijksdienst voor het Oudheidkundig Bodemonderzoek* 34: 39–332.

Williams, D. 2005. 'From Phokaia to Persepolis. East Greek, Lydian and Achaemenid Jewellery.' In Villing 2005: 105–14, plates 1–12.

Willis, I. 2007. 'The Empire Never Ended.' In L. Hardwick and C. Gillespie, eds., *Classics in Post-Colonial Worlds.* Oxford: 329–48.

Wilson, P., ed. 2003. *The Archaeology of Roman Towns.* Oxford.

Wilson, P. R. 2002. *Cataractonium. Roman Catterick and Its Hinterland: Excavations and Research 1958–1997.* 2 vols. York.

Winter, I. J. 1995. 'Homer's Phoenicians: History, Ethnography, or Literary Trope?' In J. B. Carter and S. P. Morris, eds., *The Ages of Homer: A Tribute to Emily Townsend Vermeule.* Austin: 247–71.

Witcher, R. 2000. 'Globalisation and Roman Imperialism: Perspectives on Identities in Roman Italy.' In Herring and Lomas 2000: 213–25.

Woolf, G. 1990. 'World Systems Analysis and the Roman Empire.' *Journal of Roman Archaeology* 12: 223–34.

——. 1994a. 'Becoming Roman, Staying Greek: Culture, Identity and the Civilizing Process in the Roman East.' *Proceedings of the Cambridge Philological Society* 40: 116–43.

——. 1994b. 'Power and the Spread of Writing in the West.' In Bowman and Woolf 1994: 84–98.

——. 1997. 'Beyond Roman and Natives.' *World Archaeology* 28: 339–50.

——. 1998. *Becoming Roman: The Origins of Provincial Civilization in Gaul.* Cambridge.

——. 2000. 'Literacy.' In A. K. Bowman, P. Garnsey, and D. Rathbone, eds., *Cambridge Ancient History, XI: The High Empire, AD 70–192.* Cambridge: 874–97.

——. 2001a. 'Inventing Empire in Ancient Rome.' In S. Alcock, T. N. D'Altroy, K. D. Morrison, and C. M. Sinopli, eds., *Empires: Perspectives from Archaeology and History.* Cambridge: 311–22.

——. 2001b. 'The Roman Cultural Revolution in Gaul.' In Keay and Terrenato 2001: 173–86.

——. 2002. 'Afterword: How the Latin West Was Won.' In Cooley 2002a: 181–8.

——. 2004. 'The Present State and Future Scope of Roman Archaeology: A Comment.' *American Journal of Archaeology* 108: 417–28.

Wrede, H. 1981. *Consecratio in formam deorum, Vergöttlichte Privatpersonen in der römischen Kaiserzeit.* Mainz.

Wulff Alonso, F. 1991. *Romanos e Itálicos en la Baja República. Estudios sobre sus relaciones entre la II Guerra Púnica y la Guerra Social (201–91 a.C.).* Brussels.

——. 2003. *Las esencias patrias: historiografía e historia antigua en la construcción de la identidad española (siglos XVI-XX).* Barcelona.

Wyke, M. 1994. 'Woman in the Mirror: The Rhetoric of Adornment in the Roman World.' In L. J. Archer, S. Fischler, and M. Wyke, eds., *Women in Ancient Societies: An Illusion of the Night*. London: 134–51.

Wyke, M., and M. Biddiss, eds. 1999. *The Uses and Abuses of Antiquity*. Bern.

Yaeger, J., and M.-A. Canuto. 2000. 'Introducing an Archaeology of Communities.' In M.-A. Canuto and J. Yaeger, eds, *The Archaeology of Communities: A New World Perspective*. London: 1–15.

Young, L. 1990. 'A Nasty Piece of Work: A Psychoanalytic Study of Sexual and Racial Difference in Mona Lisa.' In Rutherford 1990a: 188–206.

Younger, J. G. 2005. *Sex in the Ancient World: From A to Z*. London.

Zahlhaas, G. 1975. *Römische Reliefspiegel*. Kallmünz.

Zanker, P. 1988. *The Power of Images in the Age of Augustus*. Ann Arbor. (German edition 1987. *Augustus und die Macht der Bilder*. Munich.)

——. 1994. 'Nouvelles orientations de la recherche en iconographie. Commanditaires et spectateurs.' *Revue Archéologique*: 280–93.

——. 1995. 'Individuum und Typus. Zur Bedeutung des realistischen Individual porträts der späten Republik.' *Archäologischer Anzeiger*: 473–81.

——. 2000. 'Bild-Räume und Betrachter im kaiserzeitlichen Rom.' In Borbein, Hölscher, and Zanker 2000: 205–26.

Zanker, P., and B. C. Ewald, eds. 2004. *Mit Mythen leben. Die Bilderwelt der römischen Sarkophage*. Munich.

Zifferero, A., ed. 2000. *L'architettura funeraria a Populonia tra IX e VI secolo a.C. Atti del Convegno. Castello di Populonia, 30–31 ottobre 1997*. Rome.

INDEX